Observation Points

OBSERVATION POINTS

The Visual Poetics of National Parks

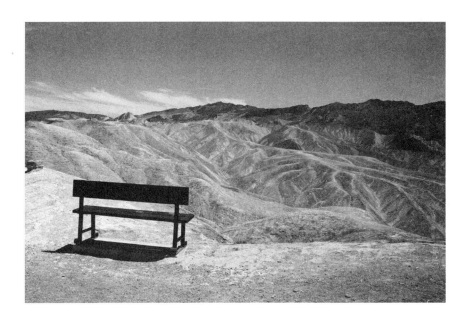

THOMAS PATIN, EDITOR

University of Minnesota Press
Minneapolis
London

An extended version of chapter 3 was published in Peter Frank Peters, *Time, Innovation, and Mobilities: Travel in Technological Cultures* (London: Routledge, 2006), 73–99; reprinted with permission.

Unless credited otherwise, photographs were taken by the authors.

Published by the University of Minnesota Press
111 Third Avenue South, Suite 290
Minneapolis, MN 55401-2520
http://www.upress.umn.edu

Library of Congress Cataloging-in-Publication Data

Observation points : the visual poetics of national parks / Thomas Patin, editor.
 Includes bibliographical references and index.
 ISBN 978-0-8166-5145-0 (hardback)
 ISBN 978-0-8166-5146-7 (pb)
 1. Visual communication—Social aspects—United States. 2. National parks
and reserves—United States. 3. Landscapes—Social aspects—United States.
4. Cultural landscapes—United States. I. Patin, Thomas, 1958– author, editor
of compilation.
 P93.5.O28 2012
 719'.320973—dc23

 2011049359

Printed in the United States of America on acid-free paper

The University of Minnesota is an equal-opportunity educator and employer.

20 19 18 17 16 15 14 13 12 10 9 8 7 6 5 4 3 2 1

To my parents,
for taking me to all those parks when I was a kid

CONTENTS

INTRODUCTION
Naturalizing Rhetoric

Thomas Patin

> When he sits down in front of a literary work, the poetician
> does not ask himself: What does this mean? Where does
> this come from? What does it connect to? But, more simply
> and arduously: *How is this made?*
> —Roland Barthes, "The Return of the Poetician,"
> in *The Rustle of Language*

IN THE SUMMER OF 2009, President Barack Obama and his family visited Yellowstone and Grand Canyon National Parks. Followed by the press, the president and his family looked at geysers and bison in Yellowstone, and the president recounted to Yellowstone officials (and to the press) his childhood visits to that park as well as to the Grand Canyon. Shortly after their visit to Yellowstone, the First Family, again with the press in tow, was gazing over the rim of the Grand Canyon and enjoying a ranger-led tour about geology. Only a few weeks later, in early September, Obama proclaimed September National Wilderness Month to recognize and celebrate the forty-fifth anniversary of the Wilderness Act. Toward the end of that same month, Ken Burns debuted his documentary series *The National Parks: America's Best Idea* on PBS. Interior Secretary Ken Salazar neatly tied this series of events together in March 2010 on the White House blog. In a short written statement with a twelve-minute video as illustration, Salazar recounts the president's visit to the national parks the past summer, situates that visit in the tradition of presidents visiting the national parks, and describes the parks as a "fundamentally American and democratic idea." In fact, Salazar calls the parks "America's best idea," echoing Burns and Wallace Stegner. This idea, Salazar explains,

protects the landscapes, history, and culture that "define us as a nation."[1] The video includes historical photographs of earlier presidents, like Chester Arthur and Theodore Roosevelt, childhood photos of President Obama, and interviews with park officials, historians, and Ken Burns. In the summer of 2010, as if to reinforce the point, Vice President Joe Biden visited Yellowstone and the Grand Canyon, with the press, as part of his "Recovery Summer Tour," inspecting infrastructure repairs funded by the American Recovery and Reinvestment Act.[2] The tour included a speech delivered by the vice president in the bright sunshine at the South Rim of the Grand Canyon, complete with the official vice president's podium perched on the edge of the canyon, which served as an immense backdrop.

Of course, government officials of all stripes have included national parks, monuments, and wilderness areas in visual stagecraft at least as far back as Theodore Roosevelt. In 1903, Roosevelt added a bit of public relations to a vacation in Yellowstone National Park by giving a speech at the dedication ceremony for the arch—now called the Roosevelt Arch—at the north entrance to the park. The arch served then as now as a gateway into and frame for the landscape of the park. Within two weeks Roosevelt's Yellowstone vacation was followed by a visit to the Grand Canyon.[3] More recently, in early January 2000, President Bill Clinton, Vice President Al Gore, and Interior Secretary Bruce Babbitt gathered at Hopi Point in Grand Canyon National Park to announce the creation of Grand Staircase–Escalante National Monument, Grand Canyon–Parashant National Monument, and three other national monuments, as well as the protection of roadless areas within national forests. The presidential podium was there with the canyon serving as photogenic background.[4]

In 2002 President George W. Bush gave two speeches using national monuments as backdrops. In August he discussed national security at Mount Rushmore National Memorial. For that event, the president, cameras, and the audience were positioned in such a way that the president's head was aligned with the heads of the presidents carved in stone behind him. The platform used for the press cameras covering the event was set off to one side, not directly in front of the president as is more common, so that the cameras caught the president's head in profile and in an imaginary or virtual position on the mountain with

the other presidents. "What a magnificent place on such a beautiful day to talk about America and the challenges we face," said Bush. He continued:

> I mean, after all, standing here at Mount Rushmore reminds us that a lot of folks came before us to make sure that we were free. . . . We've got problems, we've got challenges. . . . We've got the challenge of fighting and winning a war against terrorists and we're going to win that war against terrorists. . . . [Applause] I'm glad to come to share that optimism with you in this historic spot. I want to thank the Park managers, the fine, hardworking folks who work for the Park Service, for providing such a magnificent site for our fellow Americans to come and witness history and be a part of nature at its best.[5]

The second address to the nation that year was on the night of September 11, 2002. For that speech, President Bush stood on Ellis Island National Monument with the Statue of Liberty in the background. The statue was lit up with giant Musco lights, which are usually used to illuminate sports stadiums and rock concerts.[6]

Politicians, government officials, artists, and activists have long used the national parks, monuments, memorials, and wilderness areas as implicit and explicit sites of political argument. Since they were established, these places have been the locations of tension over land use, the history of Indian-white relations, and national identity. The conflicts found or set in national parks have ranged from national security, immigration, and firearm regulation to snowmobile use, bison management, wolf reintroduction and management, management of natural resources, helicopter tours and noise, viewsheds, and air pollution. While national parks, monuments, memorials, and wilderness areas of the American West may not be the first places that usually come to mind when we think about rhetoric, the use of park spaces as rhetoric in political argument and for policy announcements makes the parks important sites for the study of visual rhetoric. These culturally significant spaces are usually associated with nature, the history of human interaction with the environment, and more generally with the history of the United States. Through an articulation of the relationship of rhetoric to park spaces, we gain a greater understanding of rhetoric and its power. Even further, the use of the natural world

as a constituent material component of visual rhetoric helps to create extraordinarily powerful, "naturalized," and almost undeniable arguments and rationales for what are ultimately artificial and contingent political positions.

The considerations of visual rhetoric in this volume emerge out of a space opened by recent scholarship on representation and the related consequences for our relationship to the natural world.[7] More specifically, the study of visual rhetoric and national parks offers an opportunity to better understand the consequences of the dissolution of the categories of "the natural" and "the human." As William Chaloupka and R. McGreggor Cawley explain, the term *nature* is an unstable artificial category in constant need of maintenance and reconstruction from the first utterance and is thus implicated in a politics of the environment not only because politicians use parks as rhetorical background but also because the very process of stabilizing representation is unavoidably political.[8] Likewise, Kevin DeLuca, in his research into environmental activism in *Image Politics: The New Rhetoric of Environmental Activism,* has added a much-needed consideration of visual rhetoric to existing discursive theories of politics and social change.[9] The crucial component of representation and its relationship to nature that the authors in this volume address is, of course, visual rhetoric. There is no better place to examine visual rhetoric and its relationship to nature than the national parks, those spaces in America that stand for a seemingly untouched natural world, that act as sites of national identity rooted in the land, and where we find some of the most intense debates on land-use policies. This collection builds upon and adds to the recent scholarship linking visual rhetoric to environmental concerns and activism, as well as to more philosophical problems that include representation and the stabilization or "naturalizing" of representations.

W. J. T. Mitchell has argued that the landscape can be understood as symbolic form, that is, subject matter. A landscape can be represented by painting, but at the same time landscape itself can be "a physical medium" in and through which "cultural meanings and values are encoded," no matter if the landscape in question is a garden, a piece of architecture, or a place we call "nature."[10] Landscape, from Mitchell's view, is always already artificial even in the moment of its beholding, even before it is the subject of a painting, a photograph,

or some other form of representation. The controlled activity of viewing nature from elevated viewpoints, to pick just one small example, is itself a representation of the land as much as are paintings of the landscape. What Mitchell calls the "semiotic features" of landscape are extraordinarily useful for imperialism, for example, creating a space for the expansion of "civilization" while at the same time making expansion into the landscape a "natural" event.[11] Landscape becomes an instrument of social power used to naturalize social and cultural constructs and relations and through which national and individual identities are formed. Landscape, when understood as a historically specific invention of a new visual or pictorial medium, is integrally connected with imperialism. To pursue this possibility, Mitchell suggests that we concentrate on what landscape does, on what is done with it and for whom, rather than on what it is.[12] Mitchell's ideas are quite useful for this book, in that they help us to understand how the landscape is one of the ways in which "nature" can be enlisted for the legitimation of modernity. Instead of seeing landscape paintings, indeed the landscape itself, for its aesthetic value alone, we could see landscape as something very deeply involved in a much larger cultural project.[13]

The essays in this book cover a myriad of subjects from park architecture to landscape painting to orientation films. Each chapter studies the uses and functions of visual rhetoric in, around, and about national parks and the natural environment and helps us to deepen our understanding of such things as nature, American history, environmental policy, and nationalism. From this viewpoint, the examinations of visual rhetoric in this book position national parks and monuments as discursive apparatuses that have produced, limited, and shaped discourses on nature, including human nature, and have justified particular social policies and cultural preferences as natural and necessary. The ultimate interest is in locating the influence that these visual rhetorical devices have had upon our relationship with the world.

I define visual rhetoric as the strategic uses, functions, and operations of a wide range of visual signifying materials and practices (codes, conventions of representation, symbols, angles, motifs, spatial arrangements—whatever) used in addressing an audience in order to accomplish some kind of goal (to create emotional affect, persuade, make sense, form attitudes, induce action, build community or consensus,

negotiate policies, etc.). Of course, "visual rhetoric" also refers to efforts to understand and theorize the uses of visual material for rhetorical ends.[14] Visual rhetoric, then, is also a mode of inquiry, investigation, or criticism. A definition of visual rhetoric should, of course, distinguish it from other previously existing techniques or methods employed in numerous fields of study like art history, communication studies, and cultural studies that deal with visual material. To point to a few examples, iconography, stylistic analysis, biography, or the psychology of reception could all be used to understand visual imagery, but such approaches do not always include an instrumental investigation into the strategic uses or consequences of visual cultural production. My definition of visual rhetoric is quite brief, to be sure, but its brevity has the advantage of being useful, flexible, and widely applicable. The ultimate use of the study of visual rhetoric is to better understand the material techniques through which meaning is shaped. The essays in this volume will add to my own definition, with some of the authors dealing with the problem of visual rhetoric explicitly and directly, and others doing so indirectly.

More generally, this collection is part of a growing general interest in visual rhetoric over the past few decades among scholars in various fields across a wide range of media and historical periods. This volume contains essays by scholars practicing in fields as varied as communication studies, art history and theory, museum studies, modern languages, geography, English, political science, philosophy, and American studies. All want to understand more deeply the workings of visual representations, especially their rhetorical aspects. The investigations contained in these essays are ultimately connected with larger questions of representation that have become central to various fields in the humanities over the past several decades going back at least as far as the work of Roland Barthes.[15]

Since the late twentieth century, there have been a large number of excellent publications that have focused on the problem of visual rhetoric.[16] The range of scholarship on visual rhetoric as it stands today covers a large area delving into a number of specific topics not covered in this volume. One trend has been an investigation of popular visual culture, advertising, digital media, and web design.[17] Other scholars have pursued the uses of visual imagery in literature and in the teach-

ing of writing.[18] Some scholars have also understood visual rhetoric as the visual or "nondiscursive" equivalent to what we might think of in more traditional terms as verbal or "discursive" rhetoric.[19] Still others have been especially interested in the relationships between visual representations and scientific explorations, a development that has been especially prominent in geography.[20] While some other scholarship—most notably Lawrence Prelli's anthology on the rhetoric of display, Greg Clark's use of Kenneth Burke in articulating a generalized rhetoric connected to national parks, and writing on museums and memorials by Greg Dickinson, Carole Blair, and Brian Ott—deals with topics generally related to this volume, there is no sustained study specifically of visual rhetoric as related to national parks. The present volume is an attempt to add to our understanding of visual rhetoric as well as to expand previous studies into a region that far too few have explored in any great depth: visual rhetoric and its relationship to the natural environment.

The title of this essay, "Naturalizing Rhetoric," envelops a double entendre. The title refers to, on the one hand, an event in which rhetoric is hidden, made transparent and invisible, and through that process, it is naturalized. On the other hand, the title implies that it is rhetoric that does the work of naturalizing; that is, rhetoric positions vision and the culturally contingent as natural and through that process justifies and normalizes socially and historically specific arrangements. In both cases, we are returned to the pioneering work of Roland Barthes on the process of naturalizing.

Building on and critiquing Ferdinand de Saussure's model of the sign, Barthes developed a complex and subtle understanding of myth. Myth, to Barthes, is a specific kind of language, a depoliticized and dehistoricized one that gains its power from a transformation of history into nature.[21] From this view, language has the power to make arbitrary, contingent, and culturally specific concepts or social arrangements seem completely *naturalized*: normal, necessary, or justified.[22] Myth accomplishes this effect through the use of compromise, distortion, inflection, or a variety of other ways, in other words, through *rhetoric*. In his later work, Barthes looked closely at the power of denotation and connotation in the process of naturalizing. In discussing photographs, for example, he examined the day-to-day distinction between what is

being photographed (denotation) and how it is photographed (connotation). At first glance, we would consider the former to be simply the subject of the photograph, and the latter to be the rhetorical dimension of the image. On closer inspection, however, Barthes realized that "this purely 'denotative' status of the photograph . . . its 'objectivity'— all risks being mythical [or naturalized] . . . [but], as a matter of fact, there is a strong probability . . . that the [denoted] photographic message . . . is also connoted."[23] Through an understanding of a number of "connotation procedures" (or visual rhetorical devices), Barthes asserts, it becomes more obvious that photographs have no denoted state but exist socially within one or more categories of language. The reading of photographs or other instances of visual culture, then, is not simply an observation of something but is always historical and rhetorical.[24] Like the ostensibly denotative transparency of the photograph, the rhetorical work of national parks as representations is obscured by the stuff of nature: trees, rocks, lakes, and streams.

Following the suggestive and playful possibilities in this essay's title, we can understand the essays of this volume as belonging to two groups, each pursuing one of two paths. The first divergence leads us to consider how rhetoric is hidden, made transparent and invisible, and therefore naturalized. Robert M. Bednar examines various techniques of naturalizing national park spaces through visual and material rhetoric. His study includes visitor centers—displays, interactive didactic materials, and photographs—scenic overlooks as technologies of display, and landscapes used as naturalizing media. Both visitor centers and overlooks are discussed as "display technologies." Bednar argues that these technologies of display installed in the national parks regulate and shape the relationship of visitors to park environments.

After the Civil War and during the industrialization of late-nineteenth-century America, wilderness and national parks were seen as refuges. Zion National Park eventually came to be one prominent example. Gregory Clark examines how Zion was designed to be a place of refuge, focusing on visitors' experience of architecture in the park. This experience has a rhetorical function that prompts an idealized experience of the harmony of nature and society and induces people to remember that harmony and re-create it elsewhere. Rhetorical yet nondiscursive spaces, such as the architecture built at Zion, were de-

signed to prompt those who inhabit them—even temporarily—to new attitudes toward their relationship with nature.

Using the concept of "passages," Peter Peters explores the development of automobile travel in national parks in the American West and looks at the design of automobile access (roads, bridges, visitor accommodations, turnouts, etc.). One result of automobile access to the parks has been an increase in visitation. But, as Peters explains, another result has been the design of specific automobile-related features in virtually all park units and in turn a reconfiguration of the dimensions of space and time into a narrative experience for park visitors. Before park roads, lookout points and park museums were designed to blend into the surrounding landscape. This rustic style was abandoned when the number of visitors arriving by car rose dramatically. Helping these visitors to find their way through the parks became a main objective of the new modernist designs that the National Park Service's Mission 66 program introduced from 1956 onwards. Preserving the wilderness while at the same time circulating increasing numbers of cars through the parks not only required material innovations such as visitor centers, but also resulted in a restyling of representations and the iconography of park nature, thus creating new "intermediary landscapes."

Mark Neumann's essay deals with events that potentially disrupt and expose the invisibility of rhetoric in national parks. In the second half of the twentieth century a number of spectacular events were proposed and/or performed at Grand Canyon that became a source of public outrage and opinion. Whether it was a proposed attempt to walk across the abyss on a tightrope, drive a sports car over the edge, jump the canyon on a motorcycle, or string a chain of brassieres from rim to rim, spectacular stunts such as these were occasions that reveal the contours of the visual and rhetorical politics of nature in our national parks. Neumann argues that such events function as "critical vehicles," to borrow a term from avant-garde artist Krzysztof Wodiczko, that project alternative and marginal meanings into the established and traditionally protected public spaces of national parks. In doing so, these events typically serve to disrupt the stability of a "symbolic complex" that articulates dominant conventions for seeing and appreciating nature. The events become "vehicles" for critically examining how we symbolically and historically imagine the Grand Canyon's dominant and sacralized meaning as a national park.

Sabine Wilke's contribution to this volume begins with the idea that images of the western parks and monuments are not simply unfiltered representations of neutral or arbitrary natural features; these vistas follow a preexisting visual poetic or a grammar that is operative in places like national parks. She looks specifically at a grammar rooted in the tradition of German Romantic landscape painting, especially the work of Caspar David Friedrich. Wilke examines the rhetorical relationship of Friedrich's work to nineteenth-century American painting, especially the Hudson River School, and later paintings of the American West produced by Thomas Moran and Albert Bierstadt, for example. The representation of the sublime and the characteristic element of the "Rückenfiguren"—human subjects in landscape paintings that turn their gaze away from the viewer and toward the landscape—are especially explored in detail. Even more interesting is the idea that the visual rhetoric in operation in many paintings of the western United States is also installed at the sites depicted in those works, the famous vistas visited and viewed by millions of visitors each year in our national parks.

David A. Tschida takes a look at publications available to the general public in visitor centers. The experience of wilderness by tourists at Yellowstone National Park—what we think and know and expect when we are in the park environment—is in part and to some extent shaped by the visual and verbal rhetoric in brochures, magazines, guidebooks, and other publications. Two publications Tschida examines in detail are the National Park Service's *Yellowstone: Official National Park Handbook* and *Yellowstone: Official Guide to Touring America's First National Park*, a publication of the Yellowstone Association. He looks at specific visual rhetorical strategies and devices in both publications, concentrating on the conflicts and tensions that arise between the visual and the written components of the books. In this way, otherwise unnoticed rhetorical aspects are located and articulated.

The second path suggested by the title of this essay leads us to think about how rhetoric can do the naturalizing and, in doing so, work to justify culturally contingent and historically specific social arrangements. Gareth John investigates the "rhetorical framing" of the Yellowstone region in painting and in illustrations in popular magazines and newspapers that stemmed from exploration in the late nine-

teenth century. He looks at how images of Yellowstone were used to naturalize what he calls a "nationalistic rhetoric and capitalist commercial ethos" that was eventually installed in America's first national park and preserved through its establishment. John points to the importance of the concept of landscape as consisting of a set of rhetorical spaces that are richly woven discursive sites.

Teresa Bergman writes about orientation films at Mount Rushmore National Memorial, examining how filmic rhetoric works to stimulate ideals of unity and loyalty. She concentrates on the three orientation films that have been shown to visitors at the memorial's visitor center since 1965. Through an examination of specific rhetorical characteristics of films shown over the years at the memorial, Bergman explains how those films have worked to shape a national identity, to naturalize expansion into the western United States, and to illustrate how manipulating the natural environment defines U.S. citizenship.

William Chaloupka discusses the environmental ethics of Aldo Leopold, especially Leopold's insistence that we all empathize with the earth, as he suggested in his essay "Thinking like a Mountain." Chaloupka looks at specific visual rhetorical aspects of both the Leopold essay and Mount Rushmore National Memorial, especially the personification of nature in both, and considers some larger implications for environmental thought. Chaloupka sees Mount Rushmore as "an odd heterotopia of the personification of nature" that suggests ways to reconceptualize our relationship to nature and the effectiveness of environmental ethics.

The late art historian Albert Boime indirectly deals with visual rhetoric in the work of the nineteenth-century painter George Catlin. Catlin's idea of a "nation's park"—the first idea of its kind—was centered upon a vast wilderness that included indigenous people as well as flora and fauna. Such a park, for Catlin, would be the creation of a primordial Eden that would include the natural histories of a number of supposedly vanishing species, akin to the work of John James Audubon. Catlin was a creature of his class, but, as Boime explains, he was able to make his audience grasp the complexity of Indians as human beings. Boime looks at specific rhetorical forms in Catlin's work, especially the artist's attention to detail and what Boime calls Catlin's "self-taught look." These allowed Catlin to avoid, relatively speaking,

romantic stereotypes in his depictions of Native Americans. Catlin's drawings and paintings and his use of certain rhetorical devices helped to confirm the essential role of wilderness in shaping America's collective imagination and national identity.[25]

Stephen Germic looks at the poetics of national and Native American memorialization. He is especially interested in the complex assertion of American Indian presence in the face of the numerous and persistent assertions of their absence at national parks and monuments and other sites. Germic argues that monuments rest on the value of memory and designation of sites for both mourning and remembrance. Monuments establish their importance through a complex interrelationship of permanence and loss: the permanence of the memorial itself and the loss of that which is memorialized. One example Germic discusses is the complex relationship that Mount Rushmore has as a monument to the indigenous population of the region. He also discusses several smaller and less-known sites of memorialization and argues for an expanded understanding of those sites through a rhetorical reading of their relationship to the history of Indian-white relations and land use in the western United States.

Cindy Spurlock considers how documentary film works as a form of visual commemoration and articulates how it functions rhetorically as an exemplar of national environmental public memory. In a similar way to the "orientation films" offered to the public at many national park visitor centers, Ken Burns's documentary *The National Parks: America's Best Idea* draws heavily from a recognizable visual and narrative epideictic framework that evokes what Michael Billig has termed "banal nationalism." In this way, the theoretical lens of governmentality offers a useful analytic for understanding how "America's Best Idea" works through image and text to invoke what Spurlock identifies as the tropes of "conservation civics" in order to constitutively situate audiences as environmental citizens.

My own essay concerns specific instances of the use of museological rhetoric, or rhetorics of display, at Chaco Culture National Historical Park in New Mexico. I investigate various techniques of presentation at Chaco in order to enhance the visual rhetoric, or visual poetics, subtly installed there. I want to better understand how national park presentations operate upon the visual experience of park visitors in such a way

as to shape and enhance the significance of their encounters with park "resources," in this case ruins and other cultural materials in the park. My goal is to articulate how the presentations of cultural material in parks can be made to appear as if they are not presentations at all but "natural artifacts" that have been unearthed with meaning intact. I further investigate how the messages that park presentations deliver about history, climate change, cultural demise, and Indian-white relations are reinforced by the museological techniques installed in the park.

The reader of this collection may prefer to study its contents by following a number of interrelated themes. One way that visual rhetoric can impact visitors to national parks is by regulating vision. Bednar, Clark, Peters, and I explore not only the fact that national parks are designed but also how the design of those spaces both literally and figuratively shapes our views of parks and park "resources." Related to the shaping of vision is the management of bodies. Peters, John, Bednar, and I all examine the visual rhetoric of display and exhibition at work in national parks and monuments and try to understand the implications of the operations of visual and spatial rhetoric on the bodies of park visitors. The history of Indian-white relations is another theme that is explored in relationship to national parks, especially in essays by Bergman, Boime, and Germic. All three of them look at how the history of the United States, especially its relationships to native peoples, is articulated in and through representations of history that are found in national parks and monuments. In fact, Boime articulates the crucial relationship of American westward expansion to native peoples that existed in one of the earliest inceptions of the national park idea. Another theme, considered by Neumann and Peters, is the nondiscursive, symbolic, visual, and even invisible rhetoric in national parks. Rhetoric is not always immediately apparent and needs to be articulated to understand its importance to and effects on park visitors. Following that theme, Wilke, Spurlock, Bergman, Tschida, Bednar, and I take a look at the visual rhetoric borrowed from art, museums, film, design, and mass media and installed in various ways in parks and monuments. National parks and monuments have been used for generations in the creation and maintenance of an American national identity. Bergman and Spurlock explore how the use of national parks and monuments in filmic representations of "America" has been crucial in recent years to

the rhetorical formation of a national identity. Finally, environmental ethics and conservation is a theme that is studied in depth by Chaloupka and Spurlock and briefly by myself. The national parks and their uses as rhetorical figures make powerful messages about the environment and our relationships to it. In common to all the essays gathered here, to a lesser or greater degree, are the interrelated themes of the regulation of vision and of bodies, the import and significance of our experiences of the world, and the shaping of national identity.

Whether the author articulates a process by which rhetoric is hidden, transparent, or invisible and in that way naturalized, or whether the author is describing how rhetoric works to naturalize and therefore justify culturally specific social arrangements or notions of history and identity, each essay in this book concentrates on a specific visual, spatial, or rhetorical form found in our national parks and monuments. Each writer labors to illustrate how the rhetorical form under consideration exerts its powerful effects on our relationships with the world and with one another.

NOTES

1. Ken Salazar, The White House Blog: "Mr. President Goes to Yellowstone," posted March 16, 2010, 12:49 p.m. EDT, http://www.whitehouse.gov/blog/2010/03/16/mr-president-goes-yellowstone.

2. See Jonathan Jarvis, The Recovery Blog: "The Vice President and the Recovery Act Go to Yellowstone," posted July 28, 2010, at 04:47 p.m. EDT, http://www.whitehouse.gov/blog/2010/07/28/vice-president-recovery-act-go-yellowstone; and Jonathan Jarvis, The Recovery Blog: "The Vice President and the Recovery Act on the South Rim of the Grand Canyon," posted July 30 at 2:30 p.m. EDT, http://www.whitehouse.gov/blog/2010/07/30/vice-president-and-recovery-act-south-rim-grand-canyon.

3. See Lee Whittlesey and Paul Schullery, "The Roosevelt Arch: A Centennial History of an American Icon," *Yellowstone Science* 11, no. 3 (Summer 2003): 2–24.

4. The White House, "Preserving America's Natural Treasures," http://clinton4.nara.gov/CEQ/earthday/ch1.html.

5. The White House, released August 15, 2002, "President Discusses Homeland and Economic Security at Mt. Rushmore," http://georgewbush-whitehouse.archives.gov/news/releases/2002/08/20020815.html.

6. Elisabeth Burniller, "Keepers of Bush Image Lift Stagecraft to New Heights," *New York Times,* May 16, 2003, http://www.nytimes.com/2003/05/16/us/keepers-of-bush-image-lift-stagecraft-to-new-heights.html?pagewanted =3&src=pm.

7. The literature on the relationship of representation and the natural world is limited. See W. J. T. Mitchell, "Imperial Landscape," in *Landscape and Power,* ed. W. J. T. Mitchell (Chicago: Chicago University Press, 1994), 5–34; Verena Andermatt Conley, *Ecopolitics: The Environment in Poststructuralist Thought* (London: Routledge, 1997); William Chaloupka and Jane Bennett, eds., *In the Nature of Things: Language, Politics, and the Environment* (Minneapolis: University of Minnesota Press, 1993); and Kevin DeLuca, *Image Politics: The New Rhetoric of Environmental Activism* (New York: Guilford Press, 1999). The literature specific to visual rhetoric and national parks is even more limited. Greg Clark's *Rhetorical Landscapes in America: Variations on a Theme from Kenneth Burke* (Columbia: University of South Carolina Press, 2004) is occasionally about national parks and only partly includes analyses of visual rhetoric. Michael Halloran and Greg Clark's "National Park Landscapes and the Rhetorical Display of Civic Religion," in *Rhetorics of Display,* ed. Lawrence J. Prelli, 141–56 (Columbia: University of South Carolina Press, 2006), however, maintains more specific attention to the visual rhetoric of presentation in national parks. See also William Wyckoff and Larry Dilsaver, "Promotional Imagery of Glacier National Park," *Geographical Review* 87, no. 1 (1997): 1–26. My own work on national parks and visual rhetoric includes "Turnouts, Dioramas, Rhetoric, National Parks," presented at the Southwest Art History Conference, October 2010, Taos, N.Mex.; "Naturalizing Rhetoric: Environmental Politics and the Visual Poetics of National Parks," a panel I organized that included several of the authors in this volume at the National Communication Association annual national conference, San Antonio, 2006; "Western Views and Eastern Visions: National Parks, Manifest Destiny and American Identity," in *Preserving Western History: A Reader on Historic Preservation and Public History in the American West,* ed. Andrew Gulliford (Albuquerque: University of New Mexico Press, 2005); "Vignettes of America: National Parks, Distant Views, and Environmental Politics," College Art Association National Conference, New York City, February 2000; panel, "Landscape and Ecology in Historical Perspective," College Art Association National Conference, New York City, February 2000; "Exhibitions and Empire: National Parks and the Performance of Manifest Destiny," *Journal of American Culture* 22, no. 1 (1999); "Parks, Exhibition, and Empire," American Studies Association national conference, Seattle, November 1998; panel, "Empire, Expansion, and Environment," American Studies Association national conference, Seattle, November

1998; "The National Park as Museological Space," at People and Place: The Human Experience in Greater Yellowstone, Yellowstone National Park, 1997, a conference commemorating the 125th anniversary of the founding of the park; panel, "Yellowstone on Display," People and Place: The Human Experience in Greater Yellowstone, Yellowstone National Park, 1997 (proceedings later published in *People and Place: The Human Experience in Greater Yellowstone*, ed. Paul Schullery [Mammoth, Wyo.: Yellowstone Center for Resources, 2004]).

8. William Chaloupka and R. McGreggor Cawley, "The Great Wild Hope: Nature, Environmentalism, and the Open Secret," in *In the Nature of Things*, ed. Chaloupka and Bennett.

9. Most notably, Ernesto Laclau and Chantal Mouffe, *Hegemony and Socialist Strategy: Towards a Radical Democratic Politics* (London: Verso, 1985).

10. Mitchell, "Imperial Landscape," 14.

11. Ibid., 17.

12. Mitchell, introduction to *Landscape and Power*, 1.

13. Mitchell, "Imperial Landscape," 10.

14. For further elaboration on the idea of visual rhetoric as a mode of inquiry or study, see Janis Edwards, "Visual Rhetoric," in *21st Century Communication: A Reference Handbook*, ed. William Eadie (Thousand Oaks, Calif.: Sage Publications, 2009); and Sonja Foss, "Theory of Visual Rhetoric," *Handbook of Visual Communication: Theory, Methods, and Media*, ed. K. Smith, S. Moriarty, G. Barbatsis, and K. Kenney (Mahwah, N.J.: Lawrence Erlbaum, 2005).

15. I am thinking here especially of Roland Barthes, *Mythologies* (New York: Hill and Wang, 1972); and Barthes, *The Responsibility of Forms* (New York: Hill and Wang, 1985).

16. Some of the studies that have been published in recent years dealing specifically with the problems of visual rhetoric are Mieke Bal, "Visual Poetics: Reading with the Other Art," in *Theory between the Disciplines: Authority/Vision/Politics*, ed. Martin Kreiswirth and Mark A. Cheetham (Ann Arbor: University of Michigan Press, 1990); David Blakesley and Colin Brooke, guest eds., *Enculturation* 3, no. 2 (a special issue on visual rhetoric) (Spring 2002), http://enculturation.gmu.edu/3_2/); Norman Bryson, "The Natural Attitude," in *Visual Culture: The Reader*, ed. Jessica Evans and Stuart Hall (London: Sage, 1999); Norman Bryson and Michael Ann Holly, eds., *Visual Theory* (New York: Harper Collins, 1991); Norman Bryson, Michael Ann Holly, and Keith Moxey, eds., *Visual Culture* (Hanover, N.H.: Wesleyan University Press, 1994); Clark, *Rhetorical Landscapes in America*; Greg Dickinson, Carole Blair, and Brian L. Ott, eds., *Places of Public Memory: The Rhetoric of Museums and Memorials* (Tuscaloosa: University of Alabama Press, 2010); Edwards, "Visual Rhetoric"; Michael Emmison and Philip Smith, *Researching the Visual: Images, Objects,*

Contexts and Interpretations in Social and Cultural Inquiry (London: Sage, 2000); Jessica Evans and Stuart Hall, eds., *Visual Culture: The Reader* (London: Sage, 1999); Kristie S. Fleckenstein, Sue Hum, and Linda T. Calendrillo, eds., *Ways of Seeing, Ways of Speaking: The Integration of Rhetoric and Vision in Constructing the Real* (West Lafayette, Ind.: Parlor Press, 2007); Foss, "Theory of Visual Rhetoric"; Halloran and Clark, "National Park Landscapes and the Rhetorical Display of Civic Religion"; Robert Hariman and John Louis Lucaites, *No Caption Needed: Iconic Photographs, Public Culture, and Liberal Democracy* (Chicago: University of Chicago Press, 2007); Ian Heywood and Barry Sandywell, eds., *Interpreting Visual Culture: Explorations in the Hermeneutics of the Vision* (London and New York: Routledge, 1998); Charles A. Hill and Marguerite Helmers, eds., *Defining Visual Rhetorics* (Mahwah, N.J.: Lawrence Erlbaum, 2003); Martin Jay, ed., "The State of Visual Culture Studies," a themed issue of *Journal of Visual Culture*, 4, no. 2 (August 2005); Nicholas Mirzoeff, ed., *The Visual Culture Reader* (London: Routledge, 1998); Timothy Mitchell, "Orientalism and the Exhibitionary Order," in *The Visual Culture Reader,* ed. Mirzoeff; W. J. T. Mitchell, "Interdisciplinarity and Visual Culture," *Art Bulletin* 77 (December 1995); W. J. T. Mitchell, *Iconology: Image, Text, Ideology* (Chicago: University of Chicago Press, 1986); W. J. T. Mitchell, *Picture Theory* (Chicago: University of Chicago Press, 1994); Keith Moxey, *The Practice of Persuasion: Paradox and Power in Art History* (Ithaca, N.Y.: Cornell University Press, 2001); Lester C. Olson, Cara A. Finnegan, and Diane S. Hope, eds., *Visual Rhetoric: A Reader in Communication and American Culture* (Los Angeles: Sage, 2008); Brian Ott and Greg Dickinson, "Visual Rhetoric and/as Critical Pedagogy," in *The Sage Handbook of Rhetorical Studies,* ed. A. Lunsford, K. Wilson, and R. Eberly (Los Angeles: Sage Publications, 2009); Gillian Rose, *Visual Methodologies* (London: Sage, 2001); John Walker and Sarah Chaplin, "Visual Literacy and Visual Poetics," in *Visual Culture: An Introduction* (Manchester: Manchester University Press, 1998). There are still many more texts that explore visual rhetoric through discussions of specific cultural products and even more that deal with visual culture studies in general.

17. See, for example, David S. Kaufer and Brian S. Butler, *Rhetoric and the Arts of Design* (Mahwah, N.J.: Lawrence Erlbaum Associates, 1996); Carolyn Handa, *Visual Rhetoric in a Digital World: A Critical Sourcebook* (Boston: St. Martin's Press, 2004); Lester Faigley, "Material Literacy and Visual Design," in *Rhetorical Bodies: Toward a Material Rhetoric,* ed. Jack Selzer and Sharon Crowley (Madison: University of Wisconsin Press, 1999), 171–201; and Craig Stroupe, "Visualizing English: Recognizing the Hybrid Literacy of Visual and Verbal Authorship on the Web," *College English* 62 (2000): 609.

18. Richard A. Lanham, "What's Next for Text?" in *The Economics of*

Attention: Style and Substance in the Age of Information (Chicago: University of Chicago Press, 2006); Wendy S. Hesford and Brenda J. Brueggemann, eds., *Rhetorical Visions: Reading and Writing in a Visual Culture* (Upper Saddle River, N.J.: Pearson Prentice Hall, 2007); "Assignments for Visualizing the Writing Process," http://viz.cwrl.utexas.edu/node/391; and Mary Hocks, "Understanding Visual Rhetoric in Digital Writing Environments," *College Composition and Communication* 54, no. 4 (June 2003): 629–56.

19. See, for example, Bal, "Visual Poetics"; Heywood and Sandywell, *Interpreting Visual Culture;* and Russell Willerton, "Visual Metonymy and Synecdoche: Rhetoric for Stage-Setting Images," *Journal of Technical Writing and Communication* 35, no. 1 (2005): 3–31.

20. A few examples: Sally Gomaa, "Theorizing Practice, Visualizing Theory, and Playing by the Rules," in David Blakesley and Colin Brooke, guest eds., *Enculturation* 3, no. 2 (Spring 2002) (a special issue on visual rhetoric), http://enculturation.gmu.edu/3_2/); and Wyckoff and Dilsaver, "Promotional Imagery of Glacier National Park."

21. Barthes, *Mythologies,* 129.

22. Ibid.

23. Barthes, "The Photographic Message," in *The Responsibility of Forms,* 7.

24. Ibid., 16–17.

25. Professor Albert Boime died while this book was being assembled. He had a great influence on my research and was an inspiration to many other scholars and students, and I am honored to include one of his essays in this collection. In one of his last publications he summarized the object of his life's work: "By examining the political forces that motivated the art makers and finders, and revealing the hidden mainsprings in visual production, I truly believed that I was contributing to the emancipation of thought, at least in one small corner of the minds of my students and readers. Thus art history became my raison d'être, a vehicle for enhancing the lives of my fellow citizens, while at the same time bringing about a nanno-change toward social justice in society"; Albert Boime, *The Birth of Abstract Romanticism* (San Francisco: Sybil City Book Co., 2008), xiii.

1. BEING HERE, LOOKING THERE

Mediating Vistas in the National Parks of the Contemporary American West

Robert M. Bednar

IN *LANDSCAPE AND POWER,* W. J. T. Mitchell argues that understanding landscape means thinking of landscape as "a dynamic medium," "not as an object to be seen or a text to be read, but as a process by which social and subjective identities are formed."[1] For Mitchell, "A medium is more than the materials of which it is composed"; it is "a material *social practice,* a set of skills, habits, techniques, tools, codes, and conventions."[2] Therefore, to analyze landscape as a medium is to "trace the process by which landscape effaces its own readability and naturalizes itself," that is, the process by which landscape hides the practices that shape it, the process by which landscape presents and represents itself "as if it were simply given and inevitable," and the process by which landscape "makes that representation operational by interpellating its beholder in some more or less determinate relation to its givenness as a sight and site." In short, analyzing landscape as a medium asks "not just what landscape 'is' or 'means' but what it does, how it works as a cultural practice."[3]

Mitchell says that all landscapes obscure the mediations that constitute them, but I would argue that landscapes that are defined and experienced as "natural" landscapes, such as those in the national parks of the contemporary American West, are even more powerfully naturalized. Like other places, national parks are "implicated within complex networks by which 'hosts, guests, buildings, objects and machines' are contingently brought together to produce certain performances in certain places at certain times."[4] A national park is not a fixed, static object waiting to be witnessed by a visitor with an equally

fixed, static identity, but parks and visitors are not totally unformed either. Studying the built environment of a landscape—the material infrastructure that enacts and enables those contingent convergences—must make sense of indeterminacy but also wrestle with the objects that exist there. This is true of both the technologies that display landscape and the landscape framed as a visual object. Both appear to be already complete objects "out there" in front of a visitor encountering them, but are more accurately characterized as intersubjective, dialogic, spatio-temporal "third spaces" that are always already "real-and-imagined," subject-and-object, and actor-and-acted-upon.[5] What is more, each encounter with and in landscape is shaped by the cultural history of previous encounters, particularly those that get fed back into the visual culture of place, but this history does not predetermine the outcome of any landscape encounter.[6] In this context, practice is the key bridge between objects and bodies.[7] Tim Cresswell argues that bodies and places "only operate through constant and reiterative practice": every day, people encounter buildings they did not build, buildings for which they "had no say in their material existence." As Cresswell says, "In a very banal but important way they are the structures that, like it or not, we have to practice in and around. We can use them very creatively but within limits unless we are predisposed to walk through walls or plant bombs."[8]

The national parks interpellate visitors who want to have an embodied experience of something they may have only experienced in other mediations. The parks are designed to deliver unmediated experiences through a different, less visible medium: a park's built environment, which rhetorically promises, enacts, and enables immediacy while mediating on a more subtle, embodied level. The most deeply sedimented forms of naturalized and naturalizing rhetoric in the national parks are manifested in display technologies like visitor center installations and scenic overlooks, which present themselves as if their function, meaning, purpose, and process are materially self-evident. Within them, there may or may not be overt rhetorical appeals, but the material form is a silent instructor that manifests those more overt appeals while also working at a different level—at the level of the body, where things may be felt and responded to without necessarily being verbalized or visualized (Figure 1.1).

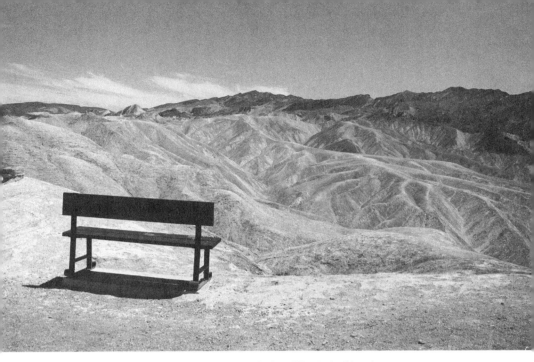

Figure 1.1. Zabriskie Point, Death Valley National Park, California.

The main purpose of this chapter is to show how the naturalized and naturalizing visual rhetoric of the national parks is always already rooted in both the material display technologies and material social practices that mediate every park experience. Roads, road signs, boundary signs, visitor center displays, scenic overlook structures, and trails in national parks are not simply the *means* for experiencing the national parks, but the *medium* through which the national parks present themselves as natural landscapes.[9]

Beginning with the boundary signs made of "indigenous" stone and wood that identify the border crossing and extending to signs pointing to some things and not to others, National Park Service (NPS) technologies of display function as *difference machines*: as material techniques that show landscape as a set of self-contained, unique vistas that are different from the tourists' home spaces, different from vistas in other national parks, and different from other vistas within the local park itself (Figure 1.2).[10] This differentiating function is echoed not only in the built environment of the parks but also throughout NPS communications and in the National Park System itself, where the separate

units of the park system must be connected enough to appear to be in the same system in order to give them all an identity as parks in relation to other spaces, but also must be internally differentiated from one another to have their own identity. And, as scholars such as David Louter and Peter Peters have shown, the standardization and differentiation function of the parks has become increasingly embedded within a presumption of automobility, where cars not only deliver visitors to mediated landscapes but also mediate their experience once there.[11] From slow, winding roads and the forty-five-miles-per-hour speed limit, which give a certain pace as well as a sequence to the experience of landscape as a "scenic narrative," to the design and choice of paving material for a hiking trail, the built environment of a national park functions as both means and medium.[12] Certainly, as scholars such as David Tschida have shown, NPS publications and guidebooks can be powerful rhetorical sites that mediate visitor experiences in important ways as well, but my main concern here is for the physical sites where that interaction occurs once visitors are in the parks.[13] There, objects in the built environment enact and rep-

Figure 1.2. Windows Trail, Arches National Park, Utah.

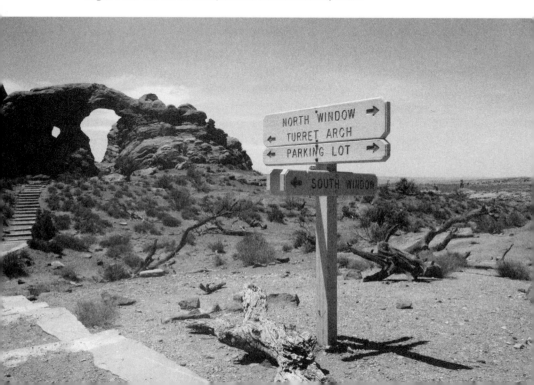

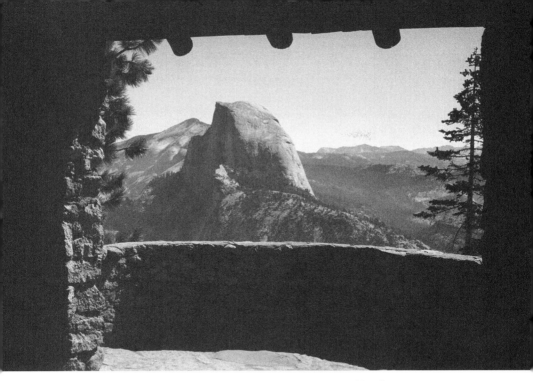

Figure 1.3. Half Dome Overlook, Yosemite National Park, California.

resent the "skills, habits, techniques, tools, codes, and conventions" that make national park landscapes function as "material social practices." They are also the primary mechanisms by which a national park "effaces its own readability and naturalizes itself" *and* interpellates visitors who come to witness them as natural sights and sites (Figure 1.3).

Both technologies and practices position eyes that see and photograph within bodies that inhabit and negotiate spaces in particular ways, so my work engages material as well as visual dimensions of the spaces and practices of tourism in the national parks. A visual/material approach to the cultural study of tourism, landscape, and photography involves analysis of the visual and material dimensions not only of the representational objects landscape tourism produces (photographs, postcards, guidebooks, maps, advertising, etc.), but also the practices within which these objects are produced, distributed, and consumed as well as the built environment that mediates both the material objects and practices and the people who are tied up with all these objects

and practices.[14] Here, I am most focused on mediating practices and on elements of the built environment that function as on-site tourist landscape media in themselves: visitor center displays, telescopes, and scenic overlooks.[15]

Inhabiting Display Technologies and Practices in the National Parks

On a wall in the log cabin–style Point Supreme Visitor Center at Cedar Breaks National Monument hangs an interactive installation (Figure 1.4). The top part is a montage of six photographs of different scales and alignments that partially overlap each other. Below this montage is a set of six hinged panels of uniform size and alignment. From a distance, the panels appear to be captions for the pictures, but closer to them, it becomes clear that the panels are part of an interactive Q&A display: each panel features a question and a handle at the bottom, and behind each panel is another panel printed with an answer.

As a visual, linguistic, and material technology of display, the installation is an example of what Gunther Kress and Theo van Leeuwen

Figure 1.4. Point Supreme Visitor Center, Cedar Breaks National Monument, Utah.

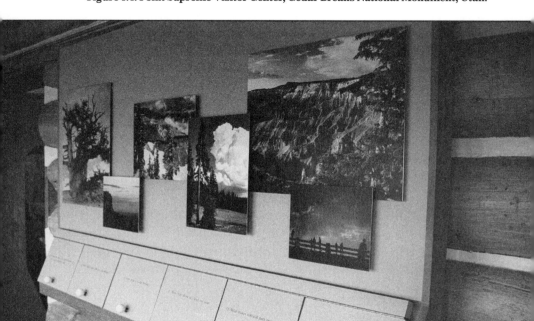

call a "multimodal" text: a culturally embedded communication form made up of different symbolic elements from different paradigms of meaning, whose overall function, use, and meaning are produced and consumed at the intersection of linguistic, visual, and material modes of communication.[16] While the Q&A installation presumes acts of looking and reading (literally as well as figuratively), it also presumes a more embodied relationship with it as a material signifying object. Indeed, the written text itself is only a small part of a complexly structured rhetorical display of knowledge whose "message" is carried not only by the words printed on the panels but also by the visual and material form of the statement as it is embedded in the larger installation. The linguistic elements are the most obvious in their attempt to educate and persuade an audience, but each mode communicates something "by itself" *and* in relation to the other modes, making for an "excessive" cultural form that is not reducible to the sum of its parts. In this way, analyzing the installation will provide a useful starting point for a more general analysis of embodied visualities in the tourist spaces of the national parks. For analytical purposes, I will separate out the three main modes—linguistic, visual, and material—before bringing them back together to theorize their interactive complexity.

The installation features six question-and-answer panels. Alongside finite, place-specific questions that presume finite answers—such as "Why is this area called Cedar Breaks?" and "How deep is Cedar Breaks?" and "How high above sea level are you?"—is an open-ended question: "What makes national park areas special?" Lifting the hinged door reveals the answer: "National park areas are set aside to preserve nationally significant resources of natural, historical, cultural, and scientific interest. The National Park Service has the difficult mission of conserving and protecting these features, yet still providing for their use by visitors."

The question "What makes national park areas special?" is misleadingly simple. It asks for readers to identify one thing that makes the parks special. Most important, the question presumes that the reader already agrees that national park areas *are* "special." By interpellating an audience that already believes that the parks are special, the question is already working to align readers with its implicit value system. The question is formulated as if it has a definite answer that can be

"known," can be formulated as *the* answer to the question, and then can be revealed behind the panel, but clearly there are multiple possible answers to this question and many possible places from which to answer the question. Is there one thing that makes them special? Special to whom? Special in relation to what? In this regard, it is interesting to imagine how readers might answer the question in their minds before lifting the panel, and how they might converge on or diverge from the one revealed on the panel.

This process of aligning readers with an objectified subjectivity and constraining possible interpretations of the installation is continued even more explicitly in the text written on the answer panel. The first sentence, "National park areas are set aside to preserve nationally significant resources of natural, historical, cultural, and scientific interest," addresses the question of what constitutes a "special" area. It seems to be a flat statement of fact, but it, too, closes down a number of questions it raises. The key terms here seem to be *preserve, nationally significant, resources, interest,* and *set aside.* Why and how are they preserved? In what condition? For what purpose? By whom? What constitutes a "nationally significant" area? What does it do to a river, a tree, a mountain, a bear, or a building to be named a "resource"? To whom, why, when, and how are these areas "of interest"?

By including the phrase "are set aside to preserve" the "resources," the statement addresses a subtle dimension of the question: the issue of *making* contained in the question about what *makes* the areas special. In this case, it is not just an objective essence of a thing that *has* interest that qualifies it for designation as a national park area, but also the act of setting it aside itself. A national park area not only *is* special, it is *designated as* special, and what makes that happen is the act of setting it aside, placing it elsewhere, beyond the realm of everyday environments as well as everyday meanings. This is especially apparent in the U.S. national parks, and particularly in the large-scale landscape- and wildlife-oriented "nature" national parks of the American West. Since Yellowstone was established in 1872, the western national parks have played the role of the Other of culture, an elsewhere where many people visit but where no one "lives." The underlying principle behind this symbolism is that the "natural" national parks are "special" because they are different from and (more importantly) *should be* maintained in

contrast to culture, to "artificial" modern and now postmodern urban America. Of course, because national parks are managed and experienced within larger discourses of place-making and meaning-making, the parks do not sustain that separation. Likewise, the visitors themselves bring their culture with them as well, so the interrelation between similarity and difference in tourist spaces is always complex. As Chris Rojek argues, "Tourism is not a break or escape from everyday life. Rather, it provides a plane of cultural difference in which everyday life routines are contrasted and developed."[17]

The Cedar Breaks visitor center panel's statement could have ended with the first sentence and been an adequate answer to the question, but it continues, moving away from describing the places that are special and moving toward articulating more directly what it means to the NPS to *manage* these "special" areas: "The National Park Service has the difficult mission of conserving and protecting these features, yet still providing for their use by visitors." This sentence defines the NPS's job in terms of an apparent conflict. I say "apparent" because using the phrase "yet still" conjoins the two parts of the sentence into a contradiction that also interpellates a reader who believes that these two acts—conserving/protecting and providing for use—*are* presumed otherwise to be mutually exclusive functions. But the statement takes it one step further, defining the mission of the NPS not only as anomalous but also "difficult." It clearly articulates its mission as a conflict, as a tension, as at best a "difficult" balancing act between what it presents as binary opposites: protecting for versus providing for, or protecting for and from, presenting to while protecting from.[18] This tension between "presenting to" while "protecting from" is present in all national parks, whether they are presenting/protecting landscape, wildlife, artifacts, "nationally significant" buildings, or preserved ruins.[19] It is also the same difficult balance that public museums must negotiate in their interface with the public. But just as museums that encourage people to "look but not touch" must do so with linguistic, visual, and material means and media, NPS display technologies present landscape as a visual object while disciplining bodies in spaces.[20] Those bodies must be organized to be able to make the parks available for temporary but not permanent inhabitation. The distinctive nature of the inhabitation demands a dialectic of connection and disconnection: come on in and

make yourself at home, but keep moving; you may visit as often as you like, but you may not stay. As explicitly and exclusively tourist landscapes, they define the relationship to what is seen and experienced as an always temporary phenomenon.[21]

While the words used in the panels are important, the medium through which they are encountered and "read" is as well. The question about what makes national park areas special both speaks from and against the rest of the installation. This particular panel comes near the end of the installation (presuming a left-to-right reading orientation), meaning that if readers had interacted with the other panels before this one and had gotten definite answers to definite questions, then the partiality of this question would be effectively masked. In this context, the question just to the left of the "special" panel—"How high above sea level are you?"—starts to look like a transition. Like the other four questions, the question about altitude sets up the question to have only one objectively true answer (10,350 feet/3,155 meters, as it says), but it also does so by using a direct mode of address, asking "you" if "you" know how high above sea level "you" are, instead of asking a question more abstracted from the subjectivity of the visitor, such as "How high above sea level is Cedar Breaks?" Opening the panel reveals "the" answer to what has now become "your" question.

The fact of the landscape's altitude is presented as if it is known but not necessarily known (yet) by "you." In asking "you" to locate yourself in relation to an objectified abstraction (feet above sea level), the question functions as a metonym of the rhetoric of display operating in the national parks in general. Recall Mitchell's point about landscape and interpellation: landscape presents and represents itself "as if it were simply given and inevitable" and "makes that representation operational by interpellating its beholder in some more or less determinate relation to its givenness as a sight and site." Completing the process here means using the technology the way it was designed to be used, which itself means inhabiting the subject position presented to "you." "Your" job is to situate yourself in relation to the generalized designs, to make the parks, as well as the NPS discourse *about* the parks, "your" own.

In this context, it is important that the structure of the interactive elements of the Cedar Breaks installation presumes that the NPS imagines and addresses a visitor that wants/needs to be instructed, a

visitor who does not know these things and therefore must be taught them. But instead of simply *telling* the visitor the information, the display presents the information in the form of a *sequential experience* for the visitor: first, reading the question; second, deciding consciously or not to follow the structure to the answer; third, imagining the answer before and while, fourth, reading the answer, which completes the process and the text. The space of narrative is focused "between" and "after" the two panels, in the imaginative act of predicting the answer as well as the reconciling act of either accepting or rejecting the answer as an appropriate answer to the question.

This sequential experience takes the form of a potential narrative waiting for particular visitors encountering it to bring it into existence through "the medium of bodily action."[22] And because it is a narrative that cannot be performed without physical interaction *at* the site, it may provide another metonymic representation of the larger NPS interpretive project, which clearly seems drawn to "experiential," instructional display practices in its approach to one-way scenic loop roads, trails, and even visitor center slide shows. With the altitude panel and the "special" parks panel, the imagined visitor is interpellated by words represented and presented in a certain visual/material object that demands a certain kind of embodied, sequential process of questioning, wondering, and then "knowing" that unfolds over time and through physical interaction within a particular space. Therefore, physically interacting with the panels materially represents *and* enacts the process of witnessing the NPS revealing the parks to visitors. The NPS presumes to know "us," presumes that it knows what we know and what knowledge we "want" (in terms of both desire *and* lack).[23] The NPS knows the answers and invites visitors to learn the answers from them by offering them structures of display that are presumed to communicate their function automatically, and where even the most open-ended questions have predetermined definite answers that the visitor must be guided toward so that they can make them their own. This reinforces the more deeply naturalized rhetorical frame materialized by the parks: that the only way to know the parks is to see them for yourself, which entails looking at them while you are physically embodied in them, moving through them, engaging them, touching them, *being* in them.

To appreciate the distinctiveness of this structure and its encoded process, it may help to imagine the process occurring through a different medium. Imagine learning the answer to the question about altitude from reading it on a map, reading it in a brochure, or reading it on the placard on top of the wall at the Point Supreme scenic overlook instead. All of these modes would rely on a visitor either having preexisting interest in the question or being somewhat randomly exposed to the answer. A more fully embodied interaction, where a park ranger personally asked "you" to guess "your" altitude, is unlikely to occur, but even if it did, it would unfold in a differently constrained interpersonal encounter, not a predetermined media structure that fully constrains the question, the answer, and the process of finding out the answer, treating visitors "as if" they themselves are also already known. Such displays position visitors in relation to both the objects *of* display and the objects *on* display. "You" are offered only one choice: enter the epistemological process as it is designed for you or keep moving.

Just as the Q&A format of the installation frames the written text in a certain way, producing a mode of interaction that communicates independently of the specific words and sentences used, the composition of the separate photographs into a text materializes and displays other extralinguistic "messages." But where the reading process with the panels is structurally linear, unfolding *temporally* in a predetermined sequence, the individual photographs, the collage of photographs, and the relationship between the photographs and the panels within the context of the whole installation are structured *spatially* (with this next to that or far from that, connected to this/that, disconnected from this/that instead of before/after this/that).

The photographs represent different objects: a weathered bristlecone pine tree, a cliffside sunset, a snowscape, a high mountain meadow ringed with tall conifer trees, a lightning strike foregrounded by the fence of the Point Supreme Overlook (which itself is just up the path from the visitor center where this installation is located), and the iconic view of the Cedar Breaks rock formation that is presented by that scenic overlook. There is no written text telling us what connects these images together or what separates them. Given their placement in a visitor center in the middle of Cedar Breaks National Monument, it makes sense to presume that the photographs represent different aspects of Cedar

Breaks, but such a reading is entirely context specific, derived from being in that space, seeing those pictures organized that way.

Considered as a single text, the photographs take the form of a collage. The photographs are set up in an irregular pattern and overlap each other. None of the photographs has a frame around it. All of the photographs are visually striking but naturalistically composed without obvious stylistic signatures that might call attention to their constructedness as photographs, which makes the elements of nature appear to be always already objectively beautiful—*naturally* well composed, vividly colored or contrasted, lush, monumental. But whatever else is communicated by the individual photographs through their internal composition, signification, and aesthetics, the collage structure itself shows something through its material and spatial form: that there are specific things to encounter in Cedar Breaks, and these things are separate but related. These different things are "naturally" self-contained objects or scenes that can be witnessed in the park. More important, these are scenes that can be captured in photographs—if not by "you," then at least by a professional photographer. Composed together into the collage, the photographs represent the identity of the place by showing the separate but connected and overlapping aspects it contains. These are the things that together give Cedar Breaks its identity, the things that make Cedar Breaks itself.

Like the Q&A structure, the collage presents itself as an incomplete text: a collection of objects, words, and/or pictures waiting for a visitor to incorporate them into their experience. However, while both components of the installation presume an embodied interaction with it to "complete" the text, they do not display any explicit instructional information about *how* to interact with the installation. There are no didactic verbal or iconic visual directions for how to use it; it simply sits there waiting for someone to come up to it and enter its material system of organization, and thus its sense world. The material form of the installation as a whole represents and enacts its own mediation: national parks are places where the NPS displays objects, words, and visions to visitors, who have come there to make them their own by temporarily inhabiting them. The whole process is presented as if it is natural for landscape to be presented as an object to be witnessed, natural for visitors to want to interact with the landscape as if it is "given," and natural to employ "inevitable" and self-evident modes of interaction as well.

Thus, while the content and the Q&A format of the hinged panels presume and address users who need to be instructed, the overall installation does not. Instead, the installation addresses visitors as if they already know how to use the installation. Instructions for use then become the taken-for-granted, commonsense thing that "everyone knows," an absent presence rendered all the more central to the functioning of the installation because it is not brought to the surface of the discursive engagement between the people who produce the parks and those who consume them. Its instructions are entirely implicit, presented as though they are already known, presented as though they already make sense, presented as though there is no question about their function and meaning, presented as if everything is materially self-evident. In a word, they are presented as though they are *natural.*

Materializing Telephoto Aesthetics: Being Here, Looking There

A good way to understand the absent presences that are naturalized in national park display technologies is to compare the absence of instructions in the Cedar Breaks installation and scenic overlooks in general to an example of a national park display technology that *does* contain explicit instructions for use. At scenic overlooks on both the South Rim and the North Rim of the Grand Canyon (as well as at many other parks throughout the United States), telescopes have instructions for "Camera Fans" embossed into their side panels (Figure 1.5). The text on the telescope is in all capital letters and composed with no punctuation, only line breaks:

CAMERA FANS
THIS IS A QUALITY
TELESCOPE AND IS EQUAL
TO A 1750MM TELEPHOTO
LENSE
INSTRUCTIONS
FOCUS TELESCOPE TO
YOUR EYE PLACE CAMERA
UP TO EYEPIECE AND
TAKE PICTURE

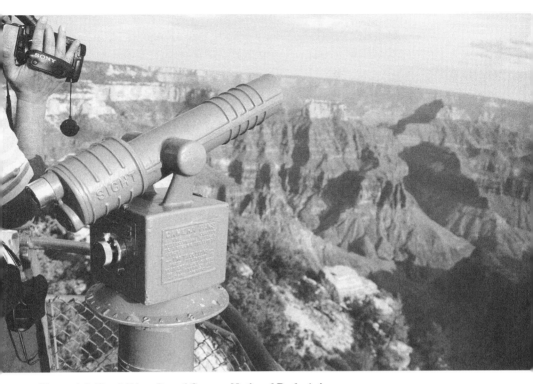

Figure 1.5. North Rim, Grand Canyon National Park, Arizona.

The text includes not only information about what the object is (including its technical specifications), but exactly how to use it and in what sequence. Thus, the instructions interpellate a visitor who does not know what to do with the technology and thus must be explicitly instructed. More important for the context of my analysis, though, is the fact that while the message does not take it for granted that visitors will know how to take a picture through the telescope, it does presume that potential users are "Camera Fans," who not only know how to use their cameras but also have come to the overlook to take pictures. The specific technologies for seeing and photographing may be problematic, but the fact that an overlook is made to be seen and photographed from is not. The telescope is presented as something that will help visitors do something that they came to do, only better.

This fact is made even more explicit in the smaller plastic panels mounted on the bases of these telescopes. The additional plastic panel on a North Rim telescope reads:

SEE AMERICA
20 POWER TELESCOPE
THIS TELESCOPE IS DESIGNED
FOR USE WITH ANY CAMERA
INSTRUCTIONS FOR USE ON SIDE OF TELESCOPE

The telescope claims not only to show America (implying both that "America" is a visual object that can be seen and photographed and that the Grand Canyon *is* "America"), but also to make that vista even more available to anyone with a camera. Like the scenic overlook where this telescope is mounted, the telescope "is designed for use with any camera."

A telescope mounted at the wall of the Desert Watchtower Overlook on the South Rim includes a different additional plastic panel. Just above a repetition of the text from the side of the telescope is this appeal:

THERE IS MORE TO EXPLORE
UP CLOSE AND PERSONAL
USE YOUR OWN CAMERA
TELEPHOTO PICTURES

The words "USE YOUR OWN CAMERA" are boxed to highlight them; they form an implicit direct address, simultaneously informing "you" that you can use your camera with the telescope *and* demanding that you do. As the text makes explicit, what you are doing when you use the telescope is using a visual technology to "explore" the landscape visually from a distance, using the technology to bring the distant vista "up close and personal" to you so you can see what is hidden from you and take "telephoto pictures" of it.

These processes of naturalizing sites, sights, and practices and interpellating visitors in relation to them are also powerful at the scenic overlooks where these telescopes are situated. Scenic overlooks naturalize not only the presented vista but also the act of sightseeing, showing that overlooking landscape and taking pictures of "it" are natural things to do in the national parks. Displays at visitor centers use scale

models, panels, artifacts, and photographs to display knowledge that is supposed to "interpret" the park as a whole for visitors and help them learn how to interpret it for themselves as they participate in the process of "reading" and representing space in the spaces outside the visitor center. Official park maps and guides highlight, preview, and frame the marked sites within the park, showing in words and pictures what constitutes an "appropriate" and "authentic" experience of each park as well as interpellating several different types of visitors with different amounts of time to spend and with attractions to different activities. The display technologies that visitors encounter at scenic overlooks within national parks serve a slightly different function: they mark the territory *within* and *at* the site, turning discursive and representational practices into concrete spaces and spatial practices experienced by tourists who temporarily inhabit the parks.

There are lots of discursive appeals to visitors at scenic overlooks that orient visitors in relation to the vistas, teach park ethics and aesthetics, and so on, but never anything that that tells people how to use a scenic overlook *as* a scenic overlook. Again, as with the Cedar Breaks installation, the instructions for their use are an absent presence that reveals just how naturalized and naturalizing a scenic overlook is as a cultural form. Their instructions for use are apparently self-evident: once you follow the visual and linguistic signs to an overlook itself, it is the material architectural form of the overlook itself that "shows" people what to do. Pathways lead toward it. The wall simultaneously marks the end of the overlook and the beginning of the vista. Thus, whatever visual and linguistic messages they may communicate in their signage and placards, their material form and presence show that there is something to see, photograph, and know there. An overlook itself never explicitly tries to persuade visitors to see things a certain way but instead simply *shows* things, making it hard to see their rhetoric as rhetoric. Their operations hide in plain sight, so obvious that they disappear beneath consciousness.

It is even more difficult to apprehend within the space of an overlook that these structures also contain their own negation: that by calling attention to some things they literally turn visitors away from others, that by showing they also hide. This is the most naturalizing and naturalized rhetoric of all. As Lawrence Prelli argues, "whatever is revealed through

display simultaneously conceals alternative possibilities; therein is display's rhetorical dimension."[24] The way the NPS organizes the space of a national park is political in that it enacts and represents choices about what to show, what not to show, how to show what it shows, and how to hide what it hides (intentionally or not). These choices have reverberating effects on tourist practices as well as the way they are represented in tourist snapshots and video.

Particularly at scenic overlooks, these technologies of display produce landscapes to be contemplated visually. In doing so, they also produce a set of subject positions for visitors to inhabit, which interpellate visitors themselves as people who come to see, contemplate, and photograph landscapes.[25] Popular iconic overlooks, like the ones on the South Rim of the Grand Canyon, at the edge of the Grand Canyon of the Yellowstone, and at the Wawona Tunnel Overlook in Yosemite Valley, are given place-names. Some, like Fairview Point, Inspiration Point, and Artist's Point, carry in their names a history of use as a place to see from; others, like Mather Point, are named for people but also have place identities tied primarily to their history as viewpoints. These sites are demarcated on park maps and surrounded by signage directing visitors to them. They have a certain structural coherence, a certain combination of visual, linguistic, and material elements within them that are common to others like them in other parks. But there are also many more overlooks in the parks that are little more than road cuts or turnouts, and these do not even contain any visual/linguistic representations or naming. It is simply that a wall with a parking pullout signifies, architecturally: "This is an overlook. You know what to do."

Taking pictures at a scenic overlook in a national park is a patterned material practice, one not derived only from reading the physical signs in the park but also from internalizing the ways of seeing, doing, and being implicit in the process of marking, reading, experiencing and representing difference in the parks in the first place. The larger cultural history and practice of representing and experiencing the national parks as a touristic space outside culture—the same set of discourses that are materialized in the stone, wood, and metal signs throughout the park—do more work than any one instructive interpretive sign could ever do. The built environment of the parks is structured in and by what Mark Neumann calls the "contradictions of an individual freely empowered by a mobilized gaze and a view that had

been prepared for an anonymous eye."[26] The contradictions are there in the North Rim panel that says that the telescope is designed for use with any camera but is used by particular visitors with particular cameras, and the contradictions are there in the Cedar Breaks installation that is made for a general "you" but used by a particular "you." Park spaces and the display technologies that mediate them are designed to be inhabited and used by "anybody," but every day are inhabited by "somebody" who must negotiate not only the built environment but the material social practices that constitute it. Overlooks and the technologies within them vary across and within parks, and, as scholars like Neumann have shown, ethnographic work on actual "somebodies" indicates a large range of motivations for and responses to inhabiting these constrained spaces, but the point remains that all of them must negotiate the material and social spaces that structure their encounters.

More important, these negotiations themselves leave traces for those who come after them to encounter as well. For instance, on the telescopes there is a different kind of display that shows a history of these interpellation practices at work: the paint is worn off around the eyepiece, the focus knob, and the coin slot (Figure 1.6).

Figure 1.6. Desert Watchtower Overlook, South Rim, Grand Canyon National Park, Arizona.

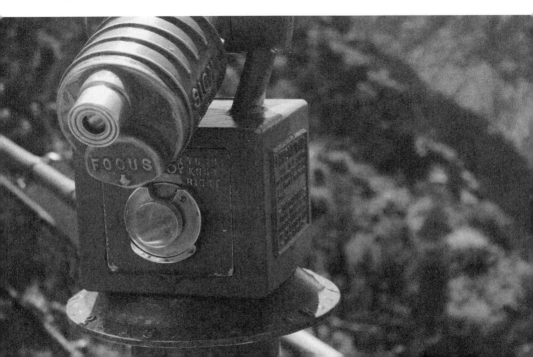

Jeffrey David Feldman calls this a "mimetic contact point," a part of a display that shows that a body that once had embodied contact with a displayed object is no longer present in body but is still materialized in an oblique representation.[27] The same material evidence of embodied interaction is there on the metal railings below them and on scenic overlook walls throughout the parks, providing yet one more metonym of national park visual/material practices in action: When people photograph landscape from an overlook, they do so for local reasons that make sense to them, but at a more global level they are materializing the use that the parks are planned for: for individual park visitors to represent themselves at the center of landscapes that are built to allow each visitor to make photographs that represent themselves at the center of the natural landscapes made available in the parks (Figure 1.7).

As Tim Edensor argues, "The process of representing tourist space is continual, constituting a hermeneutic circle in which tourists contingently (re)produce representations of tourist space as well as consuming them."[28] Tourists seek out identifiable and representable scenes that can be used to establish a relationship between the bodies of the people who photograph and the objects represented in pictures. In the national parks, visitor centers and scenic overlooks are primary locations in this articulation process. The visitor centers display the official "interpretation" of the park, the discursive and nondiscursive frames of reference that both identify the icons of the park to be appropriated and connect the disparate elements of the park into a single identity. The overlooks present the landscape as if it were already a picture, and present themselves as places to take pictures. The pictures that scenic overlooks enable complete the circuit. This is especially apparent in photographs that picture visitors in front of the distant vista, which carry with them the aura of embodied experience. As records of visual and material encounters with landscape, their most important message is also both visual and material: "Look: here we are at Yosemite."[29]

National parks produce difference, produce an Other, but they produce an Other that once it is produced as such, is then (or at the same

Figure 1.7. Diablo Lake Overlook,
North Cascades National Park, Washington.

time) brought back into relation to the Self through the same display technologies.[30] Scenic overlooks are naturalized as technologies and spaces for seeing and photographing, but they also enact and enable a certain kind of embodied experience that is more than visual. They make landscapes into scenic objects by framing and separating vistas from the rest of the landscape *and* from visitors, who are then placed into a certain distanced but still embodied relation to what they are seeing and photographing. The visual and material rhetorics of over-look displays "say" two things simultaneously: "*Look* there, but *be* here" and "Look *there*, but not *here*." Telescopes literalize this process; only necessary because the vista is separated from the person viewing it, they then "bring it closer."

This way of presenting landscape sets up a dissonance between ways of seeing, photographing, and knowing, on the one hand, and ways of inhabiting, being, and knowing, on the other. While visitors look at and photograph distant vistas, rendering them representable within their own snapshots and video, the most tangible contact that they have with that landscape occurred in a space structurally separated from the visu-ally framed landscape pictured in their photographs: the scenic overlook itself, and display technologies such as telescopes that are rooted in the space of the overlook but bridge the gap between the vista and the place from which it is viewed. They are the tangible media that represent and enact the more metaphorical medium of landscape Mitchell theorizes in *Landscape and Power* (Figure 1.8).

And yet, though they are tangible, national park display technolo-gies are also hard to "see." Daniel Miller argues that material culture approaches must account for the "capacity of objects to fade out of focus and remain peripheral to our vision and yet determinant of our behavior and identity."[31] As I have argued here, this capacity is height-ened in landscapes dominated by discursive and nondiscursive natu-ralizing rhetorics, where the built environment disappears even more profoundly into the foreground of vision—an apparently natural part of the *habitus* visitors physically and metaphorically inhabit when they visit the parks. Like other forms of media in contemporary culture, which audiences are encouraged to look *through* instead of looking *at,* landscape display technologies in the parks "hide in plain sight": they are there for all to see, but their very function makes them see-through.

Figure 1.8. Wawona Tunnel Yosemite Valley Overlook, Yosemite National Park, California.

The display technologies themselves are not the things people have come to see but the things they have come to see from; visitors are disciplined to take pictures from them but not of them. But understanding how these material structures mediate experiences of national park landscapes can reveal the less tangible cultural and metaphorical interpretive structures that are brought to bear on experiences of material space in the national parks and elsewhere. Analyzing the materiality of vision in the parks shows that *how* people experience space always already structures *what* they experience, and that how they are embodied in particular spaces structures how and what they see, know, represent, and even *are* when they are "in" that space.

NOTES

1. W. J. T. Mitchell, introduction to *Landscape and Power,* ed. W. J. T. Mitchell (Chicago: University of Chicago Press, 1994), 1.

2. W. J. T. Mitchell, *What Do Pictures Want? The Lives and Loves of Images* (Chicago: University of Chicago Press, 2005), 203, emphasis in the original. See also Raymond Williams, *Marxism and Literature* (New York: Oxford University Press, 1977), 158–64.

3. Mitchell, introduction to *Landscape and Power,* 1–2.

4. Kevin Hannam, Mimi Sheller, and John Urry, "Editorial: Mobilities, Immobilities and Moorings," *Mobilities* 1, no. 1 (March 2006): 13.

5. Edward W. Soja, *Thirdspace: Journeys to Los Angeles and Other Real-and-Imagined Places* (Malden, Mass.: Blackwell Publishing, 1996). See also Carl Knappett, *Thinking through Material Culture: An Interdisciplinary Perspective* (Philadelphia: University of Pennsylvania Press, 2005), 110, 131.

6. For an analysis of one deep influence on ways of seeing and picturing landscape in the American West, see Sabine Wilke, "How German Is the American West? The Legacy of Caspar David Friedrich's Visual Poetics in American Landscape Painting," this volume.

7. See Michel de Certeau, *The Practice of Everyday Life,* trans. Stephen Rendall (Berkeley: University of California Press, 1984); Pierre Bourdieu, *Outline of a Theory of Practice,* trans. Richard Nice (Cambridge: Cambridge University Press, 1977).

8. Tim Cresswell, "Theorizing Place," in *Mobilizing Place, Placing Mobility: The Politics of Representation in a Globalized World,* ed. Ginette Verstraete and Tim Cresswell (Amsterdam: Rodopi, 2002), 23.

9. For similar approaches to the built environment of tourist spaces

other than national parks, see D. Medina Lasansky and Brian McLaren, eds., *Architecture and Tourism: Perception, Performance and Place* (Oxford: Berg, 2004).

10. Tony Bennett has used a similar term, "differencing machines," to characterize contemporary national and local history and culture museums, which he argues "function as civic technologies in which the virtues of citizenship are acquired, and changed, in the context of civic rituals in which habitual modes of thought and perception are transformed." Tony Bennett, "Exhibition, Difference, and the Logic of Culture," in *Museum Frictions: Public Cultures/Global Transformations*, ed. Ivan Karp, Corinne A. Kratz, Lynn Szwaja, and Tomas Ybarra-Frausto, 46–69 (Durham, N.C.: Duke University Press, 2006), 66. Bennett argues that museums today often contain and present cultural and historical difference in an experiential mode that "moves" visitors' understanding of themselves and their relation to "others." Something similar occurs in national parks, where visiting the parks is tied to nationalist civic discourses and where experiential modes of interaction prevail, but the difference being produced in the parks is focused more on producing "place" identity than cultural identity. See also Tony Bennett, *The Birth of the Museum: History, Theory, Politics* (New York: Routledge, 1995).

11. David Louter, *Windshield Wilderness: Cars, Roads, and Nature in Washington's National Parks* (Seattle: University of Washington Press, 2006); Peter Peters, "Roadside Wilderness: U.S. National Park Design in the 1950s and 1960s," this volume.

12. Louter, *Windshield Wilderness*, 19, 36.

13. See David A. Tschida, "Yellowstone National Park in Metaphor: Place and Actor Representations in Visitor Publications," this volume.

14. See David Crouch and Nina Lübbren, introduction to *Visual Culture and Tourism*, ed. David Crouch and Nina Lübbren (Oxford: Berg, 2003), 3. My work on national park tourism is engaged with a growing body of work in visual culture studies, material culture studies, and rhetorical studies that explores the complex "multisensory" interplay of embodied visualities and materialities. See especially Gillian Rose, *Visual Methodologies: An Introduction to the Interpretation of Visual Material*, 2d ed. (London: Sage, 2007); W. J. T. Mitchell, "There Are No Visual Media," *Journal of Visual Culture* 4, no. 2 (2005): 257–66; Mieke Bal, "Visual Essentialism and the Object of Visual Culture," *Journal of Visual Culture* 2, no. 1 (2003): 5–32; Elizabeth Edwards, Chris Gosden, and Ruth B. Phillips, eds., *Sensible Objects: Colonialism, Museums, and Material Culture* (Oxford: Berg, 2006); Daniel Miller, ed., *Materiality* (Durham, N.C.: Duke, 2005); Victor Buchli, ed., *The Material Culture Reader* (Oxford: Berg, 2002); Charles A. Hill and Marguerite Helmers, eds., *Defining Visual Rhetorics* (Mahwah, N.J.: Lawrence Erlbaum, 2004); Jack Selzer and Sharon Crowley,

eds., *Rhetorical Bodies* (Madison: University of Wisconsin Press, 1999); Joyce Davidson, Liz Bondi, and Mick Smith, eds., *Emotional Geographies* (Aldershot, UK: Ashgate, 2005); Eeva Jokinen and Soile Veijola, "Mountains and Land-scapes: Towards Embodied Visualities," in *Visual Culture and Tourism,* ed. David Crouch and Nina Lübbren (Oxford: Berg, 2003), 259–278; and Soile Veijola and Eeva Jokinen, "The Body in Tourism," *Theory, Culture & Society* 11 (1994): 125–51. Kevin Hannam, "Tourism and Development III: Performances, Per-formativities and Mobilities," *Progress in Development Studies* 6, no. 3 (2006): 243–49, provides an excellent survey of recent performative, embodied visual/material work in tourism studies.

15. Studies of media and tourism usually concern media images of tour-ist places and peoples, tourist media production, or the relations between the two. On the interrelationship between tourism and media, see David Crouch, Rhona Jackson, and Felix Thompson, eds., *The Media and the Tourist Imagina-tion: Converging Cultures* (Oxford: Berg, 2005). For explorations of how tourism, landscape, architecture, photography, and media intersect particularly in the national parks of the American West, see Mark Neumann, *On the Rim: Looking for the Grand Canyon* (Minneapolis: University of Minnesota Press, 1999); and Bob Bednar, *Snapshot Semiotics: An Exploration of Field Work on Tourism, Cultural Studies, and Visual Culture in the Contemporary American West,* at www.southwestern .edu/~bednarb/snapshotsemiotics. For more extended work on the built en-vironment of the national parks, see Linda Flint McClelland, *Building the Na-tional Parks: Historic Landscape Design and Construction* (Baltimore: Johns Hopkins Press, 1998); Ethan Carr, *Wilderness by Design: Landscape and the National Park Service* (Lincoln: University of Nebraska Press, 1998); and Louter, *Windshield Wilderness.* Lasansky and McLaren, eds., *Architecture and Tourism* offers a range of cultural approaches to the study of tourist built environments. David M. Wrobel and Patrick T. Long, eds., *Seeing and Being Seen: Tourism in the American West* (Lawrence: University of Kansas Press, 2001) is a good introduction to the issues particular to the study of tourism in western American studies.

16. Gunther Kress and Theo van Leeuwen, *Multimodal Discourse: The Modes and Media of Contemporary Communication* (London: Arnold, 2001). See also Gun-ther Kress and Theo van Leeuwen, *Reading Images: The Grammar of Visual Design,* 2d ed. (London: Routledge, 2006).

17. Chris Rojek, "Indexing, Dragging, and the Social Construction of Tourist Sights," in *Touring Cultures: Transformations of Travel and Theory,* ed. Chris Rojek and John Urry, 52–74 (London: Routledge, 1997), 70. See also John Urry, *The Tourist Gaze: Leisure and Travel in Contemporary Societies* (London: Sage, 1990), 11–12. Neumann's *On the Rim* shows the rich complexity of this dynamic at the Grand Canyon.

18. For historical studies of how the NPS has inhabited this "difficult" mission, see Alfred Runte, *National Parks: The American Experience*, 2d ed. (Lincoln: University of Nebraska Press, 1987); Alfred Runte, *Yosemite: The Embattled Wilderness* (Lincoln: University of Nebraska Press, 1991); Richard W. Sellars, *Preserving Nature in the National Parks: A History* (New Haven, Conn.: Yale University Press, 1997); Mark David Spence, *Dispossessing the Wilderness: Indian Removal and the Making of the National Parks* (New York: Oxford University Press, 1999); and Louter, *Windshield Wilderness*.

19. For a detailed analysis of how the tension is simultaneously performed and effaced at a NPS historical site, see Thomas Patin, "America in Ruins: Parks, Poetics, and Politics," this volume.

20. For more on how this works in museums, see Edwards, Gosden, and Phillips, eds., *Sensible Objects*. Thomas Patin has explored the connection between national parks and museums more fully, arguing that national parks are organized as essentially "museological" spaces. See Thomas Patin, "The National Park as Museological Space," *Yellowstone Science* 8, no. 1 (Winter 2000): 15–18; and Thomas Patin, "Exhibitions and Empire: National Parks and the Performance of Manifest Destiny," *Journal of American Culture* 22, no. 1 (1999): 41–59. Patin traces the scenic effects of park roads to the moving panorama, a nineteenth-century visual display technology; he traces the structure and effects of the scenic overlook to the cyclorama as well.

21. Gregory Clark also ties this phenomenon to the fact that these are *public* lands, owned by all and none at the same time, "where all of us could be equally at home because it was a place where none of us could live." Gregory Clark, *Rhetorical Landscapes in America: Variations on a Theme from Kenneth Burke* (Columbia: University of South Carolina Press, 2004), 70.

22. Knappett, *Thinking Through Material Culture*, 169.

23. For an extended theoretical engagement with this dialectic, see Mitchell, *What Do Pictures Want?*

24. Lawrence J. Prelli, "Rhetorics of Display: An Introduction," in *Rhetorics of Display*, ed. Lawrence J. Prelli (Columbia: University of South Carolina Press, 2006), 2.

25. S. Michael Halloran and Gregory Clark argue that epideictic display rhetorics in the national parks produce identification among the diverse individuals encountering them, making national parks an important site for the practice of a kind of American civil religion. See S. Michael Halloran and Gregory Clark, "National Park Landscapes and the Rhetorical Display of Civic Religion," in *Rhetorics of Display*, ed. Prelli, 141–56. See also Clark, *Rhetorical Landscapes in America*, especially 69–92 and 147–62.

26. Neumann, *On the Rim*, 152, 284.

27. Jeffrey David Feldman, "Museums and the Lost Body Problem," in *Sensible Objects,* ed. Edwards, Gosden, and Phillips, 255–56.

28. Tim Edensor, *Tourists at the Taj: Performance and Meaning at a Symbolic Site* (London: Routledge, 1998), 14. See also Carol Crawshaw and John Urry, "Tourism and the Photographic Eye," in *Touring Cultures,* ed. Rojek and Urry, 176–95.

29. The photographs communicate this message most directly "back home," where personal photographs are situated within complex embodied networks of identity and social/cultural location and power. See Pierre Bourdieu, *Photography: A Middle-Brow Art,* trans. Shaun Whiteside (Stanford, Calif.: Stanford University Press, 1990); Marianne Hirsch, *Family Frames: Photography, Narrative, and Postmemory* (Cambridge, Mass.: Harvard, 1997); and Richard Chalfen, *Snapshot Versions of Life* (Bowling Green, Ohio: Bowling Green State University Popular Press, 1987).

30. For a more detailed exploration of how this process is related to similar dynamics in film spectatorship, see Rhona Jackson, "Converging Cultures; Converging Gazes; Contextualizing Perspectives," in *The Media and the Tourist Imagination,* ed. Crouch, Jackson, and Thompson, 183–97.

31. Daniel Miller, "Materiality: An Introduction," in *Materiality,* ed. Miller, 5. See also Daniel Miller, *Material Culture and Mass Consumption* (Oxford: Blackwell, 1987).

2. REMEMBERING ZION

Architectural Encounters in a National Park

Gregory Clark

ARCHAEOLOGICAL EVIDENCE SUGGESTS that the deep and warm sandstone canyon that was called Zion by the Mormons who settled there and nearby was once a refuge for some of the indigenous people of the region. Documentary evidence, as well as living memory, notes that this place was also something of a refuge for Mormon farmers who, embattled as they were in the waning decades of the nineteenth century, had moved south from Salt Lake City to the remote desert of southeastern Utah. Zion Canyon is deep, its nearly vertical walls are a thousand feet high, and its bottom, watered by the rocky creek called the Virgin River, is mild in climate. Hidden in the folds of the harsh and exposed Colorado Plateau, this seems a protected place. But it did not protect well those Mormon farmers who tried for a time to live there. The little river was prone to seasonal floods of surprising intensity that regularly washed away so much of their work that most of them eventually moved farther downstream, out of the canyon. That was early in the twentieth century, about the same time that tourists began to discover the canyon, making it a place more visited than inhabited. Stephen Mather was one of those visitors. During the years he was founding what became the National Park Service (NPS), Mather retreated to Zion Canyon almost annually. He, too, considered the place a kind of refuge, one he shared first with influential friends and then with the rest of the nation when he presided over the process of making Zion Canyon into a national park.

Mather's western national parks are all wilderness places, and by that time in the early twentieth century, wilderness in America had been for some time imagined conventionally as a place of refuge. But that

Figure 2.1. George A. Grant, Zion Canyon, Utah, circa 1929. National Park Service Historic Photograph Collection.

had not always been the convention. Two centuries before, the wilderness had long been considered an imminent threat, and colonists in the New World had imagined the communities that they built on the edges of that wilderness as places to provide them with refuge *from* it. In her riveting and best-selling captivity narrative published in 1682, Mary Rowlandson expressed their need for that refuge in biblical terms when she portrayed herself collapsed in despair after days of walking the wintry New England woods while a captive of Indians fighting King Philip's War. Kneeling on the rocks that separated the icy river she had just crossed and the dark forest she was about to enter, and surrounded by her taunting captors, she wrote:

> I fell a-weeping, which was the first time to remembrance that
> I had wept before them. Although I had met with so much afflic-
> tion, and my heart was many times ready to break, yet I could not
> shed one tear in their sight: but rather had been all this while in
> a maze, and like one astonished: but now I may say as, Psalm 137,

> By the Rivers of Babylon, there we sate down: yea, we wept when
> we remembered Zion.[1]

The Zion that Rowlandson remembered was certainly not a wilderness place. Rather, it was her New England village home, a place now lost in the collateral damage of war that she could remember as peaceful and safe. But that remembering of Zion was not a simple act of recall. Rather, it was a deliberate act of imagination that reconstructed the promise of a home place that mirrored for her an identity, individual and collective. For Rowlandson, Zion was an aspiration, an ideal of self and of community that reminded her in this circumstance that had stripped her of almost everyone who she still believed herself to be. What she was remembering when she remembered Zion was a way of life where she could live harmoniously with others toward the shared end of together living harmoniously with their God. Such is her Puritan vision of Zion, a place that for her—as for everyone who has sought Zion—could be remembered only as a location for living a life that was still yet to be.

Obviously, Rowlandson would never have considered this rugged desert canyon that the Mormons named Zion to be such a place. But by their time, late in the nineteenth century, wilderness was no longer the primary threat that unsettled the national consciousness. Rather, that threat, for most Americans, came from each other. Whether it took the form of the rich or poor, the immigrant or native, the religionist or the secularist, the governor or the governed, Americans responded by perceiving the wilderness as a place of refuge from the tension and contention of a tumultuous nation. And in that perception is much of the origin of the national park movement. One of the best expressions of the motives driving that movement is Frederick Law Olmsted's statement made on the floor of Yosemite Valley in 1865, a year after President Abraham Lincoln had transferred stewardship of that wilderness place to the state of California. Speaking as chairman of the California Yosemite Commission, Olmsted needed to articulate for it a public purpose. He reminded the commission and the press that it had been during their nation's "darkest hours" of civil war that Congress had given the state charge of this place with the intent that "this scenery shall never be private property, but that like certain

defensive points upon our coast it shall be held solely for public pur-
poses." And upon that reminder Olmsted articulated for that place a
moral project: it is "a scientific fact that the occasional contemplation
of natural scenes of an impressive character" not only "increases the
subsequent capacity for happiness" but also decreases the incidence of
the sort of "mental and nervous excitability, moroseness, melancholy,
or irascibility" in individuals that prevents their "proper exercise of the
intellectual and moral forces."[2] The personal consequences that follow
from life in industrializing America can be countered by wilderness
places such as this, places where citizens can experience a "union of
the deepest sublimity with the deepest beauty of nature, not in one fea-
ture or another, . . . not in any landscape that can be framed by itself,
but all around and wherever the visitor goes."[3] That such experiences
must be made available to all—that is, that government must establish
"great public grounds for the free enjoyment of the people . . . a politi-
cal duty"—is at the center of Olmsted's vision.[4]

The vision that Olmsted articulated that day was becoming shared
among Americans. From their beginnings, national parks were envi-
sioned as elements in the ongoing civic project of moving the United
States in the direction of a kind of Zion, for some, sacred, and for oth-
ers, secular. But neither was, at least at first glance, the kind of Zion the
Mormons had in mind when they renamed that rugged and remote can-
yon they had known first by its Paiute name of Mukuntuweap. Through-
out the nineteenth century and into the twentieth, the Mormons, in the
words of one historian, had been engaged quite deliberately in a sus-
tained "quest for refuge" from "the debilitating secularizing tendencies
of sectarian pluralism." Accordingly, for them Zion was conceived as
an actual and separate place in the landscape where they could enact
their ideal of "communal unity and homogeneity."[5] That place would,
as the remote New England village of Lancaster had for Rowlandson,
reflect back to them the individual and collective identities to which
they aspired. In the very topography of Mukuntuweap Canyon itself
the Mormons saw images of the soaring walls and sacred edifices that
would protect and unify them.

When the Mormon founder Joseph Smith located the Zion that
Christ would establish at the Second Coming within the boundaries of
the United States, he rendered as literal what generations of Americans

have considered at least symbolic: the assumption of, as described by Sacvan Bercovitch in his masterful book on the persistent Puritanism of American culture, "an American Zion, the sacred place reserved for the end-time remnant."[6] So while the theology and geography of Zion varied in the minds of Americans from Mary Rowlandson to Joseph Smith to Frederick Law Olmsted to Stephen Mather, the cultural work of the concept of Zion did not. For all of these Americans, the word *Zion* enabled them to imagine themselves withdrawn from the conflict and contention of a necessarily pluralistic society to a separate place of "communal unity and homogeneity" from which they could derive for themselves and their chosen community a unique and stable identity. Like the early New England Puritans and the Mormons who settled in the interior of the American West, early twentieth-century Americans also imagined for themselves places of refuge where they could live— even if only temporarily—harmoniously with each other within sight and sound of something greater. Those Mormons who tried living in Zion Canyon found the actual place, remote from trade routes and prone to flash floods, only barely habitable, and soon moved downstream to more practical places. But they continued to treat this canyon of spectacular verticality and pastoral bottoms as a place safe from the fractious national culture and aspiring to heaven. Indeed, they organized regular excursions to Zion, perhaps to be reminded there of aspirations that lay beyond the relentless competition and conflict of daily life.

Inherent in the national park movement in the United States—and particularly so in the case of the western parks that were established as it was becoming clear that the American wilderness could not withstand the forces of development—is an attempt to locate that sort of Zion. This is a simulation of Zion, a place where no one lives but all may visit to be reminded of the life they might create for themselves at home. This is Zion as a temporary refuge, one with edifying and even instructional capacities. That such is one purpose of the western national parks was expressed succinctly in the mid-twentieth century by their great photographer Ansel Adams when he wrote that "the earth promised to be more than a battlefield or hunting-ground; we dream of the time when it shall house one great family of cooperative beings." Adams wrote this in 1950 in a short essay titled "The Meaning of the

National Parks," which introduced his volume of images "My Camera in the National Parks." He continued there:

> Only education can enlighten our people—education, and its accompanying interpretation, and the seeking of resonances of understanding in the contemplation of nature. In contemplation of the eternal incarnations of the spirit which vibrate in every mountain, leaf, and particle of earth, in every cloud, stone, and flash of sunlight, we make new discoveries on the planes of ethical and humane discernment, approaching the new society at last, proportionate to nature.

Adams then concluded with his prediction that the national parks would eventually express a "complete adjustment of the material and spiritual aspects of the parks to human need, with full emphasis on the intangible moods and qualities of the natural scene."[7] In other words, the meaning of the national parks was, for him, that new society "proportionate to nature," that Zion that houses temporarily "one great family of cooperative beings," made available for anyone who can get there to experience.

In this essay I will examine specifically that adjustment of "the material and spiritual aspects" of Zion National Park to the human need for a temporary refuge in a better way of living, how this Zion was designed to be a place where visitors could find themselves living harmoniously with the "moods and qualities of the natural scene." My focus here is on the architecture of this national park and how that architecture was meant to prompt those who would inhabit it for a time to remember Zion later—to remember not just this particular place but also the idealized experience of inhabiting a place where society and nature are in harmony. To prompt people to remember that harmony and to aspire to re-create it as they return to their homes may be, I am suggesting, one of the prominent rhetorical functions of a national park.

The Rhetoric of Experience

National parks trade in experience. Experiences are what they offer and provide. And those experiences are, I am suggesting, essentially rhetorical. But to make that claim requires some attention to definition.

Rhetoric, traditionally understood, is engaged in what amounts to political discourse—the discourse that orders and sustains communal relations. That is Aristotle's formulation, and it continues to carry considerable weight. However, an alternative and more expansive understanding of rhetoric coexists with the Aristotelian. On this understanding, rhetoric is not limited to a particular discursive project; it is, rather, a kind of force that might be applied to that civic communicative project as well as to others, a force of influence that can take discursive as well as nondiscursive forms. I am using this second, broader understanding of rhetoric to make the claim that many of the experiences afforded by national parks are inherently rhetorical. In Michael Leff's terms, these two differing concepts of the rhetorical set up "a dichotomy between rhetoric as an art contained within some substantive domain or rhetoric as a power that ranges over various domains." It is, more concisely, "a dichotomy between the prudential and the aesthetic." But that is a false dichotomy because, as Leff notes, the rhetorical is always both prudential and aesthetic.[8] My further assertion is that this is a combination that is not so much understood as it is experienced, and that the experience of being influenced is, at once, aesthetic and prudential and can take a wide variety of forms.

For Leff, the successful interaction of the prudential—that practical address of local and immediate purposes that is the political and the aesthetic—that concrete envisioning of more orderly, more harmonious, more beautiful ways of being, is always embedded in the particular. Indeed, he defines rhetoric as "a universal activity that finds its habitation only in the particular."[9] Further, I am suggesting, the rhetorical is itself inhabited. That is, messages of influence, whether discursive or nondiscursive, are lived in temporarily by those who receive them—they are, in a word, experienced. When we are addressed rhetorically, we imaginatively try out—that is the aesthetic element—the alternative way of thinking or acting—that is the prudential element—presented to us. That presentation can take the form of words, or images, or even sounds; or, as my discussion here is asserting, it can take the form of experiences that immerse us bodily in an environment. Put another way, rhetorical experiences are encountered through a habitation of a place, a conceptual place or a physical one, and when the place

is carefully crafted to do that work of influence, those experiences can be particularly memorable and influential.

In Aristotelian terms, what I am calling a rhetorical experience can be described as an encounter with what he called the epideictic genre of rhetoric. Along with the two kinds of immediately pragmatic arguments that he described as forensic and deliberative, Aristotle identified, but did not describe in depth, a third category of rhetoric that was not so much argumentative as experiential and—though he did not use this term—aesthetic. As Chaim Perelman and Lucie Olbrechts-Tyteca famously described it, epideictic rhetoric might be compared not to argument but to the function of "the libretto of a cantata."[10] Subsequent commentators have explored further the implications of Aristotle's sources for and descriptions of epideictic rhetoric, locating it in a place that clearly includes influences of both aesthetic and rhetorical kinds. In modern formulations, epideictic rhetoric influences by asserting the validity of commonly shared values not by arguing their merits but, rather, by displaying their self-evident virtue for those it addresses to witness and affirm. Discursively, it presents values in action by narrating their reality in ways that, actually or vicariously, those addressed can experience. Indeed, in his helpful account of epideictic rhetoric, Lawrence Rosenfield finds himself describing all this as "the epideictic experience," one that functions as "an act of testimony" that must take "precedence over simple persuasion."[11]

It is in this way that the rhetorical can be understood to address purposes broader than the immediately practical and "prudential." Indeed, it is in this way that a rhetorical experience reaches beyond pragmatic persuasion to the broader dimensions of influence. Gerard Hauser has noted that "Aristotle assigned epideictic the important duty of teaching public morality,"[12] an insight for which Perelman and Olbrechts-Tyteca provided the foundation. They noted that because epideictic discourse generally asserts values that people can recognize as noncontroversial and shared with others who are also addressed, it renders the orator an educator, one authorized by a community to present to its members matters that are essential elements of their shared reality.[13] This is different from the address of arguments. What is also different is the epideictic mode of presentation: epideictic rhetoric enacts influence through an aesthetic rather than

a logical method. As Hauser puts it, epideictic renders these values and virtues concrete by displaying "nobility at the level of praxis," a display that prompts, in his words, "citizens [to] experience . . . the moral story of the community."[14] My point here is that the experience of that story—the experience of inhabiting it imaginatively—need not be prompted only by discourse.

So the motives of those who founded the national park movement seem to fit nicely into these notions of epideictic rhetorical work since the parks they developed did, indeed, enable citizens to experience there elements of what those founders considered to be the moral story of the American national community. It was a movement that emerged at a time when it was becoming obvious that the natural resources of the continent were subject to depletion by industrialization, and the national culture to fragmentation in the aftermath of the Civil War. In that context, the national park idea developed to protect exemplary landscapes and to enable citizens to access those landscapes for their recreation. Those were material purposes with rhetorical force. The act of protecting these places warned of the dangers of destruction and preached the values of conservation. And the act of making those places accessible for public retreat reminded people immersed in the competition of individual lives of shared and communal values that they could read represented in the American nature values tradition-ally read as resonant with the divine.[15] That traditional—at least since the eighteenth century—reading had two sources. One was the late Puritan reverence for nature as the unmediated handiwork of God ar-ticulated by Jonathan Edwards and, later, by Ralph Waldo Emerson and his circle. The other was the tradition, borrowed from eighteenth-century Europe, which treated an aesthetic encounter—particularly with a beautiful natural landscape—as a moment of moral instruction from the Author of the "book of nature." Art historian Barbara Novak finds in an 1830 issue of the *North American Review* a fairly typical ex-pression of the common belief that "taste for beauty in nature and art [is] 'nearly allied to the love of good'" and that such beauty is " 'visible manifestation of those amiable moral qualities of which the mere idea fills the heart with delightful emotions.' "[16]

Such are the emotions prompted by the experiences the national parks were designed to offer, emotions experienced as, drawing upon

the definition of sociologist Candace Clark, "amalgamations of feelings and actions, thoughts and perceptions, complicated cultural roles and roles for feeling and displaying feelings, and cultural values."[17] This is language that describes the elements of a rhetorical experience that prompt people to adopt, if only temporarily, an identity. Kenneth Burke's conception of identity as "a complex of attitudes . . . that constitute the individual's sense of orientation [or] sense of reality" is helpful here.[18] For him, the rhetorical always does the work of influencing identity and identifications by prompting attitudes. One illustration he offers of this work is the seemingly nonrhetorical function of a lyric poem. While "a lyric," he wrote, "may be, on its face, but a list of descriptive details specifying a scene . . . these images are all manifestations of a single attitude." Functionally, then, the lyric poem "strikes an attitude," and, in the process, invites its reader to "come attitudinize with me."[19] Rhetoric, then, does the work of "persuasion to attitude," a conception that permits us to understand ways that the poetic—and, more broadly, the aesthetic—functions as a mode of influence.[20] This notion of the rhetorical function—indeed, the rhetorical power—of the aesthetic is based on Burke's description of aesthetic form in his early book on literary aesthetics, *Counter-Statement,* as "a way of experiencing."[21] Form, he wrote there, is "an arousing and fulfillment of desires. A work has form in so far as one part of it leads a reader to anticipate another part, [and] to be gratified by the sequence."[22] Here aesthetic form exists not in the poem or the painting but in the reader's, the viewer's—and, indeed, the visitor's—experience of the encounter. And the rhetoricality of that experience is intensified when it is shared.

When people share the same encounter, when what they experience together prompts in them the same attitudes, they come away sharing an identity. Remember that identity is, for Burke, that complex of attitudes that constitutes "sense of orientation" and "sense of reality." Or, I would add, "a sense of place." Identity places us—in ideology, in aspiration, in circumstance, and, finally, in space. When people share a sense of identity, they share a sense of placement. Rhetoric, then, can do the work of influencing that sense of placement in ways that bring people together to inhabit not only the same physical location but also the same attitudes and even actions.

Essentially, the rhetorical influences people to affiliate, to connect

themselves with ideas, with attitudes, and especially with like-minded others. Those who are influenced inhabit together the experience that the rhetoric provides. It is in this sense that national parks are rhetorical, that they do rhetorical work: national parks provide people with rhetorical experiences that prompt particular attitudes. Those attitudes include the reverence for nature that Ansel Adams described, an attitude that propels the political project of conservation that was one of the founding purposes of the national park movement. But they also include the reverence for the nation's pioneering past that the western parks were also intended to express, and, perhaps most importantly, the celebration of an idealized gathering place that is made available to all in a society that aspires to be democratic. This last was the rhetorical project of Frederick Law Olmsted, articulated in practice in the context of the urban park movement of the nineteenth century and his design of New York's Central Park, though also stated in that speech he made in Yosemite Valley.[23] These ideas are what Dwight Pitcaithley, chief historian of the NPS, describes as the "philosophical underpinnings of the national park idea."[24] At their center is Olmsted's conviction of the "regenerative powers" of nature. As Pitcaithley puts it, "Olmsted envisioned a need for ordinary citizens to maintain perspective in their daily lives by being exposed to, and encouraged to contemplate, the natural rhythms of the natural world."[25] That vision was a major reason for the establishment of the NPS with its assigned mission, stated in the 1916 National Park Service Organic Act, "to conserve the scenery and the natural and historic objects and the wild life therein and to provide for the enjoyment of the same in such manner and by such means as will leave them unimpaired for the enjoyment of future generations." And that remains the primary NPS project, here articulated in the 2001 Management Policies of the NPS:

> Regardless of the many names and official designations of the park lands that make up the national park system, all represent some nationally significant aspect of our natural or cultural heritage. As the physical remnants of our past, and great scenic and natural places that continue to evolve—repositories of outstanding recreation opportunities—class rooms of our heritage—and the legacy we leave to future generations—they warrant the highest standard of protection.[26]

Specifically, that project is to protect the aesthetic experiences available within a park from "impairment," to prevent any "impact" that "would harm the integrity of park resources or values." Following that statement in the policy document is a list of those "resources and values," beginning with scenery but including all the material elements that contribute to the visitor's experience of a national park as an exemplary place of aesthetic integrity and cultural value.[27] That project is to provide visitors an opportunity to visit a place where nature and culture are, indeed, "harmonious." Inhabiting that harmony for a time, they can share there an experience of "refuge" from a world where competition, commodification, and exploitation of resources—natural, aesthetic, and human—are the values that prevail.

National Park Architecture

As you drive into Zion National Park, the first thing you notice is the roadside entrance sign, built of roughly cut blocks of sandstone that appear to have been taken from the base of the cliffs above you, and of wood from the pines rooted intermittently on the rocky hillsides. That sign blends into its environment, seeming to be all but natural there. As soon as you notice the sign, you notice the road itself—that the blacktop paving has changed color to the reddish brown that is the darkest hue of the Navajo sandstone formation that gives the Colorado Plateau its character. If you are driving down into the canyon from the high elevation of the east entrance, you soon find yourself inside the Zion–Mt. Carmel Tunnel, bored into the cliffs above the valley in 1930 in a way that renders it largely invisible to those who are driving in from the south entrance along the Virgin River and looking up in awe at the towering canyon walls.

Signs, roads, and tunnels are not structures that are usually considered to be architecturally significant. But in the context of this place they emulate the aesthetic mission of the NPS at its most practical. Early on in the history of the NPS—indeed, in the Organic Act of 1916 that created it—a dual mission was set forth: to preserve "the scenery and the natural and historic objects and the wild life therein and to provide for the enjoyment of the same in such a manner and by such means as will leave them unimpaired for the enjoyment of fu-

Figure 2.2. South entry sign, Zion National Park. Special Collections, Sherratt Library, Southern Utah University.

ture generations."[28] The essential elements of that project—preserving scenery *and* accommodating visitors—may seem inherently in conflict, but under Stephen Mather's direction, the NPS soon developed a design strategy for roads, buildings, and other facilities that would serve the increasing number of tourists who were visiting the parks, mostly in their own automobiles, and yet preserve and perhaps even enhance the scenery. That general strategy was known early on as the "rustic style," and its guiding principle was simple: that "the natural setting comes first and the man-made elements must blend into the surrounding context."[29]

An NPS version of rustic design began developing almost immediately, and by 1935 administrators and architects for the national parks, as well as the state parks that followed their lead, had in hand an encyclopedic reference source, published by the NPS, that provided photographic examples of NPS rustic design to guide the construction of all sorts of structures. The primary editor of that volume, *Park Structures and Facilities,* was an NPS architect, Albert H. Good, who introduced the volume not with a preface or foreword but with an "Apologia":

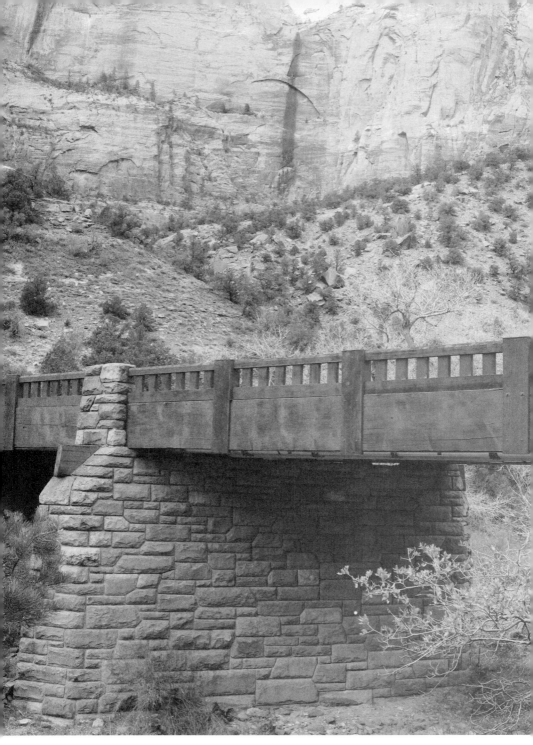

Figure 2.3. North Fork Virgin River Bridge, Zion National Park.

"Lamentable is the fact that during the six days given over to Creation, picnic tables and fireplaces, foot bridges, toilet facilities, and many other of man's requirements were negligently and entirely overlooked." To fill in those gaps appropriately, Good suggested, is the work now at hand. And as one proceeds with that work, Good continued, "he may well realize that structures, however well-designed, almost never truly add to the beauty, but only to the use of a park of true natural distinction. He has come slowly to the sense that, if trespass is unavoidable, it can be done with a certain grace." Given that reflection on the rustic ethic, Good then offered his own definition of "rustic" design:

> Successfully handled, it is a style which, through the use of native materials in proper scale, and through the avoidance of rigid, straight lines, and over-sophistication, gives the feeling of having been executed by pioneer craftsmen with limited hand tools. It thus achieves sympathy with natural surroundings and with the past.[30]

This, it seems, is a general description of NPS rustic design that is as clear and as useful as any.

By the time the NPS was organized, visitor services in many of the western parks were already being developed by the railroads. Because of the expectations of affluent tourists and the need to create for them a strong sense of place in each park that would compete with the European destinations that were an alternative for some and an aspiration for many, the railroads built lodges of unusual and sometimes eccentric design. At Yellowstone, the Old Faithful Inn was built of massive logs in an alpine style. At Grand Canyon, the Fred Harvey Company—concessionaire for the Santa Fe Railroad—built the El Tovar, a magnificent hotel evoking a Swiss design in southwestern materials. Private buildings in Yosemite Valley were being designed to use native materials to express without subtlety the verticality of that place. But soon after the consolidation of management of the parks under the NPS, Mather, as director, began overseeing that systematic development and application of a version of rustic style more appropriate to the mission of the national park movement. It was at the newly established Zion National Park that this work began.

Visitor accommodations in Zion were already being planned by the Utah Parks Company, a subsidiary of the Union Pacific Railroad. The plan was to develop lodges in Zion, Bryce Canyon, and the North

Rim of the Grand Canyon to serve visitors who would leave the train and board buses at Cedar City, Utah, and then visit each of those parks on a loop tour. The first lodge was to be built in Zion, the closest of the parks to the railroad. The design of that lodge was something of a collaborative project, with the Union Pacific architect, Gilbert Stanley Underwood, taking the lead but having to get approval for his plans from the NPS. It was in this negotiative process that much of the "NPS rustic" style evolved. What developed was a complex of low buildings tucked under the towering cliffs. At its center was the lodge with a lobby, a restaurant, and a gift shop. Separate cabins providing guest rooms spread out on either side among the low trees. In the construction of both lodge and cabins, native stone was predominant: the architec-

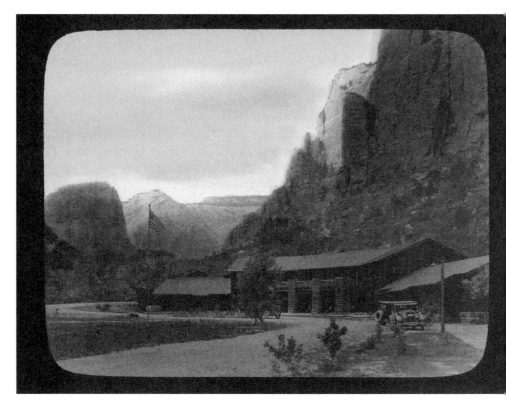

Figure 2.4. Zion Lodge, 1930s. Colored lantern slide. National Park Service Historic Photograph Collection.

tural center of the lodge was its stone columns, and of the cabins their massive chimneys. The walls were made of local, rough-sawn lumber with a "studs-out" construction reminiscent of the granary buildings of the region's Mormon farms. Underwood's biographer describes this as a "lighter rustic" than had been developed in the parks prior to the establishment of the NPS, a design that echoes the mass and verticality of the canyon, uses its materials, and yet blends with it to keep the natural formations of the place predominant.[31] Underwood went on to use the same principles to design lodge and cabin complexes for Bryce Canyon and the North Rim of the Grand Canyon that complemented their sites as well as the Zion Lodge complemented its site. The lodge at the North Rim burned just a few years after it was built, and Zion Lodge burned in 1966, but the Bryce Canyon lodge complex remains intact.

In her 1986 nomination to include the Bryce Canyon Lodge on the National Register of Historic Places, architectural historian Laura Soulliere Harrison described how Underwood's design there applied NPS rustic style to that more heavily wooded site. But it does so in terms of design principles that guided the design of the Zion Lodge as well:

> Despite the problems of designing the complex over time Underwood's buildings possess unifying qualities that create an outstanding sense of place. The larger scale of the lodge, the development's dominant building, is reinforced by the smaller cluster of deluxe cabins. The irregular massing and chunkiness of those buildings imitates the irregularities found in nature. The rough stonework and the large logs re-emphasize that connection to nature. The stones, quarried locally, match portions of the surrounding geology. The logs are the same size as the surrounding pines. The variety of exposed trusswork and the different angles of the roofs in the gift shop, auditorium, and dining room create spaces united in theme by the exposed trusswork but individually expressive in the forms of their architectural spaces. The rough stonework, the free use of logs particularly on the buildings' exteriors, the wave-patterned shingle roofs, the wrought-iron chandeliers, and the exposed framing and trusswork give the buildings a rustic honesty and informality characteristic of park architecture.[32]

Indeed, this honesty and informality extended well beyond the lodge and cabins in Zion, where checking stations, ranger stations, ranger residences, campground stores, employee dormitories, shops and garages,

trails, bridges, and even toilets were built in the same style through the 1930s. In 1987, park officials in Zion nominated many of these structures for the National Register of Historic places. That nomination form includes this general description of Zion's architecture:

> The historic structures in Zion are indicative of the "NPS-Rustic" style which dominated National Park Service architecture during the 1920s and 1930s. The intent of the style was to design buildings which would not intrude upon the natural scenic beauty and which would actually blend with the specific terrain by a use of building materials and massing similar to the natural landscape found in the park. The style was also used for other man-made structures such as gates, campsite fireplaces, water fountains, paths, retaining walls, and curbs.[33]

The description then becomes more specific, describing as the essential elements of NPS rustic in Zion "the predominant use of red sandstone to blend with the precipitous canyon walls, roughly dressed and laid with large mortar joints, combined with generally over-scaled wood elements such as beams, rafters, and eaves which extend beyond and break the edges of the roof and wall." This is NPS rustic adapted there to the particularities of Zion Canyon as a place. For example, unlike the cabins Underwood designed for Bryce and the North Rim of the Grand Canyon, which are set in forests of ponderosa pine, those at Zion are not constructed of logs. Rather, at Zion the cabin walls

> are of milled planks and laid flush, . . . and the exposed stud frame reinforces the style which derives its charm from its simple construction technique. The use of rock is not only more confined, but is limited to smaller blocks. In sum, the Zion cabins are smaller-scaled and designed for a less-timbered terrain which is dominated by rock walls, and a flat valley floor which at that date was still inhabited by pioneer settlers.[34]

Elsewhere in the nomination is this statement about Zion's architecture that might work as a summary description of its combined aesthetic and rhetorical function:

> The style's tenets were an intensive use of hand labor, rejection of regularity and symmetry in building materials, and acceptance of the premise that a structure employing native building materials

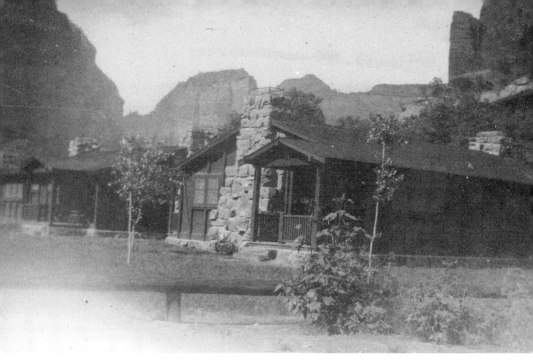

Figure 2.5. Deluxe cabins at Zion Lodge. Special Collections, Sherratt Library, Southern Utah University.

blended best with the natural environment. Properly executed, "NPS-Rustic" . . . structures achieved sympathy with their natural surroundings and the past.[35]

Remembering Harmony

Ethan Carr begins his book *Wilderness by Design: Landscape Architecture and the National Park Service* with the assertion that the "designed landscapes" of a national park "choreograph visitors' movements and define the pace and sequence of much of their experience," an experience that consists of "an aesthetic appreciation of landscapes and emotional communion with the natural world."[36] I have been describing examples of Zion National Park's architecture in order to explain how one such choreographed experience—which is certainly a rhetorical one—works. Or worked. The experience visitors have in Zion has changed since midcentury. After the 1966 fire, the lodge was rebuilt in a modernist style that looked more like a roadside motel than an

integral part of this particular landscape. And since then the number of people visiting Zion has increased precipitously, and with almost all visitors arriving by private car, a perpetual gridlock on the two-lane road that leads up to head of canyon during the summer season has resulted in closure of that road to most cars and implementation of a shuttle bus system. For the past forty years or so, Zion has provided the full experience of harmony between the built and the natural environment that Underwood planned. But what visitors encounter there still approximates it. Underwood's deluxe cabins, which did not burn in 1966 and have been kept in something resembling their original condition, are always booked a year or more in advance. His other buildings are being preserved and restored and are now used for a variety of visitor services. While the main visitor center is another modernist building, the lodge has now been remodeled to resemble Underwood's more integral original. Many other original buildings remain, as do the sandstone bridges, retaining walls, signs, and the rich, rust-colored pavement on the highway.

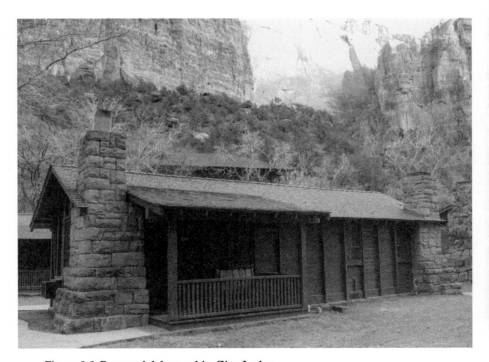

Figure 2.6. Restored deluxe cabin, Zion Lodge.

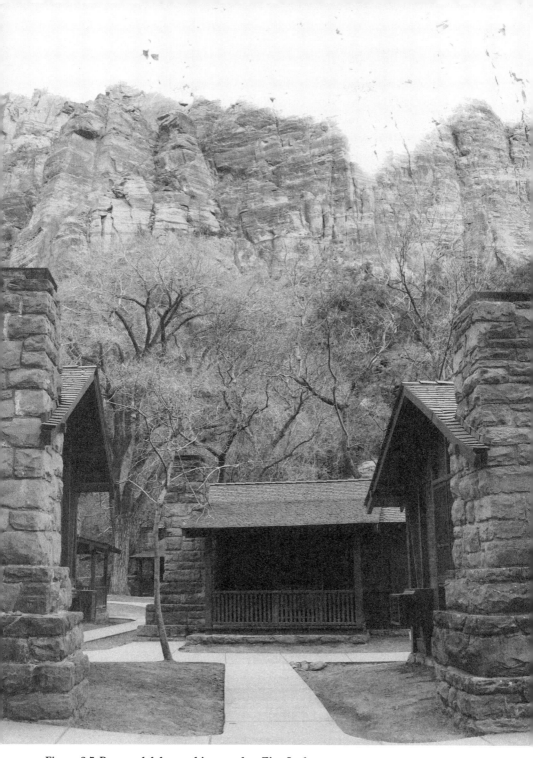

Figure 2.7. Restored deluxe cabin complex, Zion Lodge.

Zion National Park is thus an example of the ongoing rhetorical project of the American national parks to provide those who visit these places with a sense of "refuge" from the visual and environmental cacophony that constitutes everyday experience in an industrial and now postindustrial society. In that society, nature and culture coexist in perpetual conflict because an important element of the common cultural project is to dominate nature, and the predominant aesthetic often expresses defiance of what is natural. Indeed, that defiance seems to be asserted by much modern and postmodern architecture. But once in a while when we find ourselves weary and in need of hope for a more coherent and harmonious world, we stop and, like Mary Rowlandson, we remember Zion. For those who have visited Zion National Park and have experienced there a place where built and natural environments are indeed harmonious, who have, in the process, taken on for themselves for a time the identity of an inhabitant of such a place, Zion National Park might be precisely what they remember.

This is where we must return to rhetoric—and to epideictic rhetoric in particular. Perelman and Olbrechts-Tyteca wrote that epideictic rhetoric tends to appeal to "a universal order, to a nature, or a god that would vouch for the unquestioned, and supposedly unquestionable values."[37] Consequently, those who use epideictic rhetoric thus claim a role in the community not as advocates but as educators. The educator, they write, "has been commissioned by a community to be the spokesman for the values it recognizes, and, as such, enjoys the prestige attending to his office."[38] Rhetorically, then, the educator claims the right and responsibility to "appeal to common values, undisputed though not formulated, made by one qualified to do so, with the consequent strengthening of adherence to those values with a view to possible later action."[39]

I do not know what that later action might be. I do know that a woman who took a bus tour of the Zion, Bryce, and Grand Canyon National Parks sometime in the early 1960s and stayed in one of Underwood's cabins at Zion along the way had her picture taken by its massive sandstone chimney that echoes in human terms the majesty of a place that humans do not try to dominate. She wanted to remember herself there. Perhaps she thought she might be reminded by that place—by its natural and its cultural features—that there is much

Figure 2.8. Bus tour member, circa 1963, outside a deluxe cabin at Zion Lodge.
Special Collections, Sherratt Library, Southern Utah University.

more to life than our competitions and our ambitions. There is solidity, permanence, stability like the canyon walls, and there is nurture like that of the cottonwood and pine trees and the narrow and rocky, but perpetual, desert stream. There is peace of the sort that she found here. She knew that we cannot live in such a place; indeed, living in such a place renders it not such a place after all. Believers in any kind of Zion must always acknowledge that they cannot expect to live there, at least not now. But we can reach for it, and we can visit Zion occasionally—

imaginatively or actually—to help us remember what we are reaching for. In the process of doing that, we might understand how to act a little better in the places where we must live.

This is a rhetorical consequence of the national parks that have been designed to preserve exceptional natural places and provide visitors with an opportunity to inhabit them for a time. This is their message, one that comes not in words but in an experience composed of the combined resources of nature and culture—of culture carefully harmonized with nature in ways that remind us that of the two forces, nature is finally the dominant one. Indeed, it is the offering of that reminder—a reminder of how we might imagine a better way of life— that seems to have been the initial rhetorical function of these earliest national parks. And that is why, over a half century ago, Ansel Adams expressed the hope that this intention might be rendered effective in the national culture, that, in time, the national parks might prompt the American citizenry to "make new discoveries on the planes of ethical and humane discernment, approaching the new society at last, proportionate to nature."[40] It is not clear any progress has been made in that direction, but for the optimist the increasing popularity of the national parks and the emerging recognition that structures in those parks that were designed and built in the style known as "NPS rustic" have historic value and merit preservation and restoration are evidence that perhaps such progress might yet be made.

NOTES

1. Mary Rowlandson, "The Soveraignty and Goodness of God," in *The English Literatures of America, 1500–1800,* ed. Myra Jehlen and Michael Warner (New York: Routledge, 1997), 360–61.

2. Frederick Law Olmsted, *Yosemite and the Mariposa Grove: A Preliminary Report* (Yosemite Association, 1993), 12.

3. Ibid., 8–9

4. Ibid., 18.

5. Marvin S. Hill, *Quest for Refuge: The Mormon Flight from American Pluralism* (Salt Lake City, Utah: Signature Books, 1989), 35.

6. Sacvan Bercovitch, *The American Jeremiad* (Madison: University of Wisconsin Press, 1978), 66.

7. Ansel Adams, "The Meaning of the National Parks" (1950), in *Cele-*

brating the American Earth: A Tribute to Ansel Adams (Washington, D.C.: The Wilderness Society, nd), np.

8. Michael Leff, "The Habitation of Rhetoric," in *Contemporary Rhetorical Theory: A Reader,* ed. John Louis Lucaites, Celeste Michelle Condit, and Sally Caudill (New York: Guilford Press, 1999), 57–58.

9. Ibid., 62.

10. Chaim Perelman and Lucie Olbrechts-Tyteca, *The New Rhetoric: A Treatise on Argumentation,* trans. John Wilkinson and Purcell Weaver (Notre Dame, Ind.: University of Notre Dame Press, 1969), 51.

11. Lawrence W. Rosenfield, "The Practical Celebration of Epideictic," in *Rhetoric in Transition: Studies in the Nature and Uses of Rhetoric,* ed. Eugene E. White (University Park: Pennsylvania State University Press, 1980), 138.

12. Gerard Hauser, "Aristotle on Epideictic: The Formation of Public Morality," *Rhetoric Society Quarterly* 29, no. 1 (Winter 1999): 14.

13. Perelman and Olbrechts-Tyteca, *The New Rhetoric,* 51–52.

14. Hauser, "Aristotle on Epideictic," 15–16.

15. Myra Jehlen, *American Incarnation: The Individual, the Nation, the Continent* (Cambridge, Mass.: Harvard University Press, 1986). Jehlen's discussion addresses the ideological principles that early Americans tended to read as "incarnate" in the land. I am suggesting here that some of those principles border on the religious.

16. Barbara Novak, *American Painting of the Nineteenth Century: Realism, Idealism, and the American Experience,* 2d ed. (New York: Harper and Row, 1979), 42.

17. Candace Clark, *Misery and Company: Sympathy in Everyday Life* (Chicago: University of Chicago Press, 1997), 30.

18. Kenneth Burke, *Permanence and Change: An Anatomy of Purpose,* 3d ed. (Berkeley: University of California Press, 1984), 309.

19. Kenneth Burke, "An Eye-Poem for the Ear, with Prose Introduction, Glosses, and After-Words ('Eye-Crossing from Brooklyn to Manhattan')," in *Late Poems, 1968–1993: Attitudinizings Verse-Wise, While Fending for One's Selph, and in a Style Somewhat Artificially Colloquial,* ed. Julie Whitaker and David Blakesley (Columbia: University of South Carolina Press, 2005), 25–26.

20. Kenneth Burke, *A Rhetoric of Motives* (Berkeley: University of California Press, 1969), 50

21. Kenneth Burke, *Counter-Statement* (Berkeley: University of California Press, 1968), 143.

22. Ibid., 124.

23. Olmsted's Yosemite speech was lost until well into the twentieth century, but the ideas he addressed, such as the concept of public parks—like New York City's Central Park, which he designed—were well known to those

who led the national park movement. See Joseph L. Sax, "America's National Parks: Their Principles, Purposes, and Prospects," *Natural History* 85 (October 1976): 62.

24. Dwight T. Pitcaithley, "Philosophical Underpinnings of the National Park Idea" (2001), National Park Service, http://www.cr.nps.gov/history/hisnps/NPSThinking/underpinnings.htm.

25. Ibid.

26. National Park Service, "2001 Management Policies," http://www.nps.gov/refdesk/mp/chapter1.htm.

27. Ibid.

28. Robert Frankenberger and James Garrison, "From Rustic Romanticism to Modernism, and Beyond: Architectural Resources in the National Parks," *Forum Journal: The Journal of the National Trust for Historic Preservation,* Summer 2002, 8.

29. Ibid., 14.

30. Albert H. Good, et al., *Park Structures and Facilities* (National Park Service, U.S. Department of the Interior, 1935), 3–4.

31. Joyce Zaitlin, *Gilbert Stanley Underwood: His Rustic, Art Deco, and Federal Architecture* (Malibu, Calif.: Pangloss Press, 1989), 42.

32. Laura Soulliere Harrison, "Architecture in the Parks: National Historic Theme Study" (National Park Service, U.S. Department of the Interior, November 1986), 235.

33. "Multiple Resources for Zion National Park," *National Register of Historic Places Inventory—Nomination Form* (Zion National Park, Utah, 1987), Item 8, 8–10.

34. Ibid.

35. Ibid., 4.

36. Ethan Carr, *Wilderness by Design: Landscape Architecture and the National Park Service* (Lincoln: University of Nebraska Press, 1998), 1.

37. Perelman and Olbrechts-Tyteca, *The New Rhetoric,* 51.

38. Ibid., 52.

39. Ibid., 53.

40. Adams, "The Meaning of the National Parks," np.

3. ROADSIDE WILDERNESS

U.S. National Park Design in the 1950s and 1960s

Peter Peters

THE FIRST PHOTOGRAPH in this chapter was taken in 1902, when cars were still a curiosity in the United States. It shows a man sitting behind the wheel of a Toledo on the edge of the Grand Canyon. There is no road in sight, or any other sign of human civilization. How he got there is not clear, but the scene conveys an air of normality. It suggests that he simply got in his car and drove there, right to the edge, where he can look out over the vast canyon. His elevated gaze expresses control, power, and individuality. In the first decades of the past century, countless Americans must have thought what this picture so vividly suggests: the automobile provides the freedom to go anywhere whenever you want. The great attraction of the car in the 1920s and 1930s was the idea that people could go places where the railroads could not take them, that they could choose not only their own itinerary but their own tempo as well. Trains, which had once been praised for their reliability and speed, were now experienced as a coercive rather than a liberating means of transportation. The first generation of car travelers considered the slow speed of their car as an advantage, because it enabled them to enjoy the landscape at ease and up close, instead of watching it rushing by from behind the windows of a speeding train. In 1907, the American writer Edith Wharton wrote that the car brought back "the romance of travel" by "freeing us from all the compulsions and contacts of the railway, the bondage to fixed hours and the beaten track, the approach to each town through an area of ugliness and desolation created by the railway itself."[1]

In the United States, the transition from the train to the car took place in the first decades of the twentieth century.[2] In 1910, American

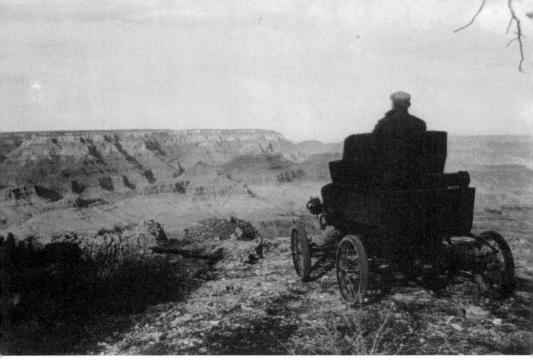

Figure 3.1. Photograph of a man in a Toledo parked at the edge of the Grand Canyon, Arizona, in 1902. Courtesy of the Library of Congress.

railroads still transported more than one billion people each year. Twenty years later, one out of every two Americans owned a car, and the railroads' share of the total number of miles traveled had fallen sharply. By 1930, the car had become the dominant means of transportation not only in, but also between, cities, at the expense of public transportation by train, electric tramways, and the subway.[3] The relatively short time span in which this transition took place is often explained by the qualities of car travel that the first generation of American motorists preferred: freedom and flexibility, not only in a geographical sense but in a temporal sense as well.[4] But these are not inherent characteristics of a car. On the contrary, this chapter argues that the individual freedom and flexibility in movement that car travel engendered should not be taken as an *explanation* for the changing practices of travel in the first half of the twentieth century in the United States, but rather they should be analyzed as the *outcome* of complex and interwoven practices of spatiotemporal ordering. To understand travel flexibility both geographically and temporally, one has to study

the practical achievements in finding design solutions to problems that had to be solved in order to create "flow."

To render a pragmatic understanding of the way people actually travel, I have developed the concept of passages.[5] As a unit of analysis in this practice-oriented approach, passages can be described and researched on three levels. They can be understood as heterogeneous spatiotemporal orderings that assume both material elements and narrative-discursive elements. These orderings always involve aspects of planning, but they are also to a certain extent contingent in that they have to be continuously repaired in real time. And once in place, passages both include and exclude people, places, and moments in time, thus accounting for the normative and political aspects of travel.

The chapter has three parts. It begins by exploring the character of American passages through the tension between standardization and contingency that characterized perceptions of car travel in the 1920s and 1930s, and the subsequent development of standardized roads and road services. I will then reconstruct how these standardized passages were linked to the quintessential American tourist destinations of that period, the national parks. In examining this association, it will become clear that journey and destination cannot be separated; the design of the national parks has always been related to the passages that made them accessible. Finally, the chapter will analyze the way design problems created by the steadily increasing number of visitors to the parks were solved by the NPS's Mission 66 program, which lasted from 1956 to 1966.[6] In my conclusion, I will answer the question, what can we learn from the historical case study of Mission 66 if we want to conceptualize the ways in which new passages reconfigure the dimensions of space and time?[7]

Making Miles

In the first decade of the twentieth century, traveling by car over long distances was an adventure. Motorists often had no idea what they would encounter on the road. When traveling by car, they had to develop the knowledge and skills to solve various problems that might arise while under way. Technically, cars were still far from perfect and broke down often. Roads were in notoriously bad condition, and there

are many photographs of T-Model Fords standing up to their axles in mud. Road signs designated local destinations. Places to buy gasoline or to eat and sleep were scarce, and car travelers had to make detours to find them. In other words, to get anywhere, the first car travelers had to do a lot of work. It was not without reason that they saw themselves as explorers and felt like the pioneers who had gone west in previous decades. The ability of motorists to solve problems resonated with the ideals of self-reliance and individuality formulated in the nineteenth-century transcendentalist philosophies of Ralph Waldo Emerson and Henry David Thoreau.[8]

From the 1910s onward, car travel changed. Ford's rationalizing and standardizing of car production led to lower prices and increased sales, which meant that a growing number of Americans could afford to own a car.[9] In 1916 the Federal Aid Road Act was passed, and shortly after World War I, the federal government began providing funds to improve regional and interregional roads.[10] From the early 1920s on, more and more local and regional roads were chosen to be part of a nationwide network of through highways. Making these regional highways into through roads that traversed the country, however, required the introduction of uniformity. To achieve this, all the regional roads that formed a through road were given one route number.[11] The American gas station developed into one of the first places of standardized consumption. Not only was the architecture of oil companies' gas stations standardized, but their logos could be seen all across the country—an orange disc, a flying horse, or a dinosaur. The aim in every detail was the immediate recognition from the road by motorists who had come from afar.[12]

Like the gas station, the drive-in restaurant underwent a process of standardization and franchising. In the 1920s, restaurants like the Pig Stand began to appear on highway edges. Its founder, J. G. Kirkby, a businessman from Dallas, Texas, was the first to serve people meals *in* their cars. To attract the attention of the car drivers, these restaurants placed large signs along the road, signs that were to have the same function as the standardized logos used by the oil companies. Uniformity in the restaurant's appearance was not the only goal. The menus were also designed to be uniform in each location.[13] John Jakle, Keith Sculle, and Jefferson Roberts describe the rise of the American

motel industry as crucially dependent on franchising chains, place-product packaging, and standardization.[14] The motel's distinct architecture and spatial layout developed out of the anarchistic autocamps, and included the familiar crisscross pattern of cabins and the U- and L-formed buildings, both of which enabled visitors to park their car in front of their room.[15] Standardized room geography meant that when a traveler entered a room, he or she could be sure that they would look more or less the same. The place of the luggage rack, the size of the drawers, and the layout of the bedroom and bathroom were fixed.[16]

The American car traveler could now experience the uniformity and interconnectedness between the different elements in the passage as a flow. As Warren Belasco has shown, instead of slowly meandering through the country, in the 1920s motorists became obsessed with the idea of covering as many miles as possible, from which the popular phrase "making miles" came. A car camper in the 1920s wondered why making miles had become an obsession: "Just why a person should travel miles to see Niagara Falls only to remain about one hour and fail to get a full appreciation of this wonder of nature, is more than I can understand. Yet we have all been guilty of this very thing."[17] As the contingencies and frictions of car travel that the first motorists sought disappeared, car travel became less of an adventure. Motorists knew precisely what to expect from a Standard Oil gas station, a McDonald's drive-in restaurant, and a Howard Johnson motel. How then did the myth of the adventurous open road survive? I argue that new travel myths appeared that can be understood as analogous to how place myths function culturally, namely, as guiding metaphors that provide "*a set of rules of conduct and procedure* for practices and regimes of thought."[18] The standardized emblems, logos, and icons and free road maps that customers could get at gas stations not only helped guide car travelers to their destination, they also helped create new representations of self-reliance and adventure that were characteristic of early motoring. The road signs that identified all 1,926 state highways— white shields with black numbers—became a powerful cultural icon, which can still be seen in the example of the mythologized Route 66.[19] Not only road shields but also drive-in restaurants and motels stood as powerful emblems of a mobile lifestyle, which has been depicted in countless road movies.[20] Literature and later pop music also provide

numerous examples in which the theme of the blue highways, roads that lead to the back regions of America, can be encountered.[21]

This tension between flow and myth, or to put it differently, between standardization and identity, is not only characteristic of American passages but also of the destinations that such passages made accessible. When being on the road hardly felt like an adventure and when reaching a destination as quickly as possible was all that counted, it became even more important that the destination was adventurous. The archetypical destinations in the United States—the national parks—owe their very existence to their unique character. But how could the parks be designed as adventurous and foreign destinations and still be connected to the standardized passages that made them accessible? This was the design problem that the National Park Service (NPS) faced after its foundation in 1916.

Designing National Parks as Car Destinations

From the moment the U.S. Congress established Yellowstone Park in 1872 as the world's first "national park," the design, use, and management of American national parks have been intertwined with the transit practices that make these often remote wilderness areas accessible. Popular accounts of Yellowstone claim that the idea for the park originated during a discussion among a group of explorers who were sitting around a campfire in 1870. Instead of allowing the area to be used for private purposes, they argued that the landscape should be preserved as a public park. But as Alfred Runte claims, although politicians quickly adopted their proposal and signed it into law, their motivation was not as altruistic as it may at first appear to be.[22] A "pragmatic alliance" between upper-class preservationists and western railroad moguls, eager to boost passenger traffic, constituted the foundation of almost all the national parks that were created in the first half of the twentieth century. Railroads were not only crucial in winning congressional support for new parks, like Glacier National Park in Montana, they also led the way in the building of many tourist facilities, including big, luxurious hotels. Initially, travel to the national parks was long, and the first roads through the parks so difficult and arduous that visitors usually remained in them for a long time. As a consequence, hotels and other tourist facilities were usually built within their boundaries.[23]

For Stephen Mather, who became the first director of the NPS in 1917, it was clear that the railroads would be replaced by cars as the chief means of transportation to and within the parks. He forged what James Flink calls a "second pragmatic alliance" between the park service and organizations that represented the interests of car drivers and the automobile industry.[24] Mather welcomed cars in the parks. He recognized the political power of car manufacturers, the American Automobile Association, and the growing number of tourists. He was convinced that broad public support was indispensable for obtaining the tax revenues necessary to create and maintain the parks, and for creating a counterforce to the increasing pressure of private companies and government agencies to exploit the parks' natural resources for commercial purposes.[25] The Federal Highway Act passed in 1921, and the institution of gasoline tax in 1919 enabled state and federal governments to build and maintain a network of new roads by 1929. These new roads made even the most remote parks in the western United States accessible for visitors traveling from the East. The National Parks Highways Association had outlined and marked a route connecting all the national parks. Mather viewed the Park-to-Park Highway, which consisted of six thousand miles of state and local roads, as an important means of turning the western national parks into a coherent and modern park system.[26]

Cars and roads brought people to the parks, thus transforming the parks into popular destinations for American holiday travelers.[27] This development also influenced the designs of the NPS's landscape architects. Mather believed incorporating park villages, buildings, roads, and walking routes into the surrounding landscape was the most important aim of landscape design.[28] In the 1920s and 1930s, the national parks' design followed what was known as a rustic style, which sought to minimize the visual impact of built objects in the parks by using materials from the surrounding landscape, thereby harmonizing handrails, vista points, bridges, and built structures such as museums with the nature surrounding these man-made objects.

The need to harmonize built structures of the parks with the natural world created a dilemma for landscape designers and park engineers. On the one hand, they saw it as their duty to remove dangerous curves, sharp bends in the road, and steep inclines, which are characteristic of mountainous roads. Car drivers wanted to drive safely and

comfortably, and the parks were no exception. On the other hand, park roads had to be built in such a way that their disturbing influence on the surrounding wilderness was minimized. Roads had to have curves that "flowed with and lay lightly on the land."[29] In the 1920s, the principles of road construction in parks were still strongly influenced by the ideas that the garden designer and horticulturalist Andrew Jackson Downing had formulated in the nineteenth century. One of these was to make circular drives in gardens and parks. National park designers adopted this principle in building loop roads in parks, such as Yellowstone's Grand Loop, which create flow by enabling the circular movement of vehicles through the parks. The loop roads fit the needs of national park designers to create flow through the parks so well that they emerged at every scale level, from the park as a whole to campgrounds, as a means to control traffic.[30]

Between 1933 and 1940 the NPS received 220 million dollars from several New Deal institutions. These funds were used mainly to rebuild and repave park roads and to construct impressive scenic roads, such as the Zion–Mount Carmel Road and Tunnel, the Wawona Road and Tunnel in Yosemite, and the Going-to-the-Sun Road in Glacier National Park. These roads featured vista points, traffic signs, road signs, softened curves, parking lots, and new plants and trees that helped to embed them into the surrounding landscape. As Ethan Carr puts it, these features were "intermediary landscapes," carefully designed to mediate between the American car tourist and the nature of the national parks.[31] Such intermediary landscapes were the product of a culture that valued the car as a means of getting everywhere and the preservation of the unspoiled nature as an icon of a powerful national identity closely linked to the ideals of freedom and individuality.

Mission 66

After World War II, easy access to the parks was increasingly seen as threatening the parks' existence. Between 1947 and 1957 the number of cars in the United States rose from thirty-seven million to sixty-seven million, mirroring the postwar prosperity of the American middle class.[32] The combination of higher incomes, higher standards of living, more leisure time, and an increased mobility led to sharply growing

numbers of visitors to the national parks, which had become popular, "democratic" holiday destinations.[33] In 1955, a total of fifty-five million people visited the parks. During the same period, the amount of tax money the federal government spent on them decreased. Reacting to the growing unease about the deterioration of the park system, the journalist and outspoken conservationist Bernard DeVoto argued in a 1953 *Harper's Magazine* article that parks like Yosemite and Yellowstone should be closed.[34] His concerns were echoed in other critical articles that appeared over the next couple of years.

Conrad Wirth, who became the NPS's director in 1955, claimed that "the public [was] loving the parks to death," and saw it as his main task to solve this problem.[35] Instead of focusing on annual budgets for maintenance and exploitation, which could easily be cut, he proposed that the NPS develop a ten-year plan that Congress must accept as a package. Wirth set up two committees to make plans for what he called Mission 66, a name that expressed a sense of mission as well as pointed to the year 1966, when the NPS would celebrate its fiftieth anniversary. After President Dwight D. Eisenhower responded positively to the proposal, the project was officially launched during the second Pioneer Dinner, held February 8, 1956, in Washington, D.C.

In the brochure for Mission 66, called *Our Heritage*, the NPS emphasized the importance of the park system as a "national resource" that greatly contributed to the American way of life and the national economy. Mission 66's main challenge, according to the brochure, was that "the National Parks are neither equipped nor staffed to protect their irreplaceable features, nor take care of the increasing millions of visitors."[36] The NPS expected the number of visitors to increase from the current fifty million annually to eighty million by 1966. Mission 66 spelled out an eight-point plan for improving the parks, which included an increase in park staff, the improvement of staff facilities, land purchases to consolidate existing parks and create new ones, the reconstruction and improvement of park roads, and the building of visitor centers. Mission 66's task thus essentially entailed adapting the parks to the expected growth in the number of visitors, all of whom came by car, without irreparably damaging the nature inside the parks. An image from *Our Heritage* (Figure 3.2) clearly reflects Mission 66's plan.

The tension between wilderness and access was not new in the

Figure 3.2. Illustration from the National Park Service brochure *Our Heritage*, issued in 1956, that depicts one of the main tasks of Mission 66: accommodating cars in the parks. Courtesy of the National Park Service.

history of the parks. Thomas Vint, the most important landscape architect for the NPS from the 1930s to the 1950s, used the term *wilderness* to designate an area where and when he wanted to prevent the construction of new roads in the parks. His master plans identified different zones in the parks, each of which served a different function, such as "wilderness," "research," "sacred," and "developed." Mission 66 stood in this tradition. The question of how zones should be qualified depended largely on whether cars should be allowed in them.[37] There had to be good visitors' facilities to preserve the parks, which Lon Garrison, one of the Mission 66 managers, called the "paradox of

protection."[38] One of the central principles underlying the Mission 66 program was the idea that the impact of large numbers of visitors could be regulated by making certain areas accessible through good roads, paths, and other facilities. Building good facilities would not harm nature, but, on the contrary, protect it.[39] For Wirth and Garrison, the difference between "roadside wilderness" and "true wilderness" was not a matter of principle but of organization. In one of the brochures published during the Mission 66 period, the NPS used the expression "accessible wilderness" for areas that could be reached after a ten-minute walk from one of the park roads.[40]

Modernism entered the parks with Mission 66. The rustic style that had characterized the NPS's design criteria until the early 1950s gave way to modern architecture beginning in 1956.[41] Among the most important modernist innovations during the Mission 66 period was the construction of visitor centers to replace park museums. The idea behind the visitor center was to offer visitors all the information they needed to enjoy a park in one place. It was for this reason that visitor centers were also called "one stop service units."[42] The visitor centers were part of a strategy that sought to guide visitors through the national parks efficiently. In contrast to the rustic design of the park museums, which were often located close to the main sights, visitor centers were located at places that were easily accessible by car, such as at the park's entrance or at important crossroads. The planning theory behind the visitor center was closely associated with contemporary design and the layout of shopping malls, business parks, and industrial areas.[43] In the visitor centers, tourists should be able to get an overview of park routes and sights, learn the location of different services, view exhibitions, and, most importantly, see an audiovisual presentation, which had become popular in the 1950s. These were all ways to accommodate the increasing numbers of people who visited the parks.

The Mission 66 program was active during the ten years it was carried out and, according to Richard Sellars, counts as one of the most successful government programs in American history.[44] Countless innovations and adaptations were made, and many of these determined what the parks look like today. However, the program was also criticized. Initially, the modernist design of the new visitor centers and lookout points was attacked. During the 1960s, conservationists and wilderness

advocates criticized the park management philosophies behind Mission 66 because they were considered dangerous for the preservation of nature.[45] Some critics observed that the parks had been submitted to a process of "urbanization."[46] An article that appeared in the *National Parks Magazine* stated that "engineering has become more important than preservation, creating wide, modern roads similar to those found in state highway systems and visitor centers that looked like medium-sized airport terminals."[47] A vivid example of modernist design that came under fire is Clingmans Dome Tower, built in 1959 in Great Smoky Mountains National Park, located in the Appalachian Mountains in North Carolina and Tennessee (Figure 3.3). A paragon of modernist architecture of the period, its spiraled tower was hated by some, who considered it an intrusion into nature. Its concrete structure, reminiscent of a highway ramp,

Figure 3.3. Observation tower atop Clingmans Dome in Great Smoky Mountains National Park, Tennessee. The tower, built in the 1950s, is still in use. Courtesy of the Library of Congress.

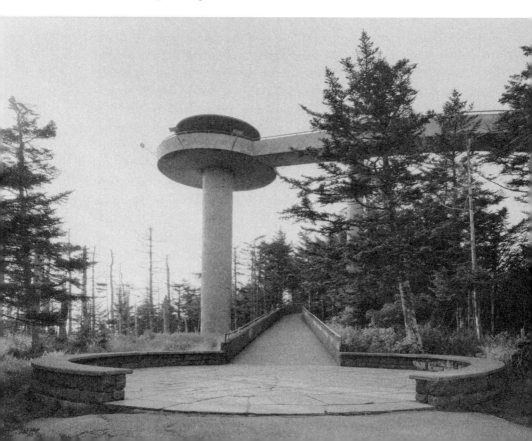

did not blend into the surroundings. The changing gaze of the visitor walking to the tower's top imitated the visual experience of driving on a parkway.[48]

Circulation and Representation

During the era of Mission 66, park designers sought new designs of physical structures to create flow inside the parks. On a material level, the goal of quicker circulation was partly achieved by building modern visitor centers, lookout points, and parking areas that were no longer judged according to the extent that they were embedded in the surrounding landscape, but to their efficiency in leading visitors to the main sites. To achieve this goal of what could be called democratic access, however, material innovations proved insufficient. The experience of being in the parks had to be restyled. What was considered to be the unique character of a park or a place had to be expressed in stylized representations or images. For example, the clearer it was to visitors at Yosemite Valley where the most beautiful places were located, the easier their tour through the park would be, and the shorter they would have to stay on the valley floor.

Thus, not only was the physical landscape reshaped in a modernist style, but the *representation* of wilderness became increasingly redesigned as well. As David Nye observes, in creating destinations like the national parks, there is always a combination of the techniques of transportation and representation.[49] In claiming that there is no "innocent eye," he emphasizes that any site, however unspoiled it may seem, is viewed through the lens of a powerful visual culture.[50] As already argued, the ideas of both the American park and landscape designers were influenced by nineteenth-century English landscape architecture in which the aesthetic, picturesque qualities of nature were foregrounded.[51] In the 1920s and 1930s, the design of the parks was dominated by the visual rhetoric of the vista point. Cars not only brought visitors to these lookout points but also set in motion the nineteenth-century landscape painting itself for those who drove through the parks in a car. The tourist's gaze became dynamic: the landscape was projected as a film on the windscreen of the car.[52] In the design of park roads and the parkways that led to them, which can be considered as a sort of extended national park, this film was directed down to the smallest of details.[53]

During the Mission 66 era, the road became an important technique in arranging the sequential order and tempo in which the park sights followed each other. The loop roads ordered the landscape in clear spatiotemporal sequences in such a way that visitors were not so much directed into nature as to pass by it. In the 1958 *Handbook of Standards for National Parks and Parkway Roads,* NPS director Wirth explained that roads had become the "principal facilities for presenting and interpreting the inspirational values of a park."[54] Just like the highways and roadside restaurants and motels, the NPS incorporated both a spatial and a temporal logic into the design of its parks. They bear a striking similarity to Disneyland, which opened in Los Angeles in 1956, the same year that Mission 66 was launched. As Alan Bryman suggests, Disneyland's design was aimed at controlling and standardizing the movements of visitors into and through the theme park.[55] Its spatial configuration, which featured Snow White's fairy tale castle as an attention magnet halfway through the park, led visitors from the park's entrance to its interior. Visitors were taken in small cars to each of the park's attractions, which enabled Disney to control the amount of time people spent on each one, which in turn made it possible to allow larger numbers of people into the park each day. Mission 66 park designers acknowledged that it would only be possible to direct the increasing numbers of visitors through the parks *and* to preserve nature by shortening the span of time that people spent in them. Walking through the parks, which can take several days, was the privilege of a very small minority—less than 1 percent of visitors. The majority spent much less time.[56]

Figure 3.4 shows a stylized image of a visitor center that appeared in one of the Mission 66 brochures. It can be viewed as an example of the intermediary landscapes created during the Mission 66 period, a place where visitors could see what they had already seen on countless photographs and other representations of the American wilderness.[57] Because the visitors to the parks were familiar with these images, they already knew what to expect from their visit to them. There was no need to stay longer than the park managers (and conservationists) thought necessary in order to have a wilderness experience.

The passages outside the parks were not the only ones to have been created as standardized spatiotemporal orders. So too were the passages

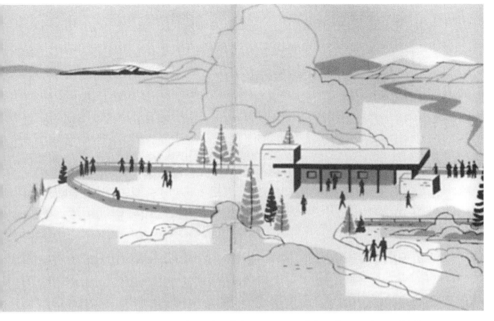

Figure 3.4. A stylized illustration of a visitor center with a vista point, which appeared on the cover of *Mission 66 in Action,* published by the National Park Service in 1959.

inside the parks. Journey and destination could no longer be separated. When the smooth transits to national parks that car practices created led to an increasing number of visitors, threatening their existence, the passages that brought people to the parks were continued within them. The same design principles that organized flow on the roads outside of the parks were used to manage visitor circulation and create roadside wilderness within them.

In the intermediary landscapes at the boundary between the American passages and the wilderness that they made accessible, the promise of unspoiled nature created by countless images and other representations was efficiently maintained. Through the stylings of illustrations and images, visitors learned what to expect and thus did not have to stay longer than what park planners and conservationists believed was desirable. During the Mission 66 era, a new type of passage was created that led people efficiently to the wilderness and back home again.

This was achieved by styling and standardizing the destination and the collective images of it. This innovation resolved, at least for the time being, the tension between use and conservation that had existed since the early years of the NPS and became more urgent in the 1950s with the dramatic rise in the number of visitors.

Conclusion

We can now interpret the photograph at the beginning of the chapter in a different way. Before the driver got to the edge of the Grand Canyon, he probably had to do a lot of work to reduce the friction of primitive car technology, bad roads, and the lack of services along the way. During the first decades of the twentieth century, this work became increasingly delegated to standardized networks of highways, gas stations, and restaurant and motel chains. Not only was the production of cars organized in a Fordist and Taylorist manner, the car journey itself changed from an uncertain and adventurous undertaking to an event that was predictable and efficiently organized. Standardization provided the connections between the heterogeneous elements in multiple networks that rendered the flow that every car driver could depend on, making it possible to get anywhere at any time. The flexibility and freedom of the car can thus be shown not as an inherent characteristic of a single technology but the result of numerous interconnected innovations.

Passages have effects that are contingent. The heterogeneous order that renders a fast and predictable journey is never finished but has to be repaired continually. Thus, once created, flow leads to new problems. This chapter has examined how such contingencies arise and are solved in the national parks. On the one hand, the parks had to be connected to the passages that made them accessible. On the other, this connection did not mean that the parks lost their uniqueness as individual places of nature and wilderness. In trying to find solutions to this design problem, the NPS had to maneuver between the exigencies of democratic access and the values of unspoiled nature. The Mission 66 program illustrates that the design of the parks was never stable. The NPS was constantly forced to renegotiate between access and preservation. Park planners had to adapt the parks' design to the

increasing numbers of visitors by building visitor centers that directed visitors to the main sites in a short amount of time. Circulation was the main way of preventing the parks from being inundated by cars. From the 1950s on, such circulation was achieved by adapting the material layout of the park design and restyling representations of nature. The national parks became places where the vast majority of people could get to easily but precisely because of this, only spend a short time.

What can be concluded from the history of Mission 66 about the ways in which new passages for the car reconfigured the dimensions of space and time in the national parks? The Mission 66 program can be read as a continuing process of solving design problems in which at least three tensions existed. First, both Mission 66 and the history of national parks in general reveal a tension between *passage* and *place,* which stems from the fact that the way a destination is made accessible cannot be separated from the design of the place itself. This intertwining of the design of access and the design of place is a curiously underresearched subject in cultural geography and social theory. As this chapter has shown, one goes to a different park when traveling by train than when traveling by car. As the phrase "roadside wilderness" in one of the Mission 66 brochures suggests, the chief design problem that architects faced was how to connect two different worlds. They resolved this problem by designing intermediary landscapes. It was in these landscapes that the freedom and flexibility of car access to the parks were constantly renegotiated in terms of the need to preserve the parks' wilderness. These intermediary landscapes were also designed according to different styles: the rustic style of the 1930s worked from different assumptions about how to solve the tension between use and preservation than the modernist design of Mission 66.

Second, there is a tension between *material* and *narrative* elements in the strategies developed by park designers. This tension can be found both in passages and in intermediary landscapes. The long and laborious journeys, like the ones the early American motorists made, could be turned into adventure stories precisely because they were contingent and unpredictable. When American passages became more standardized and thus less adventurous, stories of living on the road gave way to what could be called travel myths, as the mythology surrounding Route 66 today shows. Here, the signs used to standardize the road

system became powerful cultural icons. In the parks, the same dialectic was used by park designers to create flow and circulation through the parks. As the number of visitors who came to the parks increased, they had less time to create their own wilderness adventures within them. Instead, the wilderness experience reappeared in the form of standardized and, often, visual narratives. Experiencing nature in a short time required new representations of the unique character of the parks.

The third tension is that between *space* and *time* in design. The case of Mission 66 makes clear that designing space cannot be separated from designing time. When creating intermediary landscapes, park designers created specific zones of both spatial and temporal access to the parks. Their goal was to circulate visitors through the parks in less time than could be done using rustic designs. This meant that each visitor could stay in the park for a shorter time. To achieve this goal, they had to reconfigure space and time not by simply speeding up the cars but by redesigning the wilderness experience both on a material and a narrative level. Because car passages are spatiotemporal orderings, the national parks had to be designed not only as landscapes but as timescapes as well.[58]

John Urry has pointed out the dual character of automobility: "it is immensely flexible *and* wholly coercive."[59] This chapter builds on this claim. In taking the design of passages and places as the point of departure, it concludes that the opposition between the corridor-like journeys by train and the individual and flexible journeys by car is not as strong as it may at first appear. The photograph of the driver at the Grand Canyon's edge made in 1902 depicts the sort of freedom that had become illusory for the vast majority of visitors that went there in the 1950s and after. Ironically, the design strategies of Mission 66 made their journey to the South Rim as predictable, if not as coercive, as the train schedules the first motorists disliked so much.

NOTES

1. Lynne Withey, *Grand Tours and Cook's Tours: A History of Leisure Travel, 1750–1915* (New York: William Morrow, 1997), 335.

2. Warren Belasco, *Americans on the Road: From Autocamp to Motel, 1910–1945* (Cambridge, Mass.: MIT Press, 1979); Warren Belasco, "Cars versus Trains:

1980 and 1910," in *Energy and Transport: Historical Perspectives on Policy Issues,* ed. G. H. Daniels and M. H. Rose (London: Sage, 1992), 39–53; Stephen B. Goddard, *Getting There: The Epic Struggle between Road and Rail in the American Century* (Chicago: University of Chicago Press, 1994).

3. Martin Wachs and Margaret Crawford, eds., *The Car and the City: The Automobile, the Built Environment, and Daily Urban Life* (Ann Arbor: University of Michigan Press, 1992).

4. Belasco, *Americans on the Road,* 22.

5. Peter Peters, *Time, Innovation and Mobilities* (London: Routledge, 2006).

6. Apart from the secondary literature mentioned in the notes, my research on the Mission 66 program is based on primary sources on Mission 66 from the archives of the National Park Service History Collection in Harpers Ferry, West Virginia. I also used my interviews in 2000 with Ethan Carr (Park Historic Structures and Cultural Landscapes Program, NPS), Timothy Davis (Historic American Buildings Survey/Historic American Engineering Record), and David Nathanson (NPS History Collection, Harpers Ferry Center, Harpers Ferry, West Virginia).

7. John Urry, "Mobile Sociology," *British Journal of Sociology* 51, no. 1 (2000): 185–203.

8. Kris Lackey, *RoadFrames: The American Highway Narrative* (Lincoln: University of Nebraska Press, 1997).

9. Peter J. Ling, *America and the Automobile: Technology, Reform and Social Change, 1893–1923* (Manchester: Manchester University Press, 1990), 125; Jack E. Vance, *Capturing the Horizon: The Historical Geography of Transportation since the Transportation Revolution of the Sixteenth Century* (Baltimore: Johns Hopkins University Press, 1986), 499; Arthur M. Schlesinger and Fred L. Israel, ed., *Touring America Seventy-Five Years Ago: How the Automobile and the Railroad Changed the Nation: Chronicles from National Geographic* (Philadelphia: Chelsea House Publishers, 1999), 2.

10. Vance, *Capturing the Horizon.*

11. Tom Lewis, *Divided Highways: Building the Interstate Highways, Transforming American Life* (New York: Viking, 1997).

12. Alexander Wilson, *The Culture of Nature: North American Landscape from Disney to the Exxon Valdez* (Oxford: Blackwell Publishers, 1992), 33; and John A. Jakle and Keith A. Sculle, *The Gas Station in America* (Baltimore: Johns Hopkins University Press, 1994).

13. Jim Heimann, *Car Hops and Curb Service: A History of American Drive-In Restaurants 1920–1960* (San Francisco: Chronicle Books, 1996), 22.

14. John A. Jakle, Keith A. Sculle, and Jefferson S. Rogers, *The Motel in America* (Baltimore: Johns Hopkins University Press, 1996).

15. Ibid., 36.

16. Ibid., 270. See also John Margolies, *Home Away from Home: Motels in America* (New York: Bulfinch Press, 1995).

17. Belasco, *Americans on the Road,* 87.

18. Rob Shields, *Places on the Margin: Alternative Geographies of Modernity* (London: Routledge, 1991), 256.

19. Michael Wallis, *Route 66: The Mother Road* (New York: St. Martin's Press, 1993).

20. Ron Eyerman and Orvar Löfgren, "Romancing the Road: Road Movies and Images of Mobility," *Theory, Culture & Society* 12, no. 1 (1995): 53–79; and Steven Cohan and Ina Rae Hark, eds., *The Road Movie Book* (London: Routledge, 1997).

21. Lackey, *RoadFrames.*

22. Alfred Runte, *Trains of Discovery: Western Railroads and the National Parks* (Niwot, Colo.: Roberts Rinehart Publishers, 1990).

23. See Roderick Nash, *Wilderness and the American Mind* (New Haven, Conn.: Yale University Press, 1982); and Samuel P. Hays, *Beauty, Health, and Permanence: Environmental Politics in the United States, 1955–1985* (Cambridge: Cambridge University Press, 1987).

24. James J. Flink, *The Automobile Age* (Cambridge, Mass.: MIT Press, 1988).

25. Ethan Carr, *Wilderness by Design: Landscape Architecture and the National Park Service* (Lincoln: University of Nebraska Press, 1998), 172.

26. Ibid., 147.

27. David G. Havlick, *No Place Distant: Roads and Motorized Recreation on America's Public Roads* (Washington, D.C.: Island Press, 2002).

28. Linda Flint McClelland, *Building the National Parks: Historic Landscape Design and Construction* (Baltimore: Johns Hopkins University Press, 1997), 162.

29. *Lying Lightly on the Land: Building America's National Roads and Parkways* is the title of an exhibition on building parkways and park roads held between June 6, 1997, and March 1, 1998, by the NPS and the Historic American Buildings Survey/Historic American Engineering Record. It was curated by Timothy Davis of the Historic American Engineering Record. The exhibition can be visited online at http://www.nps.gov/history/hdp/exhibits/lll.

30. McClelland, *Building the National Parks,* 178.

31. Carr, *Wilderness by Design,* 92.

32. Vance, *Capturing the Horizon,* 499.

33. Ethan Carr used the term "democratic holiday" when I interviewed him in June 2000.

34. Bernard DeVoto, "Let's Close the National Parks," *Harpers's Magazine,* October 1953, 49.

35. Richard W. Sellars, *Preserving Nature in the National Parks: A History* (New Haven, Conn.: Yale University Press, 1998), 181.

36. National Park Service, *Our Heritage* (National Park Service: Washington, D.C., 1956), 5.

37. Carr, *Wilderness by Design*, 197.

38. Ethan Carr, *Mission 66: Modernism and the National Park Dilemma* (Amherst: University of Massachusetts Press, 2007), 28.

39. In the 1956 NPS annual report, Wirth claimed that park development was "based upon the assumption" that "when facilities are adequate in number, and properly designated and located, large numbers of visitors can be handled readily and without damage to the areas. Good development saves the landscape from ruin, protecting it for its intended recreational and inspirational values" (cited in Sellars, *Preserving Nature in the National Parks*, 181).

40. Ibid., 187.

41. Sarah Allaback, *Mission 66 Visitor Centers: The History of a Building Type* (Washington D.C.: National Park Service, 2000), 10.

42. Ibid., 21.

43. Ibid., 24. In her history of Mission 66 visitor centers, Allaback elaborates on their similarity with shopping centers, where a range of services was made available for customers arriving by car. Whereas the plan of the earlier "park village" was more decentralized, the Mission 66 visitor centers brought together different functions in one building—museum, bookshop, park administration—which enabled more control of what was called "visitor flow."

44. Sellars, *Preserving Nature in the National Parks*.

45. Carr, *Mission 66*, 70.

46. Sellars, *Preserving Nature in the National Parks*, 185.

47. Ibid., 186–87.

48. McClelland, *Building the National Parks*, 471.

49. David Nye, *Narratives and Spaces: Technology and the Construction of American Culture* (Exeter, UK: University of Exeter Press, 1997).

50. Ibid., 5.

51. Michael Bunce, *The Countryside Ideal: Anglo-American Images of Landscape* (London: Routledge, 1994).

52. John Urry, *The Tourist Gaze*, 2d ed. (London: Sage, 2002).

53. Wilson, *The Culture of Nature*, 36. Thomas Patin argues that national parks should be considered as museums not only because they were meant to preserve wilderness areas for later generations, but also because they applied the same techniques as museums did to regulate and organize the visitor's gaze, including "the design of entrances, the display of information, the control and direction of traffic patterns, and the regulation of the position of the

visitors." See Thomas Patin, "Exhibitions and Empire: National Parks and the Performance of Manifest Destiny," *Journal of American Culture* 22, no. 1 (1999): 48. See also Grusin on representing nature at Yellowstone; Richard Grusin, "Representing Yellowstone: Photography, Loss, and Fidelity," *Configurations* 3, no. 3 (Fall 1995): 415–36; and Richard Grusin, *Culture, Technology and the Creation of America's National Parks* (Cambridge: Cambridge University Press, 2004).

54. Patin, "Exhibitions and Empire," 55–56.

55. Alan Bryman, *Disney and His Worlds* (London: Routledge, 1995), 100.

56. Speeding up the experience of nature by using new technologies of representation did not end with Mission 66. Nye claims that techniques such as the IMAX theater at the Grand Canyon enable visitors to see parks in a way they could not without taking time-consuming hikes. See Nye, *Narratives and Spaces*, 21.

57. For examples, see images in Jonathan Spaulding, *Ansel Adams and the American Landscape: A Biography* (Berkeley: University of California Press , 1995).

58. Barbara Adam, *Timescapes of Modernity: The Environment and Invisible Hazards* (London: Routledge, 1998).

59. John Urry, *Sociology beyond Societies: Mobilities for the Twenty-First Century* (London: Routledge, 2000), 59.

4. CRITICAL VEHICLES CRASH THE SCENE
Spectacular Nature and Popular Spectacle at the Grand Canyon

Mark Neumann

> If democracy is to be a machine of hope, it must retain one
> strange characteristic—its wheels and cogs will need to be
> lubricated not with oil but with sand.
>
> —Krzysztof Wodiczko, *Critical Vehicles:*
> *Writings, Projects, Interviews*

TAKE A LOOK at Ned Thacker and Elsie Dodge try-
ing to get it straight with the sight of the Grand Canyon.

"Golly, what a gully," says Ned, in the awkward and affable man-
ner of a midwestern fish flapping about on the brink of an ancient sea.

"It makes me feel so unimportant," says Elsie. She's got her own
troubles, but the bigness of the canyon humbles her enough to think her
own stuff doesn't matter by comparison. Ned agrees. He throws out his
chest, points his finger to the sky, and recites quintessential bombastic
praise for the sublime chasm.

"What was God's purpose to so rend the earth under this majesti-
cally fretted dome as to horribly shake our dispositions with thoughts
far beyond the reach of our souls?" This is Ned, trying to show he's
tuned in, that he's appropriately moved. Elsie might even be charmed
because he's obviously a deep guy standing on the edge of a deep abyss.
He's quaking with spirit and nature, but even he knows it's not enough.
Ned picks up some stones and juggles them, trying to impress her, but
this act can't steal the scene. So he launches into a handstand right
there on the brink of God's handiwork. Now *that's* something to behold,
and it is the sight of Ned balancing on two hands, at the chasm's edge,
that makes Elsie gasp in awe.

Figure 4.1. Ned Thacker (Douglas Fairbanks) and Elsie Dodge (Marjorie Daw) in *A Modern Musketeer* **(1917). Photograph of screen image by Mark Neumann.**

Watching Ned and Elsie move through this scene in Allan Dwan's 1917 film *A Modern Musketeer* offers a brief display of how populist performance and spectacle sometimes collide with the well-rehearsed repertoire of responses that so often frame scenes of nature in places like the Grand Canyon. Here is a brief collision of discourses, of utterances and gestures that momentarily reveal what is at the crux of crashing

a scene. It is a moment that exhibits a broader set of cultural practices and attitudes toward nature that simultaneously celebrate the virtues of a natural world while entombing nature in a fossilized language quietly pretending to be an original and authentic evocation of the sublime.

Ned Thacker knows this intuitively when he summons his daring clown self and balances at danger's edge. Douglas Fairbanks played Ned in Dwan's film. His comic and boyish tourist—Ned Thacker from a small town in Kansas who, as an adult, still revels in the fantasies of Dumas's musketeers—aimed to win the hearts and laughs of movie audiences by making a foil of upper-class pretension. In fact, Elsie Dodge (played by fifteen-year-old Marjorie Daw) was the kind of character likely to be sitting in a theater watching a Fairbanks film. In *A Modern Musketeer*, Elsie is a working-class girl. She is at the canyon with her mother, and both are guests of Forrest Vandeteer, a high-society millionaire from Yonkers who is trying to get Elsie to marry him. Vandeteer takes them on a transcontinental automobile tour to win her over. Elsie agrees to go because she thinks Vandeteer might get her out of debt, even though she thinks he's a lecherous scoundrel. Ned tries to win Elsie's heart, too. And for what he might lack in elevated social standing and money, he makes up for with amusing displays of physicality, blind fearlessness, and a bold sense of humor, which he exhibits here on the canyon's brink. Ned's handstand is but a small emblem of performative disruption, a moment given context by his parody of upper-class pretension and given power by his execution of a popular trick that requires skill, physical prowess, and a good measure of courage. His inverted image on the canyon's edge is a vehicle for laughter and entertainment and, to some extent, a critical vantage point that typically emerges when things are turned upside down, if even for a brief moment.

Ned may have seemed a bit of a daredevil to Elsie, as well as to the movie audiences who watched *A Modern Musketeer*. Others would arrive at the rim later in the twentieth century with stunts staged against the backdrop of the Grand Canyon, and their presence was not always welcome. Stunt car drivers, motorcycle daredevils, and a high-wire aerialist have made the canyon a place to create daring popular spectacles against the mythic and iconic spectacle of nature visible from the rim. The presence of these daredevils who crash the Grand Canyon scene is, for many, understood as a threat to a landscape that has long been

regarded as America's equivalent to cultural antiquities. The canyon is a place endowed with the visions of romantic moderns looking for salvation in the arms of nature, and their accounts frame the canyon as nothing less than a work of art to be quietly studied and admired.[1] Those who drive over the rim or have ambitions to hover over the canyon on a high wire have been a source of both public outrage and public awe. In different ways, these stunts reveal some of the dominant and divergent conventions for seeing and appreciating nature. As daredevils cast themselves beyond the canyon's edge, they become "vehicles" for critically examining how we symbolically, historically, and popularly imagine the meanings of the Grand Canyon.

Creating the Scene

The same year Dwan and Fairbanks were filming *A Modern Musketeer* on the canyon's rim, preservationists and legislators were meeting at the 1917 National Parks Conference in Washington, D.C. Those testifying argued for the need to create more national parks and, in particular, for the establishment of Grand Canyon National Park. For many attending, the prospects of natural scenic wonders were an antidote to the anxieties of modern urban life. In large part, however, their notions of recreation and education tended to subscribe to the aesthetic propensities of people like themselves. "We need sometimes that poetry should not be drummed into our ears, but flashed onto our senses," Mrs. John D. Sherman, conservation chair of the General Federation of Women's Clubs, told the conference. "Man, with all his knowledge and all his pride, needs to know nothing but that he is a marvelous atom in a marvelous world." For U.S. Assistant Attorney General Samuel Huston Thompson, modern urban life amounted to a kind of sensory deprivation that dulled people to "the still small voice of nature," and he told the audience that scenery could restore them. "While man's handiwork blinds our eyes," he said, "it is only the shock of great altitudes or the vistas of nature in their most colossal and primeval state that can attune our ears and brush the scales from our eyes."[2] Sherman and Thompson echoed the archetypal romantic sentiments of elites who had been visiting the Grand Canyon and other natural wonders since the late nineteenth century, and it was their voices Ned

Thacker parodied from the rim when he spoke of the scenery "shaking our dispositions with thoughts far beyond the reach of our souls."

Places like Grand Canyon, Yellowstone, Yosemite, and a whole host of other natural environments that were becoming scenic monuments were partially valued for the therapeutic promise they might hold for discontented moderns confronting a transforming nation steeped in a discourse of progress. As Jackson Lears forcefully argues in *No Place of Grace*, Americans facing the "marriage of material and spiritual progress" in modern America found themselves on the brink of a moral void of a culture that had seemingly "lost sight of the larger frameworks of meaning" and was experiencing a "crisis of authority." While the pervasive optimism of progress thrust America into the twentieth century of industrialization and growing cities, an educated bourgeoisie often expressed the terms of an antimodern spirit that left them longing for real life in a world that increasingly felt weightless. Many sought authentic experience in practices and places where they could seek the virtues of nature and the qualities of a supposed simpler, even rustic, existence.[3] Against this backdrop, places like the Grand Canyon could appear as a place of grace, one where people might find in its divided landscape some transcendent and transparent image of greater unities, spiritual fulfillment, and recuperative powers in nature.

By 1917, when the participants of the National Parks Conference were rehearsing the merits of the canyon's natural beauty, and Fairbanks was using some of the same language as the premise for a comic Ned Thacker, the Grand Canyon had well become a dumping ground where romantic preachers and painters portrayed a landscape that could be equated with, if not surpass, the finest art, architecture, and music known to civilization. Their efforts sedimented a vision of the Grand Canyon as a place where they could witness sublime power and spiritual wonder. Romantics found nature could stir "feelings of awe before the greatness of creation, of peace before a pastoral scene, of sublimity before storms and deserted vastness, of melancholy in some lonely wooded spot," writes philosopher Charles Taylor. Since the end of the eighteenth century, nature held an inner resonance that was "in some way attuned to our feelings," refracting and intensifying those feelings we already held or awakening those that had been dormant.[4] Not everyone, however, was tuned in to the sublime channels broadcast by

an encounter with nature. In measured observations and hyperbolic declarations, canyon visitors (who eventually testified in magazines and guidebooks to grandeur they had witnessed) helped produce an ethic that understanding the scenes from the rim required a proper disposition that, if not already held, might be cultivated.

The Grand Canyon is "a great innovation in modern ideas of scenery," claimed Clarence Dutton in his 1882 *Tertiary History of the Grand Cañon District.*[5] "Great innovations, whether in art or literature, in science or in nature, seldom take the world by storm. . . . They must be understood before they can be estimated, and must be cultivated before they can be understood."[6] For Dutton, understanding of the canyon's scenes meant drawing upon familiar images of civilization and culture to orient observers to the landscape. "A curtain wall 1400 feet high descends vertically from the eaves of the temples. . . . The curtain wall is decorated with a lavish display of vertical mouldings, and the ridges, eaves and mitered angles are fretted with serrated cusps," he wrote of one scene. "And finer forms are in the quarry than ever Angelo evoked."[7] Dutton's *Tertiary History* was a government report that serves as a benchmark for mapping the aesthetic contours of the Grand Canyon. His descriptions of the landscape reappeared extensively, as lengthy quotations and nearly plagiarized paraphrasing, in canyon guides and travel accounts well into the next century. It is notable that his *Tertiary History* was largely an account of his view from the North Rim, a vantage point opposite of the one most visitors would occupy when they went to the South Rim looking for the scenes he described. But the specifics of the view were less important than the process of viewing and, more importantly, knowing what to look for inside oneself. Dutton's descriptions provided a literary rendering of the scene that instructed visitors toward an interior landscape of beauty, sensation, and power.

"The lover of nature, whose perceptions have been trained in the Alps, in Italy, Germany, or New England," he wrote, "would enter this strange region with a shock and dwell there for a time with a sense of oppression, and perhaps with horror." Anyone expecting immediate rapture would be disappointed. Instead, a process of slow acquisition could reveal the meaning and spirit of the canyon's scenes. "The study and slow mastery of the influences of that class of scenery and

its full appreciation is a special culture," he wrote, "requiring time, patience, and long familiarity for its consummation."[8] His mention of the "class of scenery" and the "special culture" that could most appreciate its meaning told Dutton's readers that gazing into the abyss was also an occasion for looking into the heart and mind of an ideal observer, a person who could quietly contemplate the canyon as if looking at a great landscape painting for a revelation of nature's power and magnificence.

In many ways, Dutton's ideal observer was nothing less than the person who looked into the canyon landscape paintings of Thomas Moran. Moran's seven-by-twelve-foot oil canvas *The Chasm of the Colorado* was unveiled in the U.S. Capitol in 1874. It was commissioned by the U.S. government to hang next to a similar size canvas, *The Grand Canyon of the Yellowstone,* that Moran had completed a few years earlier after an expedition to Wyoming. Moran's *Chasm of the Colorado* renders a hellish and desolate canyon. Sunlight dramatically lights distant monuments and patches of foreground. But a thunderstorm is breaking, and vapors rise from the dark canyon below. Above the chasm, traces of a rainbow appear in the lingering storm clouds. It is a romantic scene, where the viewer sees the canyon from an imaginary and impossible vantage point. Like many of his paintings, the scene is built with elements of the canyon he sketched at various places and times.[9] The painting soon became reproduced in the popular press. Within a year of its unveiling, and at the same time Dutton was heading west to join John Wesley Powell's survey of the North Rim, Moran's *Chasm of the Colorado* had already appeared as a woodcut in an 1875 issue of *Scribner's Monthly.*

Moran's appreciation for the philosophy of John Ruskin pointed to the common aesthetic ground the painter shared with Dutton. "Anything which elevates the mind is sublime, and the elevation of the mind is produced by the contemplation of greatness of any kind," wrote Ruskin.[10] For Ruskin, the highest forms of art seized and enhanced "that faultless, ceaseless, inconceivable, inexhaustible loveliness, which God has stamped upon all things."[11] Essential to his philosophy was Ruskin's belief that the most elevated forms of art reflected God, and those who possessed the proper state of mind could find the divine through art, architecture, and music. Moran diverged, however, from Ruskin's desire to have artists literally transcribe nature through art.

Instead, Moran favored art that could foster a transcendent relation-
ship between nature and the individual. "My personal scope is not re-
alistic; all my tendencies are toward idealization," wrote Moran. "I do
not wish to realize the scene literally but to preserve and convey its true
impression." If this required moving scenery to achieve his goal, so be
it. Art, he argued, was an emotional expression of the individual who
looked upon the scene, and this was equally true for both the artist and
those who looked at what the artist had created in the frame.

Moran's philosophy as well as his paintings effectively anticipated
the idealized canyon viewer that Dutton would describe in his 1882
Tertiary History. For both men, the truth of the canyon lay in the aes-
thetic and spiritual experience of the individual. In different ways,
their individual efforts to describe the canyon would serve literally and
metaphorically as a foundation for the creation (and re-creation) of the
canyon as a site of quiet, contemplative appreciation. By the end of the
nineteenth century, the incessant outpouring of discourse that helped
to characterize the canyon as a natural landscape of immense cultural
proportion had also put a frame around the experience of the observer.

Seemingly annoyed with the melodrama and chatter coming from
the growing stock of testimonials to awe from canyon observers, popu-
lar author and geologist James "Fitz-Mac" MacCarthy could not pass
up the opportunity to scold enthusiastic writers while slipping in a few
adjectives of his own. "Shrive yourselves, ere you approach, of all your
little, vainglorious conceits, of all your pretty, gabbling rhetorical for-
mulas of exclamatory ecstasy," he wrote. While warning writers of ex-
treme hyperbole, MacCarthy characterized the canyon as a "deep pre-
Egyptian grave of Nature's patient digging, gorgeous, mysterious and
solemn, where Time, the mother of worlds, has sepulchered her dead
children, the centuries and millenniums of the past." Yet, he claimed
that the Grand Canyon was no place for rhetoric. "Rhetoric is some-
thing worse than a presumptuous and profitless vanity; it is a profa-
nation," he wrote. "Come and interrogate your soul in this gorgeous
and appalling presence, and then you will realize (as I now painfully
realize) how inadequately I have in this lame sketch suggested to your
imagination its stupendous glories and its divine pathos."[12] In his own
awkward manner, MacCarthy had delineated the uneasy and unspoken
truth that the canyon had, indeed, become a dumping ground for rheto-

ric. By the first decades of the twentieth century, the idea of the Grand Canyon was, among other things, an empty space that poets, journalists, painters, and a whole host of visitors filled with anxious images of themselves and their desires to have a sense of culture that could stand up against European antiquities.

The pages of books, magazines, brochures, and guides chattered noisily about the canyon in a manner that not only compared nature to the highest achievements of a civilized culture; writers also staked out the aesthetic terrain as cultural property not everyone could appreciate in the same ways. The canyon offers "dreamy landscapes quite beyond the most exquisite fancies of Claude and of Turner," wrote travel writer Charles Dudley Warner in 1891, and "when it becomes accessible to the tourist it will offer an endless field for the delight of *those whose minds can rise to the heights of the sublime and the beautiful.*"[13] Anticipating the tourist crowds that would eventually arrive, Warner and others reinforced the idea not only that sublime experience was reserved for a select group, but that tourists had best learn some manners. Fearing that tourist crowds would infringe on the sanctity of their personal and emotional experience with nature, writers offered instructions that marked the canyon's scenery with prescriptions for taste, propriety, and social decorum. In short, scenic areas offered a moral and didactic landscape—a nineteenth-century "outreach" program—for building the character and "drawing out the minds" of the "vulgar" and "uneducated."[14] Scenery, like art and literature, could ideally educate the American public not only in aesthetic appreciation but also in taste and proper social conduct.

Aesthetic appreciation was more than a matter of training the eye or the ear. It also meant that a properly educated visitor should approach the wilderness as though attending the symphony or opera, or visiting an art museum—by practicing the rules of mannered social conduct and self-restraint. Some guides suggested that properly "attending" the canyon involved controlling one's emotions in an environment best comprehended through silent and distanced contemplation. "Speech is inadequate and uncalled for, at least until the scene familiarizes itself; and the nervous haste with which at first one is prone to glance from object to object gives place to a calmer and more critical mood," noted P. C. Bicknell's 1902 canyon guidebook. "A chattering

man or woman would have ruined our pleasure in that brilliant pan-
orama, just as the empty-headed creatures mar the rendering of an
opera for those who are there to enjoy the music."[15] If a visitor de-
manded contemplative quiet, it was in part because the Grand Canyon
described in the pages of popular texts seemed noisy with directions for
silence. Writing for *Motor Life* magazine in 1919, Leroy Jeffers aimed
to celebrate the establishment of Grand Canyon National Park and
employed many of the, by now, familiar conventions for describing the
experience. Like many before him, Jeffers was hearing music in the
landscape and noted the canyon's sunset conveyed the "richness and
power to suggest a Wagnerian opera." In the presence of the canyon,
"one is lifted out of his narrowness of life and into a fuller realization
of the majesty and sublimity of the Eternal," wrote Jeffers. At the same
time, he admonished the visitor with instructions. "The spirit of the
canyon is never revealed to the noisy tourist who jokes upon its brink,"
he warned. "True impressions come only with sympathy and silence."[16]

Taken together, this brief survey of early visitors' canyon accounts
hammered home the idea that a Great Silence was the proper mode of
addressing the landscape. These writers and others sketched a vision
of a canyon and an ideal observer who would visit the canyon as if
visiting a symphony hall or the Metropolitan Museum. They sketched
a contemplative canyon, a place for the discerning viewers who, if they
behaved properly, would elevate themselves in a moment of sublime ec-
stasy and would assuredly lift themselves up and away from the crowd
of ordinary tourists. The "tourist" often appears in these accounts as
a potential threat to romantic solitude, quiet, and aesthetic apprecia-
tion. The "empty-headed creatures" Bicknell saw ruining the opera
were merely synonyms for the contemptible and common tourist who
violated the canyon's contemplative atmosphere.

The canyon imagined in these accounts points to the production
and reproduction of an aesthetic sensibility that inscribed the can-
yon with visions and values of people like Dutton, Moran, Warner,
and many others. Yet, their accounts as acts of inscription eventually
became *naturalized* into the larger mythic idea of the Grand Canyon.
"What the world supplies to myth is an historical reality, defined . . .
by the way in which men have produced or used it," observed Roland
Barthes, "and what myth gives in return is a *natural* image of this real-
ity." For Barthes, the function of myth is to purify things, make them

innocent, and give them "natural and eternal justification." He wrote that in "passing from history to nature, myth acts economically: it abolishes the complexity of human acts, it gives them a simplicity of essences, . . . it organizes a world which is without contradictions because it is without depth, a world wide open and wallowing in the evident, it establishes a blissful clarity."[17] By the early decades of the twentieth century, the canyon did, in fact, have that sense of blissful clarity that above all seemed *natural*.

Yet, even as the sanguine testimony of these early observers had so reinforced a set of conventions for viewing the canyon that it seemed obvious how one should approach the abyss, there was room for yet another view, a sense of skepticism, sympathy, and even humor, for those who still didn't take in the scene as symphonic masterpiece.

In his 1909 *Doing the Grand Canyon*, John T. McCutcheon depicts canyon tourists engaged in a comedy of manners staged daily along the rim, on trails, and in hotels. His tourists are satiric and self-consciously absorbed with the conventions and decorum of canyon spectatorship: "The casual tourist approaches the Canyon with some dread. He fears

Figure 4.2. Sketch by John T. McCutcheon from *Doing the Grand Canyon* (1909).

"In silent contemplation."

that he will be disappointed. Surely nothing in nature can equal the expectations of one who has read what great writers have written about this wonderful place. He also fears that if he is disappointed, it may probably be his own fault rather than the Canyon's. It would hurt his pride to be considered lacking in the capacity to appreciate the great beauties of nature, and so, to play safe, he resolves to do full justice to the occasion if it costs him all the adjectives at his command."[18]

McCutcheon's parody is an instance of seeing the social weight of these conventions, and seeing through them, too. For all the power of the mythic symphonies, magnificent architecture, and comparisons with European masters, McCutcheon's caricature of the "casual" tourist points toward a brief moment where there might still be something missing from these "official" views of the canyon—a recognition of a different sense of the sublime or pure *awe* that does not rely on the aesthetics or decorum associated with high culture. Perhaps it is such an impulse that prompts Ned Thacker to throw a handstand. And it is this impulse that for some only becomes more spectacular in later daring incarnations.

Crashing the Scene

I imagine Leroy Jeffers, Charles Dudley Warner, and a few others I have just mentioned would be mortified if they were sitting here with me watching an old videotape of Dar Robinson driving a car over the rim of the Grand Canyon. Robinson, a motion picture stuntman and actor from Los Angeles, did the stunt for *That's Incredible!*, a reality television show that ran on the ABC network from 1980 through 1984. Denied a permit by national park officials to do the stunt in Grand Canyon National Park, Robinson was granted permission for his feat by tribal administrators on the Hualapai Indian Reservation, about eighty miles to the west. Robinson was thirty-three years old when he drove his car over the edge for a September 1980 episode of the program. Shortly after making a 1,200-foot jump from the CN Tower that put him in *The Guinness Book of World Records*, Robinson went to the canyon with the *That's Incredible!* production crew and program cohost Cathy Lee Crosby to drive his car over the edge.

In the video, Robinson climbs into the driver's seat of his white Bradley GT as a narrator calmly says, "the time has come for another

challenge to both reason and gravity." The camera shows the dirt road leading to the ramp; a superimposed blue line indicates the point Robinson will pass where there is no turning back. Once he passes this point, he is going over the edge, one way or another. Robinson then takes off and races his car toward the ramp built on the edge of the rim. A visibly anxious Crosby is standing at an overlook near the edge. Robinson's car roars up the ramp and sails out into the big empty space of the abyss. The vehicle is in the air for only a few seconds before it begins to tumble into a free fall. Robinson quickly pulls himself from the cockpit and parachutes to safety. The pulsating music dubbed over these scenes now becomes triumphant trumpets heralding Robinson's success. The camera follows Robinson gliding on his parachute into the canyon's shadowy walls while the sports car keeps falling, until it is out of the frame. We don't see the car crash into the canyon's cliffs. Crosby jumps up and down with fists in the air. "He made it!" she squeals, "He made it!"

In a slow-motion replay of the stunt, we see the sports car slowly flip and spin as Robinson climbs out and opens his chute. Crosby reflects on the event in a brief interview, but she doesn't tell us what she thinks about the stunt or the canyon. Instead, she tells us about Robinson. "There's something in him that was crazy, and I mean crazy in the best sense of the word. I don't mean it as in fly-by-night," she says. "I mean he was the ultimate professional, but there was a daring, and I think he enjoyed that a lot and that never changed. I always got that."

If Crosby was more inclined to testify to Robinson's "craziness" (in a good way) than say anything in particular about this canyon stunt, it may be that she was still awestruck by the sight of a man hurtling into the empty chasm in a sports car. Watching the video, I must confess that my stomach drops every time I watch the car's wheels leave the ramp. But there is not really that much to say about the Grand Canyon in this scene. This is a different kind of spectacle, one where the meaning of the canyon's physical magnitude is self-evident; it is an iconic backdrop for a human test of courage, daring, and, as Crosby suggests, a display of something "crazy" that is beyond the pale of expectations and experience. Such an event may conjure the familiar nineteenth-century formulas of "man versus nature" that are often the structure of stories about mountain climbers conquering a peak or exploring an unknown region.

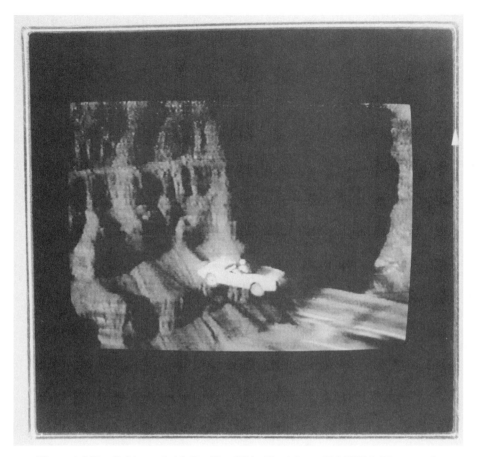

Figure 4.3. Dar Robinson in his Bradley GT in *That's Incredible!* (1980). Photograph of screen image by Mark Neumann.

Robinson's stunt was something aesthetically different. Robinson was not attempting to conquer the Grand Canyon or to leap from rim to rim in his sports car. He wanted only to drive over the edge and come out alive. Although Crosby and the *That's Incredible!* viewing audience may have been thrilled by Robinson's spectacle, not everyone looked at the stunt with such enthusiasm. A newspaper article reported Robinson's drive over the edge as a "callous desecration of the Grand Canyon for the sake of entertainment . . . staging and filming such a stunt in the Grand Canyon cheapens one of the scenic glories of the world."[19]

In contrast to the decision making that denied permission to Robinson and the public criticisms of such stunts as desecrations of scenic glory, the National Park Service (NPS) did grant a permit for a piano concert near Maricopa Point on the canyon's South Rim. In September 1979, a year before Robinson's canyon leap for *That's Incredible!*, pianist Marden Abadi performed selections from Debussy, Gershwin, Chopin, and Grofé's *Grand Canyon Suite* before an audience of several hundred spectators. Abadi could not get permission for a helicopter to lower his 1,600-pound rosewood piano onto the rim, so he had a team carry it to the canyon's edge. In an interview for a Phoenix television station, Abadi said, "This is the greatest hall in the world, even greater than Carnegie Hall. . . . That's how I feel, I like this environment with nature and I'm most interested in attracting attention to our resources, to our music." Playing classical music on the rim of the canyon may, in fact, seem like an exercise in redundancy given how many had been hearing it there for nearly a century when no piano was in sight. Gaining the permission of the NPS, however, should probably seem to be of little surprise since Abadi and his piano concert were merely another magnified performance of the dominating discourse around the canyon. "It was a real *cultural event*," Abadi told me in an interview. "The Park Service people didn't think it would come off, they though it was crazy, but they gave us permission and were quite pleased with the result. The acoustics were marvelous, just unbelievable. It was like playing in a great auditorium rather than outdoors, where sound sometimes does not carry well."

This juxtaposition of the stunts (or performances) by Robinson and Abadi offers something of the same effect found in that scene from *A Modern Musketeer* when Ned Thacker becomes the humbled yet hyperbolic visitor pontificating about the canyon and then, suddenly, pops into a handstand on the edge of the abyss. Both are gestures toward the idea of being "awestruck," but they are gestures that come from very different worlds of experience. For those who see (or speak of) the Grand Canyon as an expression of artistic grandeur, akin to a symphony or a painting, the sight of Dar Robinson's stunt might appear as nothing less than driving a sports car through the canvas of a masterpiece. For others who witness Abadi's piano selections as nothing more than a magnified incarnation of how the canyon has been pitched as

Nature's Great Symphony for more than a century, the sight of a dare-devil stuntman racing off a ramp into the magnificent scenic nothing-ness might be a thrilling sight to behold.

Clearly, the permitting policies of the NPS and the Department of the Interior have shown on which side of the aesthetic divide they stand. Given the mission of the NPS, it is entirely plausible that the stunt car driver would be asked to take his ramp elsewhere. The cus-todians of the parks might conveniently point to the National Park Service Organic Act of 1916, which established the NPS and charged them to "promote and regulate the use of the . . . national parks . . . [and] to conserve the scenery and the natural and historic objects and the wildlife therein and to provide for the enjoyment of the same in such manner and by such means as will leave them unimpaired for the enjoyment of future generations." In view of such a charge, one only needs to be flexible in the interpretation of "unimpaired," and perhaps turn a blind eye to the mule trains that daily pound the Bright Angel Trail, or to the rafting companies that navigate the Colorado River daily and are clearly visible from either of the steel suspension bridges that allow people and mules passage across the river to the North and South Rims, or to the western fantasy theme park archi-tecture of Phantom Ranch, the Indian Watchtower at Desert View, and the Bright Angel Lodge, which were all built in the years after the establishment of Grand Canyon National Park in 1919. But pointing to policies and their inevitable exceptions or contradictions does not really help us understand the daredevil who hurls his or her body into the scenic grandeur. Is there another way to interpret these stunts in this landscape?

It is worth mentioning that some of those nineteenth-century ro-mantics searching for the canyon's sublime ecstasy also envisioned throwing themselves over the edge. At least they said as much in their accounts. Wrestling to give the canyon meaning, some found a symbolic site to wrestle with the meaning of their lives. Harriet Monroe, for in-stance, simply couldn't take it anymore and felt the urge to throw herself into the chasm. "The strain of existence became too tense against these infinities of beauty and terror. My narrow ledge of rock was a prison," she wrote in 1899. "I fought against the desperate temptation to fling myself down into that soft abyss." Monroe confessed she might have

taken the plunge if not for the "trill of an oriole" in a nearby pine tree, which brought the message of "a friend who would save me from intolerable loneliness, from utter extinction and despair."[20] In 1927, John C. Van Dyke similarly recounted the emotional impact of the canyon's vistas by re-creating what had become a familiar scenario of emotional display: the visitor who feels compelled to jump over the edge. "But does not that way lie madness?" Van Dyke asked his readers. "Is it the fear of the gulf so much as the fear of the self—the fear that you may yield to an irrational impulse?"[21] For these writers the canyon is a sight where they might stage (at least textually) a momentary lapse of rationality. Like a magnet, the canyon prompts them to lose control, give way to another impulsive force but eventually regain their composure. Of course they never make the leap, but they let readers know they felt the urge. Their accounts were symbolic performances dramatizing a pull of sensation that exists beyond the bounds of control and apart from the studied contemplation of the masterpiece.

Considering the daredevil's stunt as equally symbolic may shed a different light on these events that are typically rendered as "desecrations" to the scenery. Historian Paul Johnson points to Sam Patch's 1827 jump from Passaic Falls in Paterson, New Jersey, as an instance of the contest over the meaning of recreational spaces in industrializing America. Patch, a mill worker, made his leap at the opening ceremonies for land developer Timothy Crane's Forest Garden. Crane had purchased and developed a piece of forested land near the falls, which had been a popular working-class hangout. Crane transformed the land into a retreat for supposedly refined people of leisure. The landscaped and rule-bound Forest Garden was "an artful refinement of raw nature that transformed a forbidding wilderness into an opportunity for aesthetic contemplation," writes Johnson.[22] At the opening-day celebrations staged by Crane, Patch stole the show from the developer by ceremoniously leaping from a seventy-foot cliff into the waters below the falls. The large crowd assembled to cheer for Crane suddenly turned and cheered for the daredevil mill worker. Johnson points out that the crowd cheered for Patch because they, too, had lost their public gathering place to Crane's new vision of nature. In this case, Patch's stunt reveals how divergent aesthetic practices reveal deeper class tensions. As Johnson suggests, Patch's jump "pitted the noise and physicality of

working-class recreations against the privatized, contemplative leisure pursuits of the middle class."[23] Patch's jump gestured toward another kind of nature, toward people who occupied it without pencils or paintbrushes and did not go into the forest seeking spiritual retreat yet could still find pleasure despite their absence of proper aesthetic training.

Johnson's interpretation of Patch's leap at Passaic Falls at least raises the prospect that residual and sublimated class aesthetics may be part of understanding the kinds of conflicts and acrimony that are raised when daredevils arrive at the canyon. Dar Robinson is not the only stuntman to have launched himself over the edge. In 1999 Robbie Knievel successfully completed a 230-foot leap on a motorcycle at the Hualapai Reservation. The event was called the "Grand Canyon Death Jump" and was broadcast on the Fox television network. Bob Burnquist rode a skateboard off of a 40-foot ramp over the edge at Hell Hole Bend on the Navajo Reservation. Burnquist's "Grand Canyon Skate" was recorded for the premiere of the Discovery Channel's 2006 premiere of *Stunt Junkies.* None of these events occurred within the protected boundaries of the national park, but all of them lay claim to the "Grand Canyon." In them, we see and hear the "noise and physicality" of another class's conception of nature, as well as the "art" of daring and skill required to survive such an encounter with the abyss. These stunts symbolically reimagine and repossess the *idea* of the Grand Canyon as something apart from the dominating discourses that render the canyon a contemplative retreat. Watching the trajectories of the airborne daredevils, we can see their "lines of flight" as momentary instances of "deterritorializing" the mythic landscape that is so thoroughly instantiated with the conventions of seeing the canyon that have been in place since the end of the nineteenth century.[24]

In a 2009 segment of MTV's *Nitro Circus,* Travis Pastrana and his crew of "Thrillbillies" are riding motorcycles off ramps into the canyon above the dry Little Colorado on the Navajo reservation. Three motorcyclists at a time make the leap, completing 360-degree flips before dropping the bikes to crash on the cliffs below and opening their parachutes. They have cameras mounted on their helmets to show the rider's point of view. This is the "Grand Canyon, Nitro Circus style," Pastrana tells the camera. Pastrana and Jolene Van Vugt even ride together on a single bike. Off the ramp and into the canyon's empty space,

they triumphantly raise their fists in the air before letting go of the bike. The segment is full of fast cuts and multiple camera angles, and it is loud. It's not the sound of the motorcycles, though. Rather, it's the shredding guitars and pounding bass of heavy-metal music. Danzig's song "Mother" provides the soundtrack, a song warning parents about the impossibility of guarding their children from a reality that exists outside an insulated middle-class world. "Not about to see your light," screams the singer, "but if you wanna find hell with me, I can show you what it's like." It's a song that holds obvious rebellious adolescent appeal. However, listening to the song while watching Pastrana perform a "Rodeo 720" (a complete front flip and then a lateral 360-degree turn) on a motorcycle conjures a whole different meaning to these scenes. He looks like a rodeo bull rider hanging onto a wild motorcycle gyrating over the chasm, and the scene and song are about feeling and doing something that borders on the edges of courage and skill. It is a scene of magnitude with which little compares. It is a sublime experience that is equally horrific and exalted, that calls forth the feeling of being alive because it is a spectacle that is so close to death. And the combination of music and fast-paced editing suggests an aesthetic sense that reaches toward a version of authentic experience that has little to do with conventions of quietly experiencing nature. Instead, it is a sensibility that aims to shatter the image of the humbled visitor standing on the rim and replace it with the fearless thrill seeker who is drawn to the canyon to challenge his or her own life.

In many ways, such a feeling of intense emotion and pleasure induced by watching the daredevil soar over the canyon is not so different from what early canyon visitors tried to describe in their accounts of seeing the canyon. But the romantic and the daredevil stage scenes for different audiences, and both use the canyon as a backdrop for articulating a drama that places the individual at its center. Romantically inclined observers may feel the pull of the canyon as evidence of greater spiritual nourishment and their own capacity to recognize a God and culture in nature. The daredevil's stunt, of course, is a spectacle in its own right. It is an image of life superimposed on the canyon's magnitude and perhaps holds some value for the observer who is moved by its execution. The French aerialist Philippe Petit tried for more than a decade to cross the canyon on a high wire but was continually foiled

by lack of cooperation or funding. In 1999, he thought he would finally walk a tightrope across a section of the canyon on the Navajo reservation. In an interview with Charlie Rose a few months before the event, Rose asked Petit what would he be thinking about while walking on the wire above the chasm. "I will finally be liberated of all the ties to the Earth," said Petit. "Suddenly, I will be in a world of simplicity, calm, nobleness, and beauty. I will be on a wire where there is no left and no right. And I will actually not risk my life, but I will carry my life across. And I think the spectacle of that gives people much more than their money's worth. It gives them an uplifting of the soul, which rarely in this world you see."

Petit's speculation on what would be running through his mind on the wire really sounds much like the discourse of those early canyon observers who bore witness to the canyon: a rare image of beauty, nobleness, and calm. But it is also an image of a human suspended briefly above and beyond the familiar renderings of the canyon that have offered moorings since the late nineteenth century. Here the canyon is not the masterpiece, it is the man moving through its empty space. Perhaps something similar might be said of the sight of Dar Robinson's sports car or the other daredevils flying out over the canyon's edge. As they crash through the painting, they momentarily make a different scene. If it is difficult to describe what their spectacles evoke, perhaps it is because we are all too enveloped in the discourses that have rendered the canyon as a work of art, a place of silent and sublime contemplation. Let us be clear, however, that seeing the canyon in such a manner is nothing less than sustaining the fabrications and fantasies of visitors from another century who anxiously peered into the canyon looking to feel and find something that they could call "culture." In many ways, their romantic and sublime discourse was a way of placing a ramp on the canyon's edge, a set of literary devices that would elevate them into a drama of spirit and nature. The ramps built by daredevils also serve as a launchpad for vehicles that propel people over the abyss, both literally and metaphorically. Petit's vision of himself on the wire, walking through the air, freed of all ties to the earth, is a fitting and hopeful image of what anyone might want to feel when they stand on the canyon's edge. But to stand on the rim and recite the terms of beauty and insignificance and look for art, awe, and the sublime experience spoken

of for more than a century may, in the end, feel like little more than a self-conscious pose. It is not that the daredevil flying over the edge has a more truthful response, but it is a different response, and one that pushes against the dominant views of the canyon and why people come to see it.

In the end, both stances (to the extent there are two) are attempts to believe there is something essential, authentic, or real to be found in the abyss. These daredevils who crash the scene at the Grand Canyon do so in a manner that exposes the ways we have constructed nature and our place before it. They are performances that inevitably point to constructed and *naturalized* conventions for visualizing and experiencing the canyon's landscape. They not only illuminate the contours of a rhetoric that staked out a dominant set of cultural meanings for the canyon, but also reveal the discursive moorings that bind us to a set of eyes and words that have rarely dared to imagine the scene in another way.

NOTES

1. Some portions of this essay are drawn from the research conducted for my book *On the Rim: Looking for the Grand Canyon* (Minneapolis: University of Minnesota Press, 1999). The essay expands on some new themes regarding daredevils and stunts at the Grand Canyon, and incorporates more recent research.

2. Mrs. John Dickinson Sherman and Samuel Huston Thompson, as quoted in *Proceedings of the National Parks Conference* (Washington, D.C.: U.S. Government Printing Office, 1917), 47, 50.

3. See T. J. Jackson Lears, *No Place of Grace: Antimodernism and the Transformation of American Culture, 1880–1920* (New York: Pantheon, 1981), 4–58.

4. Charles Taylor, *Sources of Self: The Making of Modern Identity* (Cambridge, Mass.: Harvard University Press, 1989), 297–99.

5. Clarence E. Dutton, *The Tertiary History of the Grand Cañon District*, U.S. Geological Survey, monograph no. 2 (Washington, D.C.: U.S. Government Printing Office, 1882).

6. Dutton quoted in Wallace Stegner, *Beyond the Hundredth Meridian* (New York: Houghton Mifflin, 1954), 142.

7. Dutton, *Tertiary History*, 58–59.

8. Ibid., 141.

9. See Joni Louise Kinsey, *Thomas Moran and the Surveying of the American West* (Washington, D.C.: Smithsonian Institution Press, 1992).

10. John Ruskin, *The True and the Beautiful in Nature, Art, Morals, and Religion* (New York: Merrill and Baker, 1858), 250.

11. John Ruskin, *Modern Painters,* vol. 1 (New York: Wiley and Putnam, 1847), xliii.

12. Fitz-James MacCarthy, "A Rhapsody by 'Fitz-Mac,'" in *The Grand Canyon of Arizona: Being a Book of Words from Many Pens, about the Grand Canyon of the Colorado River in Arizona* (Chicago: Passenger Department of the Santa Fe Railway, 1902), 96.

13. Charles Dudley Warner, *Our Italy* (New York: Harper and Brothers, 1891), 178.

14. See Robert Weyeneth, "Moral Spaces: Reforming the Landscape of Leisure in Urban America, 1850–1920" (PhD diss., University of California, Berkeley, 1984), chap. 2, cited in Lawrence Levine, *Highbrow/Lowbrow: The Emergence of Cultural Hierarchy in America* (Cambridge, Mass.: Harvard University Press, 1988), 186. Frederick Law Olmsted similarly argued for the moral and didactic power of scenery in his 1865 remarks to the California legislature advocating the preservation of Yosemite for the benefit of the masses. "The power of scenery is, in a large way, proportionate to the degree of their civilization and the degree in which their taste has been cultivated," wrote Olmsted. "This is only one of the many channels in which a similar distinction between civilized and savage men is to be generally observed." Those who did not appreciate beautiful scenery, he said, were "either in a diseased condition from excessive devotion of the mind to a limited range of interests, or their whole minds are in a savage state; that is, a state of low development" and "need to be drawn out generally." See Frederick Law Olmsted, "Preservation for All," in *Mirror of America: Literary Encounters with the National Parks,* ed. David Harmon (1865; reprint, Boulder, Colo.: Roberts Rinehart, 1989), 186.

15. P. C. Bicknell, *Guide Book of the Grand Canyon of Arizona, with the only correct maps in print* (Kansas City, Mo.: Fred Harvey Company, 1902), 25.

16. Leroy Jeffers, "Our Newest National Park: Nature's Wonders Await the Tourist at the Grand Canyon, *Motor Life,* September 1919, 40.

17. Roland Barthes, *Mythologies,* trans. Annette Lavers (New York: Hill and Wang, 1972), 142–43.

18. John T. McCutcheon, *Doing the Grand Canyon* (1909; reprint, Grand Canyon, Ariz.: Fred Harvey Company, 1922), 1–3.

19. "Grand Canyon Stunt," *Brunswick News,* October 8, 1980, sec. A, 4.

20. Harriet Monroe, "The Grand Cañon of the Colorado," *Atlantic Monthly,* December 1899, 820.

21. John C. Van Dyke, *The Grand Canyon of the Colorado: Recurrent Studies in Impressions and Appearances* (New York: Charles Scribner's Sons, 1927), 4.

22. Paul E. Johnson, *Sam Patch, the Famous Jumper* (New York: Hill and Wang, 2003), 43.

23. Ibid., 51.

24. See Gilles Deleuze and Félix Guattari, *A Thousand Plateaus: Capitalism and Schizophrenia,* trans. Brian Massumi (Minneapolis: University of Minnesota Press, 1987), 9, 3–25.

5. HOW GERMAN IS THE AMERICAN WEST?
The Legacy of Caspar David Friedrich's Visual Poetics in American Landscape Painting

Sabine Wilke

TO THE ADMIRER of the spectacular nature of the North American West, the question that titles this essay might sound like a ridiculous concept: how can nature have any national characteristic let alone one from abroad? To the modern-day observer and tourist, the parks and monuments of the American West are treasured icons of spectacular, natural grandeur best protected forever against all encroachments of civilization. This is so that future generations may be able to enjoy their beauty and partake in the feeling of sublimity that accompanies a peaceful view of the Grand Canyon, the Lower Falls of the Yellowstone River, or Yosemite Valley—just to mention a few of the best-known vistas. I want to take no issue against this position. I have adopted the American West as my home for precisely that reason. Every summer I visit the nearby parks and monuments, and I take great pride and even spiritual rejuvenation in the encounter with the spectacular nature that surrounds us here. At the same time, I wish to underscore the premise that informs all essays collected in this volume, namely, the idea that the images of the western parks and monuments are not simply unfiltered representations of neutral or arbitrary natural features, but that these vistas follow a visual poetic that is operative even in places where one least expects it (i.e., in places of nature). In this, I am following Roland Barthes's lead in his work on mythologies from the 1950s and the definition of myth as a type of speech that tends to depoliticize the historically constructed nature of its subject. In other words, our images of western nature are myths that invert historical realities into natural images of that reality, and as such they can be described

as a semiological system.[1] The essays in this volume speak to the fact that the visual rhetoric associated with the parks and monuments of the American West follows a certain grammar that can be articulated systematically and studied by individual examples. This contribution to the discussion relates to the history of that grammar and its roots in the German Romantic landscape, specifically in the landscapes by Caspar David Friedrich (1771–1840). I will show that the school that was most influential in shaping nineteenth-century American painting, the Hudson River School, developed a visual style for representing landscape closely mirroring Friedrich's art. I will also demonstrate how even paintings, which sought to capture the stunningly different and diverse nature of the American West in some form or another, are related to that tradition precisely in their attempt to capture these grand vistas.

The issue of the German legacy in nineteenth-century American painting was recently explored in the widely noted exhibition *New World: Creating an American Art,* shown in the Hamburg Bucerius Kunst Forum from February 24 to May 28 in 2007, and then later that year in the Staatsgalerie Stuttgart from July 21 to October 21. More than sixty works from the Wadsworth Atheneum Museum of Art's collection made their first appearance in Germany, including works by artists such as Thomas Cole, Frederic E. Church, and Albert Bierstadt. This exhibition was the first in a trilogy that deals specifically with American art *(150 Years of American Art: 1800–1950),* followed by a show featuring American impressionism and, finally, an exhibit on American realism. The curatorial concept of *New World: Creating an American Art* framed the art on display in terms of ambivalence toward the project of colonialism and the penetration of nature. For example, Michael Göring writes in *The Atlantic Times* that

> the Hudson River School confronts the viewer with the American dream, the promise of God's own country filled with nature's vastness and beauty. But it also contains little hints and warnings that civilization, men's urge to conquer nature, may soon destroy nature's richness.[2]

The American painter pioneers are characterized as unique and boundless, artists who created wildly romantic paintings that, in turn, led

naturalists and adventurers to venture more into these wild places and explore early forms of tourism. Bernhard Schulz, writing in a later issue of *The Atlantic Times,* captures this ambivalence in terms of the struggle between the enormous respect people had for these magnificent vistas and the underlying wish to subdue and harness that wilderness:

> Artists who belonged to this school had ateliers, lived in New York and exhibited their works at the National Academy of Design (founded in 1825), but they sallied forth to discover the landscapes along the Hudson River and in New England for themselves. This reconnaissance of nature was filtered through a knowledge of manifest destiny, the sacred mission to civilize the wilderness. . . . On the one hand, they show reverence for the Creation; on the other hand, they show its subjugation. Depictions of untouched wilderness alternate with those of cultivated, tamed landscapes.[3]

Schulz also mentions in passing that "the comparison with the landscape painting of the German Romantics, wonderfully represented in the nearby Hamburg Kunsthalle, is instructive."[4] I would like to explore this connection between the American artists who ventured out West and captured some of the most spectacular vistas on canvas (albeit reconstructed from sketches or photographs in their cosmopolitan studios) and their German models.

What did the New World look like when seen through Old World eyes and when looked at by artistic eyes trained in Old World scopic regimes? The scholars and curators writing for the *New World* exhibit catalog reaffirm the above-mentioned artistic ambivalence toward western landscape in conjunction with the issue of visual rhetoric and its roots in German Romantic landscape painting. The American curator of the exhibit, Elizabeth Mankin Kornhauser, reminds us of the viewer's pleasure when confronted with depictions of the sublime. Kornhauser speculates that sublime scenery was sought after by these artists specifically because it effected a feeling of overwhelming nature in the subject and in the context of an increasingly industrialized world.[5] Contemporary viewers of the paintings caught themselves suddenly shuddering when looking at the images displayed on canvas.[6] In other words, the first element of visual rhetoric used in New World paintings is the effect of the sublime on the viewer in the studios and

galleries back East. The western American landscape becomes the sublime reference point for a different relationship between humans and nature, a relationship that offers the (imagined) possibility of not being entirely defined by alienation.

In that context, the editor of the catalog, Ortrud Westheider, recalls the exhibit on the "American Sublime" at the Tate Britain in London in 2002 and the strong intellectual connections that were made apparent between the Hudson River School and the German Romantics, not only in artistic terms but also in intellectual-historical terms. She reminds us of Frederic E. Church's relationship with the great German explorer Alexander von Humboldt, who traveled through South America from 1799 to 1804 and then spent a lifetime formulating his scientific findings in lectures all over Europe and in a multivolume treatise on the geography, biology, and anthropology of the region, *Le voyage aux régions equinoxiales du Nouveau Continent, fait en 1799–1804, par Alexandre de Humboldt et Aimé Bonpland* (Paris, 1807, etc.). Following in the footsteps of Humboldt, Church traveled to South America and captured the landscape in paintings such as *Heart of the Andes* from 1859.[7] Westheider also establishes the intellectual tie between the Hudson River School and the German Romantics in their particular reception of Carl Gustav Carus's letters of landscape painting, *Briefe über Landschaftsmalerei: Zuvor ein Brief von Goethe als Einleitung* (1819–31), and the philosophy of nature (*Naturphilosophie*, 1797) of the Jena philosopher Friedrich Wilhelm Joseph von Schelling.[8] In this essay, however, I am primarily interested not in tracing the intellectual-historical roots of American nineteenth-century art back to the German intellectual tradition—although that would, of course, be a worthy and rich project—but, following Barthes's lead on mythical speech, in pursuing an analysis of the visual grammar operative in nineteenth-century American painting, especially as it relates to the depiction of the American West.

If the intended effect of the sublime is the first element of that grammar, the invention of wilderness is the second. I do not mean to suggest that these artists did not encounter actual wilderness, but that by "wilderness" we signify a space that is carefully constructed by a scopic regime that presents nature in ways that we have come to identify as "wild," namely, virgin and untamed nature (as opposed to tamed nature such as German woods and English gardens), that is, excessive

nature. I suggest that the trope that poetically defines the aesthetics of wilderness as it manifests itself in depictions of the American West is the trope of hyperbole, framing the idea of "virginity" and translating it into "wildness" for the viewer. The American sublime is presented as the opposite of European nature such as the nature of the British countryside or even the famed German woods. Besides the intended effect of the sublime, it is visual excess that characterizes the grammar of images of the American West. Nature in the new continent is depicted as hyperbolic, as excessively wild, as excessively virgin, and as excessively grand and beautiful.

Alan Wallach suggests that we think of the scopic regime of the panorama as a third element of the visual grammar operative in the mythical semiology of the paintings of the Hudson River School and its predecessors, such as Thomas Moran, possibly as a reinforcement of the allegory of manifest destiny.[9] According to Wallach, Hudson River School paintings were composed according to the visual dialectic between panoramic breadth and telescopic detail in order to create three-dimensional effects without showing any traces of the painting's construction, that is, creating the famous trompe-l'oeil effect.[10] A combination of all of these elements—the effect of the sublime, the visual excess of the hyperbolic, and the scopic dialectic of panorama and telescopic detail—leads us to the fourth element of the visual grammar at work in Hudson River School paintings and their inherently performative composition. The works of the Hudson River School show nature as if it were displayed on a realistic stage, where elements of nature appear as actors in a drama. Winfried Fluck puts this feature into an art historical context for us and argues that in the latter half of the nineteenth century representations seem to dominate in which natural phenomena appear more independently, no longer tied to moral or religious meaning.[11] The standard art historical reading of this scenario is to think of the artist as a conduit "through which natural images are transformed into something transcending simple transcription in order to depart an idea or emotion."[12] I would like to push this idea of independent nature further and suggest that the wild and untamed American landscape depicted by Hudson River School painters presents itself as a seemingly untouched, virgin scene with the sky as the region for the theatrical sublime. It may be helpful to think of this view of

wild nature in terms of Barthes's concept of the mythical image in his
Mythologies in which he struggles with the common notion of "natural-
ness" with which the media of his day dress up a reality "which, even
though it is the one we live in, is undoubtedly determined by history."[13]
In his essays from the mid-1950s Barthes comments on the confusion
of Nature with History that makes contingency appear to be eternal.[14]
This mythical image (in Barthes's sense) of seemingly untouched na-
ture makes the viewer feel as if he or she is able to study its intrinsic
workings and manifestations in telescopic detail from the vantage point
of the panorama—the viewer is invited to become a naturalist. As we
will see, the elements of this grammar were developed on the basis of
a common tradition that goes back to Friedrich's art and the challenge
of having to represent a nature that was entirely new to art (to mention
Thomas Cole's famous statement).

Before we can turn to a specific analysis of images of the American
West and their German heritage, we need to establish the fact that
landscapes were always already invented. When we go to museums
and art shows, one of the subject matters we encounter frequently is the
depiction of nature and landscape. I saw a spectacular show on land-
scape drawings—*Claude Lorrain: The Painter as Draftsman. Drawings from
the British Museum* at the National Gallery of Art in summer 2007—that
brought home the centrality of the topic within the history of modern
art, along with the precariousness of the genre. In order to first appear
on canvas, it seems that (outer) nature needs to be "invented" before it
can be seen, observed, and reproduced artistically. This includes na-
ture such as trees, mountains, rivers and streams, plants and birds of
a specific climate—in other words, landscape that is geographically
rooted. In this part of the essay I will trace the emergence of outer
nature in the painting of Romantic landscape art from an eco-critical
perspective that foregrounds the subject of nature and tries to approach
its material in a decidedly interdisciplinary fashion. I am not writing as
an art historian, art connoisseur, or art collector but as a cultural critic
trained in textual analysis and literary history. I will make no sweeping
generalizations about the history of art other than a few introductory
remarks that are needed to frame the concept of landscape art and
that are indebted to current research in art history and art criticism.
Coming from the German tradition, the centerpiece of my discussion

will be the work of Caspar David Friedrich, the German Romantic painter.

I will begin by joining Simon Schama in his conviction that "landscapes are culture before they are nature; constructs of the imagination projected onto wood and water and rock."[15] This is a fundamentally post-Kantian position that frames all conceptions of nature in modern culture, and I highlight it here as a sine qua non, a position that cannot be undermined by simply pointing to the existence of outside nature. Having reiterated his claim about the cultural construction of nature, Schama continues by saying that "it should also be acknowledged that once a certain idea of landscape, a myth, a vision, establishes itself in an actual place, it has a peculiar way of muddling categories, of making metaphors more real than their referents; of becoming, in fact, part of the scenery."[16] The images Schama has in mind when he writes this are Albert Bierstadt's "Big Tree" paintings from the latter half of the nineteenth century. These are romantic representations of California redwood and cedar trees, which at the time of their creation "were seen as the botanical correlate of America's heroic nationalism at a time [1868] when the Republic was suffering its most divisive crisis since the Revolution."[17] Metaphors, constructed of the imagination (i.e., Bierstadt's trees), became more real than the trees themselves as they adopted a symbolic significance in the cultural context of the time, that is, a nation divided by civil war and the question of slavery. The trees, which date back to the beginning of the Christian era, assume the role of authentic living monuments of a pristine America; they even adopt an aura of heroic sanctity that can create a feeling of national magnitude and spiritual redemption.[18] The context that is important for my argument is, of course, Bierstadt's indebtedness to the Romantic tradition of landscape painting, specifically Friedrich's visions of nature's grandeur. In an insightful essay on "The Tree and the Origin of the Modern Landscape Experience," German literary historian Helmut J. Schneider argues that the making of nature is a sine qua non for the aesthetic perception of nature as landscape.[19] The modern landscape experience is a decidedly constructed experience that "lets nature happen, it sets the stage for nature to 'appear.'"[20] The next question we must ask is when was nature made in order for it to be appreciated aesthetically in the first place?

According to German art historian Norbert Schneider, the history of landscape painting from the later Middle Ages to Romanticism is intimately tied to a growing awareness of an ecological crisis in modern times. Landscape paintings, Schneider claims, are motivated by a compensatory longing for images of unspoiled nature.[21] In other words, they are metaphors that have become real, more real than the thing itself. Landscapes appeal to the predominance of nature over the egocentric interests of humans. In other words, landscapes are never nature in and of itself but affectively manipulated acts of reception. The first pictorial treatments of autonomous landscapes (i.e., landscapes that are not allegorical like biblical or classical landscapes), landscapes that are rooted in a cultural and physical geography and that make it onto the canvas without having to stand in for something else, can be observed in the work of Albrecht Altdorfer. He is generally credited as the founder of modern German landscape painting; he was committed to painting en plein air and without any major props and was interested in depicting natural phenomena, with an intense focus on the motif of the forest. From Altdorfer, the line is usually drawn to Annibale Carracci as the founder of idealized landscapes, to Claude Lorrain as the prime example for heroic landscapes and as a model for the English landscape garden, and, finally, to Joseph Mallord William Turner and Friedrich, who became more and more interested in the depiction of natural phenomena. They depicted landscapes as dynamic entities and carried forward the protest against the economic depletion of nature in modern times.[22]

Friedrich was working in Europe, where there was very little wilderness left. His landscapes radically foreground the subject as producer of landscape. Many of his paintings feature the famous element of the *Rückenfigur*, the figure who is depicted from the back looking into the landscape. His painting from 1822 *Frau am Fenster* shows a female figure (most likely his wife, Christiane) standing in a room, looking out the window into the landscape as if contemplating, her gaze framed and overdetermined by quasi-religious meaning created by the wooden cross of the window pane.[23] His famous painting *Mann und Frau, den Mond betrachtend* from 1830 likewise features a man and a woman as they contemplate life and the meaning of existence on an evening walk during a moonlit night. Friedrich scholarship has generally focused on

the role of Protestantism in terms of interpreting landscapes as metaphors of religious existence or on the role of the artifice.[24] While these are valuable and interesting reactions, we can also read Friedrich's landscapes as spaces in which the relationship between humans and nature is constantly renegotiated. Ilaria Ciseri has eloquently argued that in the case of Friedrich's landscapes, the sublime arises from an essential connection between man and nature. The human beings depicted by Friedrich derive the experience of the sublime from their contemplation of the forces of nature in the Kantian tradition.[25] On the other hand, Joseph Leo Koerner has shown that there is no landscape visible behind Friedrich's trees and that his canvases are empty. I want to tweak this argument even further, as it leads directly into a discussion of his visual poetics.

Koerner begins his analysis of the subject of landscape in Friedrich with a reflection on *Bäume und Sträucher im Schnee* from 1828. According to Koerner, there is no landscape behind the thicket, meaning that what is depicted on canvas becomes an extension of the viewer. These "barren scenes of thicket, grove and hovel were achieved only through a deliberate and epochal purgation of landscape painting's subject."[26] Even though Friedrich's intentions may have been shaped by religious feelings, his art radically breaks with that tradition and introduces a Kantian aesthetic by internalizing the *Rückenfigur's* perspective into the structure of the painting: "what we see is not nature, but the experience of nature belatedly re-imagined."[27] We are denied the view of landscape beyond the thicket and become the true reference point of landscape painting. The landscape on Friedrich's canvases is already a scene that was viewed by us. The *Rückenfiguren* simply enact that fact. Koerner pushes his interpretation of Friedrich's landscape paintings even further by suggesting that, as opposed to classical landscape painting, which observes strict axial symmetry and resists the eye's movement into depth, Friedrich's visual poetics produces fragmentary constructions of chaos with the effect that his frames underscore the radical discontinuity of space. His canvases are open on both sides, and even his grid-like compositions block the eye's passage into the distance. For Koerner, Friedrich's art is the aesthetic equivalent of Romantic ideas about nature and the representation of nature expressed in Schelling's lectures about nature and art. I agree, but for a

different reason than the one given by Koerner. Schelling conceived nature as a much more active concept, which he called *"natura natur-ans."* Only a nature that is conceived as material can play that role. A nature that is depicted solely as conceived by a viewing subject cannot be a *natura naturans.*[28]

I would like to introduce another perspective into the discussion of Friedrich's art, namely, one that is actively shaped by environmental concerns. In a discussion of the framing of nature in the early German Romantic period, environmental historian Joan Steigerwald interprets Friedrich's paintings as articulating a different attitude toward the re-lationship between humans and their environment. In the painting *Der Mönch am Meer* (1808–10), the human being "almost disappears into the greater environment of which he is part—the earth, sea and sky."[29] Steigerwald uses this scenario to underscore her point about environ-mental history in the early German Romantic period. She argues that at the turn of the nineteenth century it was assumed that the character-istics of each individual human being could only be understood in terms of his or her relationship to the rest of nature: "[h]uman beings were regarded as a part of nature and as affected by their environment."[30] The human being was considered to be a part of the greater environ-ment, and to conceive of the relationship between humans and nature required an act of imagination, a creative leap across an uncharted domain. Steigerwald also works with the concept of the *Rückenfigur* and the fact that we are looking at someone looking into nature, but, as opposed to Koerner, who interprets this scenario as an affirmation of the lack of deep structure, she sees it as a tool to reflect on the paint-ing's epistemological underpinnings. In Friedrich's paintings nature is experienced only in separation from the subject, through a reflective gaze so to speak, and is hence always already culturally framed. In the Romantic period this framing becomes ironic. Steigerwald's examples for such ironic frames include Goethe, Humboldt, and Schelling, but in Friedrich, these frames of nature are most carefully articulated. In the remaining part of my essay, I will show how this epistemological problem that becomes manifest in Friedrich translates into aesthetic strategies adopted for the depiction of nature in the American West. In the visual poetics operative in representations of western vistas, the sublime is created by the grammar of hyperbole and visual excess, the

dialectic between panorama and telescopic detail, and an inherent the-
atricality in a further development of the epistemological problem pre-
sented in Friedrich's landscape art.

Before we turn exclusively to Western painting, I want to discuss
two paintings specifically as evidence for the link between Friedrich's
visual poetics and Hudson River School painting, namely, Friedrich's
Der Mönch am Meer (1808–10, Nationalgalerie) and Bierstadt's *Beach Scene*
(1871–73, Seattle Art Museum).[31] The compositional parallel between
these two works is striking. Friedrich's scene enacts the epistemological
problem of the lone subject gazing into the barren landscape (as affec-
tively reimagined gaze) and its solution in the specific visual grammar
discussed above: the central figure of the monk is depicted from the back
standing on a lone beach, gazing into the empty landscape, a darkly ren-
dered sea and the exaggerated and theatrically dramatized night sky, as
if staring into the abyss. The German critic Rüdiger Safranski has called
this a radical abyss of emptiness (echoing Koerner's belief that there is
nothing beyond Friedrich's landscapes).[32] Safranski points us to the fact
that the monk is the only vertical line in the painting. *Der Mönch am Meer*
derived, like most of Friedrich's paintings, from sketches made on loca-
tion, which finally grew into a final product by Friedrich's rearranging
and, in this instance, eliminating individual elements from the composi-
tion. Safranski and others remind us of the fact that when the painting
was first shown, it caused quite a stir. The German writer Heinrich von
Kleist, for example, commented on its disturbing effects by claiming that
when one looked at it, it felt as if one's eyelids were cut off.[33]

Bierstadt cites Friedrich's composition and style very closely but
adds to it visual excess and theatricality. His rendition of the theme is,
like all of Bierstadt's landscapes, a study of light and the source of illumi-
nation. Instead of Friedrich's abyss, the viewer is looking at a dramatic
spectacle. This sky exists beyond what the *Rückenfigur* sees. American
landscape emerges from Friedrich's confinement to the subject as a the-
atrical spectacle of visual excess. Friedrich's lone vertical line is repro-
duced many times over in the formation of the clouds, adopting a much
greater independence. The art historian Mathew Baigell claims:

> So varied are his skies and so persistently did they assert themselves
> in his works that it seems impossible and unnecessary to assign
> influences. He probably absorbed ideas and techniques from what-

ever sources were available to him throughout his career, including paintings or reproductions of paintings by Andreas Achenbach and Turner as well as the writings by John Ruskin, especially the lengthy section on clouds in the first volume of his *Modern Painters,* the first American edition of which was published in 1874.[34]

The reference to Ruskin is helpful and may explain why Bierstadt turned to this topic just around that time in his career. To fully understand the significance of Bierstadt's visual conversation with Friedrich, however, we need to place Bierstadt's style in the context of his overall career trajectory.[35]

Bierstadt was born in Solingen, Germany, in 1830. In 1832, the family moved to New Bedford, Massachusetts, where the father worked as a cooper. When Bierstadt was ready for some formal training in painting, he went back to Germany, intent on studying with his mother's cousin who taught at the acclaimed Düsseldorf Academy. The "Düsseldorf school" of painting placed a new emphasis on landscape painting from life. Its hallmarks were a precise, quite literal, characteristic design and a synthetic combination of vast members of minutely observed and tightly painted details, which Bierstadt developed further into the scopic regime of panorama and telescopic detail. The leading academicians at that time were Andreas Achenbach and Carl Friedrich Lessing, whose trademarks were the placement of light sources hidden behind clouds, tortured trees, dramatic skies, reflective water, and a sweep of valley and plain views. Bierstadt's Westphalian oil sketches owe much to these detailed compositions of bucolic landscapes in the nineteenth-century tradition of the pastoral.[36]

In 1856 and 1857 Bierstadt traveled through Europe, mainly south to Switzerland and Italy, and for the first time became acquainted with the Alps and the European concept of natural grandeur. The typical Bierstadt composition from those days features a lake in the center, trees and animals in the foreground, and a dramatic sky with alpine scenery in the background. The animal figures often appear more as visitors to the scene than natural inhabitants, frequently staring into the scenery and depicted from behind; in my reading they serve as an interesting comment on Friedrich's *Rückenfiguren* and the epistemological problem of the subject as the producer of a landscape belatedly reimagined. In 1858, Bierstadt completed his first historical painting,

Gosnold at Cuttyhunk, 1602, chronicling the landing of British pioneer Bartholomew Gosnold at Cuttyhunk, one of the Elizabeth Islands near New Bedford, Massachusetts. Similar to the alpine scenes, the painting has water in the foreground framed by trees, Gosnold's ship in the background, and deer as characteristic bystanders of the scene, looking into the painting. In a break with the tradition of historical painting, human figures are absent. Instead of the European conqueror, it is the virgin landscape that is featured prominently at a point in time in which this space will be forever changed by civilization. It is not the heroic act of the explorer that is depicted but the moment of penetration from the perspective of nature. We are looking at Gosnold's ship, so to speak, through the eyes of the deer.

Later in 1858, Bierstadt joined Colonel Frederick W. Lander's trip to explore and survey the American West. On the trip, Bierstadt painted realistic and unadorned oil sketches that would later be transformed into larger oil paintings in his New York studio. Bierstadt's monumental paintings are created largely from memory. He took ample liberty with details, moving scenes around, changing locations, creating artistic statements that produced the effect of natural grandeur and that reflect on the moment of crucial, frequently deadly, contact between native cultures and animals, on the one hand, and white civilization, on the other. His *Thunderstorm in the Rocky Mountains* from 1859 drives this point home very clearly. The composition of this painting contains elements that derive from Bierstadt's Düsseldorf training: the preciseness of detail, the emphasis on the framing, a reflective body of water in the center, and the dramatic sky. We are witnessing the onset of a theatrical drama underscored by threatening skies. Bierstadt invented the western American landscape by skillfully joining carefully observed and meticulously rendered detail with freely configured compositions that met national needs, thus perfecting the visual grammar derived from the German tradition. The art historian Nancy Anderson states that "Bierstadt's painting offered sanctuary to an idea Americans were reluctant to give up despite their headlong rush into an industrial age."[37] Bierstadt's compositions reflect this conceptualization of landscape as a place where national myths are negotiated.

In 1863, Bierstadt joined the writer Fitz Hugh Ludlow on another expedition to Colorado, California, and Oregon, where he saw Yosemite

for the first time. *The Rocky Mountains, Lander's Peak,* 1863 (Figure 5.1), was Bierstadt's first great western panoramic landscape. At that point, Bierstadt was clearly working on a model for the depiction of the American West: nature that is new to art, with the lake in the middle, the jagged mountains in the background, the snow-tipped peaks, and the animals in the foreground as reconceived *Rückenfiguren,* gazing into the excess and watching the theater of the virgin scene unfold. This panoramic view of the sublime is always staged. It is a theatrical drama where the West metaphorically becomes real. In Yosemite Valley and other iconic western vistas, Bierstadt found a landscape so spectacular, so unique in its grandeur, that he was finally able to offer his viewers a national landscape for which there was no equivalent. William Talbot has called these images allegories of western expansion where the majestic wilderness appears as awesome, unthreatening at the same time, and well worth possessing.[38] Bierstadt's "Alps" provide hyperbolic images of the American West as dramatically staged sublime. *Among the Sierra Nevada, California* from 1868 (Figure 5.2) and *The Rocky Mountains, Lander's Peak* work particularly well as examples of composites from his earlier work and represent the quintessential visual grammar that Bierstadt helped

Figure 5.1. Albert Bierstadt, *The Rocky Mountains, Lander's Peak,* 1863. The Metropolitan Museum of Art, Rogers Fund, 1907 (07.123).

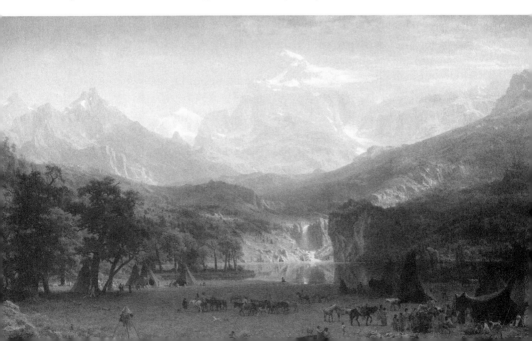

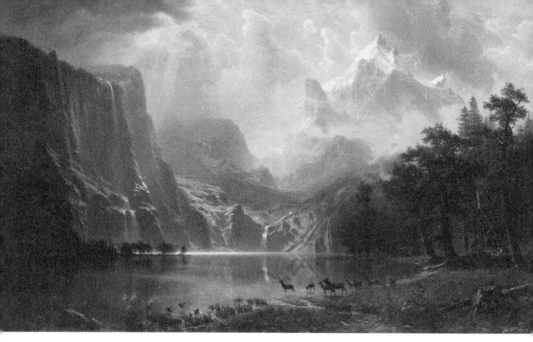

Figure 5.2. Albert Bierstadt, *Among the Sierra Nevada, California,* 1868. Smithsonian American Art Museum, Bequest of Helen Huntington Hull, granddaughter of William Brown Dinsmore, who acquired the painting in 1873 for "The Locusts," the family estate in Dutchess County, New York.

shape and bestowed with hyperbolic features. The stunning vistas from the American West emerge as staged images characterized by visual excess. The hyperbolic stage of wilderness as theater of the sublime spoke to the viewers of Bierstadt's paintings and their ambivalent attitude toward the project of western expansion. Many of the locations depicted by Bierstadt later became national parks or, at the very least, now have some kind of protected status. Bierstadt depicted them as divinely favored, laden with threatening and nonthreatening features, unconsciously asking to be possessed and needing to be protected at the same time. Bierstadt showed his viewers a landscape that would soon change due to western settlement. Americans were eager to fill that landscape and become part of the sublime, but filling the empty space of the frontier also meant destroying it. It is this reflection on the project of western expansion that Bierstadt stages in his art. Bierstadt creates for us what western landscapes looked like at the moment of arrival of western men and women. Nature replaces Friedrich's *Rückenfiguren,* and this shift introduces an entirely new set of epistemological concerns into painting. These early images of iconic vistas shaped by painters

like Bierstadt, trained in Europe and influenced by the visual poetics of a Caspar David Friedrich, are products of a conversation between this tradition and the challenge of representing a nature that is new to art.

One of the world's leading experts on nineteenth-century American art of the West, Peter H. Hassrick, underscores the man-made nature of the first and quintessential American national park. He calls Yellowstone an "anthropocentric arcadia" and the finest experiment in effecting a benevolent interaction between nature and culture mirrored in art.[39] I will conclude by comparing one more set of paintings: Thomas Moran's famous *The Grand Cañon of the Yellowstone,* 1872 (see Figure 7.1), and Bierstadt's *Lower Falls of the Yellowstone,* 1881.[40] Hassrick reminds us that "despite the fact that Holmes's and Elliott's images of Yellowstone were widely dispersed, it was always Thomas Moran who set the standard for pictorial representation of its beauties."[41] As pointed out by many scholars, it was his watercolor that inspired lawmakers to create the first national park. The painting was later purchased by the U.S. government for $10,000, and "after a multi-city tour, it was placed in the Senate lobby, the first landscape to join the Capitol Collection."[42] Moran framed the significance of Yellowstone in aesthetic terms and thus helped plant the seed for the idea that Yellowstone was a sacred place. He altered nature in scale and perspective to create dramatic effects, and worked with the scopic regime of the panorama by sketching the walls and thereby "recording their extraordinary formations and lines," effectively referencing classical antiquity in the visual excess of the spires and falls.[43] He also included bystanders gazing into the scenery to show scale and to integrate the structure of the subjective gaze into the painting in the tradition of Friedrich's *Rückenfiguren.* In fact, there is a debate about the significance of who these figures are. Joshua Johns tells us that

> some believe that they represent Dr. Hayden and his executive officer, James Stevenson while others believe that they are not geological surveyors, but visual surveyors who represent Moran and Jackson. . . . A Native American, turning away from the view, and a slaughtered deer behind him are small elements which may infuse the painting with Moran's own understanding of the region. Moran knew that to the Native American, Yellowstone was not a new discovery, as the indifferent pose of the man in the painting suggests. When coupled with the slain deer, however, the inclusion of the Native American signifies the darker side of the Yellowstone expedition.[44]

To push this interpretation further, I suggest that Moran put these figures into the colonial archive in order to include the indigenous perspective. The Native American turning away from the famous vista actively refuses the agency that comes with the gaze of the western *Rückenfiguren*, thus introducing an entirely different dynamic into the epistemological problem of the western landscape and giving an ironic twist to Cole's dictum that everything here is new to art. Though it may be new to European styles of art, it is certainly not new to Native American art and the indigenous perspective.

Interestingly, this is the one element that Bierstadt—and later Moran in his 1893–1901 rendition of the same theme in his famous *Grand Canyon of the Yellowstone*—decides to eliminate from his composition. After having replaced Friedrich's *Rückenfiguren* with deer and trees in his many renditions of iconic western vistas, Bierstadt no longer feels the need to include this element to create an effective composition of the quintessential western scene. Even without this element, his vista remains the same. It is the view of the Lower Falls of the Yellowstone River from the perspective of nature (or the Native American) that will cease to exist unless protected. Bierstadt presents the panorama and molds the telescopic gaze onto the lower canyon of the Yellowstone to create drama and the effect of the sublime through hyperbolic excess. He paints with the aid of the visual poetics that he owes to his Düsseldorf training and his spiritual mentor Friedrich, but develops it further by addressing the aesthetic challenges presented by the wish to represent a nature that is new to art. The New World seen through painterly eyes trained in the scopic regimes of the Old World results in a bird's-eye view of a theatrical stage. Western nature becomes a sublime drama of hyperbolic visual excess and panoramic and telescopic detail. The German signature still informs the grammar of this drama.

NOTES

1. See Roland Barthes, *Mythologies*, trans. Annette Lavers (New York: Hill and Wang, 1957), 142.

2. Michael Göring, "Conquering Nature: Masterpieces from the Hudson River School in Hamburg," *The Atlantic Times*, January 2007, 21.

3. Bernhard Schulz, "God's Creation in Its Original State: Hamburg Shows 19th Century American Paintings," *The Atlantic Times*, March 2007, 18.

4. Ibid., 18.

5. Elizabeth Mankin Kornhauser, " 'All Nature Here Is New to Art,' " in *Neue Welt: Die Erfindung der amerikanischen Malerei,* ed. Ortrud Westheider and Karsten Müller (Hamburg: Bucerius Kunst Forum, 2007; Munich: Hirmer, 2007), 14.

6. Ibid., 15.

7. Ortrud Westheider, "Kunst und Wissenschaft: Die Hudson River School und die deutsche Romantik," in *Neue Welt,* ed. Westheider and Müller, 69.

8. Ibid., 70.

9. Alan Wallach, "Die Künstler der Hudson River School und das Panorama," in *Neue Welt,* ed. Westheider and Müller, 80.

10. Ibid., 81.

11. Winfried Fluck, "Theatralität und Exzess: Ein europäischer Blick auf die Hudson River School," in *Neue Welt,* ed. Westheider and Müller, 95.

12. Judith Hansen O'Toole, *Different Views in Hudson River School Painting* (New York: Columbia University Press, 2005), 12.

13. Barthes, *Mythologies,* 11.

14. Ibid., 142.

15. Simon Schama, *Landscape and Memory* (New York: Knopf, 1995), 61.

16. Ibid., 61.

17. Ibid., 187. Bierstadt's paintings can be viewed online at Wikipedia, Artcyclopedia, or Artchive.

18. Ibid., 193.

19. Helmut J. Schneider, "The Tree and the Origin of the Modern Landscape Experience," in *The Idea of the Forest: German and American Perspectives on the Culture and Politics of Trees,* ed. Kenneth Calhoon and Karla Schultz (New York: Lang, 1996), 89.

20. Ibid., 92.

21. Norbert Schneider, *Geschichte der Landschaftsmalerei: Vom Spätmittelalter bis zur Romantik* (Darmstadt: Wissenschaftliche Buchgesellschaft, 1999), 7.

22. Ibid., 194.

23. Friedrich's landscape paintings can be viewed online at Wikipedia, WebMuseum, Artcyclopedia, Artchive, Geocities, ArtofEurope, and many other sources.

24. See Andreas Aubert, *Caspar David Friedrich: "Gott, Freiheit, Vaterland"* (Berlin: B. Cassirer, 1915); and Thomas Kellein, *Caspar David Friedrich: Der künstlerische Weg* (Munich and New York: Prestel, 1998).

25. See Ilaria Ciseri, *Die Kunst der Romantik,* trans. Bernd Weiss (Stuttgart: Belser, 2004), 264.

26. Leo Koerner, *Caspar David Friedrich and the Subject of Landscape* (New Haven, Conn.: Yale University Press, 1990), 16.

27. Ibid., 19.

28. See Sabine Wilke, "From *Natura Naturata* to *Natura Naturans: Naturphilosophie* and the Concept of Performing Nature," in *InterCulture* 4 (2007): 3.

29. Joan Steigerwald, "The Cultural Enframing of Nature: Environmental Histories during the Early German Romantic Period," in *Environment and History* 6 (2000): 452.

30. Ibid., 452.

31. Friedrich's painting is cataloged in all major art books and available for online viewing through Wikimedia Commons. Bierstadt's painting is also available through Wikimedia Commons.

32. Rüdiger Safranski, "Über Caspar David Friedrich: 'Mönch am Meer,'" in *Thalia Magazin* 3 (2007): 13.

33. Ibid., 113.

34. Matthew Baigell, *Albert Bierstadt* (New York: Watson-Guptill, 1981), 78.

35. For a more extensive discussion, see my essay "Albert Bierstadt's Images of the American West: An Eco-Critical Reflection on Nature Painting," *Reconstruction* 7 (2007): 1–18.

36. See Gordon Hendricks, *Albert Bierstadt: Painter of the American West* (New York: H. N. Abrams, 1974), 6ff. See also Gordon Hendricks's discussion in *Bierstadt* (Fort Worth, Tex.: Amon Carter Museum, 1972); and Thomas W. Leavitt, introduction to *Albert Bierstadt, 1830–1902: A Retrospective Exhibition, Santa Barbara Museum of Art, August 5–September 13, 1964* (Santa Barbara, Calif.: Museum of Art, 1964).

37. Nancy K. Anderson, "'Wondrously Full Invention': The Western Landscapes of Albert Bierstadt," in *Albert Bierstadt: Art and Enterprise*, ed. Nancy K. Anderson and Linda S. Ferter (New York: Hudson Hills, 1990), 94.

38. William S. Talbot, "Albert Bierstadt 1830–1902," http://www.butlerart.com/pc_book/pages/albert_bierstadt_1830.htm.

39. Peter Hassrick, *Drawn to Yellowstone: Artists in America's First National Park* (Seattle: University of Washington Press, 2002), 9.

40. Both paintings are available at Wikimedia Commons.

41. Hassrick, *Drawn to Yellowstone*, 54.

42. Joshua Johns, "The Lure of the West: Thomas Moran and the American Landscape," http://xroads.virginia.edu/~cap/nature/cap3.html.

43. Hassrick, *Drawn to Yellowstone*, 46.

44. Johns, "The Lure of the West."

6. YELLOWSTONE NATIONAL PARK IN METAPHOR
Place and Actor Representations in Visitor Publications

David A. Tschida

TOURISTS TRAVELING TO NATIONAL PARKS often rely on publications found in visitor centers and gift shops to learn more about each park's features, consulting these items during their visit or taking them home as souvenirs. Richard Grusin asserts that the rhetorical significance of these items lies in their power to inform visitors about the park while managing their relationship to it.[1] They are, as Tarla Rai Peterson contends, part of a public relations effort to influence visitors' beliefs and values or direct their behaviors while in the park.[2] Ultimately, they provide arguments for and legitimation of the mission and administrative vision of the National Park Service (NPS).

In defining its mission, the NPS maintains it "preserves unimpaired the natural and cultural resources and values of the national park system for the enjoyment, education, and inspiration of this and future generations."[3] David Graber contends that the resource preserved in Yellowstone National Park is "wilderness," noting that the first national parks "were meant to protect spectacles of nature—geysers, waterfalls, and huge trees—and promote them as virtuous attributes" of the nation.[4] Arguably, the vision of wilderness tourists to Yellowstone experience is one constructed for them, in part, through the publications created by the NPS and other influential rhetors.

Within its Yellowstone publications, the NPS rhetorically constructs "wilderness" through, among other things, its use of archetypal metaphors. Michael Osborn argues that such metaphors are popular because they tend to be timeless and culturally universal, providing a version of reality that audiences understand and accept.[5] George Lakoff

and Mark Johnson maintain that these metaphors serve persuasive purposes while masking opposing realities and interpretive possibilities.[6] James Cantrill and Christine Oravec contend that "the environment, beyond its physical presence, is a social creation" that is built or maintained through rhetorical action.[7]

Archetypal metaphors may be supported or enhanced, perhaps gaining greater power, through photographs, illustrations, and other visual forms of rhetoric that accompany the written text and reinforce the metaphorical constructions. In some instances, these visual elements are so iconic or familiar as to stand alone as a rhetorical statement. American culture trains its citizenry to interpret certain images of nature through frames that include the sublime and the sacred. Yet, the images in these publications are not standing alone. Along with the written text, the images co-construct the meaning of Yellowstone National Park's wilderness, and taken as a whole, these elements support the vision and mission of the NPS. Thus, while this essay examines the visual rhetoric of two Yellowstone publications, such an examination would be incomplete without including the written textual accompaniment.

In this essay, I explore two archetypal metaphors for the environment presented in the publications: "place" and "actor." These archetypes are common in environmental rhetoric, and their strategic visual and written use in national park publications needs further exploration because they provide a framework for interpreting and experiencing nature and the park. However, in exploring their present use in the Yellowstone publications, one finds interesting tensions between the visual and the written presentation of the metaphors. Whereas the written, in line with the apparent intent of the publications, emphasizes the place metaphor, the visual confuses this preference by drawing greater attention to the actor metaphor. This essay examines the tensions created by these contrasting emphases.

Two publications purchased in Yellowstone National Park and available through the NPS website were used for this study. The first is the NPS-produced *Yellowstone: Official National Park Handbook* (hereafter cited as *Handbook*).[8] It is 127 pages in length and the size of a standard greeting card. The second is *Yellowstone: Official Guide to Touring America's First National Park* (hereafter cited as *Guide*), produced by the Yellowstone

Association, a private organization operating within the park whose interests lie in researching and protecting Yellowstone and its features while supporting the mission of the NPS. Its publication is 80 pages in length and slightly larger than the average magazine.[9] Given their placement and quantities in the park's visitor centers and gift shops, these publications clearly represent two popular items targeting visitors. Each is easy to read and accompanied by plentiful images that visitors can consume while in the park. Because they are produced by influential organizations affiliated with Yellowstone National Park, target a diverse audience, and make an argument for how humans should relate to the park, their critical examination is warranted.

Socially Constructed Environment

Humans socially construct the natural environment through communication. While nobody doubts that bison, pine trees, and waterfalls existed in nature before our naming or photographing of them, they take on significance through these actions. The archetypal metaphor serves as an effective tool in the process of naming, classifying, and understanding the environment by offering a condensed yet rich description of that to which it is applied. It is, however, always incomplete in its perspective. James Shanahan and Katherine McComas contend that such metaphors allow us to "fall back on ideologies and belief systems" such that "what we 'think' about the environment is in many ways much more important than what we 'know' about the environment."[10] In other words, these metaphors may shape and reflect the constructs we draw upon in our process of making sense of the environment. They do not necessary reflect the full character of nature or our complete knowledge of it. Yet, as Christine Oravec and Tracylee Clarke assert, when a rhetorical construct becomes a basis for how we view nature, this rhetoric is epistemic.[11]

In a previous study, Grusin found that similar texts offered arguments based on an "exploration" metaphor that encouraged tourists to rediscover Yellowstone National Park in the tradition of Lewis and Clark.[12] In a second study, Dayle Hardy-Short and Brant Short examined news reporting of the 1988 fires within the park, noting that fire took on cultural significance because of the competing archetypal

metaphors of "death" and "rebirth" that were used by the media, park or government officials, and citizens in describing the fires and the effects.[13] In both instances, metaphors were central to the competing perspectives offered about the park and the actions advocated therein.

Two conflicting historical perspectives influence the use of the place and actor metaphors. In anthropomorphism, Neil Evernden contends, humans interpret their natural surroundings by making metaphorical comparisons to our body types, personality types, or cultural types.[14] These comparisons themselves are often the source of rhetorical and cultural (i.e., environmental) conflict. Holmes Rolston suggests that such an epistemology inevitably locates humans as the defining framework for what we know about nature.[15] That knowledge is always a product of the human-created and human-centered language that is available and employed within any given situation. Thus, what we know about nature is a product of what we know about ourselves, not what we know about nature. The second perspective of scientific objectivity creates a dualism that separates humanity from nature and turns it into an object for our study. Such objectivity, while distinguishing humanity from nature, often identifies in nature that which we commonly refer to as "resources." Through this dualism, nature loses much of its position as a subject with which humanity has a relationship, and so it too is charged with conflict. It should not be difficult for the reader to imagine the numerous possibilities that these two perspectives may have in influencing our use of or response to the place and actor metaphors.

Several scholars argue that modern environmental conflicts are the product of anthropomorphism versus objectivity, humanity versus nature, or other dualistic epistemologies.[16] Locked in epistemological conflict, rhetors employing one perspective are unlikely to understand, accept, or adopt the positions of an opponent. Clearly, communication situates us in relationship to natural spaces and entities. Yet, Donal Carbaugh notes, "communication is not created the same in all natural places, and it does not create in all such places the same sense of—or relations with—the natural realm." When applied to nature, Carbaugh adds, communication is particularly localized to one space, defining it in "distinctive ways, in particular cultural contexts, tolling specific tropes, fertilizing particular fields."[17] In other words, commu-

nication about the natural has been hard to generalize beyond a singular instance, leaving environmental protection efforts struggling to find the most appropriate and successful rhetorical tools. However, a better understanding of two of the most common archetypal metaphors for the environment may provide the foundation necessary for more encompassing discussions.

Roger Aden and Christine Reynolds note that nature-specific metaphors for place, which are part of the larger archetype, may draw from both anthropocentric or objective frameworks and assist us in understanding particular sites by defining symbolic places, legitimating actions appropriate for such places, and encouraging rhetoric befitting particular places.[18] Cantrill asserts, "Those interested in the construct seem to agree that a sense of place is the perception of what is most salient in a specific location, which may be reflected in value preferences or how that specific place figures in discourse."[19] A problem with some versions of the metaphor, as noted by Robert Sack, is that place is, to one degree or another, "created by and for mass consumption."[20] Clearly, connecting humanity meaningfully to nature and fostering environmentally friendly behaviors may require a respect for nature that extends beyond its ability to serve our consumptive needs. We must call into question the power of the place metaphor to create a healthy sense of environmental awareness. Furthermore, Carbaugh notes that some versions of the metaphor do injustice to the plants and animals, which are not equivalent to the physical sites they occupy.[21] Thus, we must be aware that this metaphor may not always allow us to understand, value, and protect a particular physical location along with the species found at that location.

The actor metaphor, while at times drawing inspiration from anthropocentric or objective perspectives, typically defines nature as another character(s) in a shared scene and emphasizes the agency that character has within its location. That agency may be the metaphor's salvation. Connie Bullis notes that while some language can create and maintain detrimental relationships between humanity and the earth, positive options exist.[22] The ideal actor metaphors would not be based in anthropocentrism but would move us toward an epistemology that privileges the unique qualities of a "living" nature and the rightness of nature and humans coexisting but striving toward our own purposes.

Yet, Bullis contends that the healthy relationships humanity can have with the environment will always have some material component; after all, we rely on nature for our own survival.

This metaphor has additional limitations. It is often difficult for Western societies to view nature through this archetype because our emphasis on capitalism, consumption, and industrialized technologies returns us to an objective view. The practices or ethics that would regard nature as an independent subject are awkward and strange. Further, those uses of the metaphor that are the most familiar may also be the most negative in terms of fostering a healthy relationship, such as when the natural actors are defined as being "dangerous" or "hostile" (e.g., bears, wolves, sharks). Finally, Lynn Stearney suggests that the metaphor fails if it reduces our relationship to the earth to only the Mother Nature relationship.[23]

Methodological Considerations

As noted earlier, one cannot fairly assign meaning to the visual elements in the selected publications by divorcing them from the written elements. To understand the content of these publications as an example of visual rhetoric, one must also make sense of the substance of included captions and pages of written text. This is especially true when the user of these publications, while perhaps not reading the items in detail from cover to cover, is likely to read the captions to any pictures of interest and/or read the subsections of written text connected to any tourist attraction of interest. After all, these are guides for exploring the park, and the majority of the images have far less meaning without their written accompaniment. Thus, I first examine written examples of the two archetypal metaphors operating in these texts before turning attention to the visual.

The process of identifying the two metaphors (in written and visual forms) is informed by the work of Kenneth Burke, who argues that "associated clusters" of terms or images collected from an instance(s) of rhetoric can, through analysis, aid one in understanding the "acts and images and personalities and situations" substantiated by the rhetoric.[24] In examining these clusters, we come to see the connotative complexity of particular terms and images within the clusters and the implications

of the rhetor using them. Burke is interested in studying these rhetorical devices "not from the standpoint of their truth or falsity as statements, but purely for the light they might throw upon the forms of language" or communicative practices.[25] He suggests that the terms used to label an item will reflect the constructed truth we choose to accept about an item.[26] Burke notes that identifying the item with certain terms and not others also entails by implication negating alternative meanings and understandings.[27]

This research is also guided by the work of Lakoff and Johnson, who suggest, "Our ordinary conceptual system, in terms of which we both think and act, is fundamentally metaphorical in nature."[28] This system, which allows us to understand one concept (i.e., an entity or an experience) by comparing it to another, is problematic because it obscures aspects of the concept to which one is making the comparison. Yet, when using a metaphor to understand some concept in our physical world, we do learn about that concept, and we learn about the appropriate relationship to that thing reflected in the concept. This "learning" is significant if one is to believe that metaphors for the environment shape the beliefs, values, and actions taken by humans relating to the natural environment. Lakoff and Johnson claim that "once we can identify our experiences as entities or substances, we can refer to them, categorize them, group them, and quantify them—and, by this means, reason about them."[29]

Textual Analysis

The NPS and the Yellowstone Association live up to their public relations mission early in their publications, offering statements that serve as invitations and directives to the park visitors who would use these items as tools for exploring and understanding Yellowstone National Park. There should be little doubt that these publications function as persuasive materials. Yet, some interesting tensions are created in or revealed by these publications. To understand the tensions created between how one may read or respond to the written versus the visual, it is important to make sense of what each provides. The identification and clustering of the written place metaphors revealed three significant themes operating within this archetype in these publications. These

themes can be examined in light of the same themes created within the visual rhetoric of the publications.

The first theme is that of place as a site or stage for human action or existence. It includes the 11,000-year history of indigenous peoples living in the area, Yellowstone's development as a park, and its current reputation as a popular recreation site. The *Guide* observes:

> According to what many historians consider a legend, one evening during the Henry Washburn Expedition of 1870, several of the men discussed the notion that this amazing area should be removed from settlement and preserved as a park. That campfire discussion is said to have occurred at the base of this mountain. Not surprisingly, many people today consider this spot to be the birthplace of national parks.[30]

This narrative creates a history and a modern birth for Yellowstone National Park and in noting the location of that birth ties humanity to the very existence of the park. Visitors can gaze at the mountain (in person or in a photograph) in whose shadow the park was born. Yellowstone can now exist not only because of humanity but also for the human actor (i.e., the tourist).

Visually, the *Guide* supports this theme through the number of maps it contains. Early in the publication, a map of the entire park is offered (the *Handbook* offers a similar map). This map indicates the major roads through the park (e.g., the famous figure 8–shaped Grand Loop Road), the campgrounds, the lodging, the picnic areas, and the major historic sites and natural attractions. Supplemental regional maps illustrate sections of the park and point out additional features. These maps obviously direct the visitor through the park and suggest that the park is a stage for their tourist-centered enjoyment.

Both publications also use several photographs and illustrations to support this theme. The historic images, for example, such as those of Fort Yellowstone and the Old Faithful Inn, tell the story of Yellowstone's creation and administration. Yet, what is nearly missing among the more recent photographs is the presence of tourists or signs of tourist activity (e.g., boardwalks, scenic overlooks, roads) in the park. The only photograph in the *Guide* with contemporary tourists appears midway through and is a photo of two adults and a child walking along a

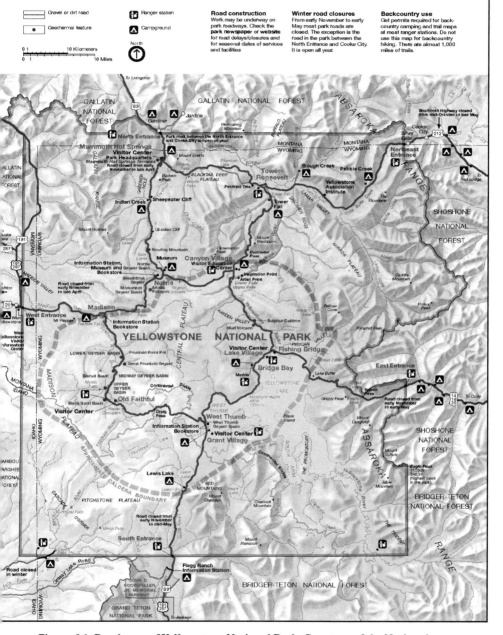

Figure 6.1. Road map of Yellowstone National Park. Courtesy of the National Park Service. From David Rains Wallace, *Yellowstone: Official National Park Handbook* (Harpers Ferry Center: National Park Service—Division of Publications, Number 150, 2011), 122–23.

gravel path. In the *Handbook,* it is not until late in the publication, in a section titled the "unforeseen values of preservation," that modern tourists make an appearance. In a series of four photographs, readers are presented with an image of photographers taking pictures of elk, of families enjoying a stagecoach ride near Roosevelt Lodge, of an angler fishing in a river, and of snow skiers observing the eruption of a geyser.

While the maps are directing visitors through the park, the lack of photographs or illustrations showing tourists or containing signs of tourist activity functionally removes thousands of visitors from the park. This omission creates the first tension that exists in the publications: a tension over place that exists between the Yellowstone National Park as represented in the publications and the Yellowstone National Park that exists in reality. Instead of showing a Yellowstone that can be a crowded location, the majority of photographs represent the people-free sublime image that the current tourists may wish to witness. To justify this contradiction, one can return to the previously stated mission of the NPS, which works to present an "unimpaired" attraction that visitors can "enjoy." Tourists purchasing these publications find the written text telling them how to enjoy the park, and then photographs give the false impression that nobody else will be there to enjoy the park with them. One has to leave the beaten path to find the solitude seen in pictures, an act that only a small portion of visitors are likely to do.

The second theme is place as a site or stage where animal, plant, and geologic life exists. The *Guide* notes, "Yellowstone is one of the largest, richest ecosystems in the temperate world. . . . Among the animal species found in the park are approximately 61 mammals, 16 fishes (11 native, 5 non-native), 6 reptiles, 4 amphibians, and more than 315 birds."[31] Both publications provide detailed information noting Yellowstone's status as a location to find flora and fauna. Referenced as an ecosystem, Yellowstone becomes a stage alive with the life that thrives there. Furthermore, Yellowstone contains a large collection of thermal features (i.e., geysers, mud pots, hot springs, fumaroles), which themselves are described as alive and active. In their written descriptions, the publications recognize the entities in the park while seemingly favoring the interpretation that animals, and undoubtedly plants and geysers, are part of a larger stage that is Yellowstone National Park.

Turning to the visual, and consistent with this theme, the *Guide* provides an illustration of the vegetation zones for Douglas fir, lodgepole pine, and spruce trees. The *Handbook* provides an illustrated cutaway of the Yellowstone region, showing the magma chamber belowground at Yellowstone and the lakes, geysers, and mountains on the surface. The *Handbook* also offers an illustrated menagerie of the animal life (e.g., ground squirrel, grizzly bear, trumpeter swan) that lives in the park. These images clearly reflect Yellowstone as a stage on which many forms of "life" dwell.

If the publications contained exclusively written or visual text, there would be little to no tension inherent in this theme. However, the juxtaposition of the written and the visual, as reflected through the inclusion of the abundant number of photographs, suggests three additional areas for rhetorical tension. First, the NPS and the Yellowstone Association want the tourists to know what animal and plant species and geological features the Yellowstone stage contains and to be able to identify these entities when spotted. To that end, both publications offer a field guide of close-up photographs containing plants, animals, and geology. Yet, this style of photography, by its very nature, removes the park (i.e., the stage) from view. Without the park, attention must be focused on the animal, plant, or geologic entity, which may then be read as a subject-actor. This reading is most understandable for the photographs of the animals. We see a pronghorn elk parenting two young, an owl perched on a branch but looking as if hunting, and a pika with its mouth full of plant shoots, possibly for a nest. Readers give a story to the animal actors engaged in an act (just as this author did). That story turns the animal from object, and part of the stage, into a subject. It is not impossible to believe that audiences may view close-ups of plants living in hostile conditions or geysers and mud pots spewing and bubbling in a similar fashion. Thus, the close-up photography no longer references the stage so important to this theme, and the absence of that stage or place reference increases the possibility that audiences will see subject-actors.

Second, given the photographer's composition and the tourist's interpreting of the publications' wide-angle shots, attention typically gravitates to animals, trees, or geysers prominently featured. Everything else remains backdrop (i.e., place) in the story the readers supply for the

featured entity. Thus, the potential for audiences to interpret the animal, plant, or geyser as actor distinct from but on the stage is increased. This furthers a potential for the theme to seem as internally inconsistent, especially since the animal is still an agent who is hunting, nursing young, or building a nest. The *Guide* even offers a photograph of a pine tree clinging to the rocky and barren side of a steep cliff. The photograph reflects an iconic image seen in posters and fine art, that of an entity whose story is about struggling against adversity to survive. In instances such as these, even a tree is an actor. Certainly, such interpretive possibilities also exist for wide-angle shots with prominently featured geysers. Therefore, it seems possible that only in the few wide-angle images with panoramic views of the park will tourists interpret a distant grouping of trees or a geyser as simply part of the scenery or place.

A third tension arises in the presentation of this theme, a tension that conflicts with the first theme. These photographs may remind audiences of all that is to be found on the Yellowstone stage. However, the presentation of photographs as a tool for identifying species and features suggests that these species and features have a place to exist because humans want to view them (which, of course, they do). This theme, working in conjunction with the previous theme and the tourist-centered purpose of the publication, deprives the nonhuman entities in Yellowstone of having the park solely as a place whose existence and creation are justified by their need to have such a place of their own to exist (which has been the case for the bison and wolf). Instead, Yellowstone National Park becomes a "natural" place for humans to see these species and features existing. Yellowstone, functionally, becomes a zoo or, as Thomas Patin and Sabine Wilke suggest in other essays in this book, a museum.

The final place theme is as a site containing the symbolic. Both publications treat the unique symbolic features in similar fashion. One representative example, from the *Handbook,* is the following:

> After all, Old Faithful Geyser is one of the United States' fundamental symbols. It ranks up there with Old Glory. Since 1872, when Congress created Yellowstone National Park from the public domain in a vast rectangle of Wyoming, Montana, and Idaho territories, other aspects of the park have become symbolic. Its bears and other wildlife symbolize the freedom and wealth of a continent that seemed boundless to Old World colonists. Its monumental

scenery, such as the Grand Canyon of the Yellowstone, symbol-
izes the pride and aspirations of a relatively new nation. For many,
Americans and non-Americans alike, Yellowstone itself is a symbol
of America.[32]

Multiple exhaustive descriptions bring detail to the natural and the
human-created symbols contained within the park, such as the buffalo
(or bison), the gray wolf, Old Faithful geyser, the Old Faithful Inn, the
Roosevelt Arch at Gardiner, and Fort Yellowstone.

Photographs also point out the symbols of Yellowstone. The first
significant photograph in the *Guide* is of the Grand Canyon of the
Yellowstone and the Lower Falls. Both texts offer multiple photographs
of the Old Faithful Inn, with the *Guide* noting its international fame as
a log structure. Buffalo, elk, and wolves are seen in several additional
photographs. Other images are less iconic themselves, yet a symbolic as-
sociation is quickly made between the park and the image. Photographs
of mountains, waterfalls, and thermal features fill the publications. The
entities in these images are central to the mission and public relations
purpose of these materials. Further, they illustrate the history, both
natural and human-influenced, of the park's features, and as noted ear-
lier, Americans have been culturally trained to understand these images
since the point of first being introduced to the uniqueness of Yellowstone.
However, symbols are only as symbolic as the reading we are encour-
aged to adopt. Through these publications and their verbal and visual
representations, we are left without the tools to see Yellowstone National
Park outside of our need or desire to "consume" the park's place-based
symbolic and museum-quality place-associated features.

Attention now turns to the actor archetype. There were far fewer
written actor metaphors within these publications than there were writ-
ten place metaphors, certainly a factor of NPS intentions, the histori-
cal reputation of the park as a site, and the tourist's familiarity with
the place archetype emphasized in the publications. While two possible
actor themes were emerging, that of nature as a thoughtfully active
agent or subject and that of a nature as a biologically—or geologically—
driven active agent or subject, the limited occurrence of this archetype
in these two forms leads to collapsing the two themes. In either, what is
important is that a species or entity is operating as an active subject on
the stage that is Yellowstone National Park.

One reads of an active agent in the grizzly bear of Yellowstone when the *Guide* argues, "While grizzlies can be dangerous, especially when surprised, most avoid encounters with humans."[33] Statements such as this one, tied to an animal's effort to protect itself or its offspring, lead readers to potentially interpret the animal as a thought-driven agent. Likewise, the *Handbook* notes the geologically driven agent, suggesting that "increased understanding of the nature of geysers led many to regard them not as alien and threatening but as attractive and alive with warm colors and memorable sounds and smells."[34] Efforts to define a geyser as being active and alive move us from interpreting it as object toward interpreting it as a geologically driven subject whose form is simply different from our own.

The animal as subject is the most obvious location for the actor metaphor to take root. We already commonly anthropomorphize animals (e.g., pets, animated characters) and treat them as subjects. Expanding that effort beyond pets and cartoon characters could do much to foster an actor-subject epistemology. Certainly, there is an effort by the NPS and the Yellowstone Association to have tourists give the park's largest animals (i.e., bears, bison, moose, elk, mountain lions) the respect they deserve, but that respect is often the product of the threat the animals could create. It falls short of seeing a well-rounded subject.

Select photographs and illustrations are better at supporting the actor metaphor than most. In the *Handbook,* a two-page spread resembling a large placard appearing in a visitor center features a photograph of a grizzly bear with a trout in its mouth, and most readers would quickly understand the story of the hunt. However, anyone taking the time to read the passage contained within the spread will also find the actor metaphor. A photograph in the *Guide* (referenced earlier) is of the Grand Canyon of the Yellowstone and the Lower Falls. While a symbolic image, its symbolism is in part the agency exhibited by the river and falls. A deep canyon has been cut by the "strength" of this "powerful" river. Likewise, Old Faithful is an agent with a different agency. The "schedule that the geyser keeps" and the "roaring" sound it makes are character traits suggested in images and words.

As explored in conjunction with the place archetype, many photographs in these publications may already support the actor metaphor, depending on the storytelling ability or interpretive willingness

of the reader. It is likely that color photographs do more to support the metaphor than other forms of visual representation, only because the photographs adds a level of realism missing in drawings, paintings, and other forms of illustration. However, from the perspective of visual rhetoric, creating a well-rounded understanding of the animals, plants, and geology through the actor frame is difficult to accomplish in these publications—even if that was a goal of the NPS and the Yellowstone Association. Thus, we find a final tension in the joining of the written and the visual content under this archetype.

Unlike video and film, which are easily able to represent a story of animal, plant, or geologic activity in the steady playing of images, photographs and illustrations freeze a story (a moment) in time. While either the photograph or the illustration may indicate that motion is occurring (e.g., the flow of a river), a single image in a publication or similar source often leaves the reader to apply a story to that image (especially if one is not provided). That story is then only as useful as the storyteller's ability to tell it. Given the general unfamiliarity with actor-subject epistemologies (by comparison to the place ones), the story may be missing from the tourist's repertoire. Thus, the activity that defines animals and plants, perhaps giving them subjecthood, becomes difficult to represent in still pictures alone. One may find the occasional photograph of an animal with its offspring or a bird taking flight, and we generally know what object it is we are being shown, but are we able to see the subject in this photograph? Since many subjects in the publications' photographs are not provided their "active" story through the captions and other written text, photographs may be only as useful in supporting the actor metaphor in NPS and Yellowstone Association publications as the tourist is in providing it. It is unclear if audiences can and do interpret the metaphor beyond what the publications lead them to do.

Implications and Discussion

After examining the two publications, conclusions can be drawn about their use of the two archetypal metaphors and the implications in and beyond Yellowstone National Park. Not surprisingly, these publications maintain the designation of Yellowstone as a site where human action

(i.e., tourism) should continue to take place. "Exploration," as noted previously by Grusin, serves as an appropriate analogy for the type of tourist activities encouraged in the park. Visitors should explore in wonder the geysers, waterfalls, bison, and wolves. They should discover the so-called fundamental symbols that make Yellowstone so remarkable. From its early designation through today, promotional campaigns for this and other western national parks, such as the See America First campaign, centered on the unique place features of Yellowstone, Yosemite, and Sequoia National Parks. The place metaphor establishes a scene for tourists wherein our personal narratives of exploration within the parks can be located.[35]

On the other hand, stronger use of the actor metaphor would have left us telling narratives about relationships with subjects with which we should in the case of Yellowstone have very little relationship. We are warned to be wary of the bison and bears, that if we see a wolf, it will certainly be at a distance, and that the geysers are dangerous and should be viewed from a designated boardwalk. These publications, like other environmental rhetoric, draw upon an existing and powerful place archetype to promote (safe) exploration over relationships.

For the actor metaphor to fully compete with or replace the place metaphor (or at least lessen its limitations), it must reflect a fully developed and accepted alternative to the historically powerful place-based imagery addressed in this essay and in those by Wilke and Patin. Otherwise, the place metaphor, with its interpretations of nature favoring humans and defining the environment as an object, will retain its privileged position, allowing more room for individual interpretations of and meanings for nature than the actor metaphor can provide. Furthermore, in the case of Yellowstone, the place metaphor gives the NPS a level of zoo- or museum-like control over our experience with nature and protects us from a realization that relationships with the actors in nature can be less than desirable, such as when sharks are in the waters where we swim.

Yellowstone National Park stands as one of the strongest illustrations of how the place metaphor functions. Like Gettysburg, Chaco Canyon, and the landscape paintings of the North American West, Yellowstone takes on a meaning all its own, and that meaning is, undeniably, tied to place metaphors. When we think of the natural actor,

few examples carry the weight that the place metaphors do. We may think of examples associated with Mother Nature or Smokey the Bear, but these examples have not maintained their power as those of the place metaphor have done. When it comes to how we understand the environment through metaphor, Yellowstone (and nature in general) is currently a site for humans to enjoy, not a character with which we have a relationship. While there are certainly positive uses (or outcomes) of the place metaphor, as I have illustrated in this essay, oftentimes the metaphor may, as Stearney claims, "inadvertently promote an uncritical approach to dominant value systems."[36] In other words, we focus more on nature as a resource and less on its "living" potential. Any efforts to understand and appreciate the environment and to position ourselves in a relationship with a worthy natural subject (while valuable) are currently overwhelmed in the existing value system.

Yet, not all hope is lost for an ecological epistemology that would respect the natural subject-actor. This study finds meaningful support for a claim that the place and actor elements of various narratives may operate not only in tandem but as the same element. Burke wrote about this possibility in discussing the dramatistic pentad, noting that through narratives we could have an agentification of a scene.[37] To this end, places such as geysers, forests, and mountains could come to be seen, in visual rhetoric at least, as having a real "life" to them, even when the written/verbal rhetoric does not employ this metaphor. If this happens, addressing that life may serve as an effective tool for protecting or conserving these sites, in the absence of the respect encouraged through a fully realized actor metaphor. The two archetypal metaphors examined in these publications provide environmental rhetors with tools to describe or interpret much environmental rhetoric, not just that of the NPS or the Yellowstone Association. The general familiarity of the metaphors means that the perspectives they provide will not soon disappear or change. Given the tie that place metaphors have to Yellowstone National Park and to other prominent locations across America, environmental rhetors must strategically employ the place metaphor and, when possible, the actor metaphor to accomplish their goals of environmental protection and conservation.

However, the problems that this research can identify concerning the place metaphor cannot be overlooked. The biggest problem is reflected

in the theme that made "place" a scene for human action and the natural actors little more than resources on that stage. While human actions such as logging, mining, or other industry are among the most environmentally damaging options for how we could act in relation to the earth, it should be a little troubling that even the idea of place as a scene for soothing the tired human soul still creates nature as a resource for human needs. It is unlikely that all places are thought of as being as soothing as Yellowstone, Glacier, or Grand Teton National Parks. A respect for nature that relies on the best that this metaphor has to offer may still be one that we have to approach with a great deal of caution.

It is also important to make a positive observation about the materials selected for this study. I do not wish to condemn these publications as somehow irresponsible or damaging to tourist perspectives on the environment. On the contrary, they tackle a difficult job of promoting a positionality in relation to Yellowstone National Park that is generally positive through their primary use of place metaphors. Given the constraints related to creating these publications for a national park administered by people with specific environmental orientations, along with the desire and need to make a product that visitors to the park will want to purchase and use, it is somewhat surprising that the publications are as good as they are.

The *Handbook* concludes with a passage suggesting much about the reasoning that guides the use and management of the park and that speaks to the two powerful metaphors examined in this essay. Noting that in the ancient world, oracles were located in sites like Yellowstone, spaces "in wild mountains where the Earth smokes," the NPS asserts, "Yellowstone is a kind of oracle. It's a conduit of wisdom from deep, mysterious places to living people."[38] This statement emphasizes the spiritual side of Yellowstone as agent and scene and, like all ancient oracles—perhaps most famously those of ancient Greece—their current status as museum-like sites (or, at least, as sites interpreted through a museum-like lens, as Patin and Wilke also note). The publications, in their effort to remove visually modern humans from the park while verbally noting human presence, are faithful to the NPS mission and park visitors' desires: to re-create an experience of the sublime on a landscape touched by humanity and with agents whose own purposes

are constructed as supportive of this objective. In speaking to us as oracles should do, the *Guide* asks that we

> Visit Yellowstone often. Adopt it as our own. Help in any way you can to make sure the world's first national park will always be a place that delights and amazes—that it will forever be here to teach us how to live well with the Earth.[39]

NOTES

1. Richard Grusin, "Representing Yellowstone: Photography, Loss, and Fidelity to Nature," *Configurations* 3 (1995): 415–36.

2. Tarla Rai Peterson, "The Meek Shall Inherit the Mountains: Dramatistic Criticism of Grand Teton National Park's Interpretive Program," *Central States Speech Journal* 39 (1988): 121–33.

3. National Park Service, http://www.nps.gov/aboutus/mission.htm (accessed August 1, 2007).

4. David M. Graber, "Resolute Biocentrism: The Dilemma of Wilderness in National Parks," in *Reinventing Nature,* ed. Michael E. Soulé and Gary Lease (Washington, D.C.: Island Press, 1995), 123.

5. Michael Osborn, "Archetypal Metaphor in Rhetoric: The Light-Dark Family," *Quarterly Journal of Speech* 53 (1967): 115–26.

6. George Lakoff and Mark Johnson, *Metaphors We Live By* (Chicago: University of Chicago Press, 2003).

7. James G. Cantrill and Christine L. Oravec, eds., *The Symbolic Earth: Discourse and Our Creation of the Environment* (Lexington: University of Kentucky Press, 1996), 2.

8. David Rains Wallace, *Yellowstone: Official National Park Handbook,* Number 150 (Harpers Ferry Center, W.Va.: National Park Service, Division of Publications, 2001).

9. Yellowstone Association, *Yellowstone: The Official Guide to Touring America's First National Park* (Helena, Mont.: Falcon Press, 2004).

10. James Shanahan and Katherine McComas, *Nature Stories: Depictions of the Environment and Their Effects.* (Cresskill, N.J.: Hampton Press, 1999), 7.

11. Christine L. Oravec and Tracylee Clarke, "Naming Interpretation, Policy and Poetry: Communicating Cedar Breaks National Monument," in *The Environmental Communication Yearbook,* vol. 1, ed. Susan L. Senecah (Mahwah, N.J.: Lawrence Erlbaum Associates, 2004), 1–14.

12. Grusin, "Representing Yellowstone."

13. Dayle C. Hardy-Short and Brant Short, "Fire, Death and Rebirth: A

Metaphoric Analysis of the 1988 Yellowstone Fire Debate," *Western Journal of Communication* 59 (1995): 103–25.

14. Neil Evernden, *The Social Creation of Nature* (Baltimore: Johns Hopkins University Press, 1992).

15. Holmes Rolston III, "F/Actual Knowing: Putting Facts and Values in Place," *Ethics and the Environment* 10, no. 2 (2005): 137.

16. Donal Carbaugh, "Naturalizing Communication and Culture," in *The Symbolic Earth,* ed. Cantrill and Oravec, 38–57; Oravec and Clarke, "Naming Interpretation, Policy and Poetry."

17. Carbaugh, "Naturalizing Communication and Culture," 38.

18. Roger C. Aden and Christine L. Reynolds, "Lost and Found in America: The Function of Place Metaphor in *Sports Illustrated,*" *Southern Communication Journal* 59 (1993): 2.

19. Cantrill, "The Environmental Self and a Sense of Place: Communication Foundations for Regional Ecosystem Management," *Journal of Applied Communication Research* 26 (1998): 301–18.

20. Robert D. Sack, *Place, Modernity and the Consumer's World* (Baltimore: Johns Hopkins University Press, 1992), 1.

21. Carbaugh, "Naturalizing Communication and Culture," 38.

22. Connie Bullis, "Retalking Environmental Discourses from a Feminist Perspective: The Radical Potential of Ecofeminism," in *The Symbolic Earth,* ed. Cantrill and Oravec, 123–48.

23. Lynn M. Stearney, "Feminism, Ecofeminism, and the Maternal Archetype: Motherhood as a Feminine Universal," *Communication Quarterly* 42, no. 2 (Spring 1994): 145–59.

24. Kenneth Burke, *The Philosophy of Literary Form* (Berkeley: University of California Press, 1941), 20.

25. Kenneth Burke, *Language as Symbolic Action* (Berkeley: University of California Press, 1966), 47.

26. Kenneth Burke, *The Rhetoric of Religion* (Berkeley: University of California Press, 1961).

27. Kenneth Burke, *A Rhetoric of Motives* (Berkeley: University of California Press, 1950).

28. Lakoff and Johnson, *Metaphors We Live By,* 3.

29. Ibid., 25.

30. Yellowstone Association, *Yellowstone,* 19.

31. Ibid., 72.

32. Wallace, *Yellowstone,* 13, 18.

33. Yellowstone Association, *Yellowstone,* 67.

34. Wallace, *Yellowstone,* 18.

35. Roger C. Aden, "Back in the Garden: Therapeutic Place Metaphor in *Field of Dreams,*" *Southern Communication Journal* 59 (1994): 307–17.

36. Stearney, "Feminism, Ecofeminism and the Maternal Archetype," 157.

37. Kenneth Burke, *A Grammar of Motives* (Berkeley: University of California Press, 1945).

38. Wallace, *Yellowstone,* 121.

39. Yellowstone Association, *Yellowstone,* 80.

7. IMAGE/TEXT/GEOGRAPHY
Yellowstone and the Spatial Rhetoric of Landscape

Gareth John

The "Big Picture"

ON MAY 2, 1872, just two months after Yellowstone was established as America's first national park, the English-born artist Thomas Moran unveiled what he compellingly referred to as his "Big Picture": a twelve-by-seven-foot oil painting, *Grand Cañon of the Yellowstone* (Figure 7.1). Moran, who accompanied Dr. Ferdinand Vandeveer Hayden and his U.S. Geological Survey team on their expedition to the upper valley of the Yellowstone River in the summer of 1871, had worked tirelessly in his Newark, New Jersey, studio over the winter to commit his many sketches and notes to canvas. His "Big Picture" would be his most ambitious piece to date, but while confident in his ability to render Yellowstone's outstanding Romantic qualities in a single scene, Moran was also determined not to sacrifice geological accuracy. And so, in a letter to Hayden in early March 1872, Moran sought the geologist's eye for detail. "I cannot finish it until you have seen it," he wrote, as "your knowledge of cause and effect in nature, would point out to me many facts connected with the place that I may have overlooked."[1] Whether Hayden imparted his advice to the artist is unclear;[2] what is clear is that the result impressed Hayden, art critics, and the public alike.[3]

The painting's unveiling and single-night exhibition at Clinton Hall in New York City was attended by a host of dignitaries, the "literati," and some of the men who had recently raised the spectacle of Yellowstone in the public imagination: the U.S. Geological Survey leader Ferdinand Hayden, officials of the Northern Pacific Railway, and publishing executives, such as *Scribner's Monthly* editor-in-chief Richard Watson Gilder.

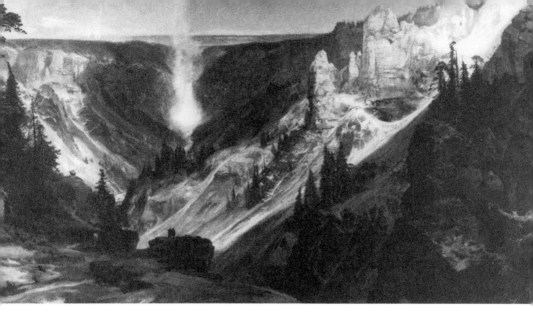

Figure 7.1. Thomas Moran, *The Grand Cañon of the Yellowstone,* 1872. Oil on canvas. Department of the Interior/American Art Museum, Smithsonian Institution, Washington, D.C.

Reviews of the piece were outstanding. Gilder, in an editorial in the "Culture and Progress" section of the June 1872 issue of *Scribner's,* affirmed the painting as "the most remarkable work of art which has been exhibited in this country for a long time."[4] A composite of multiple views up and down the canyon below the Lower Falls, Moran's heroic picture epitomizes a range of environmental perspectives toward the American landscape during the immediate post–Civil War era in the United States.[5] Those perspectives and the geographical knowledge and practices that informed them were, moreover, formative of what Yellowstone would become and, in part, how it would be understood thereafter. Indeed, over the course of just two years (1869–71), during which time four organized exploratory expeditions were made to the region, Yellowstone emerged from myth and obscurity as a place of intense nationalistic significance, a revered landscape spectacle, and this emergence was very much a discursive one dependent on words, pictures, utterances, and practices executed with varying degrees of authority and across different geographical scales. In Moran's "Big Picture," as well as the establishment of the park itself, Yellowstone consummated and naturalized in landscape a set of discourses of local,

regional, and national scope motivated toward ends far removed from the late-nineteenth-century preservationist impulse with which the park is often popularly associated today.

With the naturalization of rhetoric being the thread running through this volume of essays, I modestly contribute to this theme by examining the rhetorical framing of one of the most potent and enduring symbols of America's relationship to its natural and national heritage, Yellowstone National Park. By analyzing the ways that early explorers represented various features they encountered in the region, I examine the mechanisms by which this previously little-known area in just a few years came to be viewed as a nationally iconic landscape. Consideration is given to the role of the literary and pictorial practices of exploration, particularly relating to the 1871 Hayden survey, in framing an understanding of the region as a landscape worthy of federal protection. Through written and pictorial representations in popular magazines and newspapers, often highlighting the region's "beautiful," "wonderful," and "sublime" qualities consistent with Romantic conventions for representing western American landscape,[6] Yellowstone naturalized a nationalistic rhetoric and capitalist commercial ethos that, I argue, ultimately became enshrined in the establishment of the place as the nation's first national park.

Image/Text/Geography: The Rhetoric of Landscape

As part of the cultural turn in the social sciences, appreciation for rhetoric as a mode of critical discourse in geography has accompanied recognition that geographical knowledge is highly contingent on rhetorical structures and therefore necessarily constructed.[7] According to John Paul Jones III and Wolfgang Natter, "geography is all about texts and images, and these in turn are all about geography";[8] that is, geography comprises texts and images about the world that in essence become the world, at least what we know about it and how we know it. One of the most productive areas of the rhetorical or, more broadly, discursive approach in geography has been the interpretation and analysis of landscape in the innovative subdiscipline of cultural geography. Work in this area has focused on the cultural production and reproduction of the meaning of places and landscapes through a range of texts, im-

ages, and practices. Concern with the politics and poetics of place and landscape has maintained a lively dialogue with studies in rhetoric, and for good reason.[9] Landscapes lend themselves in a peculiarly effective way to rhetorical processes. Through their apparent fixity, inherent materiality, and taken for grantedness (that is, the fact that they largely go unquestioned as apparently innocent features of our world), landscapes can have the effect of reifying, normalizing, and thereby appearing to validate the ideas and associated meanings with which such places are invested. This is not least so because they are often understood as a part of nature, whether designated wilderness areas, rural countrysides, or green spaces in urban settings. Consequently, cultural geographers have alerted us to and deconstructed landscape's less obvious iconographical, textual, discursive, and even theatrical and performative qualities to reveal it as an orchestrated, richly encoded, inevitably embodied, and by the same token highly contingent, multifaceted phenomenon.[10]

Furthermore, landscape's "dual ambiguity," as Denis Cosgrove referred to it, enhances its rhetorical and ideological efficacy.[11] Landscape is at once material and representation, a physical place and an image, a wholesale region as viewed on a map and a specific framed view captured on a postcard. Landscape is both a noun and a verb. We enjoy a landscape and strive to make a landscape to enjoy by landscaping. On the other hand, most people barely give their surroundings a second thought. As cultural geographer Peirce Lewis famously once wrote, for most Americans, "landscape just *is*."[12] And perhaps the taken for grantedness of most landscapes is lent credence by W. J. T. Mitchell's thesis that like life itself "landscape is boring."[13] Nevertheless, art historians, geographers, planners, writers, architects, painters, film makers, advertising executives, landscape gardeners, photographers, and assorted cultural theorists and historians (including Mitchell) have long understood the agency of landscape to evoke powerful cultural, political, and social sentiment. In this way, landscape functions as a medium for communication "between persons" and "most radically between the Human and the non-Human":

> Landscape mediates the cultural and the natural, or "Man" and "Nature," as eighteenth-century theorists would say. It is not only a natural scene, and not just a representation of a natural scene, but a *natural* representation of a natural scene, a trace or icon of nature

in nature itself, as if nature were imprinting and encoding its essential structures on our perceptual apparatus.[14]

As such, landscape is a "way of seeing" or a "signifying system" that naturalizes and communicates in subtle form specific forms of rhetoric. Indeed, as Mitchell proffers, as "a *natural* representation of a natural scene, a trace or icon of nature *in* nature itself," landscape is a medium invested with the ability to naturalize a range of social discourses by clothing them in the material of nature itself.[15]

In theorizing the discursive and rhetorical dimensions of land-scape, a number of geographers have explicitly and implicitly drawn on the work of Michel Foucault in order to posit and explore ways discourses of landscape form and operate.[16] In *The Archaeology of Knowledge* (1972) Foucault explains that a "discourse finds a way of limiting its domain, of defining what it is talking about, of giving it the status of an object—and therefore of making it manifest, nameable, describable."[17] Consequently, a "discursive object" is formed, "circumscribed, ana-lysed, then rectified, re-defined, challenged, erased" through statements that name it within a particular finite and limited "field" or grouping of "discursive events."[18] In the nineteenth-century United States, west-ern landscape was a discursive object that was named within a range of discursive fields—for example, art, geology, exploration, tourism, journalism—wherein it was given visual and linguistic form, meaning, and relevance. And just as the question for Foucault is not what the object of a discourse meant but rather what institutional and discursive relations the object maintained and was in turn constituted by, this essay is not concerned with attempting to "reveal" the early meaning of Yellowstone as landscape as a thing in itself. To paraphrase Foucault, Yellowstone was constituted by all that was said in all the statements—made by explorers, newspaper and magazine editors and correspon-dents, railroad financiers, artists, photographers, mountain men, state and national politicians—that named and visualized it, divided it up, described it, depicted it, explained it, traced its development, judged it, and possibly gave it speech by articulating, in its name, discourses that—while related to other discourses such as those on landscape art, nationalism, westward national expansion, geology, and national and regional economic development—were to be taken as its own.[19] Tracing

Yellowstone's emergence as landscape is, as Mitchell argues in reference to the landscape tradition more generally, to "trace the process by which landscape effaces its own readability and naturalizes itself."[20] As told here, the story of Yellowstone's beginnings as a place/landscape consists in explicating the discourses and practices by which it was explored and became known, and, ultimately, through which were set in place the conditions of possibility for the establishment of the first national park.

Exploring Yellowstone as Landscape

Throughout the nineteenth century, exploration constituted a varied set of practices in the making of geographical knowledge.[21] Far from a straightforward process of mapping and describing the characteristics of previously undocumented lands, successful exploration depended on applying the right blend of cultural practices, physical objects, and institutional relationships. Beginning with the three-man Cook-Folsom-Peterson expedition in 1869, followed by the Washburn-Langford-Doane expedition in 1870, and culminating with the coincident 1871 Hayden and Barlow-Heap expeditions, Yellowstone's "definitive exploration" involved a gradual but concerted and orchestrated framing of the region as landscape. By the end of 1870 Yellowstone was described as a set of wonderful features, a living painting that required the language of art to approximate it. It was also projected as a future attraction for railroad travelers along the proposed line of the Northern Pacific Railway. The subsequent 1871 Hayden expedition (and to a lesser extent, the Barlow-Heap expedition that same year)[22] lent national scientific validation to previous accounts, ultimately "authorizing" formerly attained knowledge of the region and, significantly, bringing it within the purview of national government, a process critical to the legislative process that established the park.[23] But primarily through the work of Thomas Moran and photographer William Henry Jackson, what the Hayden expedition also did was picture Yellowstone as landscape and in so doing gave visual expression to rhetorical themes—of Romantic nature, nationalism, and regional development—that had hitherto existed in largely textual (and doubtlessly verbal) form.

Accounts and reports from the expeditions to the Upper Yellowstone

in 1869, 1870, and 1871, which increasingly featured images, were published and performed in a variety of venues, some local (e.g., Bozeman, Helena, Virginia City, all in Montana), some located in the East (e.g., New York, Philadelphia, Washington). They included newspapers, weekly and monthly magazines (some of which were illustrated), official government reports, and public lectures. Taken together, they constituted the product of the practices of exploring Yellowstone and contributed in a critical way to the understanding of Yellowstone as landscape. "Registers" by which Yellowstone as landscape was named, designated, divided, pictured, and delimited in these venues included terms such as "scenery" and "nature"; descriptors such as "picturesque," "beautiful," "sublime," "wonderful"; as well as allusions to emotional responses such as "awe," "terror," and "wonder," often dictated by Romantic conventions for recognizing and appreciating the beautiful, the sublime, and the picturesque in scenery.[24]

From Mysterious Wilderness to Picturesque Wonderland

Prior to the 1869 Cook-Folsom-Peterson expedition, knowledge of Yellowstone, "though extensive, was yet fragmentary and often contradictory."[25] Nevertheless, the return of the Cook-Folsom-Peterson party did not immediately have the effect of clarifying what indeed was truth versus myth in Yellowstone's upper valley. As Langford retold it, Folsom feared being regarded in a similar manner to the prospectors and mountain men whose tales were taken with little more than a proverbial pinch of salt.[26] In July 1870, Folsom and Cook, having had their "amplified diary" rejected by *Scribner's* and *Harper's*, would tentatively recall their experiences for readers of the Chicago-based *Western Monthly*. Appealing to commonly understood nineteenth-century artistic-literary tropes, in their 1870 *Western Monthly* article attributed to Cook they recorded their encounter with Yellowstone's Lower Falls but with the qualification that "language is entirely inadequate to convey a just conception of the awful grandeur and sublimity of this masterpiece of nature's handiwork." Instead, they limited their "brief description" to the "bare facts."[27]

The Washburn-Langford-Doane expedition was the second of three, "whose cumulative accomplishment," according to Aubrey Haines, "was a definitive knowledge of the Yellowstone region."[28] But as historian

W. Turrentine Jackson points out, in contrast to that of the Cook-Folsom-Peterson venture, it was "a more pretentious exploration."[29] In particular, the presence of a sizable contingent of influential Montana civilians—among them the leader Henry Dana Washburn, surveyor-general of public lands in Montana; Nathaniel Pitt Langford, former governor of Montana Territory; Samuel T. Hauser, president of the First National Bank of Helena; Cornelius Hedges, lawyer and correspondent for the *Helena Daily Herald*; Truman C. Everts, former assessor of internal revenue for Montana; and Walter Trumbull, son of U.S. Senator Lyman Trumbull of Illinois[30]—not only signaled especial local interest in the region but lent much needed credibility to former unverified accounts of the strangely exotic physical phenomena. Langford was one of the most influential of Yellowstone's explorers prior to the park's establishment, having delivered an eastern lecture series in the winter of 1870–71, and written newspaper articles and a two-part illustrated *Scribner's Monthly* article (Figure 7.2).[31] Langford's role in promoting Yellowstone as a lecturer on the eastern circuit representing Jay Cooke and Co., financiers to the Northern Pacific Railway, underlines the potential of carefully crafted descriptions of Yellowstone's features to promote the interests of the railroad that was planned to pass just north of the Upper Yellowstone valley.[32] Just as he concluded his *Scribner's* article, Langford ended each of his lectures by asking,

> What, then, is the one thing wanting to render this remarkable region of natural wonders, accessible[?] I answer, the very improvement now in process of construction, the N.P.R.R. [Northern Pacific Railroad] by means of which, the traveler, crossing the rich lands of Dakota, will strike the Yellowstone a short distance above its mouth, travels for 500 miles the beautiful lower valley of that river with its strange scenery, and will be enabled to reach this region from the Atlantic seaboard within 3 days, and can see all the wonders I have here described.[33]

Langford campaigned on behalf of the Northern Pacific Railway for the opening up of Yellowstone as a tourist resort, and his descriptions of the region as a picturesque and wonderful landscape in his lectures and published articles served that end.

Like many others after him, Langford frequently appealed to the

SCRIBNER'S MONTHLY.

VOL. II. MAY, 1871. No. 1.

meeting with several gentlemen who expressed like curiosity, we determined to make the journey in the months of August and September.

The Yellowstone and Columbia, the first flowing into the Missouri and the last into the Pacific, divided from each other by the Rocky Mountains, have their sources within a few miles of each other. Both rise in the mountains which separate Idaho from the new Territory of Wyoming, but the headwaters of the Yellowstone are only accessible from Montana. The mountains surrounding the basin from which they flow are very lofty, covered with pines, and on the southeastern side present to the traveler a precipitous wall of rock, several thousand feet in height. This barrier prevented Captain Reynolds from visiting the headwaters of the Yellowstone while prosecuting an expedition planned by the Government and placed under his command, for the purpose of exploring that river, in 1859.

The source of the Yellowstone is in a

I HAD indulged, for several years, a great curiosity to see the wonders of the upper valley of the Yellowstone. The stories told by trappers and mountaineers of the natural phenomena of that region were so strange and marvelous that, as long ago as 1866, I first contemplated the possibility of organizing an expedition for the express purpose of exploring it. During the past year,

Figure 7.2. Nathaniel Langford, "The Wonders of the Yellowstone—Part I," *Scribner's Monthly* (May 1871): 1. Reproduced courtesy of Cornell University Library's Making of America Archive.

pictorial qualities of Yellowstone. Drawing comparisons with Albert Bierstadt's recent painted work *Passing Storm over the Sierra Nevadas* (1870), Langford's lectures extolled the drama and spectacle of Yellowstone's landscape:

> The magnificent changes in mountain scenery, occasioned by light and shade, during one of these terrific tempests, with all the incidental accompaniments of thunder, lightning, rain, snow and hail, must be seen to be appreciated. Bierstadt, with all the genius and glow of a thorough artist has united but little of more enthusiasm in his magnificent delineation of "A Storm in the Sierras," [sic]—a work which today ranks foremost among the great paintings of the age. Nature affords no more awe-inspiring exhibition. While in the valley above you the sky is cloudless, the adjacent mountain is at one moment completely obscured in darkness, at the next perhaps brilliant with light, all its gorges, recesses, seams and cañons illuminated:—these fade away into dim twilight broken by a terrific flash, and, echoing to successive peals, the "live thunder leaps among the rattling crags," in innumerable reverberations.[34]

Langford's published articles deployed a similar rhetorical device to promote Yellowstone's scenery, paying considerable attention to the region's waterfalls, a classic subject for artists of the Romantic movement. In the first installment of his two-part *Scribner's Monthly* article titled "The Wonders of the Yellowstone," published in May 1871, Langford argued the utter perfection of the Lower Falls as a scenic composition:

> A grander scene than the lower cataract of the Yellowstone was never witnessed by mortal eyes. The volume seemed to be adapted to all the harmonies of the surrounding scenery. Had it been greater or smaller it would have been less impressive. . . . The shelf over which it falls is as level and even as a work of art. . . . It is a sheer, compact, solid, perpendicular sheet, faultless in all the elements of grandeur and picturesque beauties.[35]

Of the Upper Falls (Figure 7.3) he wrote, "What this cataract lacks in sublimity is more than compensated by picturesqueness."[36] But for Langford, it was the canyon's immensity that bespoke the grandeur and sublimity of Yellowstone's landscape:

> The great cataracts of the Yellowstone, are but one feature in a scene composed of so many of the elements of grandeur and sublimity,

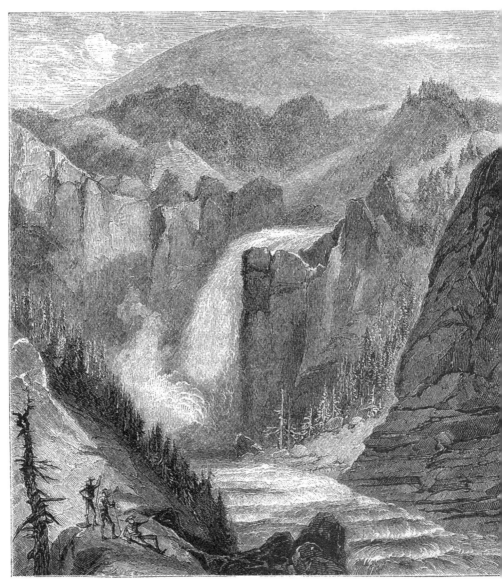

Figure 7.3. Thomas Moran, *Upper Falls of the Yellowstone, Wyoming,* 1871. Wood engraving. From "The Wonders of the Yellowstone—Part I," 14. Reproduced courtesy of Cornell University Library's Making of America Archive.

that I almost despair of giving you the faintest conception of it. The immense cañon or gorge of rocks through which the river descends, perhaps more than the falls, is calculated to fill the observer with feelings of mingled awe and terror.[37]

Though essential to the creation of an explorative record, words could only convey so much about what was so unfamiliar and novel. Visual forms of reference were essential for a more complete representation of Yellowstone's scenery, and the editor for *Scribner's* was patently aware of this iconological necessity. Though there was no official artist or photographer on the Washburn-Langford-Doane expedition of 1870, artist Thomas Moran was commissioned to produce ink sketches from descriptions and a few crude field sketches.[38] From these sketches were made wood engravings, which provided illustrations for Langford's two-part *Scribner's* article. Though they have since been criticized for their topographical inaccuracy,[39] they were nonetheless the first popular images of Yellowstone to be published. More importantly, perhaps, Moran's commissioning forged a set of artistic, scientific, and commercial relationships between the artist; *Scribner's Monthly*; Northern Pacific Railway financiers Jay Cooke and Co., for whom Langford worked; and Hayden's U.S. Geological Survey of the Territories, relationships that would prove professionally profitable to all parties.

Art, Science, Commerce, and the Nationalization of Yellowstone

The expedition in 1871 led by civilian scientist-explorer Hayden as part of his U.S. Geological Survey of the Territories would effectively serve to verify former accounts by the authority of his party's nationally recognized scientific and technical qualifications. Though for the most part the written reports produced by the 1871 surveys merely confirmed earlier accounts, as important as that was, the new pictures from Yellowstone, especially Jackson's photographs and guest artist Moran's paintings, would bring a powerful new dimension to the public understanding of and appreciation for the region as a place of actual, and not just imaginary, visual wonder. The production, reproduction, and dissemination of images that resulted from the deliberate and

calculated pictorial practices of the 1871 explorations thus marked a critical stage in the iconological emergence of Yellowstone as a discursive object. Through the explorative efforts of the 1871 Hayden survey, Yellowstone took on national significance most forthrightly realized in the establishment of the country's first national park.

Hayden was in attendance at Langford's lecture on the wonders of the Yellowstone region delivered at Lincoln Hall in Washington, D.C., on the evening of January 19, 1871. As "geologist-in-charge" of the U.S. Geological Survey of the Territories, one of four major surveys of the American West,[40] Hayden skillfully negotiated the technical demands of his chosen profession and the political concerns of national government in securing federal patronage for his western fieldwork. Taking advantage of the publicity generated by Langford's Northern Pacific Railway–sponsored public lectures on Yellowstone, as well as the hype surrounding the nationally reported saga concerning Truman Everts, who had survived thirty-seven days alone in Yellowstone after becoming separated from the main party on the 1870 expedition,[41] Hayden managed to secure a $40,000 congressional appropriation for his 1871 survey, an increase of $15,000 over that of the previous year.

Hayden's approach to exploring Yellowstone was significantly more visual than that of his predecessors. Like Folsom, Cook, and Langford before him, Hayden maintained that so much of what he experienced in Yellowstone was beyond description. But what set him apart was his inclusion of artists and photographers in his party. While Yellowstone had been introduced to the public by the likes of Langford and Everts through their more verbal and descriptive accounts of the region's features, with the publication of firsthand illustrations in accounts from the Hayden expedition in popular journals, the circulation of Jackson's photographs and Moran's watercolors in Congress, and the completion of Moran's "Big Picture," Yellowstone began evolving into a visual rhetorical phenomenon.

Moran was not himself an official member of the Hayden expedition but was permitted to accompany the party courtesy of a request made to Hayden by A. B. Nettleton of Jay Cooke and Co., financiers to the Northern Pacific Railway. That Hayden was willing to accept an additional member to his already overly large exploring party, and one as unproven in the bodily rigors of field exploration as was Moran

(who had only once before ridden a horse),[42] suggests something of the potential value Moran's work held for Hayden's survey. Hayden was acting out of self-interest to the mutual advantage of Jay Cooke and Co., the Northern Pacific Railway, Scribner's and Co., and not least of all the artist himself. The premium of Moran's work to his sponsors was made explicit in the official letter of introduction to Hayden from Nettleton, which Moran carried with him on his western voyage:

> Mr. Moran is an artist (landscape painter) of much genius, who de-
> sires to take sketches in the upper Yellowstone region, from which
> to paint some fine pictures on his return. That he will surpass
> Bierstadt's Yosemite we who know him best fully believe. He goes
> out under the patronage of Messrs. Scribner's and Co., Publishers,
> N.Y. and our Mr. Cooke on whom (as well as himself) you will
> confer a great favor by receiving Mr. Moran into your party when
> you start for the Yellowstone Country.[43]

Hayden was happy to have such powerful business concerns beholden to him, and Moran, Scribner's, and Jay Cooke and Co. would in turn also gain from the arrangement. In Joni Louise Kinsey's words, "Moran acquired a generous patron while Cooke obtained the services of one of the best artists of the day, one who could visually embody the goals and aspirations of the Northern Pacific Railroad."[44] The commissioning of Moran served the dual commercial purpose of promoting Gilder's *Scribner's Monthly*—by furnishing it with much-demanded illustrations—and Cooke's railroad, to which the illustrations as well as the journal's articles would entice investors, tourists, and settlers.

The many illustrated and unillustrated written reports and popular articles that were issued upon and following the return of the Hayden and Barlow-Heap expeditions in early fall of 1871 created a popular sensation. Of the first to report on the 1871 expeditions were numerous newspapers nationwide. Expressing the obvious local interest in Yellowstone, which had been ongoing since the late 1860s, the Bozeman *Avant Courier* announced on September 13 that "the results of the observations and examinations of the late scientific expedition, will soon be given to the public by the press, and through it excite a curiosity and interest, which the wonders of Vesuvius, Niagara, and the geysers of Iceland, have never yet caused to be felt."[45] Following the publicizing

of Hayden's nationally recognized scientific validation of former accounts, Yellowstone's scenery—for all its exceptionality and Romantic qualities—would become the object of nationalist cultural significance.

Similar to the iconological effect on the Western spatial imaginary of the first images of Earth from the NASA Apollo missions in the late 1960s,[46] Moran's watercolor sketches portrayed an environment alien to the known world, and paint rendered that world in a way that eluded photography. Recognizing this, Hayden wrote:

> All representations of landscape scenery must necessarily lose the greater part of their charm when deprived of color; but of any representation in black and white of the scenery of the Yellowstone it may truly be said that it is like Hamlet with the part of Hamlet omitted, for the wealth of color in which nature has clothed the mountains and the springs of that region constitute one of the most wonderful elements of their beauty.[47]

Moran's "Big Picture" best embodies the ideas that motivated Hayden's government-sponsored survey of the region. As Kinsey argues, much of "Moran's art of the 1870s can be considered a paradigm of the Great Surveys; in many ways it is based on the same ideological foundations of exploration, analysis, dissemination of knowledge, and nationalistic vision."[48] Moran managed to remain faithful to the geological character of the country, but at the same time he succeeded in creating an atmosphere charged with powerful sentiment, confirmed in the allegorical postures of the minute figures that appear in the foreground of his painting (see Figure 7.1). In the shade of the trees framing the left of the painting appear two explorers, possibly photographer Jackson and Moran himself. One stands attending to the horses, and the other sits making sketches but faces away from the scene before us as if concerned with the study of a more manageable landscape subject, perhaps a feature that would comprise but one small element of the eventual composite he would produce in his "Big Picture." Prominently positioned on a promontory is an explorer (almost certainly the survey leader Hayden) pointing out to the Lower Falls while an American Indian figure stands to his right. The presence of the Indian underlines the remoteness of the vicinity and presents Hayden and his team as the true discoverers of an as yet uncharted Yellowstone. Just like the

composition of the painting, the suggested relationship between the explorers and Yellowstone seemingly as a previously unexplored territory is a fabrication. Yet it holds true if only in terms of the claim that the Hayden survey was the first to bring the authority of government, scientific expertise, and the power of visual representation to the region. In this way, Moran's painting pictured the national significance of the Hayden survey and duly recognized the "geologist-in-charge" as key to the opening of the region to the political and commercial forces of "civilization," most emphatically realized in the establishment of Yellowstone as a national park.[49]

On October 27, 1871, A. B. Nettleton sent a letter to Hayden to initiate the movement toward the establishment of Yellowstone as a national park:

> Judge Kelley has made a suggestion which strikes me as being an excellent one, viz.: Let Congress pass a bill reserving the Great Geyser Basin as a public park forever—just as it has reserved that far inferior wonder the Yosemite Valley and big trees. If you approve this would such a recommendation be appropriate in your official report?[50]

Driven by his own self-interest of creating popular support to ensure the longevity of his survey, Hayden intensively lobbied Congress. He visited with individual congressmen, created exhibits of Jackson's photographs, Moran's watercolors, and other "curiosities" in the Capitol and the nearby Smithsonian building, and distributed copies of Langford's 1871 *Scribner's* article, which contained Moran's engravings of the first images of Yellowstone.

In February 1872, Hayden published an article for *Scribner's* containing wood engravings from Moran's firsthand illustrations (Figure 7.4). He began his account by verifying Langford's descriptions of Yellowstone published in *Scribner's* the previous year. "Indeed, it is quite impossible," he cautioned, "for anyone to do justice to the remarkable physical phenomena of this valley by description, however vivid. It is only through the eye that the mind can form anything like an adequate conception of their beauty and grandeur."[51] Hayden's own account briefly described many of the outstanding features in expressly visual terms. While extolling the visual beauty of the landscape, he often

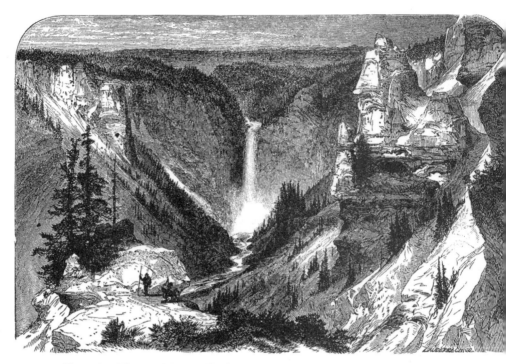

Figure 7.4. Thomas Moran, *The Great Cañon and Lower Falls of the Yellowstone,* 1871. Wood engraving. From *Scribner's Monthly* (February 1872): 388. Reproduced courtesy of Cornell University Library's Making of America Archive.

interdicted his eloquent descriptive prose with technical geological and chemical data as if to attach scientific authority to descriptions that differed little from those offered previously by Folsom and Cook, Doane, Langford, Washburn, and more recently Everts. Hayden especially emphasized Yellowstone's stratigraphical character in features like the Grand Canyon, Devil's Slide, and Mammoth Hot Springs. Crucially, Hayden concluded his article by referring to the current legislative movement in very similar language to that in the letter from Nettleton of the Northern Pacific Railway:

> We many say, in conclusion, that we have been able in this article to do little more than to allude to a few of the wonderful physical phenomena of this marvelous valley. We pass with rapid transition from one remarkable vision to another, each unique of its kind and

surpassing all others in the known world. The intelligent American will one day point on the map to this remarkable district with the conscious pride that it has not its parallel on the face of the globe. Why will not Congress at once pass a law setting it apart as a great public park for all time to come, as has been done with that not more remarkable wonder, the Yosemite Valley?[52]

In spite of Hayden's criticism of Congress dragging its heels, consideration of the Yellowstone bill was already under way in the Senate, which was to take the lead in moving the matter through Congress. Though debate about the judiciousness of establishing Yellowstone as a park did not center on the value of it as a scenic wonder,[53] had it not been pictorially valued, there would have been no reason at that time, given the interests involved, to even raise the possibility of passing such a bill. In other words, we cannot understand the establishment of Yellowstone National Park without taking into account the role of the images, texts, and practices by which the region was made manifestly known at the time or without an understanding of the multiple motives of those who executed them. Yellowstone's establishment as a park was the culmination of the formation of a discursive object that encapsulated many discursive fields—art, science, commerce, politics—and, like Moran's "Big Picture," by virtue of its appearance as a natural object, as a landscape, it inadvertently naturalized the rhetoric inherent to those fields, conferring upon them legitimacy, inevitability, and incontrovertibility. In the park and in the picture, rhetoric was visualized and naturalized.

Envoi: Visual Remnants of a Rhetorical Past

Established on March 1, 1872, Yellowstone National Park, which borders the states of Montana, Wyoming, and Idaho in the western United States, stands today as it did then, a potent and fecund symbol of American nationhood, a natural expression of what is great and unique about the country captured in nature itself. Yellowstone's preservation as a national park has enshrined the very discourses that brought it into being. The way Yellowstone came to be known and understood depended heavily on the practices of exploring the region and the specific forms of knowledge the explorers themselves brought to and took

from it. From the time of the publication in 1870 of the first report from the 1869 Cook-Folsom-Peterson expedition in the *Western Monthly* to the flurry of articles and reports that appeared in *Scribner's Monthly* and newspapers nationwide in 1871 and 1872 as a consequence of the 1870 Washburn-Langford-Doane and 1871 Hayden expeditions, Yellowstone underwent redefinition and reformulation from a place of myth and mystery, exacerbated by local reports by mountain men, trappers, and prospectors of dubious trustworthiness, to a place of scientific and scenic wonder, though no less mythical for it. What made Yellowstone so compelling as a place worthy of a new and unprecedented form of federal protection was a combination of its unique natural features and its "picturesque" and sublime scenery—characteristics especially appealing to the commercial interests of the Northern Pacific Railway and its sponsors to promote their transcontinental rail line to investors and future tourists and travelers. By virtue of its naturalness, being, as Mitchell puts it, "a trace or icon of nature in nature itself," Yellowstone National Park naturalized the rhetoric so central to its creation—rhetoric that conceived of the region as an exploitable visual resource, a landscape with use, exchange, and symbolic value as scenery. Indeed, as Chris Magoc has demonstrated,

> Popular myth has obscured the fact that, even as American attitudes toward nature were quietly shifting in 1872, the establishment of Yellowstone Park was driven ultimately by the hinged forces of nationalism and good old-fashioned capitalism. . . . Yellowstone's popular discovery appears less a progressive move toward modern environmentalism than a profound expression of the dominant threads of middle- and upper-class American life in the late-Victorian era. Those forces indelibly shaped the definition and destiny of Wonderland.[54]

There can be little doubt that today Yellowstone is in no small way understood as a visual entity. Remnants of the Romantic and nationalistic vision survive in the park's interpretation and in the way certain visual features are showcased, for example, the canyon and falls. On the South Rim of Yellowstone's Grand Canyon thousands of tourists each day stop their cars and disembark from buses to walk the short distance to Artist Point to look out toward the Lower Falls at a scene

reminiscent of Moran's "Big Picture." On the promontory a plaque exhibits a reproduction of Moran's *Grand Cañon of the Yellowstone* and offers interpretation on the coloring of the canyon walls. Here, the natural scene and the representation of the natural scene are juxtaposed, making apparent the actual field of vision as a *natural* representation of a natural scene. Coexistent with many other discourses constituting Yellowstone as an object, the park and Moran's "Big Picture" yet continue to enshrine the naturalizing rhetoric of Yellowstone as landscape.

NOTES

1. Thomas Moran to Ferdinand Vandeveer Hayden, March 11, 1872. Record Group 57, Microfilm 626, reel 2, frames 468–70, National Archives, Washington, D.C.; also quoted in Joni Louise Kinsey, *Thomas Moran and the Surveying of the American West* (Washington, D.C.: Smithsonian Institution Press, 1992).

2. Kinsey, *Thomas Moran and the Surveying of the American West.*

3. According to Clarence Cook, art critic for the *New York Tribune,* during the unveiling of Moran's "Big Picture" in Clinton Hall, Hayden stood up to confirm the geological accuracy of the painting. Clarence Cook, "Fine Arts: Mr. Thomas Moran's 'Great Canyon of the Yellowstone,' " *New York Tribune,* May 3, 1872.

4. Richard W. Gilder, "Thomas Moran's 'Grand Cañon of the Yellowstone,' " *Scribner's Monthly,* June 1872, 251.

5. Indeed, just three months after the establishment of the park, the U.S. Congress's Joint Committee on the Library resolved to purchase *The Grand Cañon of the Yellowstone* for the sum of $10,000, and it was hung in the hall of the Senate wing of the Capitol along with history paintings depicting landmark episodes of the nation's past and their heroes. Art critic Robert Hughes contends that Moran also depicted a kind of hero: a valorous landscape with "limbs of rock, belly of water, hair of trees, all done with absorbing virtuosity." Robert Hughes, *American Visions: The Epic History of Art in America* (New York: Alfred A. Knopf, 1997), 200.

6. Romanticism was an eighteenth- and nineteenth-century aesthetic movement promulgated in Europe in the writings of Edmund Burke, Immanuel Kant, William Gilpin, and William Wordsworth, and was transplanted to America largely through the work of the Hudson River School painters, most famously Thomas Cole and Frederic Church, and writers such as Ralph Waldo Emerson, Henry David Thoreau, Nathaniel Hawthorne, Washington

Irving, James Fenimore Cooper, and Henry Wadsworth Longfellow in the first half of the nineteenth century. Romanticism invested nature with highly evocative themes, such as the presence and power of God, the inevitable cycle of life, and the insignificance of "man," themes that inspired emotional, not merely intellectual, response. See Elizabeth McKinsey, *Niagara: Icon of the American Sublime* (New York: Cambridge University Press, 1985); Louise Minks, *The Hudson River School* (Leicester: Magna, 1989); William Cronon, "The Trouble with Wilderness; Or, Getting Back to the Wrong Nature," in *Uncommon Ground: Rethinking the Human Place in Nature,* ed. William Cronon (New York: W. W. Norton and Co., 1995), 69–90.

7. Trevor Barnes and James Duncan, "Introduction: Writing Worlds," in *Writing Worlds: Discourse, Text and Metaphor in the Representation of Landscape,* ed. Trevor Barnes and James Duncan (London: Routledge, 1992), 1–17; James Duncan and David Ley, "Introduction: Representing the Place of Culture," in *Place/Culture/Representation,* ed. James Duncan and David Ley (New York: Routledge, 1993), 1–24.

8. John Paul Jones III and Wolfgang Natter, "Space 'and' Representation," in *Text and Image,* ed. Anne Buttimer, Stanley Brunn, and Ute Wardenga (Leipzig: Selbstverlag Institut für Länderkunde, 1999), 239–47.

9. See, for example, Michael Crang, "On Display: The Poetics, Politics, and Interpretation of Exhibitions," in *Cultural Geography in Practice,* ed. Alison Blunt, Pyrs Gruffudd, Jon May, Miles Ogburn, and David Pinder, 255–71 (London: Oxford University Press, 2003); James Duncan, "Representing Power: The Politics and Poetics of Urban Form in the Kandyan Kingdom," in *Place/Culture/Representation,* ed. James Duncan and David Ley, 232–50 (New York: Routledge, 1993); Tariq Jazeel, "'Nature,' Nationhood, and the Poetics of Meaning in Ruhuna (Yala) National Park, Sri Lanka," *Cultural Geographies* 12, no. 2 (2005): 199–227.

10. For a discussion of landscape's iconographical qualities, see Denis E. Cosgrove and Stephen Daniels, eds., *The Iconography of Landscape: Essays on the Symbolic Representation, Design and Use of Past Environments* (Cambridge: Cambridge University Press, 1988); for its textual qualities, see James Duncan and Nancy Duncan, "(Re)Reading the Landscape," *Environment and Planning D: Society and Space* 6 (1988); and James Duncan, *The City as Text: The Politics of Landscape Interpretation in the Kandyan Kingdom* (Cambridge: Cambridge University Press, 1990); for its discursive qualities, see Richard H. Schein, "The Place of Landscape: A Conceptual Framework for Interpreting an American Scene," *Annals of the Association of American Geographers* 87, no. 4 (1997); for its theatrical qualities, see Denis E. Cosgrove, *The Palladian Landscape: Geographical Change and Its Cultural Representations in Sixteenth-Century Italy* (University Park: Pennsyl-

vania State University Press, 1993); and for its performative qualities, see John Wylie, "An Essay on Ascending Glastonbury Tor," *Geoforum* 33 (2002): 445.

11. Denis E. Cosgrove, *Social Formation and Symbolic Landscape* (Madison: University of Wisconsin Press, 1998).

12. Peirce F. Lewis, "Axioms for Reading the Landscape: Some Guides to the American Scene," in *The Interpretation of Ordinary Landscapes: Geographical Essays,* ed. Donald W. Meinig (Oxford: Oxford University Press, 1979); Lewis also famously called landscape "our unwitting autobiography," since it records our past and yet is largely unconsciously written.

13. W. J. T. Mitchell, "Imperial Landscape," in *Landscape and Power,* ed. W. J. T. Mitchell (Chicago: University of Chicago Press, 1994).

14. Ibid., 15.

15. Ibid.

16. Schein, "The Place of Landscape"; Duncan, *The City as Text;* Gareth E. John, "Yellowstone as 'Landscape Idea': Thomas Moran and the Pictorial Practices of Gilded-Age Western Exploration," *Journal of Cultural Geography* 24, no. 2 (2007): 1–29.

17. Michel Foucault, *The Archaeology of Knowledge and the Discourse on Language,* trans. A. M. Sheridan Smith (New York: Pantheon Books, 1972), 41, 27.

18. Ibid., 40–41, 27.

19. Ibid., 32.

20. Mitchell, "Imperial Landscape," 2.

21. According to Felix Driver, exploration entails "a set of cultural practices which involve the mobilization of people and resources, especially equipment, publicity and authority." More specifically, exploration included a set of interrelated practices concerning the generation of geographical knowledge. They included: *material practices* of making and organizing the equipment and other necessities for explorative travel; *social practices* of forging and maintaining relationships functionally important to exploration; *literary practices* of writing about exploration; *reproductive practices* of disseminating the findings and experiences of the explorers; and *bodily practices* of physically performing tasks related to and actually doing the work of exploration. To Driver's list I would add *pictorial practices* of exploration. Not unrelated to the literary practices, nor merely a subset of them, pictorial practices of exploration would include the recording in visual form of the "discoveries," scenes encountered, and the explorers themselves, as well as the consequent display of the results of such practices in various venues. See Felix Driver, *Geography Militant: Cultures of Exploration and Empire* (Oxford: Blackwell, 2001), 8; John, "Yellowstone as 'Landscape Idea.'"

22. By a cruel twist of fate, the work produced by Hayden's survey was

ultimately of the greatest influence, since the many field notes, photographs, and specimens taken by the Barlow-Heap party, which also explored Yellowstone in August and September 1871, were destroyed in the Great Chicago Fire in October 1871, a little over a month following the party's return from Yellowstone. Aubrey Haines, *Yellowstone National Park: Its Exploration and Establishment* (Washington, D.C.: U.S. Department of the Interior, National Park Service, 1974).

23. Chris J. Magoc, *Yellowstone: The Creation and Selling of an American Landscape, 1870–1903* (Albuquerque: University of New Mexico Press; Helena: Montana Historical Society Press, 1999).

24. Judith L. Meyer, *The Spirit of Yellowstone: The Cultural Evolution of a National Park* (Lanham, Md.: Bowman and Littlefield, 1996).

25. Haines, *Yellowstone National Park*, 41.

26. Nathaniel P. Langford, *Diary of the Washburn Expedition to the Yellowstone and Firehole Rivers in the Year 1870* (published by the author, 1905), xi.

27. Charles Cook, "The Valley of the Upper Yellowstone," *Western Monthly* 4: 60–67.

28. Haines, *Yellowstone National Park*, 45.

29. W. Turrentine Jackson, "The Washburn-Doane Expedition into the Upper Yellowstone, 1869," *Pacific Historical Review* 10 (June 1941): 187.

30. Haines, *Yellowstone National Park;* Jackson, "The Washburn-Doane Expedition."

31. Joni Louise Kinsey, "Thomas Moran's Surveys of Yellowstone and the Grand Canyon: The Coalition of Art, Business, and Government," in *Splendors of the American West: Thomas Moran's Art of the Grand Canyon and Yellowstone*, ed. Anne R. Morand (Birmingham, Ala.: Birmingham Museum of Art, 1990); John F. Sears, *Sacred Places: American Tourist Attractions in the Nineteenth Century* (New York: Oxford University Press, 1989).

32. Sears, *Sacred Places*; Magoc, *Yellowstone*.

33. Nathaniel P. Langford, "Manuscript of Lectures Given by N. P. Langford during the Winter of 1870–71," Yellowstone National Park Heritage and Research Center Archives, Gardiner, Mont., 19.

34. Ibid., 4.

35. Nathaniel Langford, "The Wonders of the Yellowstone,—Part One," *Scribner's Monthly*, May 1871, 13.

36. Ibid.

37. Langford, "Manuscript of Lectures," 8.

38. According to Kinsey, Moran probably received his commission through the magazine's editor, Richard Watson Gilder, with whom he had been a longtime friend. Kinsey, *Thomas Moran and the Surveying of the West*; Anne R.

Morand, "Thomas Moran: Yellowstone and the Grand Canyon—In the Field and from the Studio," in *Splendors of the American West,* ed. Morand.

39. Actually, considering what Moran had to work with, the results of his ink sketches are remarkably close to his later watercolors, in scale and detail. See Morand, "Thomas Moran."

40. William H. Goetzmann, *Exploration and Empire: The Explorer and the Scientist in the Winning of the American West* (New York: Alfred A. Knopf, 1966); Marlene D. Merrill, ed., *Yellowstone and the Great West: Journals, Letters, and Images from the 1871 Hayden Expedition* (Lincoln: University of Nebraska Press, 1999).

41. After being the subject of much speculation, memorializing, and then jubilance in newspapers across the country in October 1870, Everts published his tale titled "Thirty-Seven Days of Peril" in the November 1871 issue of *Scribner's Monthly.* Everts's account did much to popularize Yellowstone as landscape. See Sears, *Sacred Places*; Magoc, *Yellowstone*; Lee H. Whittlesey, ed., *Lost in Yellowstone* (Salt Lake City: University of Utah Press, 1995); Gareth E. John and Christine R. Metzo, "Yellowstone Embodied: Truman Everts' 'Thirty-Seven Days of Peril,'" *Gender, Place and Culture: A Journal of Feminist Geography* 15, no. 3 (2008): 221–42.

42. Thurman Wilkins, *Thomas Moran: Artist of the Mountains* (Norman: University of Oklahoma Press, 1966).

43. A. B. Nettleton to Ferdinand Vandeveer Hayden, June 16, 1871. Record Group 57, Microfilm 623, reel 2, frames 128–29, National Archives, Washington, D.C.; also quoted in Kinsey, *Moran and the Surveying of the American West,* 70.

44. Kinsey, *Thomas Moran and the Surveying of the American West.*

45. Bozeman *Avant Courier,* "The Yellowstone Country," September 13, 1871.

46. Kinsey, *Thomas Moran and the Surveying of the American West;* see also Denis E. Cosgrove, *Apollo's Eye: A Cartographic Genealogy of the Earth in the Western Imagination* (Baltimore: Johns Hopkins University Press, 2001).

47. Ferdinand V. Hayden, *The Yellowstone National Park, and the Mountain Regions of Portions of Idaho, Nevada, Colorado and Utah* (Boston: Louis Prang and Company, 1876).

48. Kinsey, *Thomas Moran and the Surveying of the American West,* 7.

49. Mary Panzer, "Great Pictures of the 1871 Expedition: Thomas Moran, William Henry Jackson, and *The Grand Canyon of the Yellowstone,*" in *Splendors of the American West,* ed. Morand, 43–58.

50. Nettleton to Hayden, October 27, 1871. Record Group 57, Microfilm 623, reel 2, frame 155, National Archives, Washington, D.C.

51. Ferdinand V. Hayden, "Wonders of the West-II. More about the Yellowstone," *Scribner's Monthly* 3 (February 1872): 388.

52. Ibid.

53. See Haines, *Yellowstone National Park;* Alfred Runte, "Yellowstone: It's Useless, So Why Not a Park?" *National Parks and Conservation Magazine: The Environmental Journal* 46 (March 1972); Paul Schullery, *Searching for Yellowstone: Ecology and Wonder in the Last Wilderness* (Helena: Montana Historical Society Press, 2004).

54. Magoc, *Yellowstone,* 4.

8. CAN PATRIOTISM BE CARVED IN STONE?

A Critical Analysis of Mount Rushmore's Orientation Films

Teresa Bergman

CONSIDERABLE SCHOLARLY ANALYSIS in recent years regards Mount Rushmore as a site of national symbolism.[1] Mount Rushmore has been interpreted and reinterpreted in ways that provide insight into its use and meaning as a U.S. patriotic icon. The choice of Mount Rushmore as a location for inquiry into the changing notions of patriotism stems from several sources. One reason is its prevalent cultural use as "shorthand for patriotism" in political campaigns, films, and marketing.[2] Additionally, the interest in "historically oriented tourism"[3] resulted in approximately 1,989,771 tourists visiting Mount Rushmore in 2006 and more than a million tourists attending this site each year since 1959.[4] Because of its enduring status as a popular patriotic icon, questions regarding its changing message of U.S. patriotism and nationalism have arisen. Since 1965, three different orientation films have been shown at the memorial, and each offers a substantially different rhetorical explanation of the site's symbolic meaning.

Orientation films primarily function as an introduction and invitation to learn about a significant site and its meaning.[5] The Mount Rushmore National Memorial administration employs its orientation film in precisely this manner. The layout of the visitor center encourages the viewing of the orientation film, and the main walkway feeds visitors directly to theaters. The National Park Service (NPS) rangers advise tourists to include the orientation film during their visit, and the site's printed literature promotes viewing the film. A close examination of this orientation film and its two previous iterations provides an opportunity to understand the changing messages offered regarding Mount

Rushmore's meaning. In particular, this case study examines how Mount Rushmore's three different orientation films work rhetorically to stimulate ideals of social unity and civic loyalty. Communication scholars Robert Hariman and John Louis Lucaities note that the "visual practices in the public media . . . reflect social knowledge and dominant ideologies" at the time of their production, and that an iconic patriotic image "negotiate[s] the trade-off between individual autonomy and collective action."[6] I contend that these filmic representations of Mount Rushmore work to naturalize "matrices of privilege,"[7] including expansionism and imperialism, through the techniques of selectivity, manipulation, and political expediency. The films depict social unity as constituted by an uncritical acceptance of past U.S. aggressions, and civic loyalty as little more than an appreciation of physical might.

To account for the contributions and implications of these films, or, as Cecelia Tichi puts it, the "continuous textual mediation[s]" of Mount Rushmore, I examine each of the three orientation films sequentially.[8] For the first film, I detail the reasoning for the creation of the Mount Rushmore memorial as well as for the production of the film itself. This is followed by an analysis of the drastically reconfigured second orientation film and the contemporary political and cultural conditions that contributed to its redesign. The strong reactions to the second film and its negative reception influenced the production of the third (and current) orientation film. In the discussion of the third orientation film, I examine the dominant ideologies at the time of its production as well as the significance of the NPS continuing to use the third film for the past twenty years. I conclude with a discussion of the implications of the mutable meanings of Mount Rushmore and their contribution to public memory.[9]

The 1965 Orientation Film: *Mount Rushmore* and the Memorial's Origins

On December 21, 1964, the Mount Rushmore National Memorial Society accepted Charles W. Nauman's script for Mount Rushmore's first orientation film, titled *Mount Rushmore*. The total budget was $17,800, and the proposed running time was twenty-eight minutes. When completed, the final running time was nineteen minutes. Nauman's proposal

describes the film's purpose as one that would "document and interpret the history and the ideals embodied at Mount Rushmore Memorial."[10] Of particular interest are Nauman's initial description of the film's content, and the ways in which it substantially differs from the final version. Nauman proposed two minutes on Mount Rushmore's creator, Gutzon Borglum, and eleven minutes on the four presidents depicted on the face of the mountain.[11] However, in the final cut, the first six minutes are devoted exclusively to Borglum's history. The next ten minutes are a chronological description of the actual carving of Rushmore and the dedications for each of the four presidents, scenes during which Borglum is never far removed. There is a one-minute description of Lincoln Borglum finishing Mount Rushmore after his father's death, and the last minute of the film includes current images of Mount Rushmore. In this film's interpretation, Gutzon Borglum *is* Mount Rushmore.

The narrator, Lowell Thomas, provided a "voice-of-authority commentary," which was a "richly toned male voice of commentary."[12] Additionally, Thomas was widely recognized as a preeminent broadcast journalist, a renowned war reporter, and a "contemporary and friend of the late Gutzon Borglum."[13] The importance of claiming Borglum's friendship in order to establish Thomas's ethos as narrator can be understood by looking at Borglum's role in the creation of Mount Rushmore.

The idea or concept of a Mount Rushmore–like sculpture began with South Dakota's state historian Doane Robinson in 1923.[14] In his goal to boost state tourism, he initially considered a project "commemorating some phases of American history by . . . carving massive figures on some of the granite pinnacles in the Black Hills."[15] Robinson's original concept was to depict western heroes with historical ties to the Black Hills, a tableaux that would include "notable Sioux . . . Lewis and Clark, Frémont, Jed Smith, Bridger, Sa-kaka-wea [Sacagawea], Redcloud . . . Cody and the overland mail."[16] Once the prospective mountain carving was offered to Borglum, however, the concept for the tourist attraction changed from one with a local historical focus to one of a national scale. In 1924, *The Free Press* reported that Borglum was planning "a colossal undertaking commemorating the idea of union," with Borglum stating, "The United States is without a real memorial to our nation."[17] Robinson did not contest this change of focus, and, in fact, "Robinson's contribution to the project ended almost with

its inception."[18] Borglum led the "monumental" task of getting Mount Rushmore constructed between the years 1927 and 1941, during the Great Depression.

The exact plan for Mount Rushmore was one that evolved over the course of the project and was tethered to financial and time constraints. Borglum described his desire to carve the four presidents down to their waists and to carve an entablature of U.S. history and a Hall of Records behind the presidents. Ultimately, only the heads of the presidents were completed, and work on Mount Rushmore was "finished" in 1941 by Borglum's son, Lincoln.

This orientation film conflates Mount Rushmore's symbolic meaning with Borglum as an individual, and this blurring was fueled by Borglum's conception of U.S. artistry. Borglum's idea of creating distinctive U.S. art in form and content can be understood by taking into consideration the historical theory of monumentalism. Environmental historian Alfred Runte describes monumentalism as the reasoning behind the initial idea for national parks, which "evolved to fulfill cultural rather than environmental needs," and as an essential part of "the search for a distinct national identity."[19] With the opening of the West during the late nineteenth century, Americans found landscapes that began to fill the need for an identity that was different from Europe. According to Runte, "the natural marvels of the West compensated for America's lack of old cities, [and] aristocratic traditions."[20] The concept of national parks and their monumental scenery functioning as symbols of U.S. cultural nationalism intrigued Borglum. Like many artists of the time, Borglum had studied art in Europe, but he returned to the United States determined to create an American art that was as distinct from the European traditions as possible.[21]

Borglum declared that "the amazing and expanding character of [American] civilization clearly demand[s] an enlarged dimension—a new scale. Ours will be called the colossal Age."[22] He further predicted that Mount Rushmore "will be [the] most gigantic sculpturing enterprise ever conceived."[23] Carole Blair and Neil Michel place Borglum's ideas for carving Mount Rushmore in "the culture of the corporation and giant public works projects" as well as the "skyscraper competition."[24] While colossal projects certainly defined the scale of U.S. architecture of the time, I would add that Borglum's decision to carve

four U.S. presidents on a western mountain also incorporated his desire to surpass Europe's landscapes filled with "the impress of the past."[25] Borglum's carvings on Mount Rushmore would permanently impress the U.S. landscape with historical meaning and provide the United States with a site of national identity. The question then becomes which of many possible definitions of nationalism did Borglum carve into the mountain?

Borglum quickly defined the memorial in 1925 as one that will commemorate "Empire Builders," and "will record the Revolution, the Louisiana Purchase, [and] the securing of Oregon, Texas, California, Alaska and Panama."[26] Borglum's definition of an empire builder is most clear in his proposal for the entablature that was to be carved in the shape of the Louisiana Purchase and would include the eight events that Borglum considered as defining American history: "the Declaration of Independence, the framing of the Constitution, the Purchase of Louisiana, the admission of Texas, and the settlement of the Oregon Boundary dispute, the admission of California, the conclusion of the Civil War, and the building of the Panama Canal."[27] According to Borglum, the presidents who best represented these events were George Washington, Thomas Jefferson, Abraham Lincoln, and Theodore Roosevelt. At the time of Mount Rushmore's construction, Borglum's vision of this monument as a commemoration of U.S. expansionism *was* read as a monument to imperialism, yet there was little registered discordance with his "imperial view of history."[28] The historical circumstances and prevailing political culture of the time provide some insight into the acceptance of Borglum's ideology. In the late 1920s, the United States was still in the shadow of World War I, and, as Michael Schudson describes, the "fear of anarchism, socialism, and bolshevism, plus concern about the need to Americanize immigrants [were] reasons for a renewed interest in the Constitution and all things American in the 1920s and '30s."[29] There was no objection to building a U.S. memorial that was portrayed by Borglum as one "designated as a monument to a specific form of government,"[30] and that memorialized "the principles that underlie the form of our political philosophy, and determined our territorial dimensions."[31]

In addition to Borglum's expression of U.S. nationalism as expansionist and imperialist in the entablature and in the choice of presidents,

the selection of the monument's location had imperialist implications. Arguably, according to the Fort Laramie Treaty, the Black Hills are still owned by Native Americans.[32] This dispute continues as of this writing because although the Lakota suit against the United States for the Black Hills "resulted in a Supreme Court decision in 1980 compensating them for an illegal taking of the Hills by the United States in 1877," this settlement has been refused.[33] Active Native American protest of Mount Rushmore did not materialize until the 1970s, when Native American groups occupied the monument, an event that I will discuss in more detail later.

The first orientation film avoids a discussion of Borglum's vision of the memorial as a tribute to imperialism and instead conflates the symbolic meaning of Mount Rushmore with a hagiographic representation of Borglum. The film begins with Borglum's work on Stone Mountain in Georgia, and although there are fourteen shots of his work at Stone Mountain, there is no mention of his membership in the Ku Klux Klan or how badly this project ended.[34] During his work on Stone Mountain, Borglum joined the KKK in the hope of turning the organization "into a powerful political force strong enough to make national policy."[35] The Stone Mountain sequence is followed by shots of Borglum at work in his studio and then a lengthy cataloging of his other sculptures. The narration accompanying this section of the film is triumphant, pronouncing that "his art was purely and newly American. . . . he was recognized as America's foremost sculptors [sic]. . . . Borglum was an intensely nationalistic and patriotic artist." Borglum is never far from the audience's eyes or ears in the ten-minute sequence covering the construction and dedication of each of the individual presidential carvings. In this sequence there are 194 different shots, 40 of which include Borglum. Although Nauman, the director, had indicated that the presidential sequence would be dedicated to the represented presidents themselves, this sequence instead presents *how* Borglum carved Mount Rushmore and his emphasis on spectacle, not *why* he chose these specific presidents. For Washington, the narrator states, "Gutzon had spent much time lately going over the George Washington face refining it . . . [it] was his final touch by Borglum which transformed the sculpture from colossal bulk to a portrait." For Thomas Jefferson, the narrator asserts that Borglum "spent one third of the time . . .

in rethinking it or relocating it within the mountain itself." Lincoln is described as "a work of art, as a masterpiece of great sculpture. . . . [W]e have been little more than able to indicate its fine possibilities." The description of the Roosevelt dedication postulates that "it was another Borglum performance with William S. Hart of motion picture fame and Sioux Indians attending." Borglum's skill as a sculptor is highlighted in a two-minute segment explaining his pointing technique for carving the mountain.[36] There is a closing shot of Borglum in a fedora hat, cross-fading with the "finished" Mount Rushmore that reinforces the film's hagiographic portrayal of Borglum as Mount Rushmore.

This film was well received at the time, and an NPS reviewer wrote: "It is top quality, shows deep appreciation of the purposes of the Memorial, and certainly stimulates understanding of the thorough research done, and the true creativeness of Gutzon Borglum."[37] There is no question that this film accomplishes an extended adulation of Borglum; however, there is very little coverage of the "purposes" of the memorial. This approach is consistent with the "Great Man" theory of history, which can skillfully focus an audience's attention away from larger cultural concerns. At the time of this film's production in 1964, the United States was in the midst of a growing civil rights movement that was based on recognizing and empowering those who had been left out of traditional historical representations. Historian Michael Sherry describes the political climate in 1964 as one that was increasingly unreceptive to any notion of U.S. imperialism, where "leftist radicals trained their sights on 'the establishment'—the entrenched machinery of racism, imperialism, militarism, and corporate capitalism."[38] Historian Howard Zinn sees this change as a turning away from the approach to history where "the past is told from the point of view of governments, conquerors, diplomats and leaders."[39]

The decision to focus the 1964 film on Borglum conflates nation-state loyalties and individual predilection; that is, if Borglum is patriotic and nationalistic, then Mount Rushmore is patriotic and nationalistic. Borglum is shown to be patriotic and nationalistic, and thus it follows that Mount Rushmore is also patriotic and nationalistic. This syllogism accomplishes two goals. It bridges the split between collective action and individual autonomy by placing national ideals in the man, and it limits a detailed version of U.S. history and patriotism to

the imagination of one individual. One implication of this portrayal of U.S. history is that there was no national imperialism, just outstanding individuals. Facing a rising tide of domestic challenges to U.S. imperialism, this orientation film chose to define Mount Rushmore's national symbolism using a hagiographic depiction of Borglum and to ignore his imperialist and expansionist definitions of Mount Rushmore as well as his personal political affiliations.

The 1973 Orientation Film: *Four Faces on a Mountain*

In 1973, the *Mount Rushmore* orientation film was replaced by *Four Faces on a Mountain*. This new film was produced by the NPS's interpretive branch in Harpers Ferry, West Virginia, and was funded by the Mount Rushmore National Memorial Society of the Black Hills, with a total budget of approximately $15,000.[40] The film consists of a one-minute opening of Black Hills nature shots, one minute describing Doane Robinson and Senator Peter Norbeck's involvement as well as Borglum's contribution to Mount Rushmore, seventeen minutes explaining the depicted presidents, and a one-minute conclusion. This new textual mediation of Mount Rushmore reflected a very different definition of the patriotic icon, and the most notable change was the elimination of Borglum as a patriotic synecdoche. The focus has been shifted to explaining the choice of the four presidents. Borglum is not mentioned until three minutes into the film, there are no accompanying images of his previous artworks, and his artistic history is condensed to one line of narration: "Borglum had achieved some success as a sculptor, having executed a number of prize-winning works."[41] A Mount Rushmore superintendent's report succinctly describes the change from the previous film. Whereas the first film had "depicted the engineering aspects and talents of Gutzon Borglum, the other film dwells more on the lives of the four Presidents selected to be carved into the mountain."[42] Another NPS memo takes a more direct approach and describes Borglum's role as "relegated to that of fabricator of the memorial." This memo further explains that "the overall theme is chiefly an explanation of why the mountain was carved, stressing the Nation's desire to commemorate the ideals of the four presidents depicted and the principles of democracy which they espoused . . . thus facilitating a large-scale reminder of con-

cepts vital to American culture."[43] Interestingly, this substantial change in focus was not well received by the NPS. Harvey D. Wickware, the acting superintendent of Mount Rushmore in 1973, wrote: "The financial backers of the film are generally disappointed with it. They believe it lacks the 'zing' of the previous film and will not aid in inspiring the visitor. The staff agrees that the sound and voice is generally depressing rather than being spiritually uplifting."[44]

How did this new interpretive focus evoke such a dismal reaction? There are several elements that contribute to this substantial transformation in reception. In addition to losing the celebration of Borglum, the film uses a much less prominent narrator. The choice of Burgess Meredith as narrator is intriguing because he had not been a journalist and consequently did not have the "objective" ethos that a journalist brings to the role of narrator in an orientation film. Meredith's body of work reveals no single film that would obviously qualify him to serve as narrator for Mount Rushmore's orientation film. Yet, his political activism may have played a role in his selection. He was "named an unfriendly witness by the House Un-American Activities Committee in the early 1950s. . . . He was also an ardent environmentalist who believed pollution one of the greatest tragedies of the time, and an opponent of the Vietnam War."[45] His role as an environmentalist is noteworthy because a 1972 treatment of *Four Faces on a Mountain* describes the memorial as a "harmony between the works of nature and man" that is "reborn in the modern ecology movement."[46] The previously mentioned NPS memo criticized "the environmental and history lessons worked into this film," and argued that these lessons were obstructions to the film providing a spiritually uplifting message.[47] The first minute of this orientation film contains no images of Mount Rushmore and instead is devoted exclusively to stunning nature shots of the Black Hills accompanied by soft melodic music. The portrayal of environmental concerns and Meredith's role as narrator are two significant elements that comprise this new textual mediation of Mount Rushmore. The third and by far the dominant element that contributes to this film's bleak reception is the presidential sequence.

The seventeen-minute presidential sequence is notable for its length and unconventional version of the represented presidents' contribution to building a national identity and sense of patriotism. Each presidential

section runs between two and four minutes, and each contains two major themes. Instead of depicting the presidents as "Empire Builders," the film portrays them as encountering profound national adversity during their tenure in office and drawing on nature as a source of inspiration and knowledge. The memorial's construction scenes are used to introduce each president, rather than to highlight Borglum's achievement. The dynamiting footage is used only once during the film, and the size of the carvings is never mentioned. The focus of this film is not to celebrate Borglum's patriotism or his monumental achievement but instead to provide an explanation for why these presidents are represented.

The explanation offered for the choice of presidents is couched in rhetoric that is particularly responsive to the tumultuous contemporary political climate. "There were thousands of seeds and shoots of rebellion all around . . . in this uncertain situation of the seventies,"[48] and Mount Rushmore was one center of this rebellion. On August 24, 1970, several Native American rights' groups targeted Mount Rushmore, declaring that "this protest is part of [the] fight to awaken the U.S. government to the fact that the Sioux Indians have been wronged. The government illegally seized the Black Hills and has not paid for them."[49] This protest lasted just under a month, but during the next year there was another occupation, which was primarily organized by members of the American Indian Movement (AIM), who "had come specifically to take possession of the mountain." However, this protest lasted only ten hours because "National Guard troops and NPS rangers dragged most of the group off of the mountain." Fears of an occupation at Mount Rushmore continued to escalate through the 1970s and eventually declined by the early 1980s.[50] It was amid this confrontational atmosphere, when AIM leader Dennis Banks declared the memorial a "Hoax of Democracy," that the staff at the Harpers Ferry Center produced the second orientation film.[51]

Along with Native Americans who were challenging the ownership and validity of Mount Rushmore, other U.S. constituencies were strongly opposed to viewing the nation's history through a celebratory lens. There were extensive protests concerning civil rights, the Vietnam War, free speech, women's rights, the environment, gay rights, and President Richard Nixon's actions prior to his resignation. Historian Peter N. Carroll describes the mood of the time: "The crisis of the early

seventies . . . added up to a spiritual crisis of major proportions," during which "Americans retreated to established ideals and old virtues."[52] During such a search for established ideals and virtue, Zinn claims that "the supreme act of citizenship is to choose among saviors."[53] With Mount Rushmore's continuing status as a symbol for U.S. patriotism and as a potential site for additional protest, the decision to define the memorial in terms of the former presidents is understandable.

The first president described in this film's seventeen-minute presidential sequence is Washington, and the presentation is as surprising for what it encompasses as for what it does not. The sequence does not begin with Washington's presidential election or battlefield victories but instead with Washington's farewell to his officers, which "drew tears from many." This noncelebratory introduction of Washington sets the tone for the entire film. The sequence continues with a description of Washington as drawn away from the natural setting of Mount Vernon on the Potomac River in order "to focus his country's attention on the awesome problems of internal harmony." This section ends with the narrator declaring that Washington was "the steady hand that helped the young nation redirect itself after the destruction and turmoil of the Revolution." *Four Faces on a Mountain* primarily defines Washington in terms of surviving national hardships. The focus is on the new country's problems and challenges during Washington's term instead of his successes. The representation of Washington at the end of his career and not at the beginning spotlights the challenges facing a new nation and echoes the contemporary political concerns of the 1970s. *Four Faces on a Mountain*'s Washington offers a definition of patriotism that is grounded in withstanding internal political unrest.

The theme of persevering through national adversity and maintaining a connection with nature continues in the Jefferson sequence. The film proclaims that the third president's appreciation of nature manifested itself in his Monticello home, which was "like Washington's Mount Vernon . . . where he maintained his connection with the land." The film then makes the choice to depict Jefferson not only with the familiar quote from the Declaration of Independence, "We hold these truths to be self-evident, that all men are created equal" but also with the less familiar lines: "that whenever any form of government becomes destructive of these ends it is the right of the people to alter or to abolish

it, and to institute new government." The inclusion of this reference to the Founders' belief that it would be patriotic to challenge any government that becomes destructive offers a knottier version of patriotism. This depiction defines Jefferson as more concerned with internal governmental matters, as opposed to expansion. The sequence also includes Jefferson's presidential struggles concerning slavery and ends with his lament: "I have sometimes asked myself whether my country is the better for my having lived at all. I do not know that it is. I have been the instrument of doing things; but they would have been done by others, some of them, perhaps, a little better." Instead of highlighting the Louisiana Territory and territorial expansion (which Borglum indicated as his reasons for Jefferson's inclusion), this orientation film portrays a Jefferson who doubts his contributions to the country. This section ends with his regrets, thus highlighting a patriotism that is defined by surviving the challenges of the time and serious self-reflection.

The Lincoln sequence invokes the nature-as-knowledge theme and represents his endurance during a period of national adversity. Lincoln is first described as having "a new kind of wisdom, born of the frontier. . . . He was the epitome of this fresh approach, of country wisdom." However, the emotional center of Lincoln's sequence concerns holding the country together through the Civil War. Although Borglum considered the "conclusion of the Civil War" as one of the eight events that defined U.S. history,[54] *Four Faces on a Mountain* does not focus on the war's conclusion but instead depicts a Lincoln mired in conflict and pain. This sequence includes strikingly graphic photographic images of dead Civil War soldiers that draw the audience far away from Mount Rushmore. As in the previous two presidential depictions, the focus of the Lincoln sequence is also on surviving internal national conflict. Lincoln's endurance in the face of the nation's greatest internal discord was the message for 1973 audiences, who also faced internal national dissonance.

Continuing the theme of the presidents' connections to nature, Roosevelt is described as a "conservationist" who brought "a new level of consciousness in understanding Americans and their natural environment" and who laid "the cornerstone of the gateway to Yellowstone National Park." This section portrays Roosevelt as confronting national adversity in the form of internal class warfare. His sequence be-

gins with his refusal "to accept the crimes of those few rich who were exploiting the people of the United States." The Roosevelt sequence intertwines the two themes of nature and domestic struggles: "the preservation of the scenery, of the forest, of the wilderness life for the people as a whole . . . [should] not be confined to the very rich who can control private resources." The Roosevelt depiction offers the audience another portrayal of a former president who successfully confronted internal discord. There is no mention of his Panamanian exploits.

Four Faces on a Mountain concludes with Washington's farewell address in which he questions whether the American Revolution "must be considered as a blessing or a curse." Washington's ambivalence about the future of the country recurs in the final two lines of the film's narration: "Four faces on a mountain, each reflecting part of what America was and what it can become, if we are willing." This orientation film defines Mount Rushmore's symbolism as more on the cusp of reaching Washington's ideals than as having attained them. In 1973, critical questions regarding the country's future were germane, and this orientation film depicts these presidents as the nation's saviors. This definition of Mount Rushmore's symbolic patriotism is responsive to the contemporary climate; thirteen years later, however, the cultural and political climate was very different, and so was the next iteration of Mount Rushmore's orientation film.

The 1986 Orientation Film: *The Shrine*

The Shrine lasts seventeen and half minutes, is narrated by Tom Brokaw, and received funding from both the NPS and the Mount Rushmore National Memorial Society of the Black Hills. The producer and writer of this orientation film was Robert G. McBride of Earthrise Entertainment in New York. Visually, this film differs from the previous two by using more contemporary footage of Mount Rushmore, including many aerial shots. Brokaw, as narrator, brings not only his journalistic reputation to the film but also his identity as a native South Dakotan. The film's positive reception is evidenced by the fact that it is still showing in 2007 and that there are no immediate plans for its replacement.[55]

Initially, *The Shrine* appears to fall ideologically between the two previous orientation films. It offers some definition of the presidential

choices; however, its message is not wrapped up in the person of Gutzon Borglum or in the historical adversity facing each of the represented presidents. The major sequences include Doane Robinson's contribution; two and a half minutes on Borglum, with no reference to his previous artistic work; a one-minute explanation for each of the presidents; the presidential dedications; and six and a half minutes on the construction of Mount Rushmore. Much of the archival footage of Mount Rushmore's construction is from *Four Faces on a Mountain.* The actual dynamiting and jackhammering and the individual workers at Mount Rushmore receive the lion's share of screen time.

The Shrine's overall message is a celebratory and progressivist version of U.S. history without depictions of economic exploitation, Civil War deaths, slavery, or Washingtonian regrets. In the film, the presidents are not represented as mired in national adversity but instead are shown as single-note great men. The abbreviated depictions portray only shining moments, and expansionism enters as an accomplishment. Jefferson's depiction is first, and it sets the tenor for the next three presidential portraits. The familiar lines from the Declaration of Independence are quoted, "We hold these truths to be self-evident, that all men are created equal," but his call to abolish government if needed, as quoted in *Four Faces on a Mountain,* is gone. Jefferson is described as a "great nation builder," and one of his accomplishments is the "purchase of the Louisiana territory."[56] Washington follows and is described mostly in terms of his character and of his choosing to nurture "the sacred fire of liberty." Absent in this film are any laments or sorrowful presidential moments. Lincoln is the "great emancipator," who "lent a steadying hand" to guide the country through the Civil War. He "was the prophet of America's permanence and of liberty, tolerance and social justice for all people." He is no longer depicted as emotionally damaged from the Civil War. A physically active Theodore Roosevelt extends "economic freedom" and "forg[es] new links between east and west with the Panama Canal." This presidential sequence does invoke Borglum's original expansionist reasoning for including these four national leaders; however, this brief section is followed by an extended elucidation of the memorial's construction, which becomes the film's main focus.

The Shrine commemorates the men who worked on the mountain carving, as opposed to Borglum or the presidents. The narration catalogs the kinds of workers involved: "In addition to the pointers, the

construction crew included powder men, winch men, blacksmiths, call-boys and as many drillers as the budget would allow." The final narration declares that Mount Rushmore "is a monument no less to the men who, working together, transformed the lofty ideal into a colossal reality." This change in Mount Rushmore's textual mediation reflects a new slant in defining the memorial's patriotic symbolism. In 1986, the year of this film's production, there was a definite shift in the national political climate. President Ronald Reagan was in his second term and "despite notable successes had failed to regenerate the nation's cultural foundations."[57] Michael Schudson describes a time when "civic life has collapsed," and by the late 1980s, Michael Sherry observes that "the *fact* of cultural discord . . . was not new," but the civic response to it had changed.[58] In addition to the search for saviors during the ongoing cultural discord, a new reaction to the strife was the charge of revisionism: "In the 1980s and 1990s . . . a backlash emerged against the interpretive transformations wrought in the previous two decades." Mike Wallace argues that "powerful figures, garbed as populists, claimed that historians and curators (even theme park operators) had imposed their 'politically correct' views on an unwilling populace."[59] In an effort to respond to such charges of revisionism, *The Shrine* eliminates the "environmental and history lessons" of the previous film and instead focuses on the less controversial accomplishment of the physical carving and on the actual Mount Rushmore workers.

This rhetorical move accomplished multiple goals. By highlighting the colossal physical aspects of the memorial, the film placed the audience in the position of admiring the feat of the carving without asking for reflection on (or an interpretation of) the nature of the country's history, its future, or *why* this memorial was created. Another implication of this shift in emphasis was that the visitors' experience at Mount Rushmore became more of a recreational event, with *The Shrine* defining Mount Rushmore as an amazing American spectacle. This film extolled the work of individuals in the name of a very narrowly defined collective action—that of carving Mount Rushmore—not in terms of larger nation-state loyalties.

The Shrine can be read as a partial return to Doane Robinson's original intention for Mount Rushmore, where "every community . . . should have something to draw tourists."[60] *The Shrine* offers tourists an "exciting" rendition of Mount Rushmore—one that is closer to a theme

park experience than a contemplative site of national reflection. Also embedded in this "fun" representation of Mount Rushmore is an allusion to U.S. imperialism. The inclusion of the imperialistic reasoning for the presidential choices can be seen as laying the groundwork for understanding the United States as empire and as an imperialistic power, and I offer this interpretation with the understanding that the creators of *The Shrine* may well have intended to make the film more historically accurate. Nevertheless, the memorial's message of imperialism is significantly muted because of the emphasis on the construction sequence and the workers' ability to create Mount Rushmore. One result of this particular combination of scenes is that the audience is "wowed" by the dynamiting and uncritically accepts the depiction of U.S. imperialism. Reinforcing this message is the continued absence of any acknowledgment of Native American claims of ownership to the Black Hills.

When compared to *Four Faces on a Mountain* and the first orientation film, *Mount Rushmore, The Shrine* is much more triumphant about the U.S. past. And *The Shrine* portrays the workers' skills as the main component of Mount Rushmore's patriotic symbolism. No longer is Mount Rushmore the creation of a single man—Gutzon Borglum—it is now the triumph of myriad U.S. workers. *The Shrine* offers audiences a version of U.S. nation building in terms of individuals literally and metaphorically conquering a mountain. *The Shrine*'s patriotism is depicted as individual Americans' might and not as a single great man or its leaders.

As mentioned earlier, *The Shrine* has been Mount Rushmore's orientation film for more than twenty years. Its longevity speaks to its positive reception and adherence to contemporary dominant ideologies. *The Shrine*'s emphasis on the individual in the name of a collective action is one that still resonates and offers a noncontroversial definition to patriotism. The workers' representation conveniently avoids identifying Mount Rushmore's patriotic symbolism within more contentious arenas of world affairs.[61]

Mutable Meanings

The changing rhetorical constructions of the site's meaning offer an opportunity to understand not only how these films contribute to what Roy Rosenzweig and David Thelen have observed as U.S. "histori-

cal amnesia," but also how the films illuminate what Americans *do* "know and think" about Mount Rushmore's symbolism.[62] I agree with Robert Hariman and John Louis Lucaites that iconic patriotic images "operate as powerful resources within public culture, not because of their fixed meaning," but instead because they offer an interpretation of patriotism that is "open to continued and varied articulation."[63] I have argued that there is not a unitary definition of patriotism represented in these films and that their parameters are largely determined by a selective and manipulative representation of U.S. history that is also politically expedient. From defining Mount Rushmore as Gutzon Borglum, to defining this patriotic icon through its presidents during times of crisis, to understanding Mount Rushmore as the result of individual workers' abilities, these films illustrate the changing nature of this icon's symbolism. The question then is, what are the consequent implications of these mutable meanings of one of America's most iconic patriotic symbols? Some implications of these fluid definitions include selective memory and manipulation. In the first orientation film, Borglum is offered as the definition of Mount Rushmore; however, no mention is made of his Ku Klux Klan affiliation or his belief in imperialist expansionism. The second orientation film solely concentrated on U.S. historical hardships, while the third and current film reduces U.S. nationhood to the ability of individuals to blow up mountains. In addition to this selective rendering of U.S. history, the films reduce significant concepts regarding nation building and citizenship to individual concerns informed by political expediency. From ignoring the Native American ownership of the Black Hills to celebrating expansionism, these filmic representations naturalize expansionism and imperialism in the name of patriotism.

There is the possibility of representing and remembering Mount Rushmore's patriotic symbolism differently, that is, other than through a progressivist and privileged trajectory. Despite its shortcomings, the 1973 orientation film did focus on the harsh realities of U.S. political life and offered audiences a representation that incorporated challenges into a U.S. historical narrative. An approach that incorporates the contested nature of Mount Rushmore's ownership as well as addressing the evolution in what it means to be patriotic or nationalistic would continue these orientation films' role in addressing contemporary political

exigencies and ensure greater historical accuracy. Constructing a national identity is complicated and consequential, and even though this particular patriotic icon is carved in stone, its orientation films are not. As resources in the ongoing construction of public memory, these orientation films illustrate the mutability in defining this patriotic symbol—and the possibility to redefine and (re)present its meaning.

NOTES

1. Recent critical works include Carole Blair and Neil Michel, "The Rushmore Effect: Ethos and National Collective Identity," in *The Ethos of Rhetoric,* ed. Michael Hyde (Colombia: University of South Carolina Press, 2004); Albert Boime, "Patriarchy Fixed in Stone," *American Art* 5 (1991); Leonard Crow Dog and Richard Erdoes, *Crow Dog: Four Generations of Sioux Medicine Men* (New York: HarperPerennial, 1995); Matthew Glass, "Alexanders All: Symbols of Conquest and Resistance at Mount Rushmore," in *American Sacred Space,* ed. David Chidester and Edward T. Linenthal (Bloomington and Indianapolis: Indiana University Press, 1995); Jesse Larner, *Mount Rushmore: An Icon Reconsidered* (New York: Thunder's Mouth Press/Nation Books, 2002); Edward Lazarus, *Black Hills White Justice* (New York: HarperCollins, 1991); Russell Means, *Where White Men Fear to Tread: The Autobiography of Russell Means* (New York: St. Martin's Press, 1995); Simon Schama, *Landscape and Memory* (New York: Vintage Books, 1995); John Taliaferro, *Great White Fathers: The Story of the Obsessive Quest to Create Mount Rushmore* (New York: PublicAffairs, 2002).

2. Blair and Michel, "The Rushmore Effect," 156. The exhibits outside the orientation film screening rooms at Mount Rushmore are filled with myriad examples of Mount Rushmore's use in the marketing of foods, consumer items, politicians, and cultural events.

3. Roy Rosenzweig and David Thelen, *The Presence of the Past: Popular Uses of History in American Life* (New York: Columbia Press University, 1998), 3.

4. See U.S. National Park Service, "Visitation Database," Mount Rushmore National Memorial, http://www2.nature.nps.gov/Npstats/dspSystem.cfm (accessed 2 June 2004).

5. There are many representations of Mount Rushmore in U.S. popular culture that may serve to alert visitors to its existence and possible meanings. For the purposes of this essay and my book *Chasing Patriotism* (Walnut Creek, Calif.: Left Coast Press, forthcoming), I choose to analyze the films that are shown only on-site; these are the "official" representations. This official association is defined by the location as well as the governmental association,

funding, and administration, all of which substantially contribute to the films' reception as authoritative. My goal is to analyze the rhetorical messages provided in Mount Rushmore's orientation films in terms of their instructions on how to understand the site's meaning when touring the site.

6. Robert Hariman and John Louis Lucaites, "Performing Civic Identity: The Iconic Photograph of the Flag Raising on Iwo Jima," *Quarterly Journal of Speech* 88, no. 4 (2002).

7. Barbara Biesecker, "Renovating the National Imaginary: A Prolegomenon on Contemporary Paregoric Rhetoric," in *Framing Public Memory,* ed. Kendall R. Phillips (Tuscaloosa: University of Alabama Press, 2004).

8. Cecelia Tichi, *Embodiment of a Nation: Human Form in American Places* (Cambridge, Mass.: Harvard University Press, 2001), 11.

9. There are a substantial number of critical essays concerning the rhetoric of place/monuments/landscape and of public memory, which include Carole Blair and Neil Michel, "Reproducing Civil Rights Tactics: The Rhetorical Performances of the Civil Rights Memorial," *Rhetoric Society Quarterly* 30, no. 2 (2000); Greg Dickinson, Brian Ott, and Eric Aoki, "Spaces of Remembering and Forgetting: The Reverent Eye/I at the Plains Indian Museum," *Communication and Critical/Cultural Studies* 3, no. 1 (2006); Vicky Gallagher, "Memory and Reconciliation in the Birmingham Civil Rights Institute," *Rhetoric and Public Affairs* 2 (1999); Gregory Clark, *Rhetorical Landscapes in America: Variations on a Theme from Kenneth Burke* (Columbia: University of South Carolina Press, 2004); Barbie Zelizer, *Remembering to Forget: Holocaust Memory through the Camera's Eye* (Chicago: University of Chicago Press, 1998); Marita Sturken, *Tangled Memories: The Vietnam War, the Aids Epidemic, and the Politics of Remembering* (Berkeley: University of California Press, 1997); Harry W. Haines, "What Kind of War? An Analysis of the Vietnam Veterans Memorial," *Critical Studies in Mass Communication* 3 (1986); Marouf A. Hasian Jr., "Remembering and Forgetting the 'Final Solution': A Rhetorical Pilgrimage through the U.S. Holocaust Museum," *Critical Studies in Media Communication* 21 (2004).

10. Undated four-page proposal on Nauman Films stationary, Box 20, Mount Rushmore National Memorial Archives, Mount Rushmore, S.Dak.

11. The balance of the proposal includes the following elements: President Coolidge handing Borglum the first drill bits, Doane Robinson and the early visionary phase, the construction period, present-day shots of Mount Rushmore, and a closing statement interpreting the American dream on this mountain. Charles Nauman, "Correspondence from Mount Rushmore Historical Society to Nauman Films," Box 20, Mount Rushmore National Memorial Archives. Undated four-page proposal on Nauman Films stationary.

12. Bill Nichols, *Introduction to Documentary* (Bloomington and Indianapolis: Indiana University Press, 2001), 103.

13. All quotations without endnotes in this section of the essay are from the narration in the orientation film *Mount Rushmore.*

14. Gilbert C. Fite, *Mount Rushmore* (Norman: University of Oklahoma Press, 1952), 5.

15. Ibid., 5–6.

16. Ibid., 6.

17. "Borglum Plans Memorial to Matron," *The Free Press,* September 3, 1924. Box 102, Gutzon Borglum Papers, Manuscripts Division, Library of Congress.

18. Howard Schaff and Audrey Karl Schaff, *Six Wars at a Time: The Life and Times of Gutzon Borglum, Sculptor of Mount Rushmore* (Darien, Conn.: Permelia Publishing, 1985), 227.

19. Alfred Runte, *National Parks: The American Experience* (Lincoln: University of Nebraska Press, 1979), xii.

20. Ibid., 22.

21. In 1890 Borglum studied at the École des Beaux-Arts in Paris, and in 1896 he opened a small studio in London. Fite, *Mount Rushmore,* 13–14.

22. Taliaferro, *Great White Fathers,* 153.

23. "Borglum Plans Memorial to Matron," Box 102, Borglum Papers.

24. Blair and Michel, "The Rushmore Effect," 17. Some large-scale public works projects of the era included Boulder Dam, the Tennessee Valley Authority, and the Brooklyn Bridge.

25. James Fenimore Cooper, "American and European Scenery Compared," as quoted in Runte, *National Parks,* 16.

26. Gutzon Borglum, "Letter to President Calvin Coolidge," 1925, Box 103, Borglum Papers.

27. Fite, *Mount Rushmore,* 101.

28. Ibid.

29. Michael Schudson, *The Good Citizen: A History of American Civic Life* (New York: The Free Press, 1998), 203.

30. Gutzon Borglum, "Letter to Mrs. Tueling," 1936, Box 170, Borglum Papers.

31. Gutzon Borglum, "Letter to William Mill Butler," 1935, Box 178, Borglum Papers.

32. Article Two of the 1868 Treaty of Fort Laramie provides for the "setting aside all of present-day South Dakota west of the Missouri River, including the reputedly gold-laden Black Hills, 'for the absolute and undisturbed use and occupancy of the Sioux.'" Lazarus, *Black Hills White Justice,* 48.

33. Glass, "Alexanders All," 168.

34. "Gutzon had been fired because he '. . . neglected his work, . . . found time to deliver a series of lectures . . . and to launch a movement for a great Union Memorial in South Dakota.'" Schaff and Schaff, *Six Wars at a Time,* 214.

35. Ibid., 197.

36. Borglum devised the pointing technique as a way to proportionally transfer the dimensions of the model in his studio onto the mountain.

37. Lemuel A. Garrison, "Letter to John Boland, Jr.," 1965, Box 20, Mount Rushmore National Memorial Archives. Garrison was the regional director for the Midwest region of the NPS.

38. Michael S. Sherry, *In the Shadow of War: The United States since the 1930s* (New Haven, Conn.: Yale University Press, 1995), 273.

39. Howard Zinn, *The Twentieth Century: A People's History* (New York: Harper and Row, 1980), x.

40. Box 52, Mount Rushmore National Memorial Archives. The Harpers Ferry Center is part of the NPS and has produced "interpretive tools to assist NPS field interpreters" since 1970. See National Park Service, "Harpers Ferry Center," http://www.nps.gov/hfc/resources.cfm.

41. All quotes without endnotes in this section of the essay are from the narration in the orientation film *Four Faces on a Mountain.*

42. "Superintendent Reports, Mount Rushmore Archives," 1974, 2, Box 52, Mount Rushmore National Memorial Archives.

43. Bill Sontag, "Briefing Statement on Mount Rushmore Film, *Four Faces on the Mountain,*" 1983, 2, Harpers Ferry Center Archives. Bill Sontag was the chief of the Division of Interpretation in the Rocky Mountain Regional Office of the NPS.

44. Harvey D. Wickware, "Memorandum: Review of Film, *Four Faces on a Mountain,*" 1973, Box 52, Mount Rushmore National Memorial Archives.

45. http://www.imbd.com/name/nm0580565/bio (accessed 29 June 2004).

46. "Mount Rushmore National Memorial Treatment" (Harpers Ferry Center, W.Va.,1972), 1.

47. Wickware, "Memorandum," 1.

48. Zinn, *The Twentieth Century,* 280–83.

49. Larner, *Mount Rushmore,* 283.

50. "On June 27, 1975, a bomb exploded on the terrace outside the visitor center at Rushmore." Ibid., 289.

51. Quoted in ibid., 281.

52. Peter N. Carroll, *It Seemed Like Nothing Happened* (New Brunswick, N.J.: Rutgers University Press, 1990), 135, 116.

53. Zinn, *The Twentieth Century,* 281.

54. Fite, *Mount Rushmore,* 101.

55. Jim Popovich, interview with author, 27 June 2003.

56. All quotes without endnotes in this section of the essay are from the narration in the orientation film *The Shrine.*

57. Sherry, *In the Shadow of War,* 427.

58. Schudson, *The Good Citizen,* 295; Sherry, *In the Shadow of War,* 429.

59. Mike Wallace, *Mickey Mouse History and Other Essays on American Memory* (Philadelphia: Temple University Press, 1996), xiii.

60. Doane Robinson, as quoted in Fite, *Mount Rushmore,* 9.

61. Contemporary versions of this definition of patriotism include invocations to support the troops but not the war in Iraq, thus neatly avoiding the ideological complexities of the U.S. invasion of Iraq.

62. Rosenzweig and Thelen, *The Presence of the Past,* 3.

63. Hariman and Lucaites, "Performing Civic Identity," 387.

9. THINKING LIKE A MOUNTAIN
Mount Rushmore's Gaze

William Chaloupka

> There's something addicting about a secret.
>
> —J. Edgar Hoover, quoted in Curt Gentry,
> *J. Edgar Hoover: The Man and the Secrets*

THE ENVIRONMENTAL ETHICS LITERATURE and the environmental movement have long praised Aldo Leopold's essay "Thinking like a Mountain" as canonical. Leopold pleads for empathy with the geological, with the earth itself. If we practice the exercise of thinking like a mountain, we might extend our empathies (and our moral and political support) to entities that seem to resist or even contradict the human pace and life span. But "thinking" has many modes, and perspective is fraught with potential power issues. As John Berger argued (and Simon Schama elaborated), there are ways of seeing, and the notion of "perspective" can represent power relations in not altogether expected ways. We gaze at the mountain, wishing its approval, identifying with its power, and aspiring to partner with it. These potential confusions (or even pathologies) reside alongside Leopold's laudable empathy.

The American national parks offer innumerable opportunities to ponder this puzzle. Elevated to near sacred status, they offer promises at the scale Leopold pursues, while still working at a democratic scale, too, capturing the imagination of a remarkably broad swath of the American public. From Thomas Moran's Teton paintings to John Muir's poetic descriptions of Yosemite, moral grandeur is in play, even if it is also tested by the crass commercialism and banality of everyday life. In its highest modernism, America could carve a mountain so we could see

its very eyes, which at least seem to gaze back at us, tolerating our presence at the mountain's "foot." Struggles have formed around that gaze, sometimes along surprising lines. This is what brings me to consider Aldo Leopold and Mount Rushmore, together, in this essay.

More is at stake than the odd spectacle or kitsch novelty of carved mountains. As the environmental movement considers its political thought, these visions of mountains that see and hear reflect a larger effort to assess how "nature" (including natural sites) functions politically in American culture, both generally and in the specific—and controversial—context of American environmental politics.

Aldo Leopold

Leopold's famous essay begins with a romantic reconstruction of the different ways "every living thing" hears the howl of a wolf in a remote canyon. The deer, coyote, hunter, and cowman draw different lessons from the sound of the wolf. "Yet behind these obvious and immediate hopes and fears there lies a deeper meaning, known only to the mountain itself. Only the mountain has lived long enough to listen objectively to the howl of a wolf."[1] This mountain (and, presumably, any mountain) does not move at a human pace, but it is nonetheless somehow re-enacting human consciousness: the mountain listens, lives, and knows. Indeed, the mountain is superhuman. It listens "objectively," and set against the remarkably short, if also densely historicized, human horizon, it "lives" a long time.

The essay's conceit ("thinking like a mountain") is no simple literary ploy, and the brevity of the essay only heightens the drama. The essay is a plea to thoroughly and compellingly personify the mountain. The mountain—exclusively—knows "a deeper meaning." It "has lived," and its life must be measured against the lives of the other (animal and human) listeners; it "has lived long enough." It not only knows more deeply, it hears better, too. Only the mountain can "listen objectively" to the wolf's howl. The mountain is bigger, and this contributes to its superior stability and wisdom, as well as to its better view of the landscape. Accordingly, all of its human attributes are somehow taken to a (literally) higher level. Size matters. And the larger and more inert "you" are, the longer you live, and the more superior you are.

Leopold ups the stakes in almost every paragraph: "Only the in-educable tyro can fail to sense the presence or absence of wolves, or the fact that mountains have a secret opinion about them" (129). This is a radical claim. Mountains form and possess opinions, secret to us humans, but still, "the fact" of those opinions is obvious to all but the feeblest humans. That the mountain's opinions remain "secret" suggests that "it" is either hostile or indifferent (perhaps from its sense of superiority or because the frighteningly short human life span does not allow us to enter into its perceptions, just as the opinions of ants might be hard for us to perceive). Still, the presumed fact that the mountain has those opinions is bluntly obvious, not a matter of Leopold's speculation. The mountain has somehow spoken or otherwise sent a message to this attentive human. Leopold's mountain seems to challenge its human audience, urging the humans to be worthy of the mountain's opinions, which the mountain is cleverly dangling just beyond our reach, as a way of challenging us to reach further. This is one smart mountain.

Interpreting secrets is an activity intimately implicated in human culture. We interact with secrets constantly, especially given the well-known resistance inherent in trying to know any Other. To cite a mundane example, we know there will be secrets divulged when reading a mystery novel, so we know we are expected to try to guess which character "has secrets." The ability to decode a secret quickly is a mechanism for allocating authority among humans. Just knowing a secret before it is revealed puts one in a potential position of power, since one can then ration that secret out to others. In Leopold's case, giving the mountain the respect Leopold insists is its due, we take its silence for inscrutability, which Leopold asserts indicates the presence of secrets. Our sense of the presence of secrets, in turn, allocates authority to the mountain, which gets to decide how it reveals the secrets, perhaps via the death stare a wolf gives the public lands manager who has fatally wounded him.

Implied in the interpretive activity called forth by the secret is the hope that we could, eventually, discover that secret or get its keeper to divulge it, whether through seduction, trickery, negotiation, violence, legislation, submission, or some act of confidence building. In this era of gossip—both high and low—we assume that secrets are widely distributed as well as generally discoverable. One way of establishing the

humanity or worthiness (of concern, attention, etc.) of a subject is to announce that he or she "has secrets." It establishes the cleverness or motivation of a subject that she has secrets and has somehow communicated that she has them. That communication sets the mode and structure of the clues that will lead to the secret's discovery.

The secret initiates a dramatic narrative. The secret plays out, in its discovery and decoding. Simply identifying something as a "secret" already tells us that the secret will be revealed, or at least that someone will try to unravel it. The drama typically features winners and losers. The one who decodes a secret gains some kind of mastery, some sort of access or power. Having discovered the spy's secret plot, we can foil it, or even exploit it. Divining what a lover "secretly wants" allows one to alter that relationship in some way. In the present case, it is not insignificant that simply claiming the discovery of a "secret" establishes opportunity; locating a secret sets the precondition for solving its puzzle and acting on that solution.

This is precisely the drama Leopold set in motion. The very paragraph—among the most famous paragraph in the green canon—that introduces the "fierce green fire" of the wolf's dying stare confirms that Leopold has decoded the secret; "after seeing the green fire die, I sensed that neither the wolf nor the mountain agreed" (130) that the eradication of wolves was an obvious project, one that would simply make for better deer hunting. Leopold could have made this policy claim on his own authority as a professional land manager if he had said something like, "it is clear that hunting wolves has implications for the entire landscape and ecosystem." Or he could have relied on the authority of science, as have many of his successors in the mountain policy debate.

He chose none of the available options. Presumably, he suspected that science or management would not generate the fervor that he hoped to generate. And Leopold had a more emotional and compelling case to make, because he "sensed" the mountain's position on this issue. The secret had been revealed. But the haste with which it is revealed—as well as the convenient convergence of the mountain's preferences with Leopold's own—raises suspicions. A skeptic might well want to know more. How did Leopold "sense" that? Is there evidence that might be subjected to analysis of some sort? Or was this a spiritual

communication? Without concluding anything about Leopold's intentions, we can still note that such open-ended claims can turn out to be politically useful, allowing humans to vindicate our own aspirations, borrowing the mountain's heft to make our points.

Leopold's personification of mountain and wolf may not seem strange to the contemporary reader. That is the mark of his success; Leopold's bold move succeeds in making what might otherwise seem an odd notion seem almost commonplace. The remainder of this essay tests that acceptance in the case of the mountain. As for the wolf, let us briefly consider the 2005 Werner Herzog documentary *Grizzly Man*. The film's hapless subject, Timothy Treadwell, was an amateur wildlife biologist who had made a career filming Alaskan grizzlies at close range and showing those videos during his winter lecture tours. After Treadwell and his girlfriend, Amie Huguenard, were mauled and partially eaten by a bear, Herzog obtained footage shot by Treadwell. The resulting documentary is augmented with Herzog's interviews of Treadwell's friends and others involved with the story.

Treadwell, obviously a pathetic figure, still had little understanding of the bears after thirteen summers observing them. His judgment obviously had been clouded by his romantic assumptions about the bears. He sensed that these noble, sympathetic, and intelligent bears could not do him harm. For his part, Herzog risks the opposite error, hypothesizing an utterly opaque and indifferent nature that is inevitably hostile. But the film turns on Treadwell's personification of the bears. Treadwell paid dearly, falling victim to a notion of wild animals that has a long history in Western culture but began to be popularized at the core of environmental thought following Leopold's influential essay.

Leopold took less of a risk, but his political move was still bold. We need to remember that he wrote decades before the Disney studio popularized the intensely anthropomorphic wildlife film, a genre that simultaneously distanced us from nature's dangers while promising a false intimacy with nature, via film's well-known tricks (authoritative voice-over, dramatic editing, emotional sound track music). Leopold was risking ridicule from his fellow hunters and hikers, but he knew that the romantic interpretation of nature was well enough established in Euro-American culture that his bet was well hedged. But his wager *was* hedged; it takes continuous cultural effort to maintain the view of

mountain and wolf that Leopold proposes. Those of us who hike or climb mountains know that amid a trek the landscape presents itself as nothing more than a challenge. For some reason (often less fathomable as our exertion continues), we have chosen to spend a perfectly good day struggling against a pile of rubble, which we may well be sharing with animals who could do us serious harm.

Personification is the key to Leopold's argument and to the long political line that follows from it. If it is a person who has the secret (rather than something inanimate), the plot can be thicker. If it is a person who has secrets, those secrets can be interpreted and, perhaps, revealed (confirming or refuting our earlier interpretation). Since interpersonal communication is complex, a reader often allows an author the literary strategies that emerge from problem solving and secret revealing. We know from experience that we sometimes cannot precisely say how we "sense" something about a secret or a clue, even if we are quite certain that we have sensed it. And having sensed something that matters, the one doing the sensing (the sensitive one) may well have invited the one whose secret has been sensed into a more active role in the drama.

In a mystery story, if the detective "senses" that a crucial physical clue may be close at hand, that merely reflects the detective's talent; he has sifted through numerous variables, determining "in a blink" where the clue will be found. But if that same detective "senses" that a witness is lying, the narrative has accorded authority and agency to both the detective and the witness. We now know that both will be crucial as the drama plays out. Throughout Leopold's essay, it is not only the wolf that is implicated in Leopold's moral drama—it is the wolf and the mountain. The wolf is integral to the mountain's ecology, to its health. "I now suspect that just as a deer herd lives in mortal fear of its wolves, so does a mountain live in mortal fear of its deer" (132). So the mountain not only carries superhuman capacities, secrets, and some kind of communication mechanism; it carries mortal fears as well. It is fully, elaborately human. It listens, understands, feels, fears, and lives.

We know little about how Leopold "sensed" the mountain's "secret opinion." He recited no list of the clues he gathered. That gap does not diminish the essay; after all, the essay does not need to elaborate how Leopold senses and the mountain signals. It is enough to establish that

the mountain is personified. And the fact that Leopold's essay is so brief suggests he may have understood this: the real point of the essay is to turn the mountain into a person. Even if he did not plot all this out, Leopold's many readers have generated a reading that establishes the personification of the wild landscape as the very core of what would become known as environmental politics. Environmentalists, after all, speak for nature. They have become the mountain's translator.

Although Leopold's brief essay only suggests that he sensed the mountain's preferences and that the mountain listens, personhood also raises the question of how the mountain sees. We are familiar with the mountain's role in providing a perspective from which a person could see something difficult to see (impossible, before the development of artificial flight) unless one scaled the mountain. Indeed, given the intense interest in "the gaze" in recent social and aesthetic thought, this question of vision must now loom large in any consideration of the mountain's senses. So it is to vision that I now turn.

John Berger

John Berger started his seminal politico-phenomenological manifesto *Ways of Seeing*, published in 1972, with a proclamation of ambiguity. This might seem an odd beginning for such a politicized intellectual to select: "It is seeing which establishes our place in the surrounding world; we explain that world with words, but words can never undo the fact that we are surrounded by it. The relation between what we see and what we know is never settled."[2] Still, the ambiguity Berger acknowledges is deeply rooted in relations that easily lend themselves to the political. And, notably, one of the book's first examples involves a landscape:

> Soon after we can see, we are aware that we can also be seen. The eye of the other combines with our own eye to make it fully credible that we are part of the visible world. *If we accept that we can see that hill over there, we propose that from that hill we can be seen.* The reciprocal nature of vision is more fundamental than that of spoken dialogue. And often dialogue is an attempt to verbalize this—an attempt to explain how, either metaphorically or literally, "you see things," and an attempt to discover how "he sees things."[3]

We see, and we therefore know there is at least the possibility that we might *be seen* by what we see or from the place we are seeing. The two events—seeing and being seen—are core events in our individuality and our personhood. This "reciprocal" character of sight is central not only in establishing personhood, however. As a generation of social theorists have explained since Berger's book was published, it puts vision events at a crucial social and political location. "What we have seen" establishes authority, most obviously in the case of journalists, trial witnesses, and scholars. "How we are seen" is the conceptual basis for a politics of identity, as well as for history more generally.

This matter of seeing and being seen has long been near the heart of the human fascination with mountains. After we climb up a ways, we peer down and exclaim, "Look, that's where we just were." It is a way to measure the effort it took to get to our viewpoint, a representation of our ability to make goals and then achieve them. We catalog the landscape features we can see, and remark on how far we can see from here. In a sort of economy, the effort we took to get up the mountain justifies the greater scope of vision we now have. The mountain is a pedestal on which we have placed ourselves, by our own effort (hence the disdain many hikers have for roads that let drivers get their views too easily). Such vistas make mountains important in wartime. Control of the highest observation points means one can see more of what the adversary is doing.

Historian and critic Simon Schama's *Landscape and Memory* argues the impact that landscape—inevitably influenced by human intervention—has, in return, on the humans who experience it.[4] Schama understands that mountains are crucial to this relationship. We see the mountains; we imagine possessing the power of standing on top of mountains; we experience the satisfaction of having climbed one. All of these are power relationships. Given our fascination with seeing mountains, measuring them as pedestals of power, and so on, the next step makes sense. As Schama recounts, carving a mountain in the image of a human being is something many cultures, going back a very long time, have imagined. His brief survey of the record mentions "Angkor Wat and the heads of Easter Island" (394) but quickly moves on to emphasize two other cases, one ancient and one contemporary.

Schama relates the story of how Dinocrates was hired as Alexander's

architect. Dinocrates proposed to carve Mount Althos into a human shape, implying that Alexander would be the appropriate model (401–2). (Mountains, being monumental, also have a long intersection with the notion of monuments.) Nestled in the sculpted figure's right hand would be a town, and in the left, a bowl to collect the town's water supply. Alexander reportedly turned the plan down immediately, because the town, up on the mountain, would lack a food supply. But in a way, Dinocrates's proposal worked. Alexander hired the ambitious young architect, sending him off to design Alexandria.

As Schama documents, Dinocrates entered into the literature of architecture as a case study of the folly inherent in excessively grandiose plans. Still, Schama concludes that the critique carries another story, too: "But as much as these generations of writers invoked Dinocrates as a negative model, the fantasy of a mountain colossus haunted the dreams of the superegotistical" (404). Dinocrates's ambition was not forgotten. Michelangelo wanted to carve the marble cliffs at Carrara (404). Repeated sketches and engravings over the centuries (several of which are reprinted in Schama's book) imagined possible implementations of Dinocrates's proposal.

In a memorable recent case, the Afghani Taliban sought to confirm their religious superiority by exploding several Buddhist images carved into a mountain. This was widely decried as disrespectful of Buddhism, which it surely was. But it was also an act of violence against a mountain-person; this site, the demolition confirmed, was important. It was worth fighting over. There was a war going on over disrespect (among other issues). Radical Islamists protested mightily when their religion was disrespected, as the demonstrations and violence over the mere cartoons of Muhammad subsequently revealed. Islam's importance was to be elevated by the comparison; when someone is disrespectful of Islam, churches burn and cities are in turmoil. What is more, the Taliban effectively added, our ultimate reply to your disrespect is to return it, with the stakes increased.

So, when Leopold pulled the literary move of turning the mountain into a person, he participated in a cultural ambition with a long history. The mountain sees. It makes judgments of us. It is not such a big leap from there—attaching this personification to all the power issues associated with mountains—to begin imagining the mountain

as a person. Of course, early efforts to actually carve mountains into human images were rough; it is not the same as working on a chunk of marble in a studio. But, eventually, with dogged effort and improved technology, humans got better at it.

Schama's favorite example of the personification of a mountain involves Mount Rushmore. The core issue here is monumentalism: "For [Rushmore's artist, Gutzon] Borglum, bigness was bigger than just big: it was endurance, magnificence, the spiritual awesomeness" (394). The impulse is imperial, as Schama explains: "To make over a mountain into the form of a human head is, perhaps, the ultimate colonization of nature by culture, the alteration of landscape to man-scape" (396).

Putting a human image on a mountain is an act of appropriating the mountain (and all it implies: largeness, permanence, awesomeness) into the realm of those who carve it, and then of those who contemplate the carver's work. Like many acts of colonization, the carving compensates for a discrepancy. Schama explains:

> Raw topographical scale, after all, seems to declare the littleness of man in nature. But this is to reckon without what was inside those heads: the force of ingenuity and will. The exercise of those human qualities, so the mountain-masters believed, might correct for scale, and the temerity of the peaks be transformed into a compliment to the mountainous supremacy of man. Of all landscapes, then, mountain altitudes were fated to provide a rule against which men (for this was a distinctively masculine obsession) would measure the stature of humanity, the reach of empire. (396)

Schama thus traces the personification impulse this way; the "mountain-masters" imagine that humans, enacting the best of their humanness, "correct for scale," transforming the magnitude of mountains so as to put them to work on human projects. Mountains could intimidate lesser humans than the mountain-masters, but the mountain's colonization could even further inflate those already large masters. Of course, others might trace the personification process along somewhat different lines. The architect Frank Lloyd Wright reportedly remarked, "the heads on Rushmore made it look as though the mountain had responded to human prayer."[5]

Many of the classic national parks in the United States are inflected by the aesthetic principles I have been developing in this essay. They are commonly described as "inspiring," as if they were inhabited by a moral presence. The most scenic of them were prime locales for America's classic landscape artists, who portrayed dramatic mountains as utterly luminous. The monumentalism inherent in the paintings (and then in endless "Kodak moment" snapshots) provides the perfect visual dimension of American exceptionalism.

Mount Rushmore

One National Park Service (NPS) domain (it is actually a national monument) took the personification of the mountain, as well as American monumentalism, to another level. Without question, Rushmore is among our strangest monuments. And it is also among the most popular NPS sites. Environmentalists often cite the popularity of the NPS units as confirmation of the American commitment to preserving nature; the status of NPS units was hotly debated when the Wilderness Act was passed in the 1960s (only to have the controversy move almost entirely to the U.S. Forest Service, once the NPS belatedly figured out how good the Wilderness Act would be for its own interests).

Still, many NPS sites have little to do with natural landscapes. The supremely unnatural Rushmore is one of the most popular attractions in the United States, despite its extremely remote location, hundreds of miles from any concentrated population. Yellowstone is enormous, with 2 million acres of wildlife, mountains, geysers, lakes, historical sites, and so on. It attracts 3 million visitors annually. Rushmore is a comparatively miniscule 1,278 acres, a mere 20 of which are easily accessible. It attracts 2.5 million visitors annually.[6]

The low acreage provides a hint that at Rushmore this question of monumentalism is a little tricky. In his recent book *Great White Fathers,* John Taliaferro poses a clever question: "At first sight, does Rushmore seem larger than expected or smaller? My guess—my experience, anyway—is smaller" (17). Taliaferro explains this in terms of the gigantism that has taken over human culture in the years since construction was halted on Mount Rushmore in 1941, and that is fair. Now, we look to see whether some entrepreneur has managed to paint an advertisement

in space, and even the elite newspapers and magazines regularly publish architecture reviews of ever-bigger skyscrapers.

Rushmore's scale is odd: the "correction for scale" Schama observed takes an odd turn in practice. Rushmore is obviously superhuman, and the idea of making those images at that scale captures the imagination. But the mountain is not large, by any standard pertaining to mountains. Humans added size to this mountain, by chipping its granite away and refashioning it to the human exercise. The mountain-masters both make nature grander and smaller at the same time. Even Rushmore's name combines ambitious aggrandizement and dusty underachievement. Charles Rushmore, a New York attorney, visited the region to study tin mining prospects, which turned out poor. Salvaging the trip, he noticed that while the existing mines all had names, the mountains often did not. So he attached his name to this one (209).

Taliaferro is not disappointed by his reaction to the monument's physical scale:

> When I approached Rushmore . . . , I anticipated something supernatural, like the lofty mountain spires in an Albert Bierstadt painting. But much to my surprise and satisfaction, I found myself gazing upon something very human—human in form, . . . but also human in execution. And this, I would later come to appreciate, is the glory of Mount Rushmore: It is a true piece of sculpture. (17)

I think Taliaferro has this right. The site reenacts a subtle project of personification. Rushmore reflects us back to ourselves—and not at unrecognizable scale—while it also puts Borglum's (and our) historical monumentalism to a test. At the same time, we are invited to identify with it, to imagine having that size, permanence, even that view. If anything, Rushmore's surprisingly human scale makes its emphasis on sight even more important. It is a view worth fighting over, which implies that there is something to be seen from there, that the four presidents are watching.

As a sculpture, Rushmore's great innovation (in addition to the technical problems Borglum solved) is precisely in the presidents' eyes. Borglum carefully let remain a little spike of granite in the middle of each iris, avoiding the "blank eyeball" look that gives many unpainted sculptures an "unseeing" appearance. At a distance, Rushmore's eyes

seem much more lively, much less inert than do the eyes of many other monumental sculptures. The point is emphasized by the trick Borglum performed to make it appear that Teddy Roosevelt really is wearing spectacles. Enough of the frames are included to carry that illusion, a trick Taliaferro cites as his favorite on the mountain. The seeing mountain is a crucial part of Rushmore's appeal. This mountain even wears eyeglasses.

Alfred Hitchcock's film *North by Northwest* gave the mountain "eyes" by planting a spy over Washington's shoulder, a variant on Berger's theme that sees and imagines the return gaze. In the film's conclusion, the spy (working for some adversary, presumably the USSR) maintains a swank mountain retreat a short distance from the top of the heads. In his narrative, a mountain that can see could go turncoat, be captured by the enemy. Hitchcock's Cold War masterpiece is one of the great cultural statements of that era's paranoia, and where else better to re-enact that paranoia than at Rushmore? The NPS replicated the paranoia when it skittishly set all sorts of conditions on Hitchcock's filming: "No scenes of violence will be filmed near the sculpture, on the talus slopes below the sculpture, or any simulation or mock-up of the sculpture. . . . [F]ilm editing . . . may not lead viewers of the finished . . . motion picture to believe that violence occurred on or near the sculpture."[7]

Hitchcock, perhaps predictably, ignored the prohibition, just as he managed to get an illegal exterior shot of Cary Grant entering the United Nations complex in New York for an early scene in the movie. After filming for a few days on the Rushmore grounds, Hitchcock moved to the Hollywood soundstages, where the famous chase scenes (including violent confrontations) were filmed on elaborate sets that made it appear that the actors were on the Rushmore faces, which they never were. The NPS was horrified by the final film, as if to confirm that Rushmore was no longer a mountain but some kind of personification whose honor had to be protected. Nowadays, Hollywood can film anywhere, and the idea of protecting a location's honor may seem quaint. But this was a Cold War epic; there was a hunt on to find a battlefield, a site for a struggle. Of course, it was not only the battlefield that was missing; so were the spies themselves, remaining elusive and either, according to one's politics, hidden or absent.[8] No opponent, no battlefield. Hitchcock located the battlefield precisely.

The other notable struggle over Rushmore's sight lines involved Native Americans and the American Indian Movement (AIM). In a popular AIM-era biography, Sioux medicine man John Fire Lame Deer tells Richard Erdoes about protesting atop Rushmore. Lame Deer casually deconstructs the national symbol:

> Here we are, sitting on Teddy Roosevelt's head. . . . If we get tired of the view from here, we could move over and sit for a while on Washington or Lincoln or Jefferson, but Teddy is by far the best. There is moss growing near the back of his skull, lots of trees, firewood, boulders to lean your back against, a little hollow surrounded by pines, which makes a nice campground—especially with that cliff rising behind it on which that big "Red Power—Indian Land" sign is painted.[9]

During the protest, described in detail by Taliaferro, the NPS was intensely concerned that the protestors would pour red paint on the faces, but that never happened. Russell Means, the AIM activist, did report a more minor defiling, a psycho-sexual gesture one could analyze at length: "One afternoon, I climbed over to the top of George Washington's head, opened my fly, and peed on him."[10] That gesture evidently appealed greatly to the activists; Lame Deer reports a similar incident involving a different activist.

Even environmentalists have partaken in this personification, although their official position toward the sculpture has always been that it is a desecration. Even before carving began, the Sierra Club formally opposed the project.[11] This literal, too-situated personification of nature would not do. It was too confused with American imperialism and Great Men. It could not be transferred to natural in general, or to environmentalist positions in particular. This is not what greens meant when they claimed the right to translate nature's voice!

Nonetheless, the trick proved too good to pass up forever. Greenpeace conducted the most notable post-AIM protest at Rushmore in 1987. Several climbers managed to get onto the mountain, where they released a banner ("We the people Say No to Acid Rain"), which hung under George's chin. That protest also personified the mountain: the faces presumably were included in "the people" represented by the banner's slogan, and they would have had a significant stake in acid rain's corrosion of their "skin."[12] In Greenpeace's action, there is a play of

perspectives; the greens want to speak for the (living) mountain, even presumably this one that has been defiled with human images. But the protest's joke appropriates the human images carved into the mountain.

Conclusion

Borrowing from Michel Foucault, I would call Rushmore an odd heterotopia of the personification of nature. Wishing to displace the social scientific reliance on physics (forces and resistance) or nature, Foucault argued that a geographical sense, emphasizing sites of emergence and contest, would move an understanding of human matters from the metaphysical toward the genealogical. One might study social meanings in the "relations among sites" that mattered.[13] All monumentalists, and surely Rushmore's artist, Gutzon Borglum, see monuments as implying utopia, that hypothetical place we use to confirm categories as grand as Borglum could imagine.

Introducing heterotopia, Foucault emphasizes the reality of such sites, as opposed to the unreality of utopias. A political phenomenon related to utopian fantasy, but linked to actual sites, thus enters into the political world with a different relationship to the imaginary:

> There are also . . . real places—places that do exist and that are formed in the very founding of society—which are something like counter-sites, a kind of effectively enacted utopia in which the real sites, all the other real sites that can be found within the culture, are simultaneously represented, contested, and inverted. . . . Because these places are absolutely different from all the sites that they reflect and speak about, I shall call them, by way of contrast to utopias, heterotopias.[14]

Foucault thought heterotopias have been familiar throughout history.[15] He placed much of his most famous work in this context. "Heterotopias of deviation" are privileged in the contemporary era, exemplified by the prisons and mental wards in which "individuals whose behavior is deviant in relationship to the required . . . norm are placed."[16] The examples Foucault lists—including mirrors, the cemetery, the theater, cinema, the garden, the museum, and the library—suggest an analytical approach with broad applicability.

As a spatial analytic, heterotopia provides an opening for one of

Foucault's most important contributions, the emphasis on inclusion and exclusion: heterotopias "always presuppose a system of open and closing," which further implies (while also resituating) the rules that the political world always takes so seriously. While modern politics often phrases its exclusions and inclusions as reflections of nature (whether human nature, Natural Law, or in the case of environmentalism, non-human nature), Foucault's notion of the heterotopia encourages us to see these inclusions and exclusions as human choices—strategies rather than discoveries. When Foucault discusses the functioning of heterotopias, he sets a basis for altering the sense of "nature's" personification that environmentalists inherited from Leopold:

> Heterotopias . . . have a function in relation to all the space that remains. This function unfolds between two extreme poles. Either their role is to create a space of illusion that exposes every real space, all the sites inside of which human life is partitioned, as still more illusory. . . . Or else, on the contrary, their role is to create a space that is other, another real space, as perfect, as meticulous, as well arranged as ours is messy, ill constructed, and jumbled. This latter would be the heterotopia, not of illusion, but of compensation.[17]

In this sense, the retreat to nature, an activity central to the environmental culture (in the form of hiking, backpacking, gardening, and so on), can be recast, departing from the transcendentalism and naturalism that has so characterized environmental thought. In short, although green intellectuals have insisted on a specific sense of nature moralism—sometimes in almost hysterical terms[18]—there is another way to get to the political position they want to claim. As I have argued elsewhere, this question of the status of "nature" is not merely some scholarly quibble.[19] A movement that insists on political naturalism as its first principle is, from the start, at risk of acquiring a debilitating moralism and losing the ability to strategize. Foucault's heterotopia and Schama's interpretive connection of landscape and memory both help in this intellectual recovery project; there are ways to reconceptualize the green relationship to nature, emphasizing nature but still avoiding the traps that threaten to snare the adamant naturalist.

The history of environmentalism displays the risk. Opponents discovered ways to exploit the problems inherent in green naturalism. Not long after Earth Day, critics argued that environmentalist concern for "nature" was a cover for protecting amenities for the already privileged. For a quarter of a century, greens watched resentful adversaries gain force, cordoning off environmentalism as a mere interest group, even while the demonstrably real and remarkably widespread environmental crisis grew steadily. Environmentalists responded by appealing to science's findings on natural phenomena. One of the reasons that the appeal to science is often thwarted may be that greens have also been reading Leopold and taking too literally his odd naturalism.

I am not arguing that Leopold should be discredited. After all, Leopold wrote from an urgency that could not anticipate something like "environmentalism," which could pass laws and litigate intrusions on "nature." His world-altering prose was nobly intended; to make the point that mountains are subject to forces over a longer time frame that might well be hard for humans to grasp, Leopold engaged in exaggeration, a time-worn political form. But Leopold attracted followers who did have a movement and the attendant need for power. That Leopold's "Thinking like a Mountain" could be adapted with so little caution or ambivalence says something about that movement. At the very least, greens who think it is obvious that citizens should listen to climate change scientists need to understand that it is just as obvious that when they begin translating the voice of wolf and mountain, they are opening themselves up to charges of mysticism and opportunism.

Leopold made a bold move, and the move worked: a movement was born. But that movement never sufficiently understood the need for reflection on its own motives. There is considerable irony here. It was precisely such reflection that prompted Leopold to the turn represented in his famous essay; he was, in a sense, recanting a career of "managing" public lands. For him, the change to being a translator rather than a manager was an act of humility. Leopold stands at a crucial point in green naturalism. On one hand, translating for nature (without accounting for the potential arrogance of that role) aggrandizes greens; this is the possibility that a generation of antienvironmentalists almost immediately understood and used to great political advantage. But Leopold

also posed a solution to that political puzzle. Unlike Borglum, Leopold did not personify the mountain to aggrandize himself or his nation. His humility granted the mountain its own voice, rather than rendering it a monument to some imperial impulse. Like the self-aggrandizing "mountain-masters" Schama studied, Leopold made himself larger, but he did it by making the mountain more autonomous, not less.

What Leopold did went beyond the landscape artists and the monumentalists Schama reviewed. Leopold broke through because he identified with the mountain, partnered with it, and then took its observations and emotions as his own. Not himself particularly savvy about politics, Leopold seemed oblivious to the tension carried within his essay. A generation later, Foucault's arguments about power expressed that tension precisely; when we naturalize power (our own or someone else's), we lose the ability to identify the implications of power's functions and, especially, the ways in which it is transformed or mobilized. This is why Foucault went to the trouble of explaining heterotopias in such detail, to help his readers cut through the naturalism that now seems to be contemporary power's most important project.

What was lost when the environmental movement canonized Leopold—while at the same time missing the political tension he represents—is humility or self-reflection on the scale Leopold achieved. One cannot simply announce that one is humble; that is the sort of performance we associate with blustering politicians, and we all know how to see through their bluster. Humility has to be enacted, and Leopold accomplished such an enactment, working against modern imperialism and arrogance. But building on his model, greens cannot simply revert to the habits of the blustering politician, who asserts—but cannot enact—his or her humility.

In Bruno Latour's simple articulation, merely by acknowledging the prospect for "multinaturalism," alongside the now commonplace "multiculturalism" or "multinationalism," we have already begun to revise the environmentalist reliance on a personification of a singular, moralized nature that no longer provides the basis for authority claims that once might have seemed effective and, even, necessary.[20] Were it possible for greens to read Leopold as a pioneer multinaturalist, an intellectual figure who brought nature into the ongoing political struggles of our time, we might finally move beyond naive naturalism and begin

to respond more effectively to the resentful backlash that now is the greatest obstacle for those who work in Leopold's tradition.

NOTES

I am deeply grateful to the late Hank Harrington, professor emeritus of English and environmental studies at the University of Montana, Missoula, who first suggested this topic to me, suggesting Schama and Berger as sources. I also want to acknowledge the contribution of R. McGreggor Cawley, with whom I cowrote on heterotopia in an earlier essay, cited below, as well as a number of colleagues who heard and responded to earlier versions of this essay.

1. Aldo Leopold, *Sand County Almanac* (New York: Oxford University Press, 1966), 137. Subsequent page references are given parenthetically in the text.

2. John Berger, *Ways of Seeing* (New York: Penguin, 1972), 7.

3. Ibid., 9; emphasis added.

4. Simon Schama, *Landscape and Memory* (New York: Knopf, 1995). Subsequent page references are given parenthetically in the text.

5. Ibid., 399, quoting Lincoln Borglum and June Culp Zeitner, *Borglum's Unfinished Dream* (Aberdeen, S.Dak.: North Plains Press, 1976), 68.

6. John Taliaferro, *Great White Fathers: The Story of the Obsessive Quest to Create Mount Rushmore* (New York: Public Affairs, 2002), 19. Subsequent page references are given parenthetically in the text.

7. Ibid., 332.

8. It is worth noting that Slavoj Žižek's reading of *North by Northwest* relates to the interchange between self and Other, as well as a missing actor, focusing on an earlier scene in the film. The plot is set in motion when the Russians kidnap an innocent bystander (Thornhill), mistaking him for another man who does not actually exist but was invented by the CIA to mislead them. The Russians then interrogate Thornhill. Žižek assesses the scene: "Of course, Thornhill knows nothing about it, but his professions of innocence pass for a double game. . . . Thornhill's situation corresponds to a fundamental situation of a human being as a being-of-language. . . . The subject is always fastened, pinned, to a signifier which represents him for the other, and through this pinning he is loaded with a symbolic mandate, he is given a place in the intersubjective network of symbolic relations. [T]his mandate is ultimately always arbitrary: since its nature is performative, it cannot be accounted for by reference to the 'real' properties and capacities of the subject. So, loaded with this mandate, the subject is automatically confronted with a . . . question of the Other. The Other is addressing him as if he himself possesses the answer to the

question of why he has this mandate, but the question is, of course, unanswerable." Slavoj Žižek, *The Sublime Object of Ideology* (London: Verso, 1989), 112–13. In short, the question of personifying an Other—and issuing that Other a mandate—is raised by Hitchcock earlier in the film, before that vividly personified mountain shows up in the movie.

9. John (Fire) Lame Deer and Richard Erdoes, *Lame Deer, Seeker of Visions* (New York: Simon and Schuster, 1972), 91.

10. Russell Means with Marvin J. Wolf, *Where White Men Fear to Tread: The Autobiography of Russell Means* (New York: St. Martin's Press, 1995), quoted in Taliaferro, *Great White Fathers*, 355.

11. Taliaferro, *Great White Fathers*, 59.

12. Ibid., 400.

13. Michel Foucault, "Of Other Spaces," *Diacritics* 16 (Spring 1986): 22. The essay was the basis for a lecture given by Foucault in 1967.

14. Ibid., 24.

15. This part of the argument draws on my contributions to William Chaloupka and R. McGreggor Cawley, "The Great Wild Hope: Nature, Environmentalism, and the Open Secret," in *In the Nature of Things: Language, Politics, and the Environment,* ed. Jane Bennett and William Chaloupka (Minneapolis: University of Minnesota Press, 1993), 3–23.

16. Foucault, "Of Other Spaces," 24–25.

17. Ibid., 27.

18. See William Chaloupka, "Jagged Terrain: Cronon, Soulé, and the Struggle over Nature and Deconstruction in Environmental Theory," *Strategies* 13, no. 1 (Winter 2000): 23–38.

19. See Chaloupka, "Jagged Terrain"; Chaloupka and Cawley, "The Great Wild Hope"; and William Chaloupka, "The Tragedy of the Ethical Commons: Demoralizing Environmentalism," in *The Politics of Moralizing*, ed. Jane Bennett and Michael J. Shapiro (New York: Routledge, 2002), 113–40.

20. Bruno Latour and Catherine Porter, *Politics of Nature: How to Bring the Sciences into Democracy* (Cambridge, Mass.: Harvard University Press, 2004).

10. GEORGE CATLIN'S WILDERNESS UTOPIA

Albert Boime

GEORGE CATLIN may have been the first notable American preservationist, envisioning a kind of state park in the wilderness for the ingathering of indigenous peoples. Catlin's wilderness strategy would have been the natural counterpart to his gallery of memorabilia that symbolically summed up the histories of a supposedly vanishing species.

Contemporary conservatives hated Catlin because his respectful depictions and statements about the social life (whether accurate or not) of Native Americans flew in the face of the official racist contempt and murderous rhetoric that by the 1840s had condemned them to oblivion. He spoke frankly about government fraud and its policies of signing "treaties" with the various tribes for the acquisition of vast tracts of land—treaties for which they had shown far more respect than those who promoted the exchange. Catlin was dismissed as a whining and befuddled tourist whose documented scenes were not to be trusted. Ironically, modern progressive social scientists and art historians have also criticized Catlin's project for his idealizations and distortions; unable to distinguish between a Catlin or a Remington, they behave as if any limner of Native American life was by definition racist at worst, exoticizing at best.[1] Julie Schimmel, for example, asserts that Catlin's self-portrait among the Mandans demonstrates the self-conscious posturing that "permeated the relationship between whites and Indians." She then describes the painting, based on his frontispiece for his publication of 1844 (Figure 10.1):

> Catlin stands dressed in a contrived buckskin outfit that makes of
> western garb a fashionable eastern suit. Poised with brush in hand

before his easel, he paints the Mandan chief Máh-to-tóh-pa as a reflection of his own self-conscious controlling image. The artist's stance among a spell-bound crowd of half-nude Indians leads the viewer to believe that nothing but reality is being recorded, but Catlin's relationship to his subjects comes straight from the drawing rooms of eastern society, as Indians are submitted to a portrait process that cherishes individuality, material status, and vanity— all notions less highly regarded in Indian culture.[2]

Frances K. Pohl claims that Catlin engaged in what the anthropologist Renato Rosaldo called "imperialist nostalgia," a yearning for a ruined culture by one who has indirectly or directly participated in its destruction. Pohl sees in Catlin's deliberate exclusion of certain symbolic accessories from the portrait of Máh-to-tóh-pa an attempt to sustain the ideal of the "noble savage" and thus preserve the colonial nostalgia.[3]

At the other extreme of this art historical bashing are the unrestrained claims of social scientists for Catlin's "surpassing importance to students of Indian culture," and for his vision having "become part of our understanding of a lost America." One writer declares that the aggregate of Catlin's work constitutes "the first, last, and only 'complete' record of the Plains Indians ever made at the height of their splendid culture, so soon destroyed by traders' liquor and disease, rapine, and bayonets." Excepting the omissions of detail and occasional exaggerations due to lack of time in the field, "we can trust George Catlin to show us things just as he saw them."[4]

I will argue a position between these two extremes, one that I think comes closer to the reality Catlin experienced. Catlin was a creature of his class and social biases and always ambivalent toward the Indians, but he was also unusually self-aware and tried to monitor these prejudices to trouble the stereotypes and make his readers and spectators of his pictures grasp the Indians as complex human beings, with similar flaws and virtues as themselves. His subjects are rarely romanticized or stereotyped in the way we find in John Vanderlyn and Horatio Greenough. It is true that he lacked their sophistication and talent, but in his case the self-taught look manifested and reinforced his direct engagement with his subjects.

Looking again at Catlin's frontispiece to his publication on the North American Indians, we may indeed agree with Schimmel's observation of

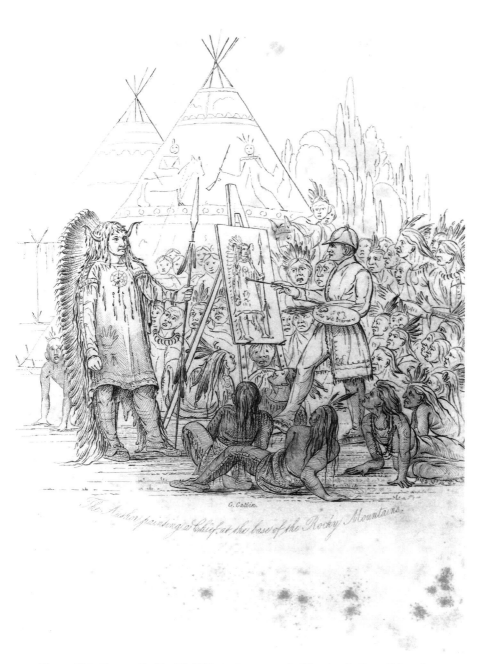

G. Catlin.

The Author painting a Chief at the base of the Rocky Mountains.

Figure 10.1. George Catlin, "Self-Portrait among the Mandan Indians," frontispiece to *Letters and Notes on the Manners, Customs, and Conditions of the North American Indians* (1844). New York Public Library, New York.

the stilted manner of the white artist in fanciful buckskin guise submitting Native Americans to a controlling gaze and re-creating a scene in the wilderness for middle-class easterners. Yet what strikes me right off is that pride of place in the composition is assigned to the chief, while the artist is all but swallowed by the crowd of admirers. Catlin deliberately satirizes himself and his outfit as out of place in this environment, and subordinates his position as reporter to the dignity and commanding stature of his subject.

Pohl, referencing Kathryn Hight, observes that the frontispiece illustration erroneously depicts the Mandan chief in front of tipis—the provisional dwelling of the nomadic Plains tribes—when the sedentary Mandans actually lived in spherical earth structures. Hight and Pohl conclude that Catlin thus participated in the creation of the generic, stereotyped Indian, a view that erases differences and makes the tipi the sign for this generic type.[5] Catlin's claim to an authentic record of the particularities of tribal life is thus contradicted by his false insertion of the conical, buffalo hide–covered lodges. However, since Catlin himself takes great pains to make the distinction in the text and paints several scenes showing the spherical dwellings, it would seem odd that he would contradict himself so flagrantly in its key illustration. In fact, the Mandan made use of both structures, as is seen in Catlin's drawing and printed illustration of a Mandan sweathouse (Figures 10.2 and 10.3).[6] In addition to being used to house the wicker bathtub, tipis are seen being used in the background of the drawing alongside of the domed-shaped huts for similarly supplemental and ritual-like functions.

Schimmel's claim that Catlin submitted the Mandan chief to a portrait process emphasizing values of individuality, material status, and vanity that ran counter to the values of Indian society betrays her own bias and idealization of American Indians. Catlin in fact documented over and over again the vanity of the chiefs in wishing to pose for the painter in their best finery surrounded by the trappings of their rank and status. On the response of the Sioux chiefs and braves to his portraits, he reports:

> The vanity of these men, after they had agreed to be painted was
> beyond all description, and far surpassing that which is oftentimes
> immodest enough in civilized society, where the sitter generally
> leaves the picture, when it is done to speak for, and to take care of
> itself; while an Indian often lays down, from morning till night, in

Figure 10.2. George Catlin, "A Mandan Sweathouse," drawing for plate 111 from *Letters and Notes on the Manners, Customs, and Conditions of the North American Indians,* volume 3 (1844). New York Public Library, New York.

Figure 10.3. George Catlin, "A Mandan Sweathouse," plate 111 from *Letters and Notes on the Manners, Customs, and Conditions of the North American Indians,* volume 3 (1844). New York Public Library, New York.

front of his portrait, admiring his own beautiful face, and faithfully
guarding it from day to day, to save it from accident or harm.[7]

It is certainly true that Catlin could have misconstrued the response,
perhaps based less on vanity than on the presumed magical power of
images, but at other times Catlin documented the need of the chiefs to
come out in full regalia and ornamentation for the representation, and
even observed certain tribal "dandies" (perhaps gay males) who strut-
ted and paraded around the village in gorgeous costumes. Lastly, he
recalled that Seneca chief Red Jacket wished to be painted standing on
the Table Rock, overlooking Niagara Falls, over which his spirit was
to hover after his death. Even if this may be interpreted in theologi-
cal rather than in material terms, the strategic choice of Red Jacket—
famous for his oratorical gifts—still projects his towering authority and
sense of the grandiose.[8]

Again, I agree that Catlin reveals the limitations of his historical
epoch, but he is a much more complex type than that characterized by
either Schimmel or Pohl. Although trained as a lawyer, Catlin gave up
that profession for art but never ceased practicing his entrepreneurial
skills. A desultory portraitist of the likes of DeWitt Clinton, Catlin's
career received a shot in the arm by Andrew Jackson's Indian Removal
Act of 1830, which presented the artist with his opportunity of a life-
time. Catlin began his quest in 1832—the year Chief Black Hawk de-
fiantly led a thousand Sac and Fox warriors back to Illinois only to be
driven back across the Mississippi—with the aim of producing

> a literal and graphic delineation of the living manners, customs,
> and character of an interesting race of people, who are rapidly
> passing away from the face of the earth—lending a hand to a dying
> nation, who have no historians or biographers of their own to pour-
> tray with fidelity their native looks and history; thus snatching from
> a hasty oblivion what could be saved for the benefit of posterity,
> and perpetuating it, as a fair and just monument, to the memory
> of a truly lofty and noble race.[9]

Catlin thus chose not to help rescue them physically as a crusading John
Brown, but rather to salvage their culture in his role as artist through
representation. Unable to make a living as a portraitist of those who
wore "black and blue cloth," he looked to a less sophisticated culture

to exploit, whose models were "unrestrained and unfettered by the disguises of art," and in an environment that "is unquestionably the best study or school of the arts in the world . . . the wilderness of North America." He wants to take credit for the originality of his enterprise, "as I was undoubtedly the first artist who ever set out upon such a work, designing to carry his canvass to the Rocky Mountains . . . long before the Tours of Washington Irving and several others, whose interesting narratives are before the world."[10]

He shows unmistakable ambivalence in his attitudes toward Native Americans: on the one hand, he rejects the stereotypical contrasts between white and tribal cultures, declaring that Indians are "human beings, with features, thoughts, reason, and sympathies like our own," but then, on the other hand, he is apt to dismiss their religious ceremonies as so many "absurdities." He unexpectedly takes on the commonplace term of *savage* as a means of deliberately stigmatizing the Indians, observing that it is "our ignorance and dread or fear of these people" that has "given a new definition to the adjective; and nearly the whole civilized world apply the word *savage,* as expressive of the most ferocious, cruel, and murderous character that can be described," but then he goes on to use the term himself ad nauseum to describe the native peoples he encounters.[11]

His paternalism also comes through in the following passage, where he proposes acculturation:

> I deem it not folly nor idle to say that these people *can be saved,* nor officious to suggest to some of the very many excellent and pious men, who are almost throwing away the best energies of their lives along the debased frontier, that if they would introduce the ploughshare and their prayers amongst these people, who are so far separated from the taints and contaminating vices of the frontier, they would soon see their most ardent desires accomplished and be able to solve to the world the perplexing enigma, by presenting a nation of savages, civilized and christianized (and consequently saved), in the heart of the American wilderness.[12]

This statement seems to agree with the one popular hope entertained by white philanthropists for saving the supposedly doomed Indian, yet Catlin differs markedly from the general line of Christian reformers in

suggesting that traditional Indian morality and religion hold out greater potential for Christianity than that of the "civilized" mass of whites living degraded lives along the frontier. Here he identifies what he valued within himself with what he esteemed about the communities subject to his scrutiny: "How I love to feel the gladdened souls of native men, moved by natural, human impulse, uninfluenced by *fashion* or a *motive*! Mine, I *know,* has something remaining in it yet."[13]

Catlin does generally accept the inevitable demise of the Native Americans, but unlike such professional apologists for Indian removal as Henry R. Schoolcraft, he does not attribute this inevitability to their inability to change or to their frail physical and mental traits.[14] Instead, he lays the blame for this demise squarely at the foot of the true culprit:

> The Indians of North America . . . less than two millions in number—were originally the undisputed owners of the soil, and got their title to their lands from the Great Spirit who created them on it,—were once a happy and flourishing people, enjoying all the comforts and luxuries of life which they knew of, and consequently cared for:—were sixteen millions in numbers, and sent that number of daily prayers to the Almighty, and thanks for his goodness and protection. Their country was entered by white men, but a few hundred years since; and thirty million of these are now scuffling for the goods and luxuries of life, over the bones and ashes of twelve millions of red men; six millions of whom have fallen victims to the small-pox, and the remainder to the sword, the bayonet, and whiskey; all of which means of their death and destruction have been introduced and visited upon them by acquisitive white men; and by white men, also, whose forefathers were welcomed and embraced in the land where the poor Indian met and fed them with "ears of corn and with pemican." Of the two millions remaining alive at this time, about 1,400,000, are already the miserable living victims and dupes of white man's cupidity, degraded, discouraged and lost in the bewildering maze that is produced by their use of whiskey and its concomitant vices; and the remaining number are yet unroused and unenticed from their wild haunts or their primitive modes, by the dread or love of white man and his allurements.[15]

Catlin's sober point of view may be contrasted with that of a younger contemporary, Charles Deas, who visited the North American Indian

Gallery and probably knew Catlin's writings. A Philadelphian working out of St. Louis—then, as now, the so-called gateway to the Far West— Deas's portrayal of frontier types made him a useful foil for conservative resentment against Catlin's single-minded program. One reviewer justified his preference for Deas in 1845 by claiming that "pictures of pure savage life, like those by Mr. Catlin, cannot excite our sympathies as strongly as do the representations of beings who belong to our own race."[16] That year Deas sent his lurid painting of a white man and an Indian locked in mortal combat, *The Death Struggle,* to the New York Art-Union.[17] Less concerned with Catlin's straightforward approach to the impact of the Indian Removal Bill on Native Americans, Deas spiced his pictorial narrative with a bloodcurdling plunge off a precipitous peak. Although seen as a sort of allegorical confrontation between white and red, Good and Evil, Deas's image is, I believe, actually a melodramatic presentation of one aspect of white encroachment on the Indian prerogatives outlined by Catlin.

As both mounted adversaries careen off the mountain precipice to their mutual destruction, the white man, a Kit Carson or Davy Crockett incarnation, desperately clutches a beaver caught in a trap—the cause of their life-and-death struggle. He is a trapper-trader, an unscrupulous and brutal frontier type ironically awarded near-mythological status at a time when westward expansion needed legitimatization in the form of pioneer heroes. It is true that much of the work of exploration was performed by the fur trappers in the 1820s and the early 1830s, roaming over large parts of the Far West in search of beaver. But the downside of their entrepreneurial ventures was their cutthroat competition and ruthless dealings with the Indians, especially when excessive trapping made the beaver scarce.[18]

In one place, Catlin uses the metaphor of "entrapment" to describe the predicament of Chief Red Jacket of the Senecas as he tried to resist "the insidious encroachment of pale faces":

> Poor old chief—not all the eloquence of Cicero and Demosthenes
> would be able to avert the calamity, that awaits his declining
> nation—to resist the despoiling hand of mercenary white man, that
> opens and spreads liberally, but to entrap the unwary and ignorant
> within its withering grasp.[19]

Finally, Catlin could understand the enormous animosity of the tribe of Riccarees (Arikaras), situated on the west bank of the Upper Missouri River, toward the "pale face" fur traders and deemed it prudent to pass their village by on his way down the river. Although the tribe had received Lewis and Clark with generous hospitality, the abuses that they subsequently suffered at the hands of the trappers made them suspicious of the entire white race. As Catlin regretfully announces:

> They certainly are harbouring the most resentful feelings at this time towards the Traders, and others passing on the river; and no doubt, that there is great danger of the lives of any white men, who unluckily fall into their hands. They have recently sworn death and destruction to every white man, who comes in their way; and there is no doubt, that they are ready to execute their threats.[20]

Deas derived from these passages of Catlin the theme of the *Death Struggle,* thus casting the relatively matter-of-fact narrative and the actual conflict into sensational form for an eastern audience. Here the red savage and white barbarian fight tooth and claw, each wielding a knife, each grimacing in horror as they suddenly realize their deathly tumble into the abyss. The centrality of the beaver trap, emblematic of the economic conflict, indicts the system that has brought out the worst in both communities and ultimately victimized them. If the trapper mounted on a white steed has been given pride of place in the composition, the last word is assigned to the internal witness of the scene: a second Indian behind a tree who reacts to the catastrophic encounter with profound pain registered on his face. Ironically, the Indians shown represent the Flathead tribe, one particularly generous and hospitable to the whites.[21]

Catlin's mission included a deeply felt need to debunk the perennial accusations of innate savagery leveled at Native Americans. Although he acknowledged the existence of hostile tribes with "warlike propensities," he generally placed the blame for their hostility and intertribal squabbling on "the incredible enormity of white men's dealings in this country." The punishments meted out to the Indians' enemies are no worse than those administered on the battlegrounds of white peoples. The real reason for treating the Indian as a beast and a brute is because "we do not understand him"; he remains invisible because "we do not

stop to investigate," and this enables him to be exploited by those who would "rob him of the wealth and resources of his country." The seeming oddities of their dress and customs are charged with historical and social meaning and no more nonsensical than the cocked hat of the white male and the useless buttons on the back part of his coat. The North American Indians never let anyone go hungry, and every man, woman, and child in the community is allowed to enter anyone's lodge "and eat when they are hungry, provided misfortune or necessity has driven them to it." Even then, declares Catlin, everyone will share as long as there is something to eat, but a social stigma is attached to those who prefer begging to hunting. He concludes that there is no social system in the civilized world "more humane and charitable."[22]

Even Mandan rituals, often involving shocking bodily mutilation and torture that may appear barbarous and disgusting to the dominant society, were connected to deeply felt religious and social expressions. Although they saddened Catlin, these repugnant customs did not at all show that they were "the most cruel and inhuman beings in the world." Indeed, "a better, more honest, hospitable and kind people, as a community, are not to be found in the world." In discussing the Sioux (Dakotas), he recalls that they are especially associated in the white mind with the totally unjustified Indian stereotype of the "poor, drunken, murderous wretch." But nothing could be further from the truth, and it is especially in his section on the practice of scalping, universally condemned by white society, that Catlin reveals his authentic concern for setting the record straight. Carried out exclusively on enemies fallen in battle, it was done by grasping the hair on the crown of the head with the left hand, then passing the knife around it through the skin and tearing off the part with the hair. The dried scalp then became a highly prized trophy. But Catlin emphasizes that scalping is not an operation designed to take life, as it is executed on a corpse and only removes the skin without injuring the bone of the head. In several cases of mistaken death, the scalped victim actually recovered and only suffered a bald spot as a memento of the encounter. Catlin then states:

> One of the principal denunciations against the custom of taking the scalp, is on account of its alleged *cruelty,* which it certainly has not; as the cruelty would be in the *killing,* and not in the act of cutting the skin from a man's head after he is dead. To say the most of it, it is a

disgusting custom, and I wish I could be quite sure that the civilized and Christian world (who kill hundreds, to where the poor Indians kill one), do not often treat their *enemies dead,* in equally as indecent and disgusting a manner, as the Indian does by taking the scalp.

Catlin half-apologizes for dragging out the discussion of scalping, but he insists that he had "met with so many acts of kindness and hospitality at the hands of the poor Indian, that I feel bound, when I can do it, to render what excuse I can for a people, who are dying with broken hearts, and never can speak in the civilized world in their own defence." But he abruptly breaks his paternalistic argument and shifts to a subtle accusatory mode, which connects scalping with official white barbarism:

> And even yet, reader, if your education, and your reading of Indian cruelties and Indian barbarities—of scalps, and scalping knives, and scalping, should have ossified a corner of your heart against these unfortunate people, and should shut out their advocate, I will annoy you no longer on this subject, but withdraw, and leave you to cherish the very beautiful, humane and parental moral that was carried out by the United States and British Governments during the last, and the revolutionary wars, when they mutually employed thousands of their *"Red children,"* to aid and to bleed, in fighting their battles, and paid them, according to contract, so many pounds, shillings and pence or so many dollars and cents for every *"scalp"* of a "red" or a "blue coat" they could bring in!

Finally, Catlin shows that the most commonly used knives for scalping were manufactured in Yankee and British factories, "made expressly for Indian use, and carried into the Indian country by thousands and tens of thousands, and sold at an enormous price."[23] Nothing the Indian produced with their primitive tools could hope to match the savage and destructive character of this "civilized" refinement on Indian barbarity.

Born in 1796, Catlin belongs to the generation of artists that includes John James Audubon. Yet like them, his ambition to do something great fired an encyclopedic enterprise: the visual chronicle of America's vanishing Native American population. Inspired by the Native American artifacts in Peale's museum, Catlin organized his collections in the form

of an Indian Gallery, which he took on the road and eventually hoped to sell to the federal government for permanent installation in the nation's capital. Although, like Audubon, he did not strive to create the single canonical work but rather to record a corner of American life—"a *pictorial history*" in his words—it is the totality of his life's work that constitutes his original contribution. He painted nearly six hundred portraits of Indian leaders, wilderness landscapes, and scenes of village customs, tribal rituals, buffalo hunts, and other events in Native American life, which formed the basis of his Indian Gallery.

Like Audubon's work, Catlin's paintings display a schematic stiffness and crudity that reveal the hallmarks of an autodidact. His landscapes are filled with diminutive stick figures that resemble toy dolls and anticipate the look of Grandma Moses. Even his best portraits lack subjectivity and strike the viewer more for the concentration on the native headdresses, ornaments, and accessories than for the flesh and blood physiognomies he tried to document for the historical record. His ambition was to function first and foremost as a kind of painterly Mathew Brady in creating a vast historical archive of heroic portraits of individuals together with views of their authentic environment. He saw himself as a scientist/ethnographer above all, searching out the endless panorama of the American West for a world that he felt was on the verge of extinction.

This attitude entailed scientific reasoning with visionary projections adduced in evidence to support his urgent demand to preserve that world. His scientific attitude is seen in his geological observations on the dramatic landscape carved by the Missouri River, attesting to his familiarity with the geological investigations of Charles Lyell and Benjamin Silliman. Along the shores of the Missouri River he discovered gigantic domelike mounds of clay shaped by the action of the water, and his discovery of fragments of pumice and basalt among the alluvial deposits suggested to him evidence of volcanic activity. These red-colored striated bluffs, known locally as "the Brick-kilns," were cut from the topography by the river's erosion, shaping the earth into the singular picturesque conical mounds hundreds of feet high (Figure 10.4). Yet at the same time their fantastic shapes reminded him of the ruins of some earlier human civilization, as if in symbolic anticipation of the disappearance of the Indian world. Stopping at the base of huge clay bluffs,

he imagined that the whole country had been dug up and thrown into huge piles,

> as if some giant mason had been there mixing his mortar and paints, throwing together his rude models for some sublime structure of a colossal city;—with its walls—its domes—its ramparts—its huge porticos and galleries—its castles—its fosses and ditches;—and in the midst of his progress, he had abandoned his works to the destroying hand of time, which had already done much to tumble them down, and deface their noble structure; by jostling them together, with all their vivid colours, into an unsystematic and unintelligible mass of sublime ruins.[24]

Figure 10.4. George Catlin, *Brick Kilns, Clay Bluffs 1900 Miles above St. Louis,* 1832. Smithsonian American Art Museum, Washington, D.C. Gift of Mrs. Joseph Harrison Jr.

Catlin's persistent displacement of his anxieties about the rise and decline of societies onto the landscape of the Far West explains his wish to preserve a record of Indian culture—and, by extension, assure his own immortality. He projected his own fear of failure and mediocrity onto the vanishing people forced to surrender "their lands and their fair hunting grounds to the enjoyment of their enemies, and their bones to be dug up and strewed about the fields, or to be labeled in our Museums."[25]

In another adventure related to his geological interest, Catlin, an Indian guide, and an English companion traveled up the St. Peter's River and then overland to a sacred Indian site, a pipestone quarry, now Pipestone National Monument in the southwest corner of Minnesota. According to Indian tradition, the Great Spirit had here assembled all the Indian nations and forged a huge pipe from the red pipestone rock on which he stood. As billows of smoke rose over the tribes in every direction, he admonished them to use the red stone—the color of their flesh—to make their pipes of peace. Here the Indians propitiated the spirit of the place and entreated permission to mine the red stones for their pipes. The surrounding rocks of the quarry were marked by petroglyphs, images of totems and medicines, and the zone also served as a gravesite. Hence it is not surprising that Catlin and his companions were halted in their tracks by a party of Sioux who, having had bitter past experiences of similar intrusions into their sacred grounds, declared the area off-limits to whites. Despite Catlin's remonstrations, the Sioux strongly suspected his motives and warned him to retreat. Catlin, however, in defiance of the Indian ban proceeded onward with his companions, showing that realizing his ambition took priority over his oft-repeated claims of respect for Indian rights and beliefs.

Here Catlin answers his critics by setting himself up as an altruistic pioneer misunderstood by an indifferent world. If he did not organize a campaign to rescue menaced native peoples, he acted in his role as professional artist, lawyer, and entrepreneur to make a cogent case for their survival. His plan to reach a mass public through his writings and paintings made his personal quest for fame and fortune a political act in its own right. He spent the better part of his life promoting and marketing the collection he had accumulated during his relatively

brief excursions among the western tribes in the 1830s. By methodi-
cally documenting and immortalizing Indian life, he could justify his
own careerist exploitation of their predicament.

His one practical solution, imaginative for the time (1832) and par-
tially realized in the concept of the reservation, now smacks of con-
temporary theme parks. He called for the entire trans-Mississippi West
to be set aide as a "nation's park." For Catlin, the boundless plains of
the undeveloped West were indispensable to his art as an appropriate
field of action for the indigenous folk, whom he represented as existing
in a state of perfect harmony with nature. These plains were stocked
with buffalo yet useless to the cultivator. In many ways, Catlin, no less
than Audubon, accepted many of the arguments for westward expan-
sion even when they contradicted his own sense of danger to the envi-
ronment. Like the landscapists of his generation, he conceived of the
wilderness as a spiritual refuge from the corruption and modernism of
eastern urban centers, but his thirst for fame could be played out only
amid the artifice of the large cities. Here his ambition coincided with
the collective ideal of westward expansion and unlimited opportunities
for accumulating wealth. This is why alongside his praise of an un-
trammeled western paradise we find dire predictions of the settling of
the land as an inevitable outgrowth of the national destiny. Mounting
a high hill overlooking the Missouri River where Sergeant Floyd of
the Lewis and Clark expedition lay buried, an utterly tranquil and
secluded environment where no sound disturbed the communication
between God and humankind, Catlin muses:

> I could not *hunt* upon this ground, but I roamed from hill-top to
> hill-top, and culled wild flowers, and looked into the valley below
> me, both up the river and down, and contemplated the thousand
> hills and dales that are now carpeted with green, streaked as they
> *will* be, with the plough, and yellow with the harvest sheaf; spotted
> with lowing kine—with houses and fences, and groups of hamlets
> and villas—and these lovely hill-tops ringing with the giddy din
> and maze, or secret earnest whispers of lovesick swains—of pristine
> simplicity and virtue—wholesome and well-earned contentment and
> abundance—and again, of wealth and refinements—of idleness
> and luxury—of vice and its deformities—of fire and sword, and
> the vengeance of offended Heaven, wreaked in retributive

destruction!—and peace, and quiet, and loveliness, and silence, dwelling *again,* over and through these scenes, and blending them into futurity![26]

In a vision noticeably influenced by Thomas Cole's *Course of Empire,* Catlin pessimistically forecloses on the good society. As I have written about elsewhere, his projection on the heights—what I term the "magisterial gaze"—was shared by many of his contemporaries whose vision of the virgin wilderness collided with their dreams of glory and domestication of that very wilderness.[27] Catlin often assumed an elevated point of view on a hilltop to embrace the infinite extending landscape unfolding beneath his western-directed gaze. A revealing passage attests to his capacity to distance his imperial gaze with a reading of the sublime: "I often landed my skiff, and mounted the green carpeted bluffs, whose soft grassy tops, invited me to recline, where I was at once lost in contemplation. Soul melting scenery that was about me!"[28] In *Mouth of the Platte River,* Catlin again takes up an aerial vantage point to command a view of a vast wilderness stretch at the junction of the Platte and Missouri Rivers close to what is now Omaha, Nebraska (Figure 10.5).[29] Several Indians clamber to the crest of the hill to admire the prospect, as if to underscore his dire prediction: "The mouth of the Platte is a beautiful scene, and no doubt will be the site of a large and flourishing town, soon after Indian titles shall have been extinguished to the lands in these regions, which will be done within a very few years."[30] Touring the "endless banks" of the Mississippi River valley, "carpeted with green, with one of the richest countries in the world, extending back in every direction," he imaginatively projected on the horizon "splendid seats, cities, towers and villas, which a few years of rolling time will bring about, with new institutions, new states, and almost empires."[31]

As mentioned earlier in connection with Audubon, American painters also posed Indians on summits and hilltops viewing the irresistible march of American society, but for them the prospect spelled only devastation and ruin. It is curious that as much as Catlin enjoyed scrambling to the tops of the many "green carpeted bluffs" he encountered to glimpse the surrounding view, he rarely depicted himself or his party in the heights but preferred to display Indian surrogates hiking up the side or already at the crown. Indeed, Catlin reports as an eyewitness to this changing landscape from the Indian's perspective:

Figure 10.5. George Catlin, *Mouth of the Platte River, 900 Miles above St. Louis,* 1832. Smithsonian American Art Museum, Washington, D.C. Gift of Mrs. Joseph Harrison Jr.

I have seen [the red man] shrinking from civilized approach, which came *with all its vices,* like the *dead of night,* upon him: I have seen raised, too, in that *darkness, religion's torch,* and seen him gaze and then retreat like the frightened deer, that are blinded by the light; . . . I have seen him . . . take the last look over his fair hunting grounds, and turn his face in sadness to the setting sun. . . . I have seen as often, the approach of the bustling, busy, talking, whistling, hopping, elated and exulting white man, with the first dip of the ploughshare, making sacrilegious trespass on the bones of the valiant dead. . . . I have stood amidst these unsophisticated people, and contemplated with feelings of deepest regret, the certain approach of this overwhelming system, which will inevitably march on and prosper, until reluctant tears shall have watered every

rod of this fair land; and from the towering cliffs of the Rocky Mountains, the luckless savage will turn back his swollen eye, over the blue and illimitable hunting grounds from whence he has fled, and there contemplate, like Caius on the ruins of Carthage, their splendid desolation.[32]

His resolution of this contradiction between his vision of a grand American civilization in the West and the looming loss of a great Indian civilization in its wake was a plan to set aside and preserve certain western prairie sites and allow the remnant of the Indian tribes and buffalo to occupy them as a permanent sanctuary. What they may have looked like is perhaps captured in his landscape of *Fort Union, Mouth of the Yellowstone River, 2000 Miles above St. Louis,* where he depicts an elevated view of a lush prairie near the junction of the Missouri and Yellowstone Rivers with a large Indian encampment (Figure 10.6). At the same time, almost in willful disruption of the pristine view of the site, we see in the remote distance on the riverbank the stockade of the American Fur Company built for defense.

Catlin envisions these theme parks as spectacles for viewing by urban dwellers, a virtually real complement to his Indian Gallery:

> And what a splendid contemplation too, when one (who has trav-
> elled these realms, and can duly appreciate them) imagines them
> as they *might* in future be seen, (by some great protecting policy
> of government) preserved in their pristine beauty and wildness, in
> a *magnificent park,* where the world could see for ages to come, the
> native Indian in his classic attire, galloping his wild horse, with
> sinewy bow, and shield and lance, amid the fleeting herds of elks
> and buffaloes. What a beautiful and thrilling specimen for America
> to preserve and hold up to the view of her refined citizens and the
> world, in future ages! A *nation's Park,* containing man and beast, in
> all the wildness and freshness of their nature's beauty!

Catlin quickly adds rather immodestly (and betrays his private anxieties about his place in history), "I would ask no other monument to my memory, nor any other enrolment of my name amongst the famous dead, than the reputation of having been the founder of such an institution."[33]

Here Catlin pictures the Native Americans as "noble savages" perpetually congealed in a frigid time warp. Identified with primordial, Edenic nature, they and their ecological niche with the flora and fauna

Figure 10.6. George Catlin, *Fort Union, Mouth of the Yellowstone River, 2000 Miles above St. Louis,* 1832. Smithsonian American Art Museum, Washington, D.C. Gift of Mrs. Joseph Harrison Jr.

they need to replenish their race would be preserved under glass, as it were, to bring home the moral lesson for future inhabitants of a vice-ridden society and as a memento of what had been lost to civilization on its triumphant march. Indeed, the preservation of Indian culture may ultimately hold out the possibility for humankind's redemption from the inevitable catastrophe. Catlin's dual legalistic and visual mind arrived at a solution that could alleviate his own personal sense of complicity and failure by guaranteeing Indian survival in the form of a synecdochic construction that would henceforth be associated with his name. At the same time, he confirmed the important role of wilderness in America's collective imagination and in shaping the national identity. In the end Catlin may be considered the visionary of the environmental movement, underscoring the innate connections between religion and humankind's responsibility toward the earth and its inhabitants.

NOTES

1. The recent exhibition organized by the Smithsonian American Art Museum tries to redress this recent criticism, but in the end attributes the negative reassessment of Catlin's contradictory motives to heightened awareness of the historical abuses of ethnic minorities. See W. Richard West, introduction to *George Catlin and His Indian Gallery*, ed. George Gurney and Therese Thau Heyman (Washington, D.C.: Smithsonian American Art Museum; New York: W. W. Norton, 2002), 18–23.

2. Julie Schimmel, "Inventing 'the Indian,'" in *The West as America: Reinterpreting Images of the Frontier, 1820–1920*, ed. William H. Truettner (Washington, D.C.: published for the National Museum of American Art by the Smithsonian Institution Press, 1991), 149.

3. Frances K. Pohl, "Old World, New World: The Encounter of Cultures on the American Frontier," in *Nineteenth-Century Art: A Critical History*, by Stephen F. Eisenman et al. (London: Thames and Hudson, 1994), 151–55. In a more recent study, Pohl moderates her comments but still retains the central theme of her earlier essay. See Frances K. Pohl, *Framing America: A Social History of American Art* (New York: Thames and Hudson, 2002), 155–60.

4. Brian W. Dippie, *Catlin and His Contemporaries: The Politics of Patronage* (Lincoln: University of Nebraska Press, 1990), xvi; George Catlin, *North American Indians*, ed. Peter Matthiessen (New York: Penguin Group, 1989), viii; Marjorie Halpin, introduction to *Letters and Notes on the Manners, Customs, and Conditions of the North American Indians*, by George Catlin, 2 vols. (New York: Dover Publications, 1973), 1:xiv.

5. Pohl, "Old World, New World," 153, 155; Kathryn S. Hight, "'Doomed to Perish': George Catlin's Depictions of the Mandan," *Art Journal* 49, no. 2 (Summer 1990): 122–23.

6. Another Catlin scholar accepts Pohl's mistaken conclusion but justifies the artist's use of the tipi as a "metarepresentational" image designed for a "generalizing frontispiece." See Christopher Mulvey, "George Catlin in Europe," in *George Catlin and His Indian Gallery*, ed. Gurney and Heyman, 91.

7. Catlin, *Letters and Notes*, 227.

8. Ibid., 2:104.

9. Ibid., 1:3.

10. Ibid., 1:2–4.

11. Ibid., 9.

12. Ibid., 184.

13. George Catlin, *Episodes from Life among the Indians and Last Rambles*, ed. Marvin C. Ross (Norman: University of Oklahoma Press, 1979), 54.

14. Henry Rowe Schoolcraft, *Personal Memoirs of a Residence of Thirty Years*

with the Indian Tribes on the American Frontiers (New York: AMS Press, 1978), 311–12.

15. Catlin, *Letters and Notes,* 2:6.

16. "The Fine Arts," *Broadway Journal* 1, no. 19 (April 1845): 254.

17. For previous analyses of this painting, see Carole Clark, "Charles Deas," in *American Frontier Life: Early Western Painting and Prints,* by Ron Tyler et al. (Fort Worth, Tex.: Amon Carter Museum; New York: Abbeville Press, 1987), 51–77; Elizabeth Johns, *American Genre Painting* (New Haven, Conn.: Yale University Press, 1991), 73–77; David M. Lubin, *Picturing a Nation: Art and Social Change in Nineteenth-Century America* (New Haven, Conn.: Yale University Press, 1994), 89–91.

18. Schoolcraft, *Personal Memoirs,* 292. Catlin was always on a collision course with the fur trade post and the American Fur Company, which hosted him in 1832 and on which he relied for transport. See Brian Dippie, "Green Fields and Red Men," in *George Catlin and His Indian Gallery,* ed. Gurney and Heyman, 40–41, 46.

19. Catlin, *Letters and Notes,* 105.

20. Ibid., 1:204.

21. Lewis Saum, *The Fur Trader and the Indian* (Seattle: University of Washington Press, 1965), 58–59.

22. Catlin, *Letters and Notes,* 1:84–86, 102, 103, 122.

23. Ibid., 1:182, 210, 236, 238–40.

24. Ibid., 1:69.

25. Ibid., 2:256.

26. Ibid., 2:5.

27. Albert Boime, *The Magisterial Gaze: Manifest Destiny and American Landscape Painting c. 1830–1865* (Washington, D.C.: Smithsonian Institution Press, 1991).

28. Catlin, *Letters and Notes,* 2:3.

29. Joan Troccoli, *First Artist of the West: George Catlin's Paintings and Watercolors from the Collection of the Gilcrease Museum* (Tulsa, Okla.: Gilcrease Museum, 1993), 66.

30. Catlin, *Letters and Notes,* 2:12.

31. Ibid., 2:148.

32. Ibid., 2:156.

33. Ibid., 2:260–62.

11. MEMORIALS AND MOURNING

Recovering Native Resistance in and to the
Monuments of the Nation

Stephen Germic

> America is an idea to which natives are inimical.
> The Indian represented permanence and continuity to
> Americans who were determined to call this country
> new. Indians must be ghosts.
>
> —Richard Rodriguez, *Days of Obligation*

THE LEGAL POSITION occupied by American Indians
in the United States is, to say the least, vexed, and the juridical history
of the federal government's relationship with Indian nations and indi-
viduals is complicated and contradictory in the extreme. At the same
time, and far less recognized, it should be acknowledged that the role
of the European powers, the United States, and their agents in the dip-
lomatic and legal histories of American Indians is equally vexed and
complicated. Consider, for instance, both the Indian and European per-
spectives regarding Columbus's very first action on making landfall in
Hispaniola. The original "deed" of the encounter era in the Americas
was a legal proclamation. As Columbus reported to the equivalent of
legal bureaucrats back in Spain, "I passed from the Canary Islands
to the Indies with the fleet which the most illustrious king and queen
our sovereigns gave to me. And there I found very many islands filled
with people innumerable, and of them all I have taken possession for
their highnesses, by proclamation made and with the royal standard
unfurled, and no opposition was offered to me."[1] Columbus is report-
ing that he has been doing things by the book, strictly according to the
proscriptions of papal law and the Doctrine of Discovery. He went to

the beach, stuck the flag in the sand, and read the text that declared possession for the crown. *Most* importantly, "no opposition was offered." Under the Doctrine of Discovery—a legal code developed during the Crusades that effectively denied sovereign rights to non-Christians[2]— the "discovered" peoples had the right to protest their dispossession, but as the Taino and Carib peoples whom Columbus encountered apparently did not, then possession was complete and legal.

Of course, one might wonder who among the assembled Indians spoke Spanish, though it bears mentioning that in keeping with proper legal procedure Columbus brought with him a translator, whose principal expertise was most likely in Arabic (Spain was, in 1492, at war with North Africa). No doubt little resistance was offered to the act of dispossession declared in that language, either. The point, of course, is that the first legal act between Europeans and American Indians was characterized by virtually complete incomprehension. Such a situation, however, would not long remain the case.

Considerations of the legal history and relationship between American Indians and European powers have almost exclusively described the actions European powers have imposed on Indians. These actions are usually characterized as deceitful and often dishonest impositions in which the Indian peoples were variously duped or drugged into joining agreements that invariably led to their downfall.[3] There is a great deal to recommend such considerations. At many councils and meetings with European and, later, American representatives, bribes and alcohol were generously distributed, treaties were signed where all parties were aware that the signatories did not legally represent their people, and legal concessions were frequently obtained that violated previous legal agreements and were often forced under extraordinary duress and threat. All of this is indisputable. However, reducing the history of legal relations that by definition are characterized by the interests of multiple parties to the history of what is considered the dominant party in the negotiations reiterates the most troublesome aspect of the variously popular, political, and ideological conceptions of Indians in America: namely, the Indian appears to disappear, like a ghost, paradoxically both present and absent.[4] By this I mean that Indian people are seen to enter the political stage only to be ushered off in short order and that their continued presence as historical actors goes unrecognized. The

implications of the suppression of Indian presence include the effective denial of the record of Indian intervention in national and geopolitical processes that powerfully testify against, as Robert A. Williams writes, the "underlying legal legitimacy and moral foundation of the West's continuing colonial hegemony over indigenous tribal peoples."[5]

My principal intention in this essay is to explore through a reflection on American Indian memorials and the rhetorics of national and Indian memorialization the complex assertion of American Indian presence in the face of the multiply deployed insistences of absence. We have probably all visited and experienced the often powerful rhetorics of the various memorials—from gravestones to immense national and cultural monuments (I first drafted this essay virtually in the shadow of the Great Pyramid at Giza while teaching at the American University in Cairo)—that stand as pronouncements on the value of memory and that denote appropriate locations for the rituals of mourning. The importance of the monumentalized memory and, almost invariably, of its place in a certain national story is asserted by the permanence of the memorial.

Perhaps most exclamatory in this regard is the Mount Rushmore National Memorial. This epic monument stands as a powerful physical and rhetorical assertion regarding the importance of key figures to the national story of the United States. Initially proposed as a regional monument by South Dakota state historian Doane Robinson in 1923, the sculptor Gutzon Borglum—who achieved national recognition for his Confederate memorial at Georgia's Stone Mountain—envisioned a much more massive celebration of national figures. According to the history provided by the National Park Service (NPS), Borglum saw Mount Rushmore and declaimed, "America will march along that skyline."[6] The sculpted faces of George Washington, Thomas Jefferson, Abraham Lincoln, and Theodore Roosevelt render 150 years of American history as a decidedly triumphalist history. The NPS offers an explanation for why these four president were chosen for memorialization:

> As we reflect on why these four men were chosen to be placed on this mountain, we might feel ourselves drawn closer to our past; so that, our nation's ideals, our form of government, mans' [sic] civil liberties, our National lands will continue to remain as our dream for America. As we preserve this stone monument, we preserve our

own Nation's government by keeping the dreams, and honoring the hard work of our forefathers.[7]

As the inclusive rhetorical assertion of "We the people" was intended to obscure the deep national divisions over the Constitution's assertion of federalism as the law of the land, so the plural possessive "our" functions to obscure a long record of conflict. It is hardly an accident of geography that the Mount Rushmore National Memorial was established on what remains, to this day, the legally equivocal land in South Dakota known as the Black Hills—or Paha Sapa, or Wamaka Og'naka I'Cante, "the Heart of Everything That Is." Almost certainly the reference to "National lands" in the NPS statement is intended to offer a sense of territorial security belied by the land's contested status. What is beyond equivocation is the fact that the Black Hills represent an area of unfathomable cultural importance to the Lakota, Cheyenne, and other Plains Indian peoples. Indeed, recently offered over $100 million to settle the outstanding issue of legal title,[8] the impoverished Lakota people refused, "believing," as Lakota people testified in numerous statements, "that the land is more important than money and that one day, somehow, [they] will get the land back, either by congressional action or, as many [Lakota] believe, on that day . . . when the white man . . . disappear[s] and the bison . . . returns."[9]

I would like to briefly explore this indirect reference to the essential meaning of the Ghost Dance religious movement of the late nineteenth century, a movement that foretold an apocalyptic disappearance of Euro-Americans, a magnificent return of the buffalo, and a general restoration of Indian cultures and peoples. The Ghost Dance movement, which began in the Southwest among Paiutes in 1889, is the Indian revitalization movement that led eventually to the murder of the great political and spiritual leader Sitting Bull and to the calamitous massacre at Wounded Knee, South Dakota, in 1890. Though original in many respects, the Ghost Dance was also the latest iteration of revitalization movements that include those led by Handsome Lake among the Iroquois in the late eighteenth century, the Shawnee Tenskwautawa of the early nineteenth century, and the Wanapum Smohalla of the mid-nineteenth century.[10] This is to say that the Ghost Dance, the latest "specter" that haunted U.S. efforts to control terri-

tory in the late nineteenth century, appeared to disappear from the perspective of those who violently repressed it. Clearly, however, the dance persists and justifies claims on land.

There is a complex irony contained in the above reformulation of the hundred-year-old Ghost Dance belief as the later rationalization for refusing payment for expropriated land. The money was refused, in part, on the premise of a reversal of presence. Money— essentially immaterial (if you would allow such an oxymoron) and the vehicle through which, as Marx and Engels famously submitted in *The Communist Manifesto*, "all that is solid melts into air"—is rejected in the hopes that those who have rendered American Indians "ghosts" on the American landscape will suffer the fate they have themselves imposed, however fantastically, on Indian peoples. In short, the Lakota refuse their own memorialization, and while mourning, they refuse to become memories even as they provide another level of meaning to the sculpted faces of Mount Rushmore. The memorial might be regarded as nothing less than an impressively dramatic attempt to render American claims manifest, that is, to make presence out of absence, to assert the very opposite of ghostliness. The vastness of the sculpture— the famous Sphinx at Giza could fit between the end of Washington's nose and his eyebrow—is, in this reading, compensatory for the anxiety of uncertain land claims and, by implication, the territorial foundations of American nationhood in the West. We might, in light of the Ghost Dance, read the monument not so much as the site for variously mourning and celebrating the heroes of an American past as a memorial for the ghosts of the future.

While the Ghost Dance is a powerful and persistent testament to the complexity of American Indian denials and fantasies of memorialization, it also, I would like to submit, contains the structure of a legal agreement. The highly respected ethnographer James Mooney provided a thorough contemporaneous account of the Ghost Dance, including the "message" of the young Paiute Indian prophet Wovoka, who initiated the movement. According to Mooney's interviews, Wovoka

> fell asleep . . . and was taken up to the other world. Here he saw
> God, with all the [Indian] people who had died long ago . . . happy
> and forever young. . . . God told him he must go back and tell his

people they must be good and love one another, have no quarreling, and live in peace with the whites; that they must work, and not lie or steal; that they must put away all the old practices that savored of war; that if they faithfully obeyed his instructions, they would at last be reunited with their friends in this other world, where there would be no more death or sickness or old age. He was there given the dance which he was commanded to bring back to his people. By performing this dance at intervals, for five consecutive days each time, they would secure this happiness to themselves and hasten the event.[11]

Wovoka's vision proposes a covenant remarkable for its similarity to the terms of John Winthrop's "Model of Christian Charity," a sermon delivered aboard the *Arabella* in 1630. Winthrop, a well-trained lawyer and arguably European America's first great juridical theorist, also provided the divinely sanctioned terms for a peaceful and bountiful "city upon a hill" to be realized if the contentiously divided immigrants could treat each other with kindness and respect, put away quarrels, and "be knit together in brotherly affection." If they manage a "strict performance of the articles contained" in the covenant that "He" ratified, then New England will be a "praise and glory" forever.[12] Reading Wovoka (albeit through Mooney) alongside Winthrop as iterations of divinely mediated legal proposals of beleaguered people is rich and suggestive territory, but for now I want only to emphasize that Winthrop's gesture toward monumentalization (the "city upon a hill") partakes of the logic of the *legal* memorial while foreshadowing the later construction of such national monuments as Mount Rushmore.

Memorial is, after all, a juridical term, referring to a petition presented to a legislative body or a principal executive generally employed by those with somehow limited or compromised access to full legal protections or privileges. The legal memorial was employed repeatedly by American Indian nations and individuals in their efforts to resist displacement, expropriation, and possibly annihilation. Thus, a Cherokee memorial of 1829 reads, in part, "our safety as individuals as well as a Nation requires that we should be heard by the immediate representatives of the people of the United States, whose humanity, and magnanimity, by permission and will of Heaven, may yet preserve us from ruin and extinction."[13] As the rhetorical strategy of this memorial indicates,

there is a sense in which monumental memorials such as the Indian Memorial at Little Bighorn Battlefield National Monument and the developing monument to Crazy Horse near Mount Rushmore bear witness to the failure of legal memorials. Their visual and historical rhetoric both testifies to and obscures, both ignores and mourns, the failure of the juridical memorial. More simply, such memorials may be seen as functioning ironically to mourn the failure of memorials. This might be called the "tragic" reading of Indian memorials wherein the visual rhetoric submits and confirms an inevitability regarding the un-folding of U.S. nation-building processes.

We might usefully consider the statue by Glenna Goodacre (most famous for her Vietnam Women's Memorial in Washington, D.C.) that appears in downtown Rapid City, South Dakota, the major city near-est to the Black Hills and Mount Rushmore. The statue, titled *He Is, They Are,* standing almost ten feet tall, depicts a powerful, bare-chested Indian with his hands tied behind his back and his face looking at the ground. It is the very image of defeat, however strongly suggestive it is of dignity. The inscription on the statue reads, "The Sioux and the Plains Indians were moved from their homelands and placed on res-ervations. Though their 'hands are tied,' the dream of their homeland remains." The local Indian community is admittedly split over the value of the statue, but one recent protester stated what he considered the obvious: "Our homeland is not a dream; we are not a conquered people."[14] The protestor might have pointed over his shoulder at the Black Hills and declaimed that the legal case for those hills as Lakota property was powerfully compelling. He may, in fact, have made such a statement, and was certainly implying it in his attempt to contest the monumental rhetoric of disappearance. He might even have defined the massive sculpted faces of Mount Rushmore as so much whistling in the dark, arrogant assertions of ownership intended to dispel the linger-ing fact of legal equivocation.

This equivocation came home in 1970, when, in the spirit of the occupation of Alcatraz Island by a group called Indians of All Tribes a year earlier, representatives of various Indian peoples scrambled up the side of Mount Rushmore and began an occupation protest that lasted through the summer and well into the fall. Principal spokesperson and organizer Lehman (Lee) Brightman asserted frankly that

we wanted to dramatize the plight of the Black Hills. Around 1868 they made a treaty with us giving us this land for as long as the sun shines and the grass grows. And, of course, the treaty didn't mean shit. Six years later Custer discovered gold. Immediately they took the land from us, and they haven't paid us for it since.[15]

Brightman refers to the 1874 topographical expedition in the Black Hills led by George Armstrong Custer. The expedition included a number of civilian gold prospectors, strongly suggesting that the intention was to precipitate a conflict over a region that was unambiguously a part of Sioux territory according to the Fort Laramie Treaty of 1868. Also included as Indian territory by that same treaty is a curious property included in the state park system of South Dakota. Though rightly famous among Plains Indian peoples, this place has been almost entirely ignored by critics and scholars of America's parks.

Bear Butte, located in Bear Butte State Park, is a mountain that erupts from the plains of South Dakota several miles to the east and north of the Black Hills and Mount Rushmore (Figure 11.1). Though considered part of the Black Hills and composed principally of the greenish shale and red sandstone that distinguishes (along with abundant granite) the pre-Cambrian formations of the Black Hills, Bear Butte, in fact, *appears* geologically independent. From the northeastern approaches, it presents itself as a relief and a surprise after more than a few hours of fairly tedious flat or mildly rolling landscape—a few hours, that is, by the luxury of highway speeds. It would quite likely appear as something of a revelation after days, weeks, even months of travel in the centuries before asphalt, rubber, and gasoline. And, in fact, it does stand as a sacred site of revelation for the Lakota and the Cheyenne. A plaque at the foot of Bear Butte offers the following: "Sacred Mountain of the Plains Indians: Noavosse (Cheyenne) 'The Good Mountain,' Mato Paha (Sioux) 'Bear Mountain.' Here through the centuries, plains Indians received spiritual guidance from their Creator. Here the Cheyenne prophet, Sweet Medicine, received the 4 sacred arrows, the 4 commandments, and a moral code. Here the Sioux worshipped Wankan Tanka and paid tribute to the Spiritual Ruler. To this day the Indians still make their visits and pray at their sacred mountain."

The plaque (while a bit curious in its use of definite and indefinite articles: why "a" moral code for the Cheyenne but "the" Spiritual Ruler

Figure 11.1. Bear Butte State Park, Sturgis, South Dakota, 2009.

for the Lakota?) makes an argument for ownership founded on spiritual importance that has merit both in its reference to religious history and in the context of American jurisprudence.[16] The American Indian Religious Freedom Act of 1978 (not to mention the First Amendment to the Constitution) insures the rights of Indians to locations and rituals of traditional forms of worship. The act has been used with some success to protect Indian sacred places from development.[17] To avail themselves of the act, Indian plaintiffs must prove the enduring traditional religious value of a particular place, and though the historical record is conflicted to say the least, the case, especially for the Cheyenne at Bear Butte, is very strong.[18] Nevertheless, the district court in Rapid City, the Eighth Court of Appeals, and, finally, the U.S. Supreme Court in 1983 each, in turn, found against the plaintiffs' argument that rights to religious practices were being compromised by managers of Bear Butte State Park, who in 1982 forbid the gathering of ritual herbs and closed the sweat lodge area—in order to expand a parking lot.[19]

The dynamics of presence, absence, claims to ownership, sacred history, and denial of the sacred with regard to Bear Butte characterize

the contentious debates that surround public land rights and use issues in the American West. Bear Butte is especially revealing and instructive in terms of the frame of visual rhetoric supplied by this current volume. Intentions aside, there can be little doubt that the managers of Bear Butte State Park carried with them and saw as their duty to enforce a continuously reiterated conception of the western landscape as spacious, open, and, to all possible extent, free of the signs of human interaction, sacred, merely traditional, or otherwise. This is, in fact, the very core of the rhetoric of the American West, indeed, of America itself: the vast and rugged territory of freedom and independence. Thus, Bear Butte was already inscribed with a kind of sacred argument, an argument to some degree reinforced by a competing plaque at the park. Placed by the NPS, it reads, "Bear Butte has been designated a registered national landmark under the provisions of the Historic Sites Act of August 21, 1935. This site possesses exceptional value in illustrating the natural history of the United States." According to this version of a kind of geographic cum visual rhetoric, Bear Butte is marked a commemorated place according to some unspecified natural, rather than human, value and history. I submit that this commemorative neglect of the human is more than a bit disingenuous, as the site was almost certainly chosen for symbolic reasons: the Butte rises out of the plains as a geologic figure of the individual amid western vastness, what we can easily imagine as *the* sacred symbol of an American nationalist rhetoric of the West.

The plaque that memorializes the place of Bear Butte in Cheyenne and Sioux cosmologies is, it would appear, a legally hopeful if ineffective counterargument. Though, it might reasonably be loaded with yet another symbolic reading as a metaphor for the fraught ironies of American Indian presence in the West and in American public parks of the West especially. The landscapes of the West are saturated with thousands of years of human history that occasionally erupt out of the vast force of American denials. Bear Butte, physically separated from the body of the Black Hills of which it is also an integral part, signifies insistent Indian claims of presence and, indeed, ownership.

It is no small matter that Bear Butte teems with memorialization. The place is, for the Cheyenne, of an importance analogous to that of Moses and Mount Sinai for Jews and Christians. On Bear Butte the

prophet Sweet Medicine received four sacred arrows and the commandments of the Cheyenne moral code. Today, brightly colored strips of cloth, some enclosing small bundles, hang from the branches of literally every tree it is possible for a person to reach on Bear Butte (Figure 11.2). These are prayer bundles, often placed by individuals after the death of a close friend or relative. The Cheyenne had to struggle through many denials, legal and bureaucratic (as cited above), for the right to place these prayer bundles and for the limited right to perform other religious ceremonies, but the property remains legally contested. Currently petitions—legal memorials—are circulating to create a five-mile buffer zone around Bear Butte. The petitioners argue that a nearby shooting range and a proposed saloon/campground intended to profit from the flood of Harley-Davidson enthusiasts who visit nearby Sturgis each summer violate the 1851 Treaty of Fort Laramie, which assures Indian peoples the "right to gather, pray, seek solitude, and maintain their culture without disruption and annoyance."[20] In fact, Lee Brightman spoke to the importance of this place during the 1970 occupation of Mount Rushmore: "These are our demands. We want payment for the

Figure 11.2. Prayer bundles, Bear Butte State Park, Sturgis, South Dakota, 2009.

Black Hills, for all the minerals mined, for the timber taken out. And we want our sacred mountains back. The Cheyenne probably will want Bear Butte back—that was their most holy place."[21]

In this context of the insistence of presence, I would like to turn again briefly to the record of written and officially submitted legal protests that offer a countermeasure to the boisterous rhetorics of disappearance. What these memorials principally assert is the claim to land. Speaking from the compromised legal position of a petitioner, the memorialists generally begin by expressing an attitude of humility, though in many memorials this expression is perfunctory, as in the following from the 1832 memorial of the Creek Nation to the U.S. Congress: "Your memorialists, the Chiefs, Headmen, and People at large of the Muscogee or Creek Nation of Indians, most humbly pray that you will listen attentively to that which they desire to make known to you, and to the reclamation which they are about to make in the names of justice and good faith."[22] The Creek memorialists turn quickly to the matter at hand: "Before any white men settled in Georgia and Alabama, almost the whole country subsequently erected in these two . . . States, belonged to the Muscogee confederation . . . and also some 400,000 acres in what is now the State of Mississippi."[23] Several pages then follow of detailed description of the affairs related to the history of property ownership and control between the Creeks and the federal and state governments. The general argument proceeds by recounting a historical episode in which land claims were shifted, and then summarizing the juridical implications. Foreshadowing the assertion made by the activist in Rapid City, the memorialists emphasize that lands taken by the United States "were not a *conquered* country." The Creeks continue: "Thus the United States took from the friendly Creeks, for political purposes and without any fault on [the Creeks'] part—from her friends and faithful allies, who had poured out their blood like water by the side of her own people in battle—she took from them, without making any compensation whatever, nearly nine million acres of land, beyond dispute belonging to them alone."[24]

As petitions for redress, or, as the Creeks write, "reclamation," there is little evidence—none so far as I have found—that suggests the powerful vision of reversal articulated in the Ghost Dance and affirmed by the later Lakota refusal to accept money for land. On the contrary,

such legal memorials comprise a record of the American Indian attempt to forge what the legal historian Robert A. Williams describes as "a new type of society with Europeans on the multicultural frontiers of [early] North America."[25] They assert the fact of Indian *presence* amid the ongoing territorial process of erasure. They assert the fact that land claims are an ongoing negotiation, that there are Indian claimants with compelling arguments. Today's scholars, lawyers, activists, and Indian communities busy striving to assert and maintain Native rights and privileges of sovereignty appeal principally and quite rightly to the existing treaty record that self-evidently "affirms the . . . capacity of Indian [peoples] to engage in bilateral governmental relations, to exercise power and control over their lands and resources, and to maintain their internal forms of self-government."[26] However, an examination of the record of legal memorials reveals strategies employed for resisting precisely what has necessitated the iteration of the argument for sovereignty, namely, the erasure of presence. Treaties obviously signify the presence of nations who recognize and respect each other's existence. Memorials are one of the earliest records we have that acknowledge that such an obvious recognition of mutual sovereignty was being compromised by U.S. imperialist nation building. We are not a memory, the petitioners insist. We are still here, and we have claims to the land.

American Indians began the political process of reversing termination policies and initiating self-determination by appropriating the methods of their adversaries, or, more specifically, by reversing the patterns of occupation. Beginning with Alcatraz Island, they moved on to a series of occupations, most notably of the offices of the Bureau of Indian Affairs in Washington, D.C., of Mount Rushmore, and of the tragically infamous Wounded Knee, South Dakota, but also of baseball fields, of local federal offices throughout the United States, of local and national parks, and of a variety of shopping and industrial places. The years of 1969–74 might well be described as the era of reverse occupation, when native peoples symbolically took the land back from their occupiers. They forcefully occupied space, and having mastered the language of law and politics, they made forceful arguments that brought real political and cultural rewards. American Indians persisted in these methods because they were important aspects of activist campaigns that realized results. Largely in the course of the 1970s, several

tribes that had suffered termination were reinstated, important legal cases such as *Oliphant v. Suquamish Indian Tribe* granted increased tribal juridical powers on reservation property, and the American Indian Religious Freedom Act was passed. The principal questions were no longer how or when American Indians would become assimilated— assimilation and termination were off the table—but how will the United States and its wildly various peoples and interests manage to accommodate the compelling legal and cultural claims of American Indians? That question has not yet been resolved.

The literary and cultural critic Priscilla Wald writes that

> an official story of "a people" invariably lags behind the seismic demographic changes and corresponding untold stories that ultimately compel each revision. A national narrative must make the concept of a "home" for a "people" appear intrinsic and natural rather than contingent and, ultimately, fictive. At the same time, the narrative must make the concept of home able to accommodate both changing and contested frontiers and the mobility within its borders. "Home" must be sufficiently elastic to incorporate the local into the national.[27]

Wald asserts that official stories "constitute Americans." In fact, such stories are frequently bound to place. It is even the very function of important national symbolic places to geographically articulate rhetorics of nationhood. Inevitably such places become critical points of ideological negotiation and resistance from competing narratives displaced or repressed by national official stories. When American Indian Movement activist Russell Means pissed on the sculpted faces of American national icons at Mount Rushmore in 1970, he was both protesting an official story and asserting a counternarrative that held the same geography as part of a much different, albeit "unofficial," story.

Mount Rushmore's official story, the core of its verbal rhetoric, is simple and, as we might expect, officially articulated: "Mount Rushmore National Memorial is host to almost three million visitors a year from across the country and around the world. They come to marvel at the majestic beauty of the Black Hills of South Dakota and to learn about the birth, growth, development and the preservation of our country. Over the decades, Mount Rushmore has grown in fame as a symbol of

America—a symbol of freedom and a hope for people from all cultures and backgrounds."[28] Quoted from the memorial's official website, the statement has three themes and an implicit argument. The themes are national development, freedom, and unity. The argument submits that millions of visitors come to Mount Rushmore to celebrate the nation and the values of freedom and unity. The "memorial" rhetoric of Mount Rushmore would repress the memorial submission of American Indian plaintiffs, whose legal arguments have in fact often won the day. As Brightman asserted during the 1970 occupation that witnessed Mean's act of resistant urination, such official memorials are the result of American nationalist processes that "violated scores of treaties." The nation, according to Brightman, labeled such "booty 'national parks' and 'national forests' to cement the thefts into law."[29] From the perspective of the nationalist actors who established Mount Rushmore, the memorial, through the very rhetoric of its vastness, would repress the equivocations of legal entitlement. Clearly, the memorial has failed to render legal protestations history. Indians, and their claims, still haunt the place.

The Indian Relocation Act of 1954 was one of the last significant efforts to force assimilation on Indian peoples. In fact, by the mid-1960s a critical mass of displaced Indian youth had gathered in American cities who enthusiastically embraced and helped to define the militant civil rights movement. The takeover of Alcatraz Island in 1969 by a pan-Indian association calling themselves Indians of All Tribes is largely seen as initiating the rich, fruitful, and tragic years of American Indian militant activism. Alcatraz Island was chosen for its ironic punch: like so many reservation lands, it was devoid of economic resources and abandoned by "white people." Furthermore, the activists proposed the following compelling legal justification: according to the Fort Laramie Treaty of 1868, all abandoned federal lands would be conceded to the Indian peoples from which they were initially acquired. Furthermore, by the terms of this treaty, most of what is now Yellowstone National Park in Montana was defined as reservation land. When Yellowstone was established in 1872, the reservation was unilaterally reduced.[30] In 1969 relevant U.S. offices ignored this legal assertion for territorial reclamation by American Indians. The takeover of Alcatraz lasted for eighteen months before U.S. marshals

retook the island under an effort code-named "Operation Parks." The Rock is now part of the Golden Gate National Recreation Area.

It is rhetorically just here that I would like to focus the effort I have made in this essay: among, that is, these vacillations from presence to absence, from "disappearance" toward a ghostly return of or to the repressed that is both a manifestation of what was always there and a reiterated legal claim to a place. American Indian territory becomes an *American national* place, and, in most cases, names are changed to erase the claims of the supposedly vanquished. In the case of Alcatraz, the vanquished returned, and consequently the process was repeated: Indians were removed, and a park was invented to secure U.S. territorial assertions. In activist practice the response to this repeated "ghosting" is memorialization, including all the implications of both legal petition and mourning. The Golden Gate National Recreation Area remains a site of mourning after the failure of a legal assertion by Indians of All Tribes.[31] It is another lost land, in fact, a doubly lost land, that, like Mount Rushmore and Bear Butte, also happens to be a park.

NOTES

1. Christopher Columbus, *Four Voyages to the New World,* ed. R. H. Major (New York: Citadel Press, 1992), 2.

2. See Eric Cheyfitz, "Doctrines of Discovery," in *Common-Place: The Interactive Journal of Early American Life* 2, no. 1 (2001), http://www.historycooperative .org/journals/cp/vol-02/no-01/cheyfitz/index.shtml.

3. See, for instance, Edward Lazarus, *Black Hills, White Justice: The Sioux Nation versus the United States, 1775 to the Present* (New York: Harper Collins, 1991); and Francis P. Prucha, *The Great Father: The United States Government and the American Indians* (Lincoln: University of Nebraska Press, 1984).

4. My concern in this essay is principally with how legal land claims are articulated both poetically and juridically. An excellent analysis of the complex literary meanings of American Indian "ghosts" can be found in Renee L. Bergland, *The National Uncanny: Indian Ghosts and American Subjects* (Hanover, N.H.: University Press of New England, 2000).

5. Robert A. Williams Jr., *American Indian Treaty Visions of Law and Peace, 1600–1800* (New York: Routledge, 1999), 5.

6. National Park Service, "Carving History," Mount Rushmore Na-

tional Memorial, http://www.nps.gov/archive/moru/park_history/carving_hist/carving_history.htm (accessed 14 June 2009).

7. National Park Service, "Why Were These Men Chosen?" Mount Rushmore National Memorial, http://www.nps.gov/archive/moru/park_history/carving_hist/why_these_pres.htm (accessed 14 June 2009).

8. See Lazarus, *Black Hills, White Justice,* 403–28.

9. Jake Page, *In the Hands of the Great Spirit: The 20,000 Year History of American Indians* (New York: Free Press, 2003), 399.

10. See Alice Beck Kehoe, *The Ghost Dance: Ethnohistory and Revitalization* (Fort Worth, Tex.: Holt, Rinehart and Winston, 1989), 113–27; Clifford E. Trafzer and Margery Ann Beach, "Smohalla, The Washani, and Religion as a Factor in Northwestern History," in *American Indian Quarterly* 9, no. 3 (Summer 1985): 309–24; R. David Edmunds, *The Shawnee Prophet* (Lincoln: University of Nebraska Press, 1983).

11. James Mooney, *The Ghost Dance Religion and Wounded Knee* (Washington, D.C.; Government Printing Office, 1896), 771–72.

12. John Winthrop, "A Model of Christian Charity" (1630), in *Early American Writing,* ed. Giles Gunn (New York: Penguin, 1994), 108–18.

13. "Memorial of the Cherokee Council, November 5, 1829," in *Cherokee Phoenix and Indians' Advocate,* April 14, 1830, 1.

14. Scott Aust, "Students Present Statue Protests," *Rapid City Journal,* October 4, 2005.

15. Lee Brightman, quoted in John (Fire) Lame Deer and Richard Erdoes, *Lame Deer, Seeker of Visions* (New York: Washington Square Press, 1972), 88.

16. See John H. Moore, *The Cheyenne* (New York: Blackwell Publishers, 1999), 193–98.

17. See Fergus M. Bordewich, *Killing the White Man's Indian: Reinventing Native Americans at the End of the Twentieth Century* (New York: Anchor Books, 1997), 204–39.

18. The argument made by Donald Worster rather to the contrary ("The Black Hills: Sacred or Profane?" in *Under Western Skies: Nature and History in the American West* [New York: Oxford University Press, 1992]) has, I believe, been effectively repudiated. See, for instance, Mario Gonzalez, "The Black Hills: The Sacred Land of the Lakota and Tsistsistas," in *Cultural Survival Quarterly,* Winter 1996; Linea Sundstrum, "Mirror of Heaven: Cross-Cultural Transference of the Sacred Geography of the Black Hills," *World Archaeology* 28, no. 2 (October 1996): 177–90.

19. See Peter Nabokov, *Where the Lightning Strikes: The Lives of American Indian Sacred Places* (New York: Viking, 2006), 218–20.

20. "Save Bear Butte Petition," http://www.petitiononline.com/1851Site/petition.html (accessed 21 August 2009).

21. Lee Brightman, quoted in Lame Deer and Erdoes, *Lame Deer, Seeker of Visions,* 88.

22. Muscogee (Creek) Nation, "Creek Indians; Memorial of the head men and warriors of the Creek Nation of Indians. February 6, 1832, referred to the Committee on Indian Affairs" (Washington, D.C., 1832).

23. Ibid.

24. Ibid.

25. Williams, *American Indian Treaty Visions,* 9.

26. Ibid.

27. Priscilla Wald, *Constituting Americans: Cultural Anxiety and Narrative Form* (Durham, N.C.: Duke University Press, 1995), 299.

28. National Park Service, "History and Culture," Mount Rushmore National Monument, http://www.nps.gov/moru/historyculture/index.htm (accessed 21 July 2009).

29. Lee Brightman, quoted in Russell Means, *Where White Men Fear to Tread: The Autobiography of Russell Means* (New York: St. Martin's Press, 1995), 170.

30. See Stephen A. Germic, *American Green: Class, Crisis, and the Deployment of Nature in Central Park, Yosemite, and Yellowstone* (Lanham, Md.: Lexington Books, 2001), 79–106.

31. See Jerry Reynolds, "A Myth in the Making: Alcatraz at 35," in *Indian Country Today,* November 19, 2004, http://www.indiancountry.com/content.cfm?id=1096409889.

12. AMERICA'S BEST IDEA

Environmental Public Memory and the
Rhetoric of Conservation Civics

Cindy Spurlock

> I have to admit that in some ways I've made the same film
> over and over again. Each one asks a deceptively simple
> question: who are we? Who are those strange and compli-
> cated people who like to call themselves Americans?
>
> —Ken Burns, at a screening of *The National Parks:*
> *America's Best Idea,* University of Miami, 2009

WHETHER THROUGH THE ICONIC POWER of Ansel
Adams's photographs or by their enduring presence as the scene of
reunion and renewal in countless family albums, national parks have
captivated the imagination of the American public for more than one
hundred years. Some of the most visible and vulnerable articulations
of "nature" and "culture" in American public life, national parks have
long been celebrated as the quintessentially American idea that ma-
terially demonstrates our collective, cultural commitments to the de-
mocratization of the extraordinary and the everyday. As sanctioned,
sacred, and often strategic public places, national parks do much more
than preserve natural resources. These forests, lakes, deserts, canyons,
and glaciers are often displayed as evidence of America's maturity as a
nation—as one of democracy's finest achievements—in ways that make
particular claims on civic pride and citizenship. In some instances,
however, the existence of national parks is taken as a reason to justify
a host of predatory and unsustainable practices (such as mountaintop
coal removal and the proposal to bury toxic waste on Native American
lands) that take place elsewhere because of the perceived (and legal)
differences between public and private land. To extend Anne Mackin's

and Carol Rose's research on the history of private property and the distinctive characteristics of the "American" land ethic that articulates property, prosperity, and political independence, I suggest that national parks complicate the cultural and economic rationales used to support particular ways of thinking about and using land designed as "the commons."[1] In this way, national parks offer an alternative land ethic, which Ken Burns brings to life as a unifying narrative in *The National Parks: America's Best Idea*. Here, as Burns and his colleague Dayton Duncan argue, "We have found in the story of the parks quite simply a reminder of our best selves, a connection to the most primitive impulses we human beings have, and an appreciation of the value of commonwealth that these parks represent on both a spiritual as well as material level."[2]

In this regard, the national park idea may be rooted in the European notion of the commons, but its execution, celebration, and exportation are distinctly American. It is perhaps not too surprising, then, that the idea of national parks as places of spectacular nature and the mythic narrative that parks are crucibles where the character of the nation—and of individuals—has been (and continues to be) forged work as a powerful form of symbolic capital that "performs" the nation and cultivates civic identification in popular culture and political life.[3] And as the first decade of the new millennium comes to a close on the eve of the National Park Service's centennial anniversary, the importance of America's national parks will become more evident if external advocates, partners, and allies, such as Burns, are successful in their efforts to repackage national parks as a worthy investment to the American public.

Greening Citizenship: Power, Discourse, and the State

In this essay, I offer a critique that may provide a useful theoretical heuristic for understanding and explaining how individuals come to understand themselves in relation to the environment as citizens whose identification with particular narratives of public memory also serves to situate them as environmental subjects. Known as eco-governmentality or environmentality, this paradigm draws significantly from the work of Michel Foucault in order to think through the enactments of power

that ascribe legitimacy and normativity to particular ways of being in nature and culture at a particular moment in history. As a deeply contextual theory of subjectivity, environmentality traces the ways in which official and authorized discourses enable and constrain practices, relations, and beliefs by, as anthropologist Arun Agrawal suggests,

> 1) attend[ing] carefully to the formation of new expert knowledges; 2) the nature of power, which is at the root of efforts to regulate social practice; 3) the type of institutions and regulatory practices that exist in a mutually productive relationship with social and ecological practices and can be seen as the historical expressions of contingent political relationships; 4) and the behaviors that regulations seek to change, which go hand in hand with the processes of self-formation and struggles between expert- or authority-based regulation and situated practices.[4]

Here, environmentality is a useful, situational "optic [for examining] the long process of changes in environmental politics, institutions, and subjectivities" that "encourages attention to the processes through which these concepts are consolidated and naturalized."[5]

Following a trajectory of thought opened by the work of Eric Darier, Paul Rutherford, Robyn Eckersley, Jim Cheney, and Timothy Luke, Agrawal's study of the Kumaoni blends ethnographic field research with statistics and archival evidence to explain how "changes in individual behavior" are produced as "governmental strategies" that contribute toward the resolution of particular social and ecological issues that have been defined as problematic under the aegis of neoliberalism.[6] While, as Agrawal notes, "environmentality . . . refers to the knowledges, politics, institutions, and subjectivities that come to be linked together with the emergence of the environment as a domain that requires regulation and protection," what is missing, however, is a sense of *how these* discourses work to move the social.[7] Environmentality complements a critical-cultural orientation toward rhetorical theory and criticism because it makes a critical move from governmentality toward a more specific and situated understanding of how power and subjectivity are produced under the sign of nature. Here, as Darier, Luke, and others have suggested, environmentality specifically acknowledges the material *and* discursive characteristics of "the environment"

as both socially produced, governed, and regulated while also acknowl-
edging it as a material reality that exists (as "nature") without human
intervention.

Recently, however, critical debate and scholarly research about
environmentality have largely overlooked those discourses that do
the work of making, contesting, and remaking environmental subjects
through rhetorical and performative modalities. To the point, the optic
of environmentality is indeed capable of addressing everyday or banal
forms of publicity enacted by the nation-state or on behalf of its citi-
zens in those endeavors that aim to constitute publics. Time and again,
Burns positions viewers as recipients of the gift of conservation and
environmental stewardship. The parks, then, may be understood as
technologies for expressing the environmental reason of the state—the
subtle (and not so subtle) regulation of discourses and practices that
govern both people and place in ways that seem natural or reasonable
but are nevertheless represented and situated as such through rhetori-
cal discourse. Thus, as Richard Grusin argues, national parks function
as public "technologies for reproducing nature according to the sci-
entific, cultural, and aesthetic practices of a particular historical mo-
ment."[8] However, he cautions, critics should be aware of the particular
ways in which "national parks always reproduce 'nature as': that is,
they reproduce nature not as anterior to discourse, but in terms of a
particular place, location, or environment."[9] Thus, Grusin suggests,
national parks are not only technologies for producing nature, but they
may also be understood as technologies for producing environmental
subjects.

Ronald Walter Greene's work offers a productive foundation for
locating environmentality as rhetorical and performative.[10] Thus, by
attending to the rhetorical features of environmentality, critics may be
better positioned to trace the specific ways in which nature and culture
are articulated by the nation-state in the ongoing effort to produce
knowledges, experiences, and memories of *place* that conjure, inform,
and cultivate identification.[11] Moreover, a rhetorical orientation toward
environmentality requires critics to attend to the contingent nature of
power and to the strategic enactments of the visual, material, and em-
bodied ways in which official discourses about the environment are
made public.

In this regard, Burns's *The National Parks: America's Best Idea*, a twelve-

hour documentary aired by PBS in September 2009, is a useful example of contemporary environmentality because of the ways in which it positions viewers as a public constituted by an interest in or identification with *American memories* of national parks as the ultimate exemplar of shared (i.e., democratic) nature and culture. Drawing extensively from Burns's signature blend of archival footage and photography, expert and lay testimony, and spectacular imagery of natural scenery, *National Parks* aims to invent a particular kind of environmental citizen-subject who values the parks and who may come to understand them through Burns's lenses. As I discuss below, *National Parks* aims to circumscribe or define what does and does not count as "the environment" in ways that suggest how the public should imagine appropriate ways of regulating the self and others. Here, the future(s) of particular places and of conservation are not necessarily determined through public policy and political debate, but through deeply personal ways of relating to and interpreting what it means to be a "good" (environmental) citizen. Similarly, Timothy Luke's observation that

> enviro-discipline . . . must methodically mobilize particular assumptions, codes and procedures to enforce specific understandings of the economy and society [that] generate eco-knowledges, like those embedded in notions of sustainability or development, . . . [because] they simultaneously frame the emergence of collective subjectivities suggests that environmentality is clearly a discursive process that normalizes the "ordinary practices of governance."[12]

Thus, by generating its own specific iconicity that confers status upon particular historical actors and particular kinds of nature at the expense of others, *National Parks* makes claims upon the present by articulating its version of the past to a narrative that endeavors to produce a safe, neoliberal outlet for green citizenship. This vision of environmental public memory offers a conservation-oriented citizenship that has little in common with many calls for sustainability and conservation promoted in the contemporary moment. In this way, *National Parks* positions viewers in a present past that requires little or no personal or political investment in social and economic change. Ultimately, this may backfire in ways that hamper the film's own calls to action for renewed investment and support for National Park Service (NPS) services and initiatives.

Visual Culture, Public Memory, and Ken Burns's Vision of America's (Imagined) Past

While early scholarship had to carve a niche within the predominantly speech-oriented focus of rhetorical studies in the 1970s and 1980s, its initial emphasis on the architecture and design of public places such as war memorials, national monuments, and museums provided a foundation for inquiry into how memory, national identity, and power become entangled in semipublic places like shopping malls, tourist destinations, and baseball stadiums. As the idea of what "counted" as rhetorical expanded with an eye toward popular and vernacular culture, scholars were free to explore a range of new artifacts and fragments. Within this context, a growing number of rhetoricians have offered variations on this theme by devoting their critical energies toward case studies demonstrative of nationalism, the contexts in which they are (re)produced and (re)circulated, and the cultural and political work that these discursive practices aim to accomplish.[13] Gregory Clark's analysis of rhetorical landscapes, for example, embraces a distinctly Burkean perspective that relies upon the explanatory power of the representative anecdote. Michael Bruner, following Nietzsche's approach to critical history, focuses on "controversial public speeches" and reactions to them in order to map "strategies of remembrance and their functions."[14] Robert Hariman and John Lucaites's contributions toward a rhetorical theory of civic identity have also made a significant impact on how conceptions of "the public," following Jürgen Habermas and Michael Warner, also require conceptualization of nation and identification. As they note, "concepts such as 'citizenship,' emotions such as civic pride, acts such as public advocacy, and practices such as critical reflection can only be taken up by others if they provide some basis for identification, some grounding in the positive content of lived experience."[15] Carole Blair and Barbara Biesecker, drawing from Foucault and critical-cultural studies, have also made significant contributions to these debates through their critiques of public commemorative practices that also raise the specter of nationalism. In their analyses of commemorative public art and popularly circulated rhetorics of World War II, respectively, they identify and call into question the problematic ways in which ideologically conservative discourses are granted normative status to frame historical events for present political gains.[16]

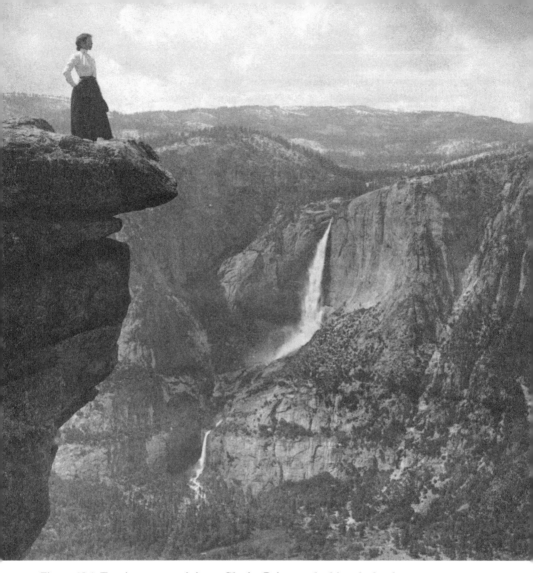

Figure 12.1. Tourist on a precipice at Glacier Point overlooking the landscape of Yosemite Valley near Yosemite Falls, circa 1902. Courtesy of Library of Congress Prints and Photographs Division, LC-USZ62-100935.

Nationalism, as Craig Calhoun and Tim Edensor have keenly observed, is discursively produced.[17] Continuously rehearsed and performed, its production takes place on numerous stages simultaneously. As a discursive practice that aims to produce or constitute a public that understands itself in relation to the nation in particular ways, nationalism's banal quality is anything but rhetorically uninteresting. Arguably,

it works together with public memory to cultivate common narratives and experiences capable of engendering affective responses to the idea of "the nation" and fulfilling the human need for identification.[18] The intersections of nationalism and public memory are frequent and, as demonstrated by Barbara Biesecker, are deeply rhetorical.[19] Michael Bruner notes that "nations do not have stable or natural identities. Instead, national identity is incessantly negotiated through discourse. What the nation is at any given moment for any given individual depends on the narrative accounts and arguments they bring to bear on the subject."[20]

One of the most visible, highly anticipated elements of the Centennial Initiative—a multiyear campaign and agenda comprised of public events, public-private partnerships, and media campaigns designed to stimulate political and economic support for the parks—was the fall 2009 PBS broadcast of Ken Burns's latest documentary, *The National Parks: America's Best Idea.* Burns is, arguably, the most influential, popular, and award-winning documentary filmmaker in contemporary American culture. For nearly thirty years, he has claimed the mantle of accessible and usable public history through his engagement with public broadcasting (PBS) and his obsessive focus on those elements of popular and political culture that are uniquely American. In this regard, Burns has crafted an enviable position as a director and producer whose ethos and popular credibility are perhaps unprecedented: for many people, Burns is a hero. As a self-described "emotional archaeologist" who takes issue with critical perspectives toward history, Burns's agency as a rhetorical actor often remains unquestioned and uncritically accepted in most media coverage of his films. Although his work has been soundly critiqued by academics for its endorsement(s) of neoliberal ideology, its interpretive liberties, its avoidance of intellectual controversies, and its misleading articulations of evidence in the service of advancing an entertaining narrative, his interpretations of history continue to be celebrated by the mainstream media. As he has done in the past to support the release of other documentaries, Burns spent much of 2008 and 2009 completing a heavily publicized national media tour designed to build anticipation and spark public interest in *National Parks.* On at least one occasion, Burns has referred to himself as an "evangelist" who preaches "the gospel of Americanism" while

remaining committed to the separation of church and state.[21] Perhaps not surprisingly, then, Burns has suggested in multiple interviews that America's national parks are a logical extension of democratic thinking into the natural world because they represent common ownership of sublime wilderness. These interviews work as a strategic rhetorical scaffolding that provides the media and the public with an a priori interpretive framework for situating and understanding his documentaries before they reach the public. Arguably, Burns is promoting not only his films but also a softer, gentler nationalism that is both banal and spectacular in its reach and scope.

Seen from this perspective, Burns's films are captivating because they offer a comforting narrative framework steeped in the pathos of national mythology and buttressed by the ethos of the archive. Despite the occasional gesture toward the darker side of American history, Burns's documentaries do not ask viewers to consider the contemporary implications or consequences of war, racism, or market rationality despite his insistence in the companion coffee-table book to *National Parks* that his films take up questions of race and space.[22] From *The Civil War* (1990) to *Baseball* (1994), *The West* (1996), and *Jazz* (2001), Burns's choice of subject matter demonstrates his personal commitment to extolling those particular elements of American history and culture that are, as Gary Edgerton notes, "epic and heroic in scope."[23] Indeed, as Stephen Ambrose once suggested, "More Americans get their history from Ken Burns than from any other source."[24] While Burns's work is well received by millions of viewers, academic and professional historians continue to lodge well-placed critiques against the ways in which his films present "the past" through teleological and nationalistic lenses that often oversimplify the contexts and contradictions of everyday life around issues of race, class, gender, labor, and power.[25] Jill Godmilow argues that Burns presents a "frightening" vision of American history "because he uses documentary as a kind of national therapy, producing a kind of mourning moment, a nostalgia for the past, in which one can find no useful questions or analyses that we could employ in today's realities."[26] Her concern is amplified by the fact that Burns's documentaries are often screened in educational contexts and supported by a wealth of supplemental materials—from lesson plans and class activities on the PBS website to coffee-table books and sound tracks—that

amplify and reinforce Burns's interpretation of American history as *the* most reasonable one.

Of particular significance is the way in which Burns has strategically positioned his work (and his dual role as an auteur and amateur historian) as demonstrative of what he has termed "emotional archaeology."[27] In his words, "There is something in the process of filmmaking that I do in the excavation of these events in the past that provoke a kind of emotion and a sympathy that remind us, for example, of why we agree against all odds as a people to cohere."[28] Thus, it is perhaps not too surprising that Burns often responds to scholarly criticism about his films by dismissing the notion that his work should be held to the same standards applied to scholarly historical inquiry. At the same time, however, Burns insists on the prominent role played by his team of researchers and the extent to which he consults and interviews academic historians throughout the production process.[29] As he did in May 2009 at a Miami preview of *The National Parks,* Burns often uses media interviews and public speaking engagements as opportunities for rhetorically positioning his work as an expression of a "third way" toward history. Here, Burns positions himself as rejecting a politically conservative view of history that privileges its most powerful actors while simultaneously rejecting liberal or critical-cultural orientations:

> I'm interested in that power of history, and I'm interested in as many varied voices. Not just the voices of the old top-down version of our past which would try to convince us that American history is only the story of Great Men—capital G, capital M—and not just those pessimistic voices that have recently entered our studies. Voices which seem to suggest that American history is only the study of white European crimes. I'm interested in listening to the voices of a true, honest, complicated past that is unafraid of controversy and tragedy, but equally drawn to those stories and moments that suggest an abiding faith in the human spirit.[30]

Such statements provide significant backing to Edgerton's argument that Burns's work "presents an image of the United States eventually pulling together despite its many chronic differences rather than a society coming apart at the seams. Exploring the past is Burns's way of reassembling an imagined future from a fragmented past."[31]

While Edward Casey is clear to maintain distinctions between in-

dividual, social, and collective memory that together create the category of public memory, he argues that "it always occurs in some particular place."[32] As he sees it, public memory thus requires a public place, public presence, public discussion, a common topic, and commemoration in place.[33] A telling example of the ways in which *National Parks* works to rewrite public memory by articulating unrelated historical events to place occurs in episode four ("Going Home"). After introducing the struggle to save the Smokies from deforestation as a grassroots, public effort funded by rich and poor alike, *National Parks* leaves the viewer suspended at a pivotal moment of crisis. Despite the efforts of schoolchildren and local boosters in Knoxville and Asheville to raise the funding required by the federal government to purchase the land, their collective efforts fall significantly short. Here, Burns moves the story line out west to Yosemite in order to focus on John D. Rockefeller's charitable contributions to the NPS and to celebrate his commitment to conservation. Shortly after, the film returns to the Smokies and to the Rockefeller family's ability to contribute the funds needed to establish the park. In these moments, *National Parks* positions the Rockefellers as exemplary environmental citizens able to transcend geographic, political, and class differences in order to contribute to the public good. In this way, the melodrama and material struggles of the Great Depression are forgotten amid the celebratory, heroic actions of the nation's wealthy philanthropists. In this way, the rationale for "saving" the Smokies and Yosemite from development is situated as evidence that the nation's wealthy elite shared a common interest in special, sacred, scenic places with common folk. Despite their differences, *National Parks* implies, Horace Kephart and John Rockefeller should be remembered as good citizens who loved nature and nation enough to make monumental sacrifices as part of a "shared" quest to democratize the wilderness.

"Prosthetic Memory" and the Situated Icon in *National Parks*

Despite its rich engagement with multiple techniques of visual representation, *National Parks* draws much of its rhetorical power from Burns's signature technique of incorporating historical photography into the documentary frame. By moving "through" the photographic image in

ways that bring the frame to life, Burns's technique borrows heavily from the representational practices of photojournalism in ways that transfer the ethos of the still image and its perceived abilities to capture and represent an objective truth or vision of reality. In this way, *National Parks* positions viewers as witnesses to an "authentic" past that can be known and experienced through explicit references to an image from "our" shared visual archive. And despite the fact that many of the images that Burns uses to tell "the" story of the national parks are not commonly recognized referents of collective memory, these images function as a form of "prosthetic memory" that provides the viewing public with a set of common rhetorical resources that can be used to navigate everyday life.[34] These "prosthetic memories" are both usable and accessible, as they "fit" rather adroitly into commonly held beliefs and values (i.e., cultural myths) about conflict, resources, individual achievement, and the spectacular, spiritual power of nature to improve the human condition. Although they may not necessarily be reproduced with the same frequency as the meta-iconic photographs that Hariman and Lucaites refer to in their project, the specific iconicity of the photographs in *National Parks* matters because they have been articulated to Burns's narrative of History and situated within the context of the film *as if* they always were, are now, and will always be iconic representations of a shared national past. As Hariman and Lucaites suggest in their detailed analysis of photojournalistic practices and the role played by iconic photographs in public life in the twentieth century as a tool in the creation of citizen-subjects, iconic photographs are important rhetorical resources because they are capable of "reproducing ideology, communicating social knowledge, shaping collective memory, modeling citizenship, and providing figural resources for communicative action."[35] In their discussion of iconic photographs like *Raising the Flag on Mount Suribachi,* the *Times Square Kiss,* and *Migrant Mother,* Hariman and Lucaites argue that a photograph must be widely circulated, influential on public opinion, and reappropriated across multiple mediated contexts.[36] From this perspective, the potentiality for a photograph's iconicity is, to some extent, defined by its origins. To *become* an iconic photograph, then, an image must originate with a photojournalist and then circulate in print media *as* a photograph before being taken up in other contexts.

While the photographs selected by Burns might not necessarily be recognized as icons of cultural memory, nor do they necessarily originate from behind the lens of the print-based photojournalist, I suggest that their selection from the archive and their incorporation by Burns as "moving" icons serve to amplify their visibility. Furthermore, Burns's aesthetic permits the reuse of the same photographs as visual "bookmarks" or heuristics for particular historic moments. This repetition confers them with a different kind of iconic status that is perhaps bolstered by Burns's own ethos and popular reception as a vernacular historian. Many of these archival photographs accrete new meaning as prosthetic memories that suggest a softer, gentler American history despite other evidence to the contrary. And because Burns's documentaries benefit from extraordinarily high rates of visibility and circulation in public and educational settings, they are often perceived as highly credible, accessible narratives by the viewing public long after their initial broadcast window. In this regard, the archival photographs incorporated into Burns's documentaries have significant potential to become iconic within a particular context or discourse and, by extension, accrete cultural resonance as *the visual representation* of that discourse. Here, specific iconicity is a rhetorical tactic that simultaneously confers and reaffirms recognition of the photograph as culturally and historically significant. In the case of *National Parks,* this specific iconicity matters because these photos articulate an American (environmental) history tied to a particular vision of democracy and citizenship. Here, *National Parks* offers a compelling narrative that is perhaps best described as environmental public memory. As trusted sites/sights, images and narratives about national parks aim to induct visitors into a "powerful constitutive rhetoric [whose] function is to constitute in those who experience it individual identities of collective affiliation and division" that produce, according to Clark, "public experience."[37] According to a 2001 report commissioned by the NPS and produced by the NPS Advisory Board, chaired by John Hope Franklin, "A third of all adults of this country have visited a unit of the National Park Service sometime within the past two years. Surveys show visitors give the parks an approval rating of 95 percent for their inspiring sights, useful information, and helpful personnel. The experience is often powerful and sometimes memorable over a lifetime."[38] These levels of public

trust translate in ways that ascribe a particular ethos or gravitas to the NPS and work to bolster its presentations of nature and culture as representative—even if interpreted—truth.

As noted by Michael Hyde, ethos is a fundamental component of rhetorical practice that "takes form as a result of the orator's abilities to argue and to deliberate and thereby to inspire trust in an audience."[39] And, as Edensor suggests, "the staging of the nation for education and entertainment is a long-standing feature of national culture . . . [and] stagings of officially sanctioned forms of knowledge demand a particular kind of audience participation."[40] Thus, *National Parks* activates the credibility of the archival photograph as evidence that supports the film's other claims to historical accuracy. In this way, the specific icon works to cultivate a visual ethos that translates into authenticity of experience— itself a critical component of prosthetic memory. While national parks are similar to other public memory places, such as memorials and monuments that provide situated instruction in the care of the self as a constituent of the nation, *National Parks* draws from a multiplicity of places to articulate a comprehensive perspective toward the past and the present.

From the initial foray into the series, "The Scripture of Nature" (episode one), through its conclusion in "The Morning of Creation" (episode six), *National Parks* juxtaposes impersonal yet spectacular moving imagery of iconic nature with still portraits of those individuals who contributed to the enactment of the "park idea" alongside those who refined it, challenged it, or benefited from it. From high-definition color footage highlighting the formation of new islands born from lava in Hawaii and sunrise at the foot of the Tetons to the repetitive use of a sepia-toned photograph of John Muir, *National Parks* articulates these still and moving images as if they were part of a unified visual, cultural, and geographic history. Rather effortlessly (and with the appearance of historical accuracy), *National Parks* weaves in and out of time and place in ways that visually destabilize the specificity of history, culture, and geography while situating the continued, intergenerational perseverance of the nation and its people as the ultimate unifying factor in contemporary American life. In doing so, *National Parks* presents its version of the American past and the birth of the "park idea" as family story or an inherited narrative—a preliterate, oral history—that had been temporarily lost to the demands of modern life until unearthed and pieced back together as a virtual scrapbook by Burns and company. Indeed,

National Parks brings recognition to the idea of multicultural difference as a fundamental component of the mythical "melting pot" in ways that preserve the homogeneity of the metafamily narrative. Despite its circulation as a form of mass media, *National Parks* seems to fulfill a prosthetic need for identification across difference. As Alison Landsberg contends,

> Prosthetic memories do not erase difference or construct common origins. People who acquire these memories are led to feel a connection to the past but, all the while, to remember their position in the contemporary moment, an experience quite different from that of medieval Christians, who were invited to experience the biblical past as if it were part of the present. [Thus] prosthetic memory creates the conditions for ethical thinking precisely by encouraging people to feel connected to, while recognizing the alterity of, the "other."[41]

Here, *National Parks* invites viewers to "take on memories of a past in which they did not live."[42] In this way, those photos and images that are seemingly "anonymous" at first glance take on an extended meaning or value as synecdochal representations for "our" shared or collective past. In a word, images like this one *become* iconic through their deployment, repetition, and articulation to the narratives offered by historical witnesses from "the past": these narratives are accessible and general enough to invite the viewer's identification with an "imagined community" of others in the present whose experiences and family histories resonate within the spaces of ambiguity that the specific iconography of *National Parks* seems to invite. In this way, Landsberg's proposition that "prosthetic memory makes possible a grounded, nonessentialist, nonidentity politics based on a recognition of difference and achieved through 'strategic remembering'" leads to the idea of a technology of the self that provides access to a desired encounter with the past and a set of strategically ambiguous heuristics that can be adapted to the particular, individual needs and desires of the viewer.[43]

Engaging the (Therapeutic) Rhetoric of Conservation Civics

Although the cultural impact of *National Parks* remains to be seen in the years leading up to the NPS's centennial anniversary, I suspect that this documentary will garner significant attention and accolades because of its connection with Burns. While Burns and Duncan have claimed a

particular rhetorical space for their agenda as one that advances the rich complexity of American history for everyday use and inspiration, *National Parks* is a declaration of environmental public memory that advances an agenda of conservation civics. Arguably, discourses that contribute to an ethic of conservation civics warrant critical attention because of the political, cultural, and rhetorical work that they purport to do. As highlighted in *National Parks,* conservation civics deemphasizes or elides the role of conflict, presents conservation *as* commemoration, positions the relationships between nature and culture as national and free of local complexity or nuance, and encourages the public to value these particular places as scenic and abundant natural resources of cultural and environmental inspiration. Discourses that deploy conservation civics do not generally rely on scientific evidence to make their claims but instead depend on experiential ways of knowing that are often deeply affective, embodied, and pleasurable. Perhaps predictably, these discourses aim to make conservation an acceptable part of public life by *not* interrupting, challenging, or contesting the status quo. As conservation civics are performed, crisis is rendered invisible, but the future of the parks is still contested in the sense that these discourses position viewers and visitors as patrons of democracy: to support the parks is to support the nation, and vice versa.

Within the discourses of conservation civics, the ecological futures of the parks themselves are simply not discussed. Instead of engaging the public by presenting the precarious nature of the parks' ecological situations as a fundamental element of how we should value (and revalue) the relationships that shape how people negotiate nature and culture in everyday life, the question is simply not raised. "What crisis?" seems to be the dominant refrain of the day, despite mountains of evidence—scientific, as well as anecdotal reports from NPS employees—that indicate that the parks are in danger due to overuse, underfunding, abusive forms of recreation that irreparably damage the terrain, and off-site pollution that undermines air and water quality, as well as other aesthetic considerations. And while there are clearly different registers of resistance, appropriation, and rejection taking place that undermine and challenge these ways of presenting nature and culture to the public, the rhetorics and performances of conservation civics aim to produce an environmental subject who is generally un(der)informed about environmental issues and whose affective relationship with place is rooted in

patriotic identification with the nation. In essence, viewers are figured as park supporters and as good citizens simply by tuning in: viewers are rewarded for embracing a definition of conservation offered by *National Parks* that has little to do with its material, political, and ecological realities. Indeed, viewers are encouraged to interpret their patronage of the NPS as visible proof that they are ethical subjects—good citizens, as it were. Conservation civics, then, encourages business as usual and consumption as usual. Critical awareness of the discourses of conservation civics may enable critics to begin formalizing a theoretical framework for understanding the specific ways in which environmentality is produced as a way of relating to nature and culture.

Perhaps inevitably, viewers are positioned within the discursive framework of Burns's interpretation of liberal democracy. As *National Parks* suggests, environmental citizenship can be achieved through heroic individualism and decorous rhetorical acts that work within "the system" to make it more inclusive over time. This vision of citizenship is problematic because it continues to embrace (and perhaps even endorse) market-driven initiatives and enactments of official or state power that constrain the possibilities for political judgment and action while claiming to do the exact opposite. In this regard, *National Parks* engages in what Dana Cloud has referred to as consolatory or therapeutic rhetoric.[44] As the film cultivates patriotic affect, it gestures viewers away from critical reflection and deliberation. In this regard, it equips viewers with rather traditional resources for rhetorical invention and critique; as Cloud notes, "the political effect of the therapeutic is to shut down the possibility of public deliberation and collective engagement in politics."[45] Thus, this essay offers a preliminary way of thinking about *how* power is materially and discursively circulated, as "America's Best Idea" is used to inspire and discipline viewers to adopt new positions toward the environment, one another, and the ways in which "we" remember ourselves.

NOTES

1. Anne Mackin, *Americans and Their Land: The House Built on Abundance* (Ann Arbor: University of Michigan Press, 2004); and Carol Rose, *Property and Persuasion: Essays on the History, Theory, and Rhetoric of Ownership* (Boulder, Colo.: Westview Press, 1994).

2. Ken Burns, preface to *The National Parks: America's Best Idea,* by Dayton Duncan (New York: Knopf, 2009), xv.

3. See, for example, Mark Neumann's essay in this volume and his *On the Rim: Looking for the Grand Canyon* (Minneapolis: University of Minnesota Press, 1999). See also Gregory Clark's essay in this volume and his *Rhetorical Landscapes in America: Variations on a Theme from Kenneth Burke* (Columbia: University of South Carolina Press, 2004).

4. Arun Agrawal, *Environmentality: Technologies of Government and the Making of Subjects* (Durham, N.C.: Duke University Press, 2005), 229.

5. Ibid., 230.

6. Ibid., 219.

7. Ibid., 226.

8. Richard Grusin, *Culture, Technology, and the Creation of America's National Parks* (New York: Cambridge University Press, 2004), 161.

9. Ibid., 14.

10. Ronald Walter Greene, "Another Materialist Rhetoric," *Critical Studies in Mass Communication* 15 (1998): 21–41.

11. As Nikolas Rose and Tony Bennett both discuss at length, these rationalities were manifested through architecture, design, and planning to produce public places that furthered the objectives of the state by increasingly governing at a distance. Nikolas Rose, *Powers of Freedom: Reframing Political Thought* (New York: Cambridge University Press, 1999); and Tony Bennett, *The Birth of the Museum: History, Theory, Politics* (New York: Routledge, 1988). To this point, Rose argues that "the project of responsible citizenship had been fused with individuals' projects for themselves . . . thus, in a very significant sense, it has become possible to govern without governing society—to govern through the 'responsibilized' and 'educated' anxieties and aspirations of individuals and their families" (88). In this way, national parks may be interpreted as places that position visitors as environmental subjects who learn how to successfully navigate, negotiate, and internalize the particular ways in which nature and culture are articulated through a common framework as public national values or conservation civics.

12. Timothy W. Luke, "Environmentality as Green Governmentality," in *Discourses of the Environment,* ed. Eric Darier (Malden, Mass.: Blackwell, 1999), 145–51.

13. See, for example, Lawrence Prelli, *Rhetorics of Display* (Columbia: University of South Carolina Press, 2006).

14. Michael Lane Bruner, *Strategies of Remembrance: The Rhetorical Dimensions of National Identity Construction* (Columbia: University of South Carolina Press, 2002), 7–8.

15. Robert Hariman and John Lucaites, *No Caption Needed: Iconic Photo-*

graphs, Public Culture, and Liberal Democracy (Chicago: University of Chicago Press, 2007), 42–43.

16. Through their respective projects, Carole Blair and Barbara Biesecker offered fundamental interventions with regard to the articulation of Foucauldian studies and rhetorical studies into the discipline in the late 1980s and early 1990s. See also their recent work on a range of nationalist and public memorials, monuments, museums, and national media.

17. See also Craig J. Calhoun, *Nationalism* (Minneapolis: University of Minnesota Press, 1997); and Tim Edensor, *National Identity, Popular Culture and Everyday Life* (New York: Berg, 2002), 37–102. See also Norman K. Denzin, *Searching for Yellowstone: Race, Gender, Family, and Memory in the Postmodern West* (Walnut Creek, Calif.: Left Coast Press, 2008).

18. See Kenneth Burke, *A Rhetoric of Motives* (Berkeley: University of California Press, 1969).

19. Barbara Biesecker, "Remembering World War II: The Rhetoric and Politics of National Commemoration at the Turn of the 21st Century," *Quarterly Journal of Speech* 80 (2002): 393–409.

20. Bruner, *Strategies of Remembrance*, 1.

21. Interview with Timothy Larsen, *The Christian Century*, 15 July 2008, 26–31, reprinted online at http://www.religion-online.org/showarticle.asp?title=3567 and prepared by Ted Brock.

22. Burns, preface to *The National Parks*, by Duncan, xv.

23. Gary R. Edgerton, *Ken Burns's America* (New York: Palgrave, 2001), 8.

24. *Ken Burns*, PBS Online, http://www.pbs.org/kenburns/filmmakers/ (accessed 8 September 2009).

25. See, for instance, Vivien Ellen Rose and Julie Corley, "A Trademark Approach to the Past: Ken Burns, the Historical Profession, and Assessing Popular Presentations of the Past," *The Public Historian* 25, no. 3 (Summer 2003): 49–59; Robert Brent Toplin, "History on Television: A Growing Industry," *Journal of American History* 83 (1996): 1109–12; and Gary Edgerton, "Ken Burns' Rebirth of a Nation: Television, Narrative, and Popular History," *Film and History* 22 (1992): 119–33.

26. Jill Godmilow, in conversation with Ann-Louise Shapiro, "How Real Is the Reality in Documentary Film?" *History and Theory* 36, no. 4 (1997): 84.

27. David Thelan, "The Movie Maker as Historian: Conversations with Ken Burns," *Journal of American History* 81 (1994): 1031–50; Megan Cunningham, *The Art of Documentary: Ten Conversations with Leading Directors, Cinematographers, Editors, and Producers* (Berkeley: New Riders, 2005), 13–45; see also "Q&A with Ken Burns," PBS Online, http://www.pbs.org/nationalparks/about/qa-ken-burns/ (accessed 18 August 2009).

28. Edgerton, *Ken Burns's America*, 14n59.

29. Cunningham, *The Art of Documentary*, 13–45.

30. Ken Burns, "National Park Screening," 6 May 2009, University of Miami, http://ka.uvuvideo.org/_Ken-Burns-National-Parks-Screening-at-University-of-Miami-part-1-of-2/VIDEO/638539/86294.html?widgetId= 145238 (accessed 12 August 2009).

31. Edgerton, *Ken Burns's America*, 20.

32. Edward S. Casey, "Public Memory in Place and Time," in *Framing Public Memory*, ed. Kendall R. Phillips (Tuscaloosa: University of Alabama Press, 2004), 20–32.

33. Ibid., 32–36.

34. Alison Landsberg, *Prosthetic Memory: The Transformation of American Remembrance in the Age of Mass Culture* (New York: Columbia University Press, 2004).

35. Hariman and Lucaites, *No Caption Needed*, 9.

36. Ibid., 5–10.

37. Clark, *Rhetorical Landscapes in America*, 26.

38. *Rethinking the National Parks for the 21st Century: A Report of the National Park System Advisory Board, July 2001*, http://www.nps.gov/policy/report.htm (accessed 29 November 2008).

39. Michael Hyde, ed., *The Ethos of Rhetoric* (Columbia: University of South Carolina Press, 2004), xvi.

40. Edensor, *National Identity*, 32.

41. Landsberg, *Prosthetic Memory*, 9.

42. Ibid., 8.

43. Ibid., 152.

44. Dana Cloud, *Control and Consolation in American Culture and Politics: Rhetorics of Therapy* (Thousand Oaks, Calif.: Sage, 1998).

45. Ibid., xx.

13. AMERICA IN RUINS
Parks, Poetics, and Politics

Thomas Patin

ON A RECENT TRIP to Chaco Culture National Historical Park in northwestern New Mexico, I visited Pueblo Bonito, an especially prominent ruin in the park. At the site were several workers making repairs to the masonry walls of the building (Figure 13.1). A small sign, titled "Preserving Chaco's Past for the Future," explained that the work is needed because the structure is

> exposed to wind, rain, snow, and freeze-thaw cycles that rapidly deteriorate the thousand-year-old rooms and walls. The NPS must constantly work to repair and preserve these walls so that they will be here for future generations to see, learn from, and admire.

The sign went on to describe the work being done by a "preservation crew" in some detail and explained the technique of "repointing" that was being used to repair the masonry. The sign described how the crew was removing sandstone blocks that had deteriorated and replacing them with "more stable" sandstone blocks that will remain in good condition for at least a decade. The sign also included a pair of side-by-side "before and after" photographs, one showing Pueblo Bonito in the late 1800s and the other showing the same site now.[1]

Decade after decade, workers replace tons of the material at the ruin, but, ironically, the site still stands for what it did before: something ancient, lasting, prehistoric, and ahistorical. In a very important and almost literal sense, we are not looking at the ruin itself when we gaze at Pueblo Bonito, but at something that has become a representation of the thing we came to see, no matter how much or how little of the "original" material is still visible. This is very similar to what Roland Barthes points

Figure 13.1. National Park Service worker stabilizing wall at Pueblo Bonito, Chaco Culture National Historical Park, New Mexico. Courtesy of the National Park Service.

out about the *Argo,* the ship from Greek mythology. Each piece of the *Argo* was gradually replaced, so that by the time Argonauts ended their journey, they had an entirely new ship but with the same form and the same name. As Barthes explains,

> This ship *Argo* is highly useful: it affords the allegory of an eminently structural object, created not by genius, inspiration, determination, evolution, but by two modest actions (which cannot be caught up in any mystique of creation): *substitution* (one part replaces another, as in a paradigm) and *nomination* (the name is in no way linked to the stability of the parts): by dint of combinations made within one and the same name, nothing is left of the *origin: Argo* is an object with no other cause than its name, with no other identity than its form.[2]

Chaco Canyon is in the middle of a high and very dry desert, far from any ocean. Still, Barthes's discussion of the *Argo* is appropriate. If stone

after stone is replaced during decades of archaeological stabilization, what is left of the ruins in the park? Like the *Argo*, Pueblo Bonito continues through a series of substitutions—replacing one stone after another—and it persists through a specific practice of nomination—the continual presentation, exhibition, and display of the ruin as "Pueblo Bonito."

The central idea I explore in this essay stems from the idea that national parks and monuments use cultural and natural materials to create naturalized representations.[3] These representations are continually stabilized and maintained in order to ensure their "authenticity," as well as to enhance their coherence and effectiveness as didactic materials. They are stabilized not only through physical labor at ruins, for example, but also through the powerful workings of a virtually invisible rhetoric upon park visitors. It is this rhetorical or poetic dimension that I address in this essay, and to some extent, this exploration has a great deal in common with Robert Bednar's essay in this volume. Bednar is working to demonstrate how the naturalized visual rhetoric used in national parks is rooted in material display technologies that mediate park experiences. In my essay, I investigate various techniques of museological presentation at Chaco Culture National Historical Park in order to enhance the visibility of rhetoric, or visual poetics, installed there. My goal is to better understand how national park presentations operate on the visual experience of park visitors in such a way as to shape and enhance the significance of their encounters with ruins and other cultural materials in the park. To some degree my aim is to show how ruins are used to deliver information, messages, and lessons. But further, I want to understand how the presentations of cultural material in parks can be made to appear natural, as if they are not presentations at all, as if the messages they deliver about history, climate change, cultural demise, or Indian-white relations are, paradoxically, "natural artifacts" that have been unearthed with meaning intact. We need to better understand how the cultural and natural materials that are available to us to see in national parks are *presented* there to be seen. It is not as if we simply stumble upon the ruins at Chaco after driving thirty or so miles down some of the worst roads in the country. We are positioned so as to gaze upon a scene, and through our positioning a scene is created to be seen.

The presentations of ruins in American national parks have had as

their ultimate aim, I want to argue, the production of stable representations of and for America. At the same time, however, those representations inevitably fall apart, into ruin, due to their unstable rhetorical foundations and unpredictable uses by park visitors. My aim here is not to celebrate instability or meaninglessness but to further understand the processes by which visual materials and their presentations can be used to produce meaning and identity, however unstable. As W. J. T. Mitchell points out, when we study visual culture, the point is not to examine the social construction of the visual but the visual construction of the social.[4] Our task, paradoxically, is to "show seeing," or as Mitchell describes it, "to rethink what theorizing is, to picture theory and perform theory as a visible, embodied, communal practice, not as the solitary introspection of a disembodied intelligence."[5]

My investigation of the museological techniques of presentation of cultural materials in Chaco is essentially an investigation of visual rhetoric, or visual poetics. As I have already defined in the introduction to this volume, visual rhetoric is the strategic uses, functions, and operations of a wide range of visual signifying materials and practices used to accomplish some particular thing (to persuade, make sense, form attitudes, induce action, build community or consensus, or believe that an illusion is realistic). Following that understanding of visual rhetoric, and using Chaco Culture National Historical Park as an example, I want to suggest that national parks are essentially museological institutions, not because they preserve and conserve, but because they employ many of the techniques of display, exhibition, and presentation that have been used by museums to regulate the bodies and organize the vision of visitors. Such a strategy is essentially visual and rhetorical and produces a "vignette of America" that insinuates the institution of the museum into park spaces, produces specific understandings of the cultural and natural world, and furthers specific ideas of America's *cultural* heritage. In a general sense, this project is similar to Sabine Wilke's essay in this volume, where she explores the possibilities of "national characteristics" of landscape paintings of the American West.

The idea that national parks can or should produce "vignettes" of America comes out of a report to the National Park Service (NPS) from the Advisory Board on Wildlife Management in 1963, the so-called Leopold Report.[6] The recommendations of this report were adopted as

part of NPS management policy, although the same general principle had been practiced since national parks were established.[7] The report produced a specific understanding of park management in the United States:

> As a primary goal, we would recommend that [the conditions] within each park be maintained, or where necessary recreated, as nearly as possible in the condition that prevailed when the area was first visited by the white man. A national park should represent a vignette of primitive America. . . . A reasonable illusion of primitive America could be recreated, using the utmost in skill, judgment, and ecologic sensitivity. This in our opinion should be the objective of every national park and monument.[8]

In the summary of the report the panel recommends that the goal of managing the national parks should be "to preserve, or where necessary to recreate, the ecologic scene as viewed by the first European visitors."[9] Explicit in the report is a specific relationship of park lands to the history of American entry into those locations, thus making the parks and their "resources" (flora, fauna, cultural materials) significant insofar as they re-create a specific moment of American history. But that relationship must be strictly implicit, as reflected in further recommendations that "observable artificiality in any form must be minimized and obscured in every possible way" so as to achieve the goal of creating or maintaining a "mood of wild America."[10] The NPS, the report recommends, should have as one objective to "manage 'invisibly'—that is, to conceal the signs of management."[11] This is especially important for my study because while the NPS attempts to manage invisibly, to conceal signs of management, to create a picture or vignette that is not painted by any hand, it nevertheless produces visual rhetoric that is demonstrable and that can be understood and examined.

The Leopold Report based its recommendations on the founding legislation of the NPS, the "Organic Act" of 1916. The legislation established the duties of the NPS:

> The service thus established shall promote and regulate the use of the Federal areas known as national parks, monuments, and reservations hereinafter specified by such means and measures as conform to the fundamental purpose of the said parks, monuments,

and reservations, which purpose is to conserve the scenery and the natural and historic objects and the wild life therein and to provide for the enjoyment of the same in such manner and by such means as will leave them unimpaired for the enjoyment of future generations.[12]

Given the NPS's essentially paradoxical mission of preserving scenery *and* accommodating visitors, as set forth in the Organic Act, the agency had to develop ways to provide access to natural and cultural park resources without damaging them.[13] One of the many ways to accomplish that task is to present the natural and historic objects in parks visually, as if in a museum, so they can be enjoyed—untouched—from a distance. From the point of view I take in this essay, the NPS's mission became an essentially visual, aesthetic, and even rhetorical task, relying as it does on techniques of visual presentation that allow park contents to be seen but also leave parks available for future enjoyment. So while we might not usually consider roads, signs, trails, overlooks, and visitor centers to be culturally significant, they all can be seen as central to the task of presentation in the national parks. Further, the specific designs of these structures have also aided in presenting the contents of parks to visitors while still "managing invisibly." One example is the so-called rustic style, or parkitecture, of the early twentieth century, which had as its guiding principle the blending of architectural elements into the surrounding natural setting.[14]

The strategy taken by the NPS is not unlike the one articulated by Timothy Mitchell in his essay "Orientalism and the Exhibitionary Order."[15] "The problem for the photographer or writer visiting the Middle East," he explained,

> was not to make an accurate picture of the East but to set up the East as a picture. . . . The problem, in other words, was to create a distance between oneself and the world and thus constitute it as something picturelike—as an object on exhibit. This required what was now called a "point of view," a position set apart and outside.[16]

My task in this essay is to make more visible the strategies—the visual rhetorics—used by the NPS to set up the park's spaces and contents to be seen. I also hope to create a better understanding of visual rhetoric in general.

The passage of the Federal Antiquities Act in 1906 was in large part a consequence of the controversy surrounding early archaeological work at Chaco Canyon.[17] The nation's first law protecting antiquities, the act allowed President Theodore Roosevelt to establish Chaco Canyon National Monument in 1907.[18] The site was seen as deserving preservation and protection due to the long history of human settlement in the area and its archaeological significance.

About one thousand years ago, Chaco Canyon was an important center of Ancestral Puebloan (a.k.a. "Anasazi") life in what is now the four corners region of the United States.[19] People in the immediate vicinity farmed the lowlands and built large towns connected to other settlements through a road system. Settlement in the area began around 900 and shortly thereafter building began on dozens of large pueblos, including Pueblo Bonito. By the year 1000 Chaco was the political, religious, and economic hub of the region, and there may have been as many as five thousand people living in a few hundred settlements in and around Chaco Canyon. At one point Chaco may have been the center of a trading network that stretched as far south as central Mexico. By 1250 the immediate area seems to have been abandoned.

The historical importance and archaeological significance of the cultural remains in Chaco were not lost on the designers of many of the more public structures built by the NPS. After the establishment of the NPS, there began an intensive campaign of standardization of design of signs, roads, architecture, and didactic materials in parks. The entry signs at Chaco were constructed using generally the same stones and masonry styles used at the ruins, complete with windows, wooden beams, and so on. One entry sign, itself seemingly in ruins, announces both the location of the park and the nature and significance of the space (Figure 13.2). A turnout at the sign allows visitors to take pictures of one another at the entrance to the park standing or sitting next to the faux ruin wall. In this way, visitors can place themselves in, on, or next to a ruin-like structure immediately upon entering.

Chaco Culture National Historical Park has a simple network of roads converging on the visitor center that includes a long east-west loop along the length of a shallow, narrow canyon. Ruins, petroglyphs, pictographs, and occasional pottery shards are available to examine on both sides of the canyon. Visitors drive slowly along the loop (or walk, or

Figure 13.2. Entry sign at Chaco Culture National Historical Park.

bicycle) using occasional turnouts to leave their vehicles and examine the area more closely. Eyes are diverted away from the wash, which is really the ecological core of the immediate area, and toward the walls of the canyon where the "cultural resources" are located. In this way, visitors are oriented to the ruins and petroglyphs in such a way that their vision is regulated outward, horizontally, and toward a wall in exactly the same way as when people visit museums. Visitors do not stumble upon or discover the remains of Chacoan culture here. Instead, the visitors are strategically routed so that objects of archaeological significance are positioned to be seen by the public. In short, these objects are on display; they are exhibited.

Nearly every ruin or archaeological site has a small parking lot some distance away. Sometimes the distance between the lot and the site is to avoid disturbing unexcavated archaeological materials, but

the location of parking and the routes of trails to the sites perform an-
other function: that of visually orienting visitors to the sites. Visitors must
take some time to walk to sites, and along the way their view of each ruin
is regulated by the paths they are obliged to walk to get to each site. The
trail to Pueblo Bonito, the largest ruin complex in the park, is a good ex-
ample (Figure 13.3). The trail directs visitors' views as they walk directly
to the ruins with one side of each ruin visible at all times. Compared to
other national park sites, there are fewer signs, walls, fences, and other
forms of traffic control. Didactic panels are few in Chaco; most of that
kind of information is at the museum in the visitor center. Once visitors
walk to the vicinity of a ruin, they can get fairly close to petroglyphs and
pictographs, ruin walls, and so on. They can even walk through some
rooms in some of the ruin complexes.

After visitors arrive at the foot of Pueblo Bonito, most of them walk
a path around the east side of the ruin up a small rise to a spot that al-
lows for a panoramic view of the complex (Figure 13.4). The overlook

Figure 13.3. Trail to Pueblo Bonito, Chaco Culture National Historical Park.

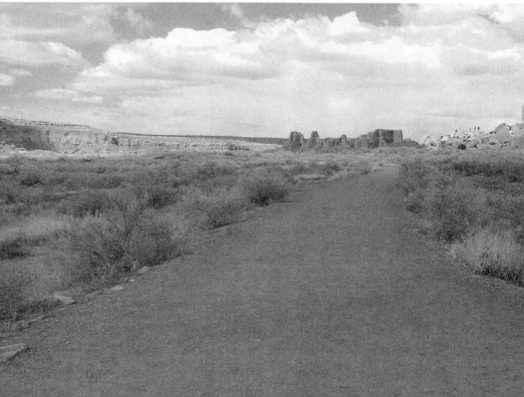

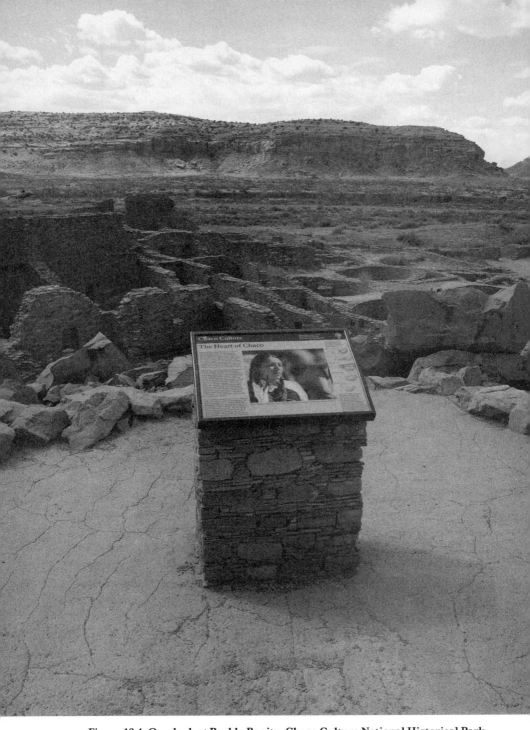

Figure 13.4. Overlook at Pueblo Bonito, Chaco Culture National Historical Park.

in effect announces "this is the place to see and that is the thing to see from here." The elevated point of view made available for viewers from overlook designs like this one produces what art historian Albert Boime has described as the "magisterial gaze." This is essentially the same gaze that Timothy Mitchell discusses, as I referred to earlier. To Boime, this viewpoint "embodies the exaltation of the nineteenth-century American cultural elite before an unlimited horizon that they identified with the destiny of the American nation." Its appearance in the art and architecture since the mid-nineteenth century reflects, according to Boime, "the sense of enormous possibility that Americans were beginning to share about the future of their new country and their desire to root out vestiges of the old world."[20] This gaze of command, or "commanding view," is "the perspective of the American on the heights searching for new worlds to conquer."[21] The magisterial gaze, to Boime, represents both a visual line of sight and an ideological vision: it supports the expansionist desire "by always projecting the vision across the valley as a step ahead of the point where the viewer is located at any given time."[22] From Boime's point of view, the location, height, and orientation of the overlook—the poetics of the overlook— suggest that Chaco Canyon is now firmly part of American territory, American history, and American culture. At this overlook, the dominant visual rhetorical device used is the positioning of the viewer at an elevated position. It allows for a comprehensive view, to be sure, but it also exhibits a specific relationship of park visitors to the history of indigenous people.

At Pueblo Bonito, as elsewhere in the park, ruins are in a state of semireconstruction, or "stabilization." They are not completely rebuilt, as is, for example, a large kiva at Aztec Ruins National Monument, fifty or so miles north of Chaco, but stabilized enough to give an idea of what the buildings may have looked like at the height of Chaco culture. At the same time, there is enough of each structure left in ruins to ensure that the visitor knows that the buildings are no longer occupied. The level of stabilization is more or less constant; the ruins are not allowed to deteriorate further. Maintenance on the ruins, like I described at the beginning of this essay, ensures that they remain visibly ruined, that they do not disappear. There is no improvement, no change, no vitality.

Consistent with the Leopold Report's recommendations, the relative absence of obvious indications that the park is constructed is purposeful. The point is to make the contents of the park visible to the public, to present things to park visitors, to exhibit, but to do so in a way that is barely visible. As I have already described, this is accomplished through the use of transparent, seemingly unmediated museological visual rhetoric. The strategic and economic use of didactic panels, the exercise of subtle traffic control, and the seeming naturalness and simplicity of trails leading to ruins all aid in the poetics of transparency and realism. The visual rhetoric of presentation here depends on the aesthetic of realism, denying its own artificiality, enhancing transparency and producing a "reality effect."[23]

There is a strategic use of detail throughout presentations in the park that aids greatly in the achievement of realism.[24] There are enough remaining, rebuilt, and stabilized ruins to allow visitors to understand exactly how buildings were constructed. Millions of small and shaped sandstone "bricks" are left exposed. Vigas and latillas used for roofs and ceilings are visible. One or more of the five masonry styles found at Chaco are used in the construction of the entry signs, the visitor center museum, didactic signs, and of course in the stabilization and reconstruction of the ruins. Thousands of petroglyphs are presented on canyon walls. All these details are engrossing and edifying. The detail enhances transparency and realism and helps to educate the public about the culture that once thrived here. More to the point of this essay, the details act as part of a larger visual rhetoric of presentations and pronounce: "all this is real." At the same time, however, these details announce their own artificiality, because the real does not need to pronounce itself as real (or at all). The realism that is achieved through this specific rhetorical strategy ultimately cannot sustain itself.

Presentational strategies at Chaco function not only through the presence of objects and details but also through absences. Consistent with the Leopold Report, the history of westerners (early traders, visitors, and archaeologists) at Chaco is also absent, with very few and hard to find exceptions. Other absences at Chaco are nearly overwhelming: the absence of a functioning Chacoan culture, buildings partly or completely missing, the absence of artifacts left by a thriving society, a lack of trees, resulting in an openness of the landscape—and there

is an enveloping silence. The ruins themselves are as much absences as presences, but their presence or absence should not be confused with either history or amnesia. The absence of ruins is related to amnesia, as Natalie Melas explains, but the relationship is the inverse of erasure: it is in fact "monumental history." "The absence of ruins," she explains, "conveys a paradoxical wholeness (the full presence of nothing) in which amnesia compensates for fragmentation precisely by failing to recall fully or clearly."[25] The presence of ruins, conversely, asserts partial history and memory. What is important in this essay is to keep in mind that absences work hand in hand with transparency, or an ostensibly invisible mediation, to create a sense of naturalized realism in park presentations.[26]

Around 2005 a new didactic sign was installed on a rise overlooking Pueblo Bonito. The previous panel described the history of construction and construction techniques used at the complex and included a large and detailed plan or map. While the new sign also discusses that history briefly, the primary point of the material is to state that there is an ongoing spiritual relationship between Chaco culture and the traditions of the Pueblo peoples in northern New Mexico and Arizona. The new panel discusses the question that has preoccupied professional archaeologists and park visitors alike: the absence of a continuing indigenous population at Chaco. Debates have long raged about the reasons for the civilization's disappearance, but the decline apparently coincided with a series of droughts, some prolonged, in the San Juan Basin starting in the late twelfth century. By the end of the twelfth century Chaco civilization had begun to decline. Droughts, combined with an overtaxed environment, may have led to food shortages and a slow social disintegration. According to this theory, people left the area for other regions with better water.[27]

The NPS's website for the unit provides an explanation of the demise of Chaco culture that includes the following:

> In the 1100s and 1200s, change came to Chaco as new construction slowed and Chaco's role as a regional center shifted. Chaco's influence continued at Aztec, Mesa Verde, the Chuska Mountains, and other centers to the north, south, and west. In time, the people shifted away from Chacoan ways, migrated to new areas, reorganized their world, and eventually interacted with foreign cultures.

Their descendants are the modern Southwest Indians. Many
Southwest Indian people look upon Chaco as an important stop
along their clans' sacred migration paths—a spiritual place to be
honored and respected.[28]

The causes of the "shift" away from Chaco and Chacoan ways are not
speculated upon in the passage above. The fact that the population at
Chaco left the area is stated, but no cause is given. In other sections
of the same website, the reader is led to the conclusion that Chacoan
people simply dispersed throughout the region:

Q: What happened to these people (where did they go)?
A: Chacoan people did not suddenly vanish! Though we are not
exactly sure of the reasons they left, possibilities might include
drought, resource depletion, social, religious, or political collapse,
time to move on, or a combination of these factors. In the 13th
century, there were migrations to the south, east and west. Today,
twenty Puebloan groups in New Mexico, as well as the Hopi in
Arizona, claim Chaco as their ancestral homeland and are tied
to this place through oral traditions and clan lineages. A number
of Navajo clans are also affiliated with Chacoan sites through their
traditional stories.[29]

So, while the people who once lived at Chaco did not "vanish," they
did at the very least leave the immediate area. The ruins that remain
are now and have been devoid of an ongoing residential indigenous
community for centuries, and we are left to wonder why. The above
passages only hint at some of the possible reasons. The NPS website
functions much in the same fashion as do the official NPS guidebooks
and handbooks, as explained by David Tschida in his essay in this
volume.

There is certainly no shortage of hypotheses for the depopulation
of Chaco. The explanation that is most often mentioned is related to
climate change, specifically, drought and resource depletion. Sometime
after 1040, when construction was at its height, Chacoans experienced
a number of short-lived, periodic droughts separated by short periods
of increased rainfall.[30] Then the periods of rain and drought began
to lengthen. Starting around 1080 there was a dry spell lasting about
twenty years followed by a thirty-year period of increased rainfall that in-

cluded a surge in building construction. Then a serious and prolonged drought was established by 1130 that lasted as long as fifty years. Local and even regional resources were quickly depleted, and by 1200 the population of Chaco canyon was much reduced and declining rapidly.[31] Scholars have identified a severe and prolonged drought that lasted at least from 1130 to 1190 as the most likely reason for the end of Chacoan culture.[32] Drought aggravated the quickly depleting natural resources in the locale, and various agricultural practices became unsustainable in the new conditions.[33] Text panels in the visitor center museum also point to drought as the primary factor that "weakened" the complex Chacoan culture.

The discussions of climate change and resource depletion as explanations for the end of Chaco culture and the realism of park presentations combine to naturalize the disappearance of Chacoan culture in two ways. First, the disappearance can be easily understood as due to a combination of natural and cultural causes: climate change together with specific cultural practices required drastic changes in the life of the people who occupied the area. Second, the realism of the presentations of ruins, petroglyphs, and other artifacts at Chaco by the NPS works to naturalize the explanations themselves: the evidence has been found; it is there, naturally, waiting to be seen. The cultural materials at Chaco are presented as if they are naturally occurring artifacts that already include their own explanation as a part of their material existence. Further significance can be extrapolated from the presentations of the evidence of climate change and cultural change: that the presence of American culture in the Chaco region is another natural turn of events—as natural as rain, or the lack of it. This can provide support, if not justification, for a federal presence in the area, and for the more generalized notion that Native Americans have virtually disappeared due to natural causes. This kind of quasi-commemoration is obviously not without its problematic and disturbing implications, as Stephen Germic details in his essay in this volume on memorials to native peoples.

I have written elsewhere about how nature has been converted into cultural heritage in American art and national parks.[34] America's vast natural resources have been converted into cultural heritage by treating them as if they are already part of our nation's *cultural* history, by

presenting nature as if it is art displayed in a kind of natural museum, the national parks. Through the use of a museological rhetoric of presentation, therefore, we can include natural wonders within a larger discourse on America's cultural heritage. Conversely, cultural materials in national parks and monuments can also be presented in such a way as to naturalize history. We can expand "America" significantly by presenting the archaeological materials at Chaco as if they are outside of any discourse on history, as if they are simply and naturally "there" to be seen without having to be presented. Presenting materials at Chaco as if they are natural components of the American landscape, as if they were not presented, inserts them—naturally—into the discourse on America. W. J. T. Mitchell, in his essay "Imperial Landscape," explains how the "semiotic features" of landscape can create a space for the expansion of "civilization," while at the same time making expansion into the landscape seem like a "natural" event.[35] Through a generally similar tactic, each block of stone that remains in ruins or that is used in the presentations at Chaco functions within a practically invisible rhetorical construction that makes the insertion of Chaco into "America" seem completely natural. Through this rhetorical process the ruins at Chaco become part of American history and American environmental politics as if they always already were part of America.

Of course, the extent to which Chaco seems to fit naturally and effortlessly into "America" depends not only on how the ruins at Chaco are presented, but also to some extent on how those presentations are received. Most visitors to parks belong to what Stanley Fish has called "interpretive communities" whose members share various assumptions, values, and, most importantly, various "strategies of understanding."[36] Meanings of texts or other cultural products do not emanate from either the object or the consumer alone, but through their interaction and through strategies of making sense. Benedict Anderson, in *Imagined Communities*, has developed generally similar ideas much further and has linked them to how nation-states developed in the colonized worlds of Asia and Africa. These states were not modeled on the dynastic empires of nineteenth-century Europe but on the specific forms through which those empires imagined themselves both at home and abroad. Anderson did not look simply at the ideologies and policies of imperial states but at "the *grammar* in which, from the mid nineteenth century,

they were deployed" (emphasis added).[37] Specifically, three institutions or practices made this grammar more visible: the census, the map, and the museum.[38] In his discussion of museums, ruins, and monuments, Anderson details how archaeological excavations and restorations on the part of colonial powers were initially used to legitimate their regimes but were increasingly linked to tourism. This positioned the imperial state as the guardian of traditions and historical legacies.[39]

The "grammar" that Anderson identified in use by both imperial nations and emerging nation-states was wide and varied but included many of the same rhetorical devices I have already discussed in this essay. For example, Anderson includes emptiness (an absence of people, except maybe for tourists) at archaeological sites as a key practice of the visual construction of history. Other practices at or about archaeological sites Anderson lists include detailed archaeological reports and lavishly illustrated didactic texts available to the general public about the ruins. "Museumized in this way," he explains, "[the sites] were repositioned as regalia for a *secular* colonial state."[40] The museum as a rhetorical colonial strategy, along with the map and the census, made the "style of thinking" of the colonial state—a style Anderson refers to as a "glass house" style—much more visible.[41] The image of the glass house transfers very well to my own discussion of transparency in this essay. Anderson calls the use of transparency in colonial museums and archaeological sites a "style of thinking" and a "grammar," and it is what I would include as examples of visual rhetoric or poetics. His discussion of the uses of ruins in colonial states as objects symbolic of those states is generally the same as my discussion of the uses of Chaco. This specific instance of a civilization in ruins, as Jonathan Culler discusses, "is a very particular semiotic frame which confers a conventional authenticity on what persists amid ruins."[42] In the case of Pueblo Bonito, I have argued that authenticity should be understood as the result of a kind of historical realism that is naturalized through transparent museological presentations.

On January 21, 1941, after a year of heavy rains, Threatening Rock fell and destroyed about thirty rooms at Pueblo Bonito that had been excavated by archaeologist Neil Judd in the 1920s. The giant wall of sandstone that once stood behind the ruin, true to its name, had separated from the main wall of the canyon and loomed over Pueblo Bonito

for eons. When the slab finally fell onto the ruins, it destroyed a large section of the complex (Figure 13.5). Pueblo Bonito and other sites at Chaco are ruined representations. They are ruins partially restored so as to shape a general importance and meaning to visitors. The idea that ruins—or indeed any form of visual culture—are simply made up of material things is an instance of extreme reification or misplaced concreteness. Instead, Pueblo Bonito is in large part an example of visual semiotic production—made of physical things, to be sure, but also part of a larger complex of meaning. So when Threatening Rock fell, it destroyed a great many possibilities of the significance of the ruin at Pueblo Bonito. Stabilizing the ruins is, in the context of this essay, and to return to my story at the start of this essay, stabilizing representations of and for America (Figure 13.6). There is another kind of stabilization going on here, however: while the NPS continually stabilizes the materials used in representations by replacing stones and setting them in mortar, park visitors stabilize the ruined representations by coming to some understanding of the sites and therefore narrowing some of the possible meanings to a smaller set of plausible understandings.[43] The rhetorical strategies that parks use to present information act as gate-

Figure 13.5. Pueblo Bonito from above, showing damage caused by the crash of Threatening Rock onto the ruins.

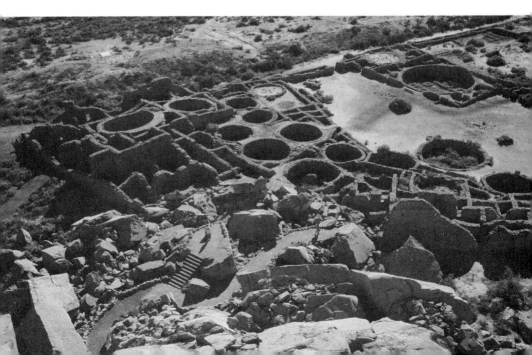

Figure 13.6. Stabilized wall at Pueblo Bonito, Chaco Culture National Historical Park.

ways that prepare visitors for their activities and attempt to prescribe their experiences to some extent.[44]

In Barthes's later work, he reminds us that the task of reading (or viewing) includes the enjoyment of the play of signs and meanings in a text. Settling meaning is neither ultimately possible nor necessarily desirable. Visitors use park presentations in varied and unpredictable ways, partly because the messages and their modes of presentation are themselves already unstable (hence, the constant need for stabilization). Following this line of reasoning, we may benefit from reimagining the activities of tourists. While we can come to some understanding about the ways in which design in national parks works on park visitors, we cannot assume too much about the actual narratives constructed or the lessons learned by park visitors. Tourists are unpredictable. They may stop at some turnouts but not others. They may read some interpretive

signs but not others. The control, organization, and regulation of vision through visual rhetoric do not have predictable results. Contrary to studies of tourist activities conducted by Dean MacCannell and others, tourism does not simply solidify, fix, construct (modernity), and colonize (nonmodernity).[45] Tourism also disrupts, destabilizes, unfixes, and critiques the dominant cultural schema. Instead of considering tourists as simply and blindly mystified about the true nature of their activities, we can understand touristic travel as producing semiotic slippages and unpredictable drifting that both defy the limitations of predetermined structures of interpretation at tourist sites and participate in what Gilles Deleuze calls "nomadic thought," a theorizing without theory. This is a practice that rethinks what theorizing is, that performs theory as a visible, embodied, and communal activity, that "shows seeing." Structures, fixed positions, and stable coherences are replaced by the tourist with an affirmation of, as Georges Van Den Abbeele explains, "travel from inauthentic marker to inauthentic marker without feeling the need to possess the authentic sight by totalizing the markers into a universal and unmediated vision."[46]

The museological rhetoric of presentation so commonly used at Chaco as well as in other American national parks at first seems to assist in the work of prescribing a kind of authenticity for park visitors. This technique of park presentation subtly inserts the space of the museum into parks and produces specific understandings of America's cultural heritage. But these presentations are unstable, and so they have an ironic outcome: an increased awareness of the visual rhetoric or poetics installed in parks. As a result, the realism and transparency of park presentations are diminished, and we can better understand how visual rhetoric operates upon the experiences of park visitors, how cultural material in parks can be made to appear as a natural part of the American landscape, and how visual materials and their (stabilized) presentations can be used to produce meaning and identity.

NOTES

1. In 1937, a two hundred–person Civilian Conservation Corps camp was constructed in Chaco Wash. The group began work at Chaco with an all-Navajo crew of stonemasons, who repaired many of the large excavated buildings that were threatened due to years of exposure to wind, rain, and freeze-

thaw cycles. Preservation measures continue to this day, and several members of the NPS preservation crew are second-generation Chaco stonemasons. See National Park Service, *A Brief History of Chaco Culture National Historical Park* (Washington, D.C.: National Park Service, 2000), http://www.nps.gov/archive/chcu/briefhis.htm (accessed July 2009).

2. Roland Barthes, *Roland Barthes* (New York: McMillan, 1989), 46.

3. My investigation into naturalized representations is strongly influenced by Roland Barthes's essay "Myth Today," in *Mythologies* (New York: Hill and Wang, 1972), 128–30.

4. See W. J. T. Mitchell, "Showing Seeing: A Critique of Visual Culture," *Journal of Visual Culture* 1, no. 2 (2002): 165–81.

5. Ibid., 178.

6. My discussion of the Leopold Report is from A. S. Leopold, S. A. Cain, C. M. Cottam, I. N. Gabrielson, and T. L. Kimball, *Wildlife Management in the National Parks: The Leopold Report* (Washington, D.C.: National Park Service, 1999 [1963]), http://www.nps.gov/history/history/online_books/leopold/leopold.htm (accessed July 2009).

7. Ibid.

8. Ibid.

9. Ibid.

10. Ibid.

11. Ibid.

12. Summary of "An Act to Establish a National Park Service (Organic Act)," 1916, from *America's National Park System: The Critical Documents,* ed. Lary M. Dilsaver (Lanham, Md.: Rowman & Littlefield Publishers, 1994). Also available online at http://www.nps.gov/history/history/online_books/anps/anps_li.htm (accessed July 2009).

13. Robert Frankenberger and James Garrison, "From Rustic Romanticism to Modernism, and Beyond: Architectural Resources in the National Parks," *Forum Journal: The Journal of the National Trust for Historic Preservation,* 2002, 8. Present discussion is indebted to Gregory Clark's "Remembering Zion: Architectural Encounters in a National Park," in this volume.

14. Frankenberger and Garrison, "From Rustic Romanticism to Modernism," 14. This style was replaced in the 1950s and 1960s by a kind of high modernism in park architecture but has more recently made a comeback. See, for example, the new Old Faithful visitor center in Yellowstone National Park, scheduled to open in 2010.

15. Timothy Mitchell, "Orientalism and the Exhibitionary Order," in *The Art of Art History: A Critical Anthology,* ed. Donald Preziosi (Oxford: Oxford University Press, 1998), 469.

16. Ibid.

17. See National Park Service, *A Brief History of Chaco Culture National Historical Park*.

18. On December 19, 1980, Chaco Canyon National Monument was redesignated Chaco Culture National Historical Park. On December 8, 1987, Chaco Culture National Historical Park was designated a UNESCO World Heritage Site, joining a select list of protected areas "whose outstanding natural and cultural resources form the common inheritance of all mankind." Ibid.

19. This summary of Chaco history is from National Park Service, *Chaco Canyon: Historical Aspects* (Washington, D.C.: National Park Service, 1996), http://www.nps.gov/history/worldheritage/chachist.htm (accessed July 2009).

20. Albert Boime, *The Magisterial Gaze: Manifest Destiny and American Landscape Painting c. 1830–1865* (Washington, D.C.: Smithsonian Institution Press, 1991), 38.

21. Ibid., 20–21. The opposite of the magisterial gaze is the reverential gaze: an upward-looking gaze common in European art and exemplified, rarely, in America in Zion National Park and a few others.

22. Ibid., 138.

23. The idea of the "reality effect" is from Barthes's essay "The Reality Effect," in *The Rustle of Language* (New York: Hill and Wang, 1986). In that essay Barthes uses the phrase "reality effect" to describe opposing constraints in representations—direct collusions of referents and signifiers—that stage an ostensibly pure encounter with the real. Many readers of art history and visual culture will be reminded of Linda Nochlin's essay on the relationship of orientalist painting to colonialism. Nochlin, following both Barthes and Edward Said, argues that nineteenth-century European orientalist painting was part of the larger rationalizing mechanism of colonialism. Orientalist painting participated in a general colonialist project through the use of a visual language of transparent naturalism (an absence of history, of westerners, and of "art" or artificiality). The realism of depictions of peoples and their cultures in the Near East helped to create a rationale for colonizing the region. See Linda Nochlin, "The Imaginary Orient," *Art in America*, May 1983, 119–31 and 186–91.

24. On the uses of detail, see Barthes, "The Reality Effect."

25. Natalie Melas, *All the Difference in the World: Postcoloniality and the Ends of Comparison* (Stanford, Calif.: Stanford University Press, 2007), 128.

26. There is also an absence of a thorough history of Indian-white relations. Granted, the European invasion of the area occurred some time after Chacoan culture shifted to other areas in the region, but there is an interesting administrative history of the park that includes Navajo population in the vicinity, as well as Pueblo tribes now living some distance away. See National Park Service, *A Brief History of Chaco Culture National Historical Park*.

27. Ibid.

28. Ibid.

29. Ibid.

30. See Brian M. Fagan, *Chaco Canyon: Archaeologists Explore the Lives of an Ancient Society* (Oxford: Oxford University Press, 2005), 198–99.

31. Ibid.

32. From Robert Hill Lister and Florence Cline Lister, *Chaco Canyon: Archaeology and Archaeologists* (Albuquerque: University of New Mexico Press, 1981), 204.

33. Ibid., 204–5.

34. Thomas Patin, "Exhibitions and Empire: National Parks and the Performance of Manifest Destiny," *Journal of American Culture* 22, no. 1 (1999): 41–59.

35. W. J. T. Mitchell, "Imperial Landscape," in *Landscape and Power,* ed. W. J. T. Mitchell (Chicago: University of Chicago Press, 1994), 17.

36. Stanley Eugene Fish, *Surprised by Sin: The Reader in Paradise Lost* (Cambridge, Mass: Harvard University Press, 1998).

37. Benedict R. Anderson, *Imagined Communities: Reflections on the Origin and Spread of Nationalism* (London: Verso, 1983), 163–64.

38. Ibid., 181–82.

39. Ibid., 181.

40. Ibid., 182–83.

41. Ibid., 184. Anderson cites the Indonesian novelist Pramoedya Ananta Toer for the figure of the glass house.

42. Jonathan Culler, "Semiotics of Tourism," in *Framing the Sign: Criticism and Its Institutions* (Norman: University of Oklahoma Press, 1988), 7.

43. Wolfgang Iser, *The Act of Reading: A Theory of Aesthetic Response* (Baltimore: Johns Hopkins University Press, 1978).

44. Hans Robert Jauss, *Toward an Aesthetic of Reception* (Minneapolis: University of Minnesota Press, 1982). Jauss explains that people within a culture share a common set of understandings about what is possible or probable. He calls this the "horizon of expectations."

45. Dean MacCannell, *The Tourist: A New Theory of the Leisure Class* (New York: Schocken, 1976).

46. Georges Van Den Abbeele, "Sightseers: The Tourist as Theorist," *Diacritics* 10 (1980): 14.

CONTRIBUTORS

Robert M. Bednar is associate professor of communication studies at Southwestern University, Georgetown, Texas. He is author of *Postmodern Vistas: Landscape, Photography, and Tourism in the Contemporary American West*.

Teresa Bergman is associate professor of communication and film studies at the University of the Pacific, Stockton, California. She is writing a book on the changing representations of patriotism, citizenship, and nationality at five U.S. historic sites.

Albert Boime taught at SUNY Stony Brook, SUNY Binghamton, and the University of California, Los Angeles. He published hundreds of books and articles that pioneered the social history of modern art, including his multivolume *Social History of Modern Art, The Magisterial Gaze: Manifest Destiny and American Landscape Painting c. 1830–1865*, and *The Art of Exclusion: Representing Blacks in the Nineteenth Century*. He died in 2008.

William Chaloupka is professor emeritus of political science at Colorado State University. He is author of *Everybody Knows: Cynicism in America* (Minnesota, 1999) and coeditor, with Jane Bennett, of *In the Nature of Things: Language, Politics, and the Environment* (Minnesota, 1993).

Gregory Clark is professor of English at Brigham Young University. He is author of *Rhetorical Landscapes in America* and coeditor of *Oratorical Culture in America*.

Stephen Germic teaches American literature and American studies at Rocky Mountain College with a focus on environmental themes and issues. He is author of *American Green: Class, Crisis, and the Deployment of Nature in Central Park, Yosemite, and Yellowstone*.

Gareth John is associate professor of geography at St. Cloud State University, Minnesota. He has published in *Cultural Geographies* (formerly *Ecumene*), *Journal of Historical Geography*, and *Gender, Place, and Culture*, and is writing a book on Yellowstone.

Mark Neumann is professor in the School of Communication at Northern Arizona University. He is author of *On the Rim: Looking for the Grand Canyon* (Minnesota, 1999).

Thomas Patin is professor of art history and director of the School of Art at Northern Arizona University. He is author of *Discipline and Varnish: Rhetoric, Subjectivity, and Counter-Memory in the Museum.*

Peter Peters is senior lecturer in the Faculty of Arts and Social Sciences of Maastricht University. He is the author of *Time, Innovation, and Mobilities: Travel in Technological Cultures.*

Cindy Spurlock is assistant professor of communication studies at Appalachian State University. She has published in *Text and Performance Quarterly* and serves as the lead Praxis editor of *Environmental Communication: A Journal of Nature and Culture.*

David A. Tschida is assistant professor of communication studies at the University of Wisconsin–Eau Claire.

Sabine Wilke is professor of German at the University of Washington. She is author of *Ambiguous Embodiment: Construction and Destruction of Bodies in Modern German Culture* and *Masochismus und Kolonialismus: Literatur Film und Pädagogik.*

INDEX

Advisory Board on Wildlife Management (1963). *See* Leopold Report
Altdorfer, Albrecht, 107
American Indian Movement (AIM), 174, 200, 242
Ancestral Puebloan (a.k.a. "Anasazi"), 273
Anderson, Benedict, 282–83
architecture, xiii, xvi, 34, 40–48, 50, 58, 65–67, 81, 83, 88, 92, 168, 195, 198, 252, 273, 277
Audubon, John James, xix, 218–19, 222, 223
automobiles in national parks, xvii, 41, 48, 55–72, 88–92, 96
Aztec Ruins National Monument, 277, 279

Barthes, Roland, ix, xiv–xvi, 86, 105, 267–68, 288n23
Berger, John, 187, 193–94
Bierstadt, Albert, xviii, 101, 110–16, 149, 198
Boime, Albert, 277
Borglum, Gutzon, 167–81, 196, 198–99, 201, 204, 231
Burns, Ken, ix, x, 247–63

Carracci, Annibale, 107
Carus, Carl Gustav, 103
Chaco Canyon National Historic Park, 134, 267–86
Church, Fredrick, 101, 103, 159n6
Civilian Conservation Corps, 286n1
climate change, 203, 269, 280–81
Cole, Thomas, 101, 159n6
connotation, xv–xvi, 124
conservation, 7, 9, 37, 39, 63, 65, 68–70, 80, 92, 135, 176, 250–52, 256–57, 262–64, 270, 272

Deas, Charles, 214–15, 216
denotation, xv–xvi, 231
documentary film, 191, 247–63

environmentality, 248–51, 263
environmental politics, xii, xiii, 122–23, 187–88, 191, 193, 202–4, 257, 262, 282

Federal Antiquities Act (1906), 273
Foucault, Michel, 144, 201–2, 204, 248, 252
Friedrich, Caspar David, 101–16